PUBLIC ART IN PHILADELPHIA

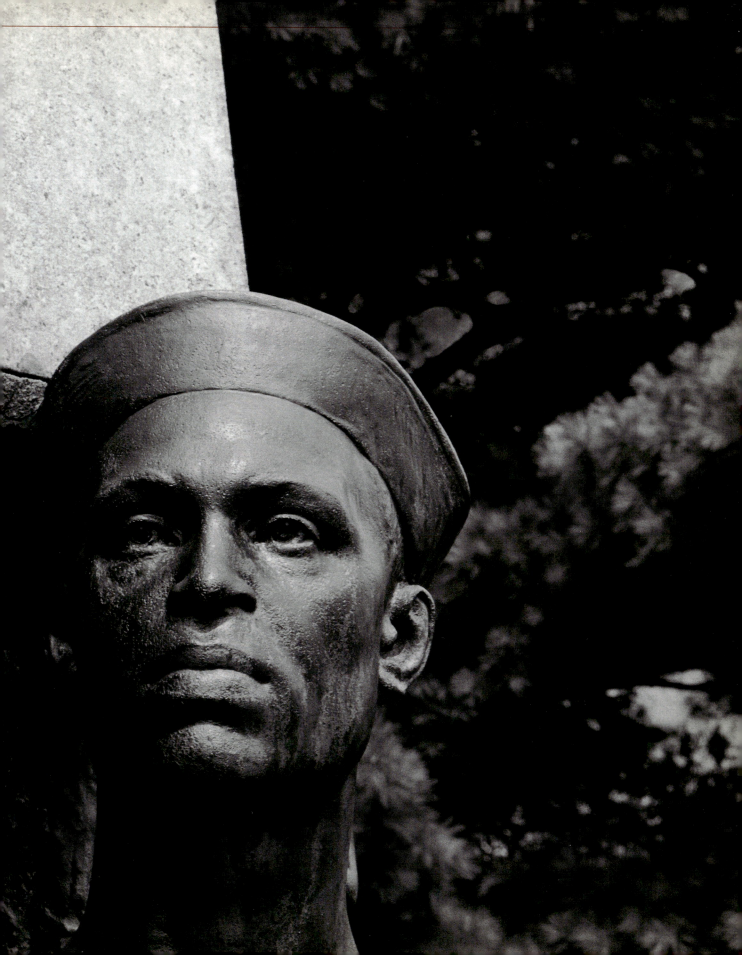

*Publication of this book, the second
in a series celebrating the cultural resources
of Philadelphia and the Delaware
Valley, has been supported by a grant from
The William Penn Foundation.*

PENNY BALKIN BACH

Public Art in Philadelphia

Design by KATZ DESIGN GROUP

Temple University Press
Philadelphia

To JC, who lent me his Watson
and his Scharf and Wescott

Temple University Press

Philadelphia 19122

© 1992 by The William Penn Foundation

All rights reserved

Published 1992

Printed in U.S.A.

Library of Congress Cataloging-in-Publication Data

Bach, Penny Balkin

Public art in Philadelphia : Penny Balkin Bach : design by

Katz Design Group

p. cm.

Includes bibliographical references and index.

ISBN 0–87722–822–1

1. Public art—Pennsylvania—Philadelphia.

N8836.P4B33 1992 92–11735

709′.748′11—dc20

Contents

For many years, the William Penn Foundation has devoted time and resources to efforts to improve the quality of life in the greater Philadelphia area. While sometimes this means addressing environmental problems, the lack of low-income housing, or the need for specialized medical facilities, the Foundation is also a regular supporter of the arts in their many and varied forms. One of its priorities in cultural grantmaking is expanding access to the arts, and this book is an expression of that goal. *Public Art in Philadelphia* is the second in a series of guidebooks planned to develop awareness and increase enjoyment of the cultural treasures in the Philadelphia area.

 Cultural Connections, published in 1991, was the first in this series. Focusing on museums and libraries in the region, it offered detailed descriptions of more than eighty institutions and a lengthy discussion of the relationship between the changing American experience and the choice of objects to preserve and display. Now *Public Art in Philadelphia* provides an opportunity to become better acquainted with the amazing variety of art, and particularly sculpture, which adorns our parks and buildings.

 Since 1792, when the first public monument—a marble figure of Benjamin Franklin—was installed over the main entrance to the Library Company of Philadelphia, the city has become well known for its extensive collection of outdoor art. In this century, Philadelphia led the way in requiring that a percentage of the cost of new construction be devoted to aesthetic enhancement. As the author, Penny Balkin Bach of the Fairmount Park Art Association, tells us, public art has frequently been associated with controversy. The familiar statue of William Penn atop City Hall, for instance, was said by its sculptor to have been placed in the wrong position, "condemned to eternal silhouette." He had intended it to face south, so that the face would be in sunlight throughout the day. The same statue was for many years the center of debate about the proper height of buildings in Philadelphia. By its nature, public art provokes arguments, in this city and elsewhere. The often acrimonious discussion about the Vietnam War Memorial in Washington, D.C., is only one of many other examples.

 Ms. Bach and the staff of the Fairmount Park Art Association—an organization which has been devoted to the promotion of public sculpture since 1872—have performed a remarkable service in collecting records and compiling the first computerized inventory of Philadelphia's public art. This achievement forms the basis for the present work. We are grateful to Ms. Bach for undertaking the task of writing this volume, and to David Bartlett, Director of the Temple University Press, for overseeing the production of the entire series.

 The William Penn Foundation is proud of the Philadelphia area: the natural beauty of countryside and rivers . . . the variety of architecture, ranging from colonial farmhouses to a baroque city hall . . . the quality and diversity of the cultural resources. These treasures, which are ours in common, deserve not only attention but celebration. This book is intended to encourage both.

Bernard C. Watson

BERNARD C. WATSON, PH.D.
President and Chief Executive Officer
The William Penn Foundation

The William Penn Foundation commissioned this book to draw attention to the city's extraordinary collection of art in public places and to inform and delight the general public for whom many of the works were originally intended. The term "public art" has been coined in recent years to describe various works of art that are located in the public domain, though not necessarily funded by the public purse. Historic works such as the *Swann Memorial Fountain* in Logan Square were created before this term evolved; but such works helped to shape the civic expectation of what would come to be called public art.

You can certainly enjoy looking at a work of art without knowing much about it, but you can't *understand* a work of art without learning something about it. Public art invites thought and engenders controversy precisely because it is there for everyone, in parks and plazas and on buildings and street corners. Our city is truly a "museum without walls," the result of a rich tradition that has become public policy.

Collecting information about public art is like maintaining a family genealogy: the challenge is to keep up with constantly changing information. There are always new arrivals, catastrophes, relocations, discoveries, and controversies. At the outset it was clear to me that for practical reasons this book could include only a selection of works. A complete record of all public art in Philadelphia would be voluminous and out of date by the time of publication. My objective therefore was to make a selection that would serve to illuminate the artistic, historical, political, and social trends and events that caused the works to be created and to become part of our public environment. Each work has its unique place in the continuum of public art in Philadelphia.

The research for this book began with the establishment of a computerized inventory of public art. Prior to this effort, there was no central repository for information about public art in Philadelphia. Works of art enter the public domain by many routes, and no single agency had maintained records to reveal the full scope of the city's impressive collection. The Fairmount Park Art Association, the city's Art Commission, and the Redevelopment Authority all commission, approve, or acquire public art. Museums, nonprofit organizations, citizens' groups, and private developers and corporations also have acquired works that are on public view. The inventory, now an ongoing project of the Fairmount Park Art Association, is a massive collection of more than a thousand records. It is updated annually to reflect the installation of new works and the removal or relocation of others, and it is available to the public in text format in the Art Department of the Philadelphia Free Library on Logan Square.

Following certain clues and hunches, I began this book by questioning how these numerous works came into the public domain. Philadelphia has acquired great examples of public art created by many of the world's most distinguished artists. How was this mostly volunteer effort sustained for so long? What conditions eventually prompted and fostered government advocacy of public art?

What risks were taken, and what patterns developed over time? The main theme that emerged was the tenacious and enthusiastic participation of individuals in civic life. The resulting works are widely disparate and represent Philadelphia's varied cultural history.

There are at least four ways to approach public art through the interrelated parts of this book. Six chapters examine the rich and diverse origins of the city's public art works. You will notice that the physical growth of Philadelphia and its planning efforts are important parts of this discussion of public art. Shorter essays make thematic "connections," cutting across the chronology to reveal links between works, ideas, artists, and civic missions. The alert observer can conjure up additional relationships among the numerous works throughout the city. The Catalog focuses on more than two hundred individual works, noting the materials and dimensions, location history, and commissioning process, and frequently exploring the artist's background and intention and the impact of the work as well. For interior works, a telephone number is listed because viewing hours, admission fees, and access for the handicapped may change over time. (Some works important to the history of public art but no longer located in their original public settings have been given abbreviated references in the Catalog.) Finally, maps have been added to encourage readers to view the works in their

public context—and to enjoy the chance juxtapositions that result from decades of placement and relocation decisions. Many works are discussed from different points of view at different places in the book, and Catalog numbers (e.g., **1-01**) are used to facilitate comparison.

Consider this a guide to understanding the nature of public art, and a companion that will prompt you to look at your surroundings with greater curiosity, heightened awareness, and a new appreciation for Philadelphia's cultural legacy.

12

Patriotism and
Pride
To 1835

CHAPTER

1

Native American Traces

Origins of a Public Art

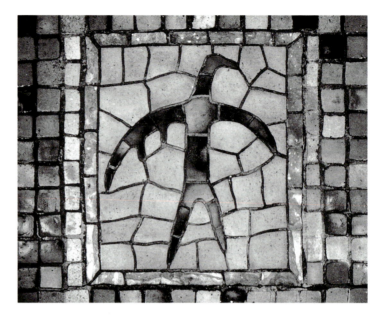

14

Henry Mercer, Moravian
Pottery and Tile Works
**Indian Rock: "The
Thunderbird with
Forked Tail" (mosaic
tile for State Capitol)**
1906

Public art is a manifestation of how we see the world—the artist's reflection of our social, cultural, and physical environment combined with our own sense of time and place. It is not an art "form," for its size can be monumental or diminutive, its shape can be abstract or figurative or both, and it may be cast, carved, built, assembled, or painted. What distinguishes public art is the unique association of its structure, location, and meaning. Public art can express civic values, enhance the environment, transform a landscape, heighten our awareness, or question our assumptions. Placed in a public site, this art is there for everyone, a form of collective, community expression—from the once-celebrated but now unrecognized general on a horse to the abstract sculpture that may baffle the passerby at first glance. Even a lack of immediate understanding

tells us something about a particular work of art; and if we ignore it altogether, that tells us something about ourselves. If we wonder why it was placed there, we soon question its origins as well: who made it, who put it there, for whom, when, and what does it mean?

The larger question of our own origins, and the powerful, instinctive desire to express them in visual terms, has been debated for years by scientists, historians, philosophers, and anthropologists. Our Paleolithic ancestors incised, carved, and painted vivid images in the dark recesses of caves in Altamira, Spain, and at Lascaux, in the Dordogne region of France. Closer to home, signs of human culture were traced on a group of small islands in the Susquehanna River in Lancaster County, Pennsylvania. There, Native Americans created petroglyphs, the earliest surviving pictorial art in this region.

Nineteenth-century anthropologists had noted the existence of these mysterious

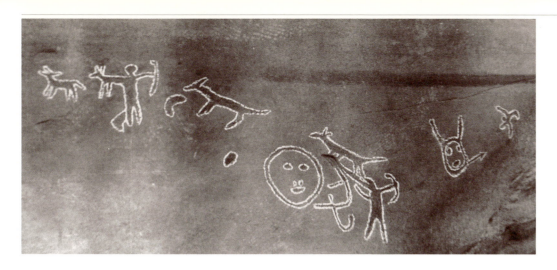

rock carvings. The craftsman and archeologist Henry Chapman Mercer reproduced some of these images in the tile pavement he completed in 1906 for the State Capitol in Harrisburg (see p. 72). When the installation of a power dam at Safe Harbor threatened the petroglyphs, the Pennsylvania Historical Commission surveyed the area. By 1934, many of the carvings had been drilled from the rock and transported as fragments to the State Museum—to save them from submergence. In the name of civilization and progress, numerous other such sites were destroyed throughout North America.

Pictograms—images derived from animal and human forms—were found below Safe Harbor at Big Indian Rock and Little Indian Rock. Meticulously incised turkeys, panthers, elk, snakes, "thunderbirds," and animal tracks are attributed to Algonquian-speaking Indians who lived along the Susquehanna between 1000 and 1400 A.D. Attempts to interpret the symbols with the help of Native American descendants were not particularly successful, no doubt because these survivors had suffered the destruction of yet another sacred and ceremonial site and were reluctant to divulge information to outsiders. The repetition of images strongly suggests a direct relationship between the pictograms and the dynamic beliefs of the culture that created them.

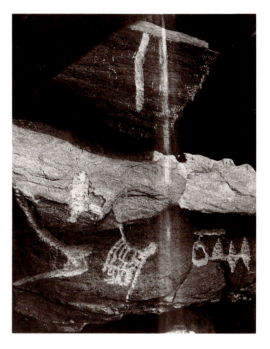

After Donald A. Cadzow
**Well of Water
(petroglyph on Walnut
Island)**
original drawing c. 1930

The symbolic carvings of an even more ancient culture existed above Safe Harbor at Walnut Island. These ideographs were less easily interpreted and decidedly more enigmatic in origin. Abstract, graphic symbols, they bear an astonishing resemblance to ancient Chinese writing. For example, variations of the Chinese symbol for "well of water" appeared frequently. The carvings remind us that Asiatic peoples traveled over the now-submerged land bridge of the Bering Strait. Following migrating animals, these hunters walked into an uninhabited landscape and became the native people of North America, bringing with them the need to communicate their physical and spiritual longings for survival and prosperity.

Although early Native American imagery was both abstract and figurative, it is unlikely that these rock carvings were "art" in the Western sense of the word. Jamake Highwater tells us that "for primal peoples . . . the relationship between experience and expression has remained so direct and spontaneous that they usually do not possess a word for art." As it turned out, the petroglyphs near Safe Harbor were not safe at all. Removed from their original context and site, they are now, as museum artifacts, no more than a poignant reminder of the ritual, ceremonial, and everyday significance that art can have for a people—our earliest reference to a public art.

> *"In no time and country was the plastic impulse
> less exercised and less encouraged than in the English colonies in America
> before the revolution."*
>
> Fiske Kimball
> **The Beginnings of Sculpture in Colonial America**
> *1919*

Practical Arts for the New World

The Craft Tradition

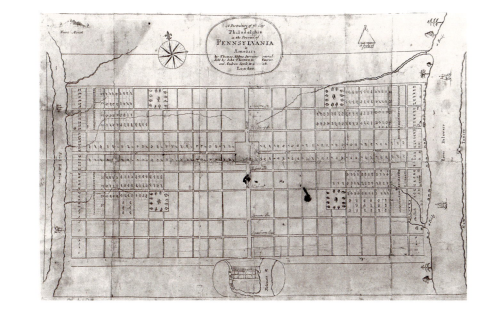

Thomas Holme
Plan of the City of Philadelphia
1682

"The air is sweet and clear, the Heavens serene." William Penn's Holy Experiment sought to establish a "free, just and industrious colony" in the New World for those seeking religious toleration and civil liberty. He described the region in utopian terms, and he envisioned a settlement with streets, parks, and other amenities designed to nurture its inhabitants.

Penn converted to the Quaker faith in 1667 at the age of 23, rejecting the established values of English society in favor of individual understanding and guidance through "Inner Light." Quaker austerity did not encourage visual expression, and many of the early immigrants to the New World were working-class people for whom the arts were unfamiliar luxuries. Thus, the Quaker colonists arrived in Pennsylvania lacking any tradition of or impulse toward art for the public. Patronage of the arts was set aside in favor of survival.

Penn was, however, a visionary planner and a lover of nature. After arriving in Philadelphia in 1682, Penn, with his surveyor, Thomas Holme, methodically established a grid of streets divided into four quadrants. In each of the quadrants, a public square of eight acres was set aside, with a 10-acre central square at the intersection of the two major thoroughfares. Every house was to be placed in the center of its lot "so that there may be ground on each side for gardens or Orchards, or fields, yet it may be a greene Country Towne."

The first European immigrants found a wilderness of forests and swamps. Most of the new settlers lived in caves, tents, and log cabins along the Delaware River. Life was far from comfortable as they began to clear the land and build their community. The bank of the Schuylkill River, although

Mill Weathervane bearing the initials of mill operators William Penn, Samuel Carpenter, and Caleb Pusey
1699

Attributed to
Joseph Rakestraw
***Hand in Hand* fire mark of The Philadelphia Contributionship**
c. 1771

only two miles to the west, was considered a formidable distance away. Initially, development stretched along the waterfront and not westward as Penn had planned. The subdivision of lots for new construction yielded alleyways, congestion, and visual disorder, thwarting Penn's concept from the start. But his vision of a "greene Country Towne" had an enduring impact on the physical and cultural growth of Philadelphia. The next three centuries would continue to test the relationship of the individual, the urban center, and the natural environment.

As the port grew, Philadelphia became a lively metropolis. A thriving import trade in furniture and household goods offered little opportunity to local artisans, who generally were asked to supply only those needs not satisfied through importation. Craftsmen were expected to carve stone markers, paint shop signs, and embellish furniture and buildings with wooden ornaments and metal weathervanes. Thus, American folk art had its roots in the practical needs of the new country. Perhaps we can think of these artisans as public artists responding to the needs of the society, artists by instinct and experience if not by formal training.

Other antecedents of public art were public amenities designed and situated for

Bicentennial re-creation of *Federal Edifice*
photograph 1987

Joseph B. Barry & Son
Label from Philadelphia *Pier Table*
c. 1810–1815

the use and benefit of Philadelphia's citizens. The city's oldest fire mark, the *Hand in Hand*, was placed on the front walls of insured houses by the Philadelphia Contributionship for Insurance of Houses from Loss by Fire. The Contributionship was established in 1752, and its symbol still can be seen affixed to housefronts: four hands united for the good of the community. Among other 18th-century "Changes and Improvements in Public and Domestic Comforts and Conveniences" noted by John Fanning Watson in his *Annals of Philadelphia* were sundials affixed to the exteriors of buildings: "To appreciate this thing, we must remember there was a time when only men in easy circumstances carried a watch, and there were no clocks, as now, set over the watchmakers' doors."

Crafts and trades prospered while the nation was being constructed. Federalists decided that as soon as the ninth state ratified the Constitution, a public celebration would be staged in Philadelphia. In the grand Federal Procession held on July 4, 1788, architects, carpenters, sawmakers, and filecutters followed the *Federal Edifice*, a structure on wheels consisting of a dome supported by 13 columns and topped by a

figure of Plenty. The Federal ship *Union* was followed by boat-builders, sailmakers, and ship carpenters. Cabinetmakers, brick-makers, sign painters, blacksmiths, and pot-ters carried flags and the tools of their trade, wore embellished costumes, or dem-onstrated their skills on carriages drawn by horses. William Rush rode with the wood-carvers and gilders. The most complete account of the pageant is chairman Francis Hopkinson's description in Scharf and Westcott's history of Philadelphia. The stonecarvers paraded after the sad-dlers and before the bread and biscuit bakers, suggesting that carving was still considered very much a trade and not yet an art.

The indigenous artist gradually emerged from the roots of American prag-matism. As the wealthy sought summer retreats on the east and west banks of the Schuylkill, local craftsmen, silversmiths, cabinetmakers, and ironworkers had more opportunities to create opulent objects and ornate woodwork and furniture. Yet when sculpture was considered, Americans tended to look to foreign artists, trained in the philosophy and techniques of the European tradition. The city's first statue of William Penn (**1-01**) was produced in England for an English patron. Philadel-phians were unaware that the diligence and passion of local craftsmen would not only bridge the gap between the "applied" and "fine" arts, but would pave the way for the emergence of an indigenous American art.

After the Revolution

An American Portrait

The Great Seal of the United States **on the Federal Courthouse and Post Office**
1934–1940; based on a design of 1782 **4-24**

By the middle of the 18th century, family portraits had assumed a particular importance for immigrants, newly established and far from their European cultural roots. Traveling artisans and portrait painters were known as "limners," a reference to the medieval European tradition of manuscript illumination. "Limning" set the stage for the development of popular interest in the art of portraiture.

Attitudes toward art changed after the Revolutionary War, when Philadelphia became the nation's first capital. With independence from colonial rule, a spirit of national honor, patriotism, and pride emerged. There was a dramatic shift in focus from private to public life, and the arts found a special symbolic place in the expression of American unity. When the Great Seal of the United States was created in 1782, an official and commonly understood image was formally adopted by the American citizenry (see *Meet You at the Eagle*, pp. 24–25).

Americans' fondness for portraiture, generally limited to family subjects and encouraged by the itinerant limner, moved from a domestic context to the public domain and from painting to sculpture. In 1783 Congress announced a decision to commission an equestrian statue of George Washington, and European artists trained in the classical tradition came to America in search of this and other opportunities. Jean Antoine Houdon arrived from France in 1785 to take a life mask of the president, on which he ultimately based his standing figure of Washington for the state capitol in Richmond, Virginia. A cast of this statue now stands in Philadelphia's Washington Square (**1-03**).

In 1792 the first public monument in Philadelphia, Francesco Lazzarini's marble figure of Benjamin Franklin, was

Jean Antoine Houdon
George Washington
c. 1790; cast c. 1922 **1-03**

William Birch
Library and Surgeon's
Hall, Fifth Street,
showing Lazzarini's
Franklin
engraving 1799

Francesco Lazzarini
Benjamin Franklin
1789 **1-02**

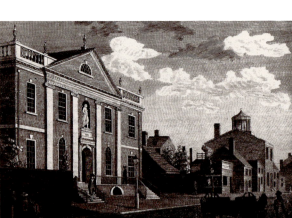

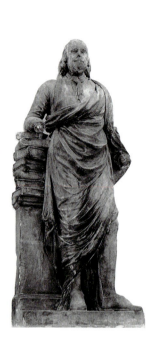

installed in a niche over the main entrance
of The Library Company's original
building on 5th Street between Chestnut
and Walnut (**1-02** and see *A Public Figure:
Franklin*, pp. 32–33). The sculpture was
damaged considerably by exposure to the
elements and was later moved to the foyer
of the new Library Company building at
1314 Locust Street to prevent further dete-
rioration of the marble. (In 1956 the Amer-
ican Philosophical Society constructed a
new building on the original site of
Library Hall, reproducing the 1789 facade
and sculpture.) Commissioned by lawyer
William Bingham for a site that was vis-
ible to the public, Lazzarini's *Franklin*
paved the way for the support of public art
by successive generations of private
patrons.

Soon thereafter the Italian sculptor
Giuseppe Ceracchi arrived with the hope
of securing public commissions. His pro-
posal for a colossal *Liberty*, over a hundred
feet tall and surrounded by mythological
and allegorical figures, was ambitious and
expensive. Congress was dissuaded by its
potential cost, but the members decided to
keep the model head of *Minerva* and
placed it behind the Speaker's chair in
Congress Hall (**1-04**).

One who expanded the boundaries of
the artist's role in public life was Charles
Willson Peale. A man of limited formal
education and considerable creativity, he
was an artist, inventor, educator, and scien-
tist. He opened the nation's first museum
in the mid-1780s and there displayed to
Philadelphia's public unusual and bizarre
specimens of natural science as well as pro-
vocative works of art. In contrast to the
work of his European peers, Peale's paint-
ings were not based on classical formulas
and were as varied as his interests. He
painted George Washington several times
from life, and in *The Staircase Group* he
surrounded a painting of his two sons with
a constructed door frame and wooden step
that project into the viewer's space. *The
Staircase Group* is a remarkable and dar-
ing combination of media, a family por-
trait that transcended contemporary
definitions of both painting and sculpture.

Peale's pursuit of the experimental in
art and science, as well as his active role in

22

Giuseppe Ceracchi
**Minerva as the
Patroness of
American Liberty**
1792 **1-04**

Attributed to
Peale's Museum
Silhouettes
c. 1802

Charles Willson Peale
The Staircase Group
1795

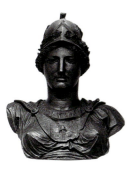

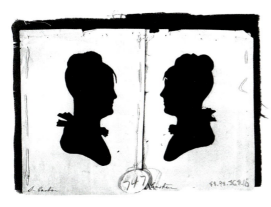

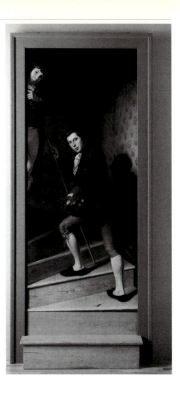

the city's cultural life, led him to extend the limits of sculpture and painting far beyond the conventions of his time. Commissioned by the State Assembly to celebrate the ratification of the Treaty of Peace in 1784, Peale created a triumphal arch with illuminated paintings. Over 56 feet wide and 40 feet high, the structure spanned Market Street between 6th and 7th Streets and was to have been lit by 1,150 lamps. For it, Peale created a monumental figure of Peace, designed to appear out of the darkness holding a flame in her hand and then descend onto the top of the arch, illuminating the structure and initiating a burst of rockets. While the crowd awaited the shot that was to signal the descent of Peace, a wayward rocket struck the arch, and the paper and cloth structure burst into flame. No known accounts explain how the instant illumination was to have been achieved, but the crowd that gathered had more than their expected share of fireworks.

In contrast to the formality of portrait sculpture and paintings, the folk arts continued to thrive in Philadelphia. In front of Peale's Museum, his slave, Moses Williams, created portrait silhouettes of visitors. In his study of the African-American experience in Pennsylvania, Charles Blockson records that the extremely proficient Williams apparently earned enough money from his craft to buy his freedom. Williams later opened his own museum a few blocks away, near Mother Bethel African Methodist Episcopal Church at 6th and Lombard Streets.

In the years after the Revolution, American portraiture in its various forms celebrated the nation's heroes, from the lone individual who dared to venture to the New World to the celebrated political patriot. As the forests of Philadelphia were gradually cleared, so was the path for an American public art.

Photographer unknown
Boy meets girl at the *Eagle* in Wanamaker's store
photograph 1940

James L. Dillon
Workers with City Hall eagle at Tacony Iron and Metal Works
photograph c. 1890

24

How a community perceives a particular image is as much a result of its citizens' yearnings as of the artists' varied interpretations. August Gaul's colossal *Eagle* (**3-27**) in the John Wanamaker department store is considered a community landmark by most Philadelphians, an image of civic pride amidst a symbol of commercial enterprise. Part of Germany's contribution to the 1904 Louisiana Purchase Exposition, it was acquired by the civic-minded Wanamaker. Generations of local residents have arranged to "meet at the eagle" after a day of shopping or visiting center city.

The eagle has figured prominently in the sculpture of Philadelphia. Despite Benjamin Franklin's known enthusiasm for the native turkey, in 1782 the American bald eagle was approved by Congress as the national symbol for the Great Seal of the United States. It rapidly became a popular emblem of patriotism.

The eagle's universal appeal was important to a nation of immigrants. It was an ancient icon of power and victory, of the spiritual principle that enables humans to reach heavenly heights. Sacred to Jupiter, it had early associations with celestial power, represented the triumph of the Roman empire, and was a medieval sign of Christ's Ascension. In the United States, the image of the eagle was at first used primarily in political contexts. As the Republic grew, so did the use of the eagle on everything from coins to building facades.

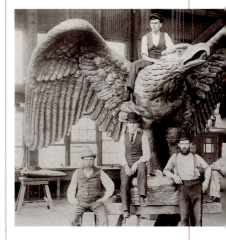

An early model for William Rush and his generation of woodcarvers may well have been the American bald eagle in Charles Willson Peale's museum. That bird was kept alive in its cage from 1795 to 1805, was stuffed upon its death, and was exhibited along with Peale's other museum specimens. Rush carved eagles for ships, trade signs, and firehouses, and the delineation of hundreds of feathers was a challenge of obvious appeal to a master craftsman. Another carved eagle, in the pediment of the First Bank of the United States, dates from 1797 and is believed to be the work of the French craftsmen, Claudius F. Le Grand and his sons (**1-05**).

In the collection of the Atwater Kent Museum is a *Gas Jet Eagle,* thought to have been part of a display mounted by the Philadelphia Gas Works in 1848 to welcome home the Philadelphia troops who fought in the Mexican War—"in honor of victory and peace and the availability of gas for the purpose of ornamental illumination." The display took place in front of Independence Hall, with the principal figure a "Goddess of Peace" seated on a

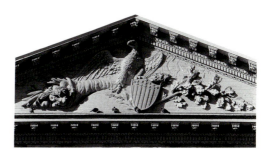

chair. "Above all hovered the eagle with wings of fire. . . . There were four thousand burners which lighted up this piece."

The Tacony Iron and Metal Works' contract for work on the new City Hall tower included, in addition to Alexander Milne Calder's *William Penn* (**3-02**), eagles with wing spans of 14 feet to be placed on all four sides of the tower. The eagles were hotly criticized as "not American" by the press, which noted that whereas the American eagle faces right, Calder's face left, like those on Mexican coins.

At the Market Street Bridge over the Schuylkill River are four huge granite eagles by Adolph Alexander Weinman (**3-25**). Weinman originally carved 22 eagles for the cornice of Pennsylvania Station in New York City, a monumental edifice built in 1903. When the station was demolished in 1963, these four fragments were given to the Fairmount Park Art Association by the Pennsylvania Railroad and subsequently donated to the city. Eagle-eyed travelers can spot two more in New York near the Seventh Avenue entrance to 2 Penn Plaza, the commercial building that replaced the former station.

The artist Jacques Lipchitz forged a new vocabulary for sculpture based on his early association with the Cubist movement and his longstanding commitment to human rights. Less immediately recognizable as our native symbol, and more ideological than political, *Spirit of Enterprise* (**4-38**) was installed at the Samuel Memorial along Kelly Drive in 1960. The sculpture evokes Lipchitz's earlier *Prometheus Strangling the Vulture* (**4-55**), but here the man and bird optimistically suggest the unity of mankind and nature.

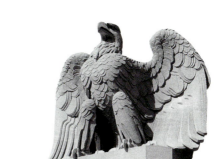

Claudius F. Le Grand and Sons
Eagle
1797 **1-05**

Artist unknown
Gas Jet Eagle (left)
c. 1848 **2-09**

Jacques Lipchitz
The Spirit of Enterprise (left)
1950–1960 **4-38**

Adolph Alexander Weinman
Eagle
c. 1903 **3-25**

Utility and Beauty

Civic Improvements and the Artist

William Rush
Tragedy
1808 **1-06**

Photographer unknown
**New Theatre on
Chestnut Street,
showing reinstalled
Comedy and *Tragedy***
(above right)
photograph 1855

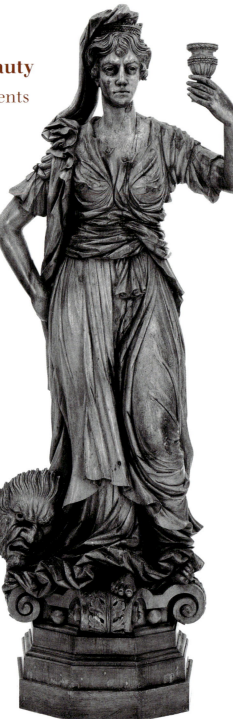

Philadelphia's emergence as a major port and shipbuilding center by the end of the 18th century created opportunities for craftsmen who carved figureheads, ornaments, and commercial advertisements for the naval industry. One such artisan was William Rush, a woodcarver's son who made the transition from craftsman to sculptor. He was a public-spirited man who served as an elected member of City Council, was an influential figure on the city's Watering Committee, and was one of two artists (the other was Charles Willson Peale) elected in 1805 to the first board of the Pennsylvania Academy of the Fine Arts. With about forty other artists, including Peale, Rush was associated with the Columbianum, Philadelphia's first artists' organization, established in 1795 to create opportunities for artists and disbanded that same year because of conflicts over the use of live models in drawing classes.

**William Rush's bill
to the city of
Philadelphia**
1809

William Nicholson Jennings
**[William Rush's]
Water Nymph and
Bittern at Fairmount**
photograph c. 1895

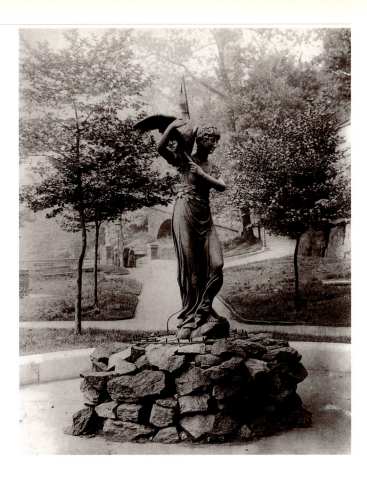

The *Philadelphia Gazette* proclaimed Rush "the father of American sculpture" in his own lifetime. He might also be designated the father of American public art. His concern for civic improvement, his work on public buildings and monuments, his park plans, and his collaborations with architects all anticipated future directions for public art in America.

In 1808 Rush carved figures of *Comedy* and *Tragedy* (**1-06**) for the exterior niches of the New Theatre on Chestnut Street, designed by the architect Benjamin Henry Latrobe. At that time Rush was over 50 years old, and his discipline and skill were affirmed through these two allegorical sculptures. While there had been craftsmen and carvers before him, Rush was acknowledged as a unique and versatile artist. In 1811, before the Society of Artists, Latrobe said of the sculptor's figureheads, "They seem rather to draw the ship after them than to be impelled by the vessel. I have not seen one on which

there is not the stamp of genius." When Latrobe's theater was destroyed by fire on April 2, 1820, the Rush figures were saved and installed as part of the facade of architect William Strickland's New Theatre, built on the same site.

The yellow fever epidemic of 1793 threatened civic life and made Philadelphians aware of their vulnerability to disease. In 1799 a public water system designed by Latrobe was built in Centre Square (now the site of City Hall), and fresh, pure water from the Schuylkill was pumped by steam power into an elevated storage tank. To embellish the square, Rush's *Water Nymph and Bittern*, or *Allegory of the Schuylkill River* (**1-07**), was installed in 1809, with jets of water spouting from the bird's beak. For this work, said to be America's first decorative fountain built with public funds, Rush was

John Lewis Krimmel
Fourth of July in Centre Square
oil on canvas 1812

Thomas Eakins
William Rush Carving His Allegorical Figure of the Schuylkill River
oil on canvas 1877

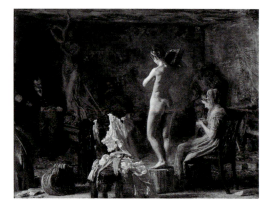

paid $200, a fee that included materials, carving, and supervising the installation of the fountain on a pedestal of native rock. Walkways were added, trees were planted, and Centre Square became Philadelphia's first public garden.

Some Philadelphians objected to the nymph's revealing and clinging drapery, demonstrating that even so esteemed an artist as Rush did not escape such criticism. Rush's model was said to have been the attractive and socially prominent Louisa Vanuxem, who apparently created a scandal when she posed for the figure. Three years earlier, when the Pennsylvania Academy of the Fine Arts' inaugural exhibition displayed 50 plaster casts of nude antique sculptures from the Louvre, public outcry demanded one "ladies only" day a week when the "indecent statues" were carefully draped. (See *The Modern Figure*, pp. 136–137.) It is not surprising, then, that Thomas Eakins' 1877 painting of Rush carving the *Nymph* in his studio

includes a "knitting chaperone" to comment on the seeming impropriety of the scene.

Rush's statue of the first American president won an award at the Pennsylvania Academy's Fifth Annual Exhibition, with appeals for "the sculptor to multiply copies of it." (Rush advertised plaster casts at $200 each, but abandoned the plan after receiving only two orders.) In 1824 the sculpture was placed on view in Independence Hall, then known as the State House. Purchased by Philadelphia's Select Council in 1831, *George Washington* (**1-08**) was moved to its present location at the Second Bank of the United States in 1970.

When the Marquis de Lafayette returned to America in 1824 as a "national guest," Rush's sculptures of *Justice* and *Wisdom* were placed above the Grand Civic Arch designed by William Strickland. The arch spanned Chestnut Street in front of Independence Hall. Like Peale's ill-fated Peace Arch of 1784, the Grand Civic Arch was made of wood and covered with canvas painted to look like marble. It was the last in a series of 13 triumphal arches through which Lafayette passed to reach the State House, where over a hundred thousand celebrants awaited his arrival. That same year Rush designed a park plan for the North East (or Franklin) Square, which was executed after his death.

By 1812 the waterworks at Centre Square had proved insufficient, and the city approved construction of a new waterworks on five acres along the bank of the

William Rush
Justice
1824 **1-09**

Attributed to George Gilbert
**Civic Arch for
Lafayette with Rush's
Justice and *Wisdom***
engraving c. 1824

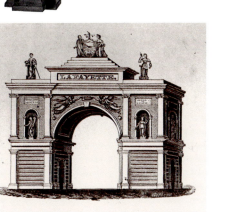

William Rush
**Plan for North East or
Franklin Public
Square, Philadelphia**
1924

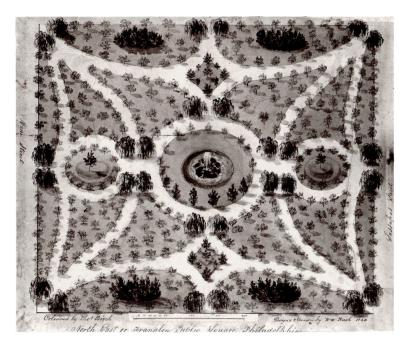

Schuylkill at Fairmount. Designed by Frederick Graff, the steam-powered system pumped water from the river to an elevated reservoir (now the site of the Philadelphia Museum of Art), from which it flowed by gravity to homes and hydrants in the city below.

The impulse to improve the city's amenities caught on, and the Watering Committee decided to extend the landscaped area to almost thirty acres. Walkways, lawns, and sculpture enhanced the environs of the waterworks, which would eventually become the nucleus of the extensive Fairmount Park system. Rush's allegorical sculptures, *The Schuylkill Freed* and *The Schuylkill Chained* (**1-10**), placed above the two entrances to the millhouses in 1825, represent the relationship between mankind and nature, a theme that would be encountered again and again as the city grew and the park expanded. A few years later other works by Rush were transferred to Fairmount: *Water Nymph and Bittern*

(**1-07**) was brought from Center Square, *Mercury* was placed on top of a gazebo, and *Wisdom* and *Justice* (**1-09**), from the Civic Arch, were put in the main hall of the engine house. (As part of a recent renovation [see **1–10**], replicas of *The Schuylkill Freed* and *The Schuylkill Chained* were cast and placed on the Entrance Houses.)

Opened in 1825, the "Fair Mount Gardens" became a pleasure garden for Philadelphians and a showcase for local enterprise. The sculpture of William Rush, the engineering and architectural achievement represented by Graff's Greek Revival buildings, and the enthusiasm of the citizenry showed the world that utility and beauty could indeed be united for commemorative and decorative purposes. *A Guide to the Lions of Philadelphia* (1837) urged, "The first thing a visitor is recommended to do by way of recreation, is to ride out to see the waterworks. Until he

J. C. Wild
**Philadelphia
Waterworks**
lithograph 1838

William Rush
The Schuylkill Freed
fiberglass cast
installed 1989 **1-10**

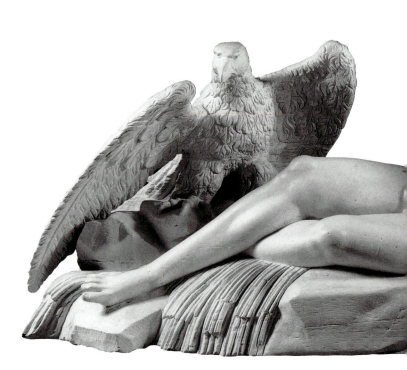

has seen them he has seen nothing." Cre-
ated in response to a public health crisis,
the Fairmount Waterworks soon became
one of Philadelphia's first international
tourist attractions. Even Charles Dickens,
otherwise critical of American life, wrote
that "the water works at Fairmount were
no less ornamental than useful, being taste-
fully laid out as a public garden and kept
in best and neatest order."

In other parts of the city, architects
were including niches for statuary in their
building facades. The capacity of art to
communicate to the public found a
poignant example in John Haviland's

designs (1824–1825) for the facade of the
Pennsylvania Institution for the Deaf and
Dumb. Statues of Charles-Michel, Abbé
de l'Epée (1712–1789), and Roch-
Ambroise Cucurron, Abbé Sicard (1742–
1822), who together developed a manual
alphabet for deaf mutes, were to be placed
in niches and identified by means of a
manual language instead of a traditional
inscription. (Haviland's building, at Broad
and Pine Streets, is now occupied by the
University of the Arts.) There is no evi-
dence that the statues were either created
or placed there, but William Rush would
have been a likely candidate for the
commission.

At the time of his death in 1833, Rush
was recognized as a major and unique

William Rush
**The Schuylkill
Chained**
1825 **1-10**

John Haviland
**Pennsylvania
Institution for the
Deaf and Dumb** (with
detail of manual language)
1824

PENNSYLVANIA INSTITUTION FOR THE DEAF & DUMB

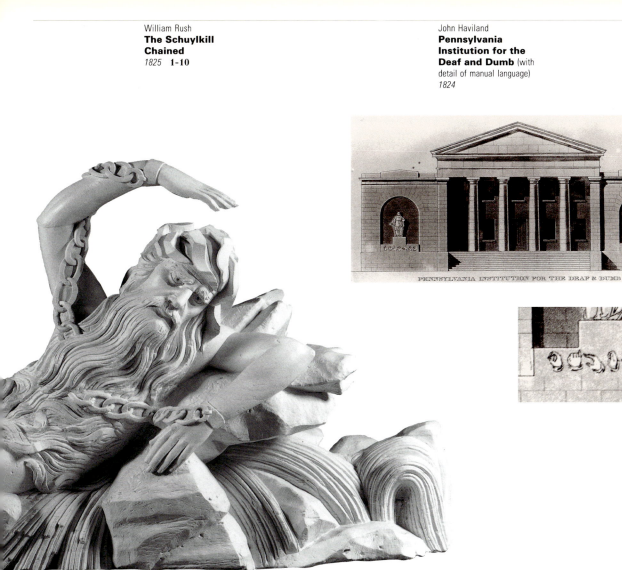

figure in American art. By painting his
carved wooden figures white, he aimed to
simulate the appearance of marble. No
fine marble was then available in the
United States, and stone was imported
from Italy at great expense and with frus-
trating delays. (Bronze casting, an ancient
technique, was not practiced in this
country until the middle of the 19th cen-
tury.) By 1825 American sculptors were
being drawn to Italy, which possessed in
abundance the materials and the skilled
technicians that America lacked, where a
great sculptural tradition flourished, and
where the fine arts were understood and
appreciated.

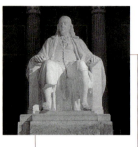

James Earle Fraser
Benjamin Franklin
1938 **4-51**

Photographer unknown
[Joseph Alexis Bailly's]
Benjamin Franklin
in front of the Public Ledger Building (above right)
photograph c. 1870
2-17

John J. Boyle
Benjamin Franklin
1899 **3-21**

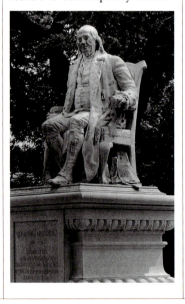

The diverse monuments to Benjamin Franklin (1706–1790) reflect the complexity of a man who was always seeking the new and the unexpected. Patriot, statesman, scientist, journalist, businessman, eccentric, and genius, Franklin is remembered through the institutions and ideas he founded and personified. His name and image are recalled in numerous paintings, murals, and sculptures, and at the Franklin Institute, Franklin Field, Franklin Square, and along the Benjamin Franklin Parkway. In 1972 Gene Davis created *Franklin's Footpath* in honor of Philadelphia's great pedestrian (see p. 149).

Franklin embraced the creative instincts that we now ascribe to contemporary artists.

His house at 141 High Street was the first in Philadelphia to have a lightning rod affixed to it, but this was not an ordinary, functional piece of metal. A clamorous installation of bells was positioned to ring and throw off sparks of electricity, calling public attention to the action and reaction of nature and the built environment. Franklin's passion for the experimental inspired "The Electrical Matter," a festival of the electronic arts held throughout the city in 1990.

Franklin no doubt would have preferred to be the stimulus rather than the subject of the many works of public art that he inspired. "I have at the Request of Friends, sat so much and so often to Painters and Statuaries, that I am perfectly sick of it," he wrote in 1780. The first sculpture placed in the public domain in Philadelphia was Francesco Lazzarini's *Benjamin Franklin* (**1-02**), installed in 1792 in a niche in the facade of The Library Company to immortalize the city's "first librarian" (see p. 22). In 1870 Joseph Bailly's sculpture of Franklin on a pedestal (**2-13**) watched over the State House from the corner of the Public Ledger Building at 6th and Chestnut Streets, a tribute to Franklin's

activities as a journalist and statesman. The statue can now be seen in the lobby of that building.

Franklin the colonial postmaster was honored in 1899 by John J. Boyle's *Benjamin Franklin* (**3-21**), commissioned for the front of the Post Office building at 9th and Chestnut Streets and now located on the campus of the University of Pennsylvania. Also on the Penn campus is *Split Button* (**6-31**), which may be considered a Franklin monument of a most unusual sort. The artists Claes Oldenburg and Coosje van Bruggen played with the idea that Boyle's nearby sculpture of a corpulent Franklin might have popped a button, and their monumental work is based on this imaginary detail.

In 1933 the young artist Isamu Noguchi proposed a monument to Franklin to be placed in Fairmount Park. At that time Noguchi's work seemed far too "modern" for Philadelphians' taste, and a contemporary news account related that the city's "advanced guard" wanted to place the monument in front of the Franklin Institute. This was not to happen in a period when abstract art was still suspect in Philadelphia. Instead, in the grand interior space of the Franklin Memorial sits James Earle Fraser's larger-than-life,

carved marble *Benjamin Franklin* (**4-51**).

Fifty years after Noguchi's original proposal, the interrelationship of art and technology was celebrated by the installation of his *Bolt of Lightning . . . A Memorial to Benjamin Franklin* (**6-41**). Reflecting on the idea, Noguchi admitted that the work probably could not have been executed when it was originally proposed. Computer-assisted engineering helped to realize this tribute to the genius of Franklin—the man who made the inconceivable possible.

Advanced computer technology also made feasible the 1987 *Benjamin Franklin Bridge Lighting* (**6-54**), designed by the firm of Venturi, Rauch and Scott Brown. The lighting, visible from the riversides of Philadelphia and Camden, has made the bridge at night a regional symbol. Again the interaction of art and technology commemorates Franklin the scientist.

Near Franklin's simple marble gravemarker at 5th and Arch Streets is a bronze plaque with the epitaph that he wrote himself when he was 22 years old:

> The body of
> B Franklin Printer,
> (Like the Cover of an old Book
> Its Contents torn out
> And stript of its Lettering
> & Gilding)
> Lies here, Food for Worms.
> But the Work shall not be lost;
> For it will, (as he believ'd)
> appear once more,
> In a new and more
> elegant Edition
> Revised and corrected,
> By the Author.

Franklin's instinct was confirmed by the many new and revised images that honor his creative and enterprising spirit.

Isamu Noguchi
**Bolt of Lightning
. . . A Memorial to
Benjamin Franklin**
1984 **6-41**

Claes Oldenburg and
Coosje van Bruggen
Split Button
(above)
1981 **6-31**

Venturi, Rauch and
Scott Brown
**Benjamin Franklin
Bridge Lighting**
1987 **6-54**

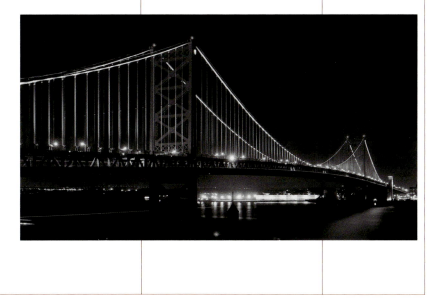

SCULPTURE AND THE LANDSCAPE
1836–1876

CHAPTER

2

35

*"The grave should be surrounded by everything that might inspire
tenderness and veneration for the dead, or that might win the living to virtue."*

Washington Irving
**Guide to Laurel Hill Cemetery
near Philadelphia**
1844

Laurel Hill Cemetery

Philadelphia's First Sculpture Garden

Gihon
**[James Thom's] *Old
Mortality* from
*Smith's Illustrated
Guide to and through
Laurel Hill Cemetery***
engraving 1852

There was a time when the owners of Laurel Hill Cemetery were compelled to issue tickets of admission to control the number of visitors. The "rural cemetery" began as yet another civic utility, a response to threats to community health. And, like the waterworks, the cemetery became a place of social gathering, a rural retreat and promenade for city dwellers, and an environment for meditation, inspiration, and the cultivation of the arts. Laurel Hill was a forerunner of the planned urban park and sculpture garden. At a time when sculpture was confined to niches or otherwise subordinated to architecture, the arrival of the garden cemetery provided a wholly new setting for public sculpture in Philadelphia.

John Notman
**Ground Plan of
Laurel Hill Cemetery**
1836

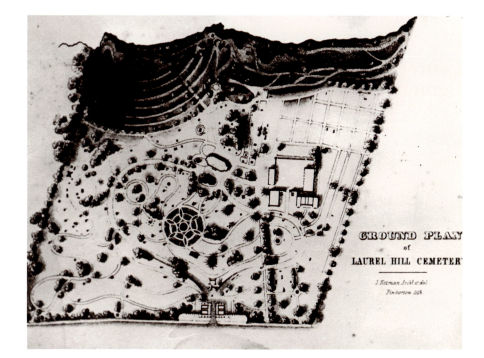

By the middle of the 19th century, the American landscape had become both a subject for art and a site for its placement. In 1837 Ralph Waldo Emerson's essay "Nature" celebrated the spiritual power of the natural world. American landscape painting flourished, based on both careful observation and a patriotic enthusiasm for the nation's natural wonders. John Ruskin's essays encouraged the escape to country dwellings for those who could afford them and the growth of city parks for the nation's swelling urban population. Before Henry David Thoreau published *Walden; or, Life in the Woods* in 1854, Philadelphians had already begun to use, appreciate, and protect their own natural resources.

In 1836 the site of Laurel Hill Cemetery (3822 Ridge Avenue) was a distant carriage ride away, more than three miles north of Philadelphia's city center. The city's traditional burial grounds in churchyards and public squares had become overcrowded and impractical. The private developers of Laurel Hill saw in the nonsectarian rural cemetery a permanent solution to the problem of finding burial sites in an expanding city. The architect John Notman planned the grounds and designed the original structures. Although most of the architectural components have since been destroyed or altered, the landscaped site remains much as he planned it, a combination of formal, geometric garden settings with informal areas and paths that follow the contours of the land. Laurel Hill was Philadelphia's first and largest garden cemetery, but Cathedral Cemetery (see **2-11**) at 48th and Lancaster Avenue, Woodlands Cemetery at 40th and Woodland Avenue, and Mount Vernon Cemetery at Ridge and Lehigh Avenues (see **2-14**) are other notable examples.

Artist unknown
Knight Marker
c. 1877

John Notman
Sarah Harrison Tomb
c. 1836–1860 **2-02**

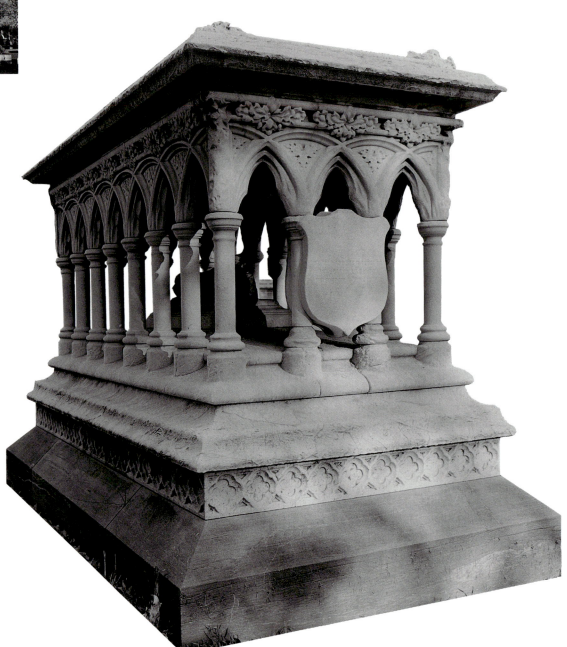

Joseph Alexis Bailly
**William Emlen
Cresson**
1869 **2-04**

Joseph Alexis Bailly
**Francis E. Patterson
Monument** (detail)
c. 1868 **2-03**

Amid the winding paths and plantings at Laurel Hill, a symbolic language unfolded in the form of architectural monuments and sculpture. Architectural historian George Thomas notes that Greek forms were used to express democratic ideals, Middle Eastern styles were deemed appropriate for Jewish patrons, and Gothic spires were seen in abundance as a favored image of Christian religious feeling. A universal vocabulary of forms embellished the landscape. A broken column signified a life cut short, as in the Knight tomb. A broken urn represented a violent end, illustrated in the marker for Robert Stewart, who was murdered by his servant. A sleeping lamb, an image often used in connection with women and children, is enclosed in the Gothic structure of Sarah Harrison's tomb. Admiration for the *Washington Monument*, the giant obelisk designed by Robert Mills in 1836 and completed in 1884, probably accounts for the numerous obelisks that appeared during that period.

Monuments by such distinguished architects as John Notman, Thomas Ustick Walter, and William Strickland can be seen at Laurel Hill, and many of Philadelphia's gifted sculptors received commissions for statuary there. The subjects were as varied as the beneficiaries. Joseph Alexis Bailly, a French woodcarver who arrived in Philadelphia in 1850 and soon became known as a prolific sculptor, is represented by a number of works, including two strikingly different monuments. General Francis E. Patterson's monument represents an idea—grief—in the form of a sensuous marble allegorical figure holding a funerary urn. By contrast, Bailly's bronze

40

memorial to William Emlen Cresson, a patron of the arts, presents its subject as a realistic, palpable figure, true to life.

In homage to the concept of renewal, the owners of Laurel Hill placed at the entrance James Thom's *Old Mortality* (**2-01**), a sculptural group representing the encounter of Sir Walter Scott and an aged peasant who recut the names of the deceased on deteriorating tombstones. Over the years, the opportunity to express the concepts of death and renewal in visual terms challenged both artist and patron. William Mullen's tomb features an elaborate biographical and allegorical display (**2-05**). For William Warner's tomb, Alexander Milne Calder, then at work on the sculpture program for City Hall, included a half-open sarcophagus with the soul of the deceased "escaping" in the form of a stone cloud (**2-06**).

By the end of the 19th century, interest in funerary monuments began to decline in favor of markers and plaques. Nevertheless, the monumental tradition continued well into the 20th century, providing opportunities for artists and architects to work together, as in Alexander Stirling Calder's monument to Henry Charles Lea (**2-07**), a collaborative effort with the architectural firm of Zantzinger and Borie. Although the individual monuments commemorated the deceased in a fixed and timeless way, the garden cemetery as a whole was an organic, self-renewing environment, becoming in the process an encyclopedia of architectural forms and sculptural innovations.

*"These two young men . . . determined that something must be done
to redeem Philadelphia from the reproach of an excessive industrialism."*

Solicitor General of the United States
James Montgomery Beck
**50th Anniversary of
the Fairmount Park Art Association**
1871–1921

The Growth of Fairmount Park

The Fairmount Park Commission and the Fairmount Park Art Association

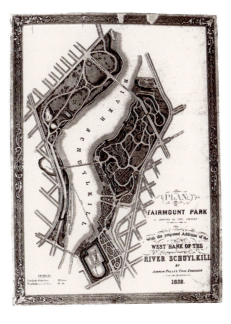

Louis Napoleon Rosenthal
after Andrew Palles
**Plan of Fairmount
Park (proposed)**
1859

Willam Penn is said to have exclaimed, "What a Faire Mount!" when he gazed from the elevated plateau where the Philadelphia Museum of Art now stands. Today, Fairmount Park, considered the largest urban park in the world, comprises more than 9,000 acres of parkland punctuated by masterpieces of art, architecture, and engineering.

The Fairmount Waterworks and the landscaped Fairmount Gardens formed the nucleus of the park system, while the nearby Laurel Hill Cemetery, although never officially part of the park, contributed to a growing appreciation of the public benefits of the landscaped garden. Private initiative also created the historic mansions that still line the banks of the Schuylkill River. Lemon Hill, the first riverside estate, was built in 1795 by Robert Morris, the financier of the American Revolution. Henry Pratt, the next owner of the property, replaced the original home with a more elaborate one, and his gardens became known as "the Versailles of America." The Pratt garden was a sumptuous collection of native and exotic trees, shrubs, plants, statues, busts, and fountains. Following the 1854 Consolidation Act, the new city Councils passed an ordinance in 1855 to make the 45-acre site a public common for the welfare and enjoyment of the people. Throughout the next decade, acreage was acquired incrementally (through purchases and gifts) on both banks of the Schuylkill, and after the Civil War the public holdings were expanded to include the wilds of the northwest Wissahickon Valley.

Fairmount Park was officially created in 1867 when an act of the General Assembly of Pennsylvania authorized the city to provide "Fairmount Park to be laid out and maintained forever as an open

Photographer unknown
[Edward Kemeys']
Hudson Bay Wolves
Quarreling Over the
Carcass of a Deer
photograph n.d.

Photographer unknown
[Wilhelm Wolff's]
The Dying Lioness
photograph n.d.

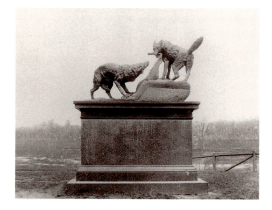

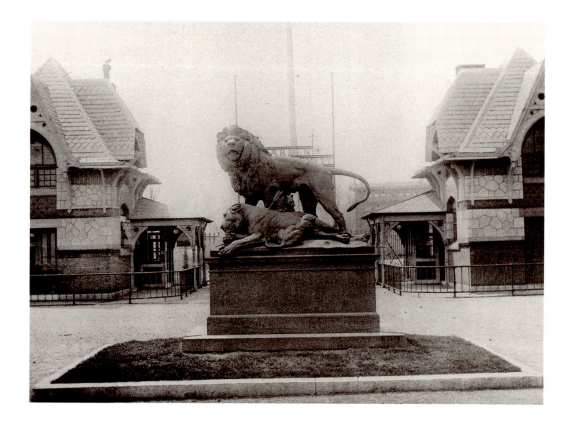

public place and a park for the health and enjoyment of the people of said city, and the preservation of the purity of the city's water supply." The Fairmount Park Commission was established later that year. Mayor Morton McMichael (see **3-04**) became its first president, and the commissioners proceeded to acquire more property, designate drives and walkways, and landscape the park grounds.

In 1871, amid the expansionist activities of the Park Commission and the excitement aroused by the confirmation of Philadelphia as the site for the 1876 Centennial fair, the Fairmount Park Art Association was conceived. Two young men— Charles H. Howell, a public-spirited member of the First City Troop, and Henry K. Fox, the son of Mayor Daniel M. Fox—persuaded 13 others to act as temporary officers and trustees. Anthony J. Drexel was elected the first president, and over 200 members subscribed by the end of the year in the belief that noble and uplifting works of art would counter the effects of the machine age.

In 1872 the Fairmount Park Art Association was chartered by the Commonwealth of Pennsylvania, and Philadelphia became the first city in America to establish a private, nonprofit citizens' organization "to increase the appreciation and love of art in our midst, to add to the number of its votaries, promote the refinements of life consequent thereon, and encourage artists in the practice of their profession." This was to be accomplished by means of contributions, legacies, and donations for the embellishment of the park. In 1906, ratifying longtime practice, the Art Association amended its charter to permit it also to "promote and foster the beautiful in the City of Philadelphia, in its architecture, improvements and general plan."

For more than a century, the Art Association has commissioned and purchased sculptures by distinguished artists, contributing much to the unique character of Philadelphia's physical development. The trustees who piloted this venture were people from all walks of life: immigrant and native-born, merchants, entrepreneurs, and lawyers. They believed that placing works of art in public spaces would enable people of all classes to share equally in a public trust. On the Art Association's 50th anniversary, its vice-president, the Honorable James M. Beck, reflected:

"You have a private art collection and it is your own. You have lovely adornments for your house; they are your own. . . . But have you ever thought of the countless millions of children yet unborn, who in the hot days of summer will stand around the fountain in Logan Square and hear those splashing waters and feel their little souls refreshed by the psychological effect of falling water?"

Early actions included the acquisition by donation of Edward Stauch's *Night* (**2-20**), the commissioning of *Hudson Bay Wolves Quarreling Over the Carcass of a Deer* from Edward Kemeys (**2-19**), and the purchase of Wilhelm Wolff's *The Dying Lioness* (**2-21**). The early work of the Art Association was characterized by civic participation, tenacity, and a high regard for artists and their creative processes.

John Rogers
**Major General
John Fulton
Reynolds**
1884 **3-07**

Walker Hancock
**Pennsylvania
Railroad War
Memorial** (right)
1950 **4-64**

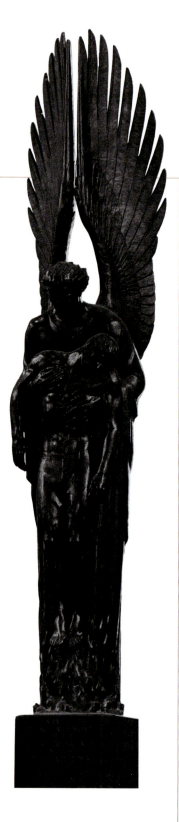

As symbols of collective memory, monuments and memorials often have very different meanings to those who erect them and those who inherit them. Some honor the deceased but continue to serve the living by providing a locus for rituals and communal observances: every Veterans Day a group gathers in Fairmount Park for solemn prayer at the *All Wars Memorial to Colored Soldiers and Sailors* (**4-48**), and each spring a stirring ceremony is held on the Parkway at the *Monument to Six Million Jewish Martyrs* (**5-06**), where community leaders recognize both the survivors and the victims of the Holocaust.

Some heroes who were celebrated in their own time have been all but forgotten a century later, and most people rush inattentively past the Civil War monuments to *Major General John Fulton Reynolds* (**3-07**) and *General George McClellan* (**3-15**) on City Hall Plaza. Such heroic equestrian monuments inspired a symbolic lore that interpreted the sculpture according to the position of the horse's legs: one hoof in the air meant the hero died in battle; two hoofs in the air, he was wounded; four feet on the ground, he survived. However, this interpretation lacked consistency: Reynolds, whose horse has one foot in the air, indeed died at Gettysburg; and *Major General George Gordon Meade* (**3-10**), whose horse has all four feet firmly planted on the ground, survived that battle; but although Washington's horse has one foot off the ground in Rudolf Siemering's statue (**3-20**), the general died in bed at Mount Vernon. By the time the *Cowboy* (**3-35**) was installed in 1908, his horse's flying hoof had more to do with artistic expression than symbolic meaning.

The most distinguished sculptors of the 19th century were commissioned to honor the principles and heroes of the Revolutionary and Civil wars, and Philadelphia was the recipient of such major works as the *Washington Monument* (**3-20**) and the *Smith Memorial Arch* (**3-19**). Both were accomplished many years after each war's conclusion, owing to the complicated tasks of fundraising, planning, and the design and execution of the work by the artists. Although it took Siemering a staggering 16 years to model and cast the *Washington Monument,* it had taken the Society of the Cincinnati almost 70 years to raise the necessary funds. However, commercial interests moved more quickly, and after the Civil War a proliferation of "ready-made stock pattern stuff" was marketed by aggressive stonecutting companies, who capitalized on the immediate emotional needs of communities throughout the nation.

By the end of World War I, the potential for a deluge of
hastily made sculpture, plaques, and markers "unworthy of the
lofty ideals they were meant to commemorate" prompted the Fair-
mount Park Art Association to suggest in its 1919 *Annual Report*
the memorial dedication of symbolic and useful reminders such as
bridges, plazas, and tree plantings: "War Memorials are intended
to endure for centuries, and therefore it is more important to do
them rightly than to do them quickly." A plaque in Logan Circle
records the planting of four central rows of pin oaks along the
Parkway as a World War I memorial. With the prolonged battles
of World War II, the impetus to create monuments began even
before the armistice. So many makeshift monuments were
installed that by 1944 the city's Art Jury, with the agreement of
City Council, adopted a policy of approving no permanent war
memorial projects until the hostilities ended. At that time, the
Art Jury noted that Philadelphia had no significant memorial to
the first World War, only "an accumulation of mediocre struc-
tures which do not enhance the city or glorify those who served."
It was not until 1950 that Paul Manship's *Aero Memorial* (**4-62**),
initiated in 1917, was installed as a monument to World War I.

In recent years, changing attitudes about the nature of war
have inspired monuments that evoke reflection, reconciliation, and
healing. Walker Hancock's World War II *Pennsylvania Railroad
War Memorial* (**4-64**) gives form to the ethereal Archangel
Michael, angel of the Resurrection. Reginald Beauchamp's *The
Whispering Bells: A Tribute to Crispus Attucks,* in front of the Afro-
American Historical and Cultural Museum, recognizes the first
American to die for the cause of national independence—a run-
away slave who led Boston protesters against a detachment of
British soldiers. There, 13 symbolic bells without clappers hum
mournfully in the wind. Designed as park settings for both com-
memoration and contemplation, the *Martin Luther King Freedom
Memorial* (**5-19**) and the *Vietnam Veterans Memorial* at Front and
Spruce Streets remind us of the basic human need to hold on to
and honor our remembrances of both suffering and courage.

Paul Manship
Aero Memorial
1948 **4-62**

J. Otto Schweizer
**All Wars
Memorial to
Colored Soldiers
and Sailors**
1934 **4-48**

Rudolf Siemering
**Washington
Monument**
1897 **3-20**

"Emblems of moral excellence and public good, such as this Park and its embellishments,
should adorn our country to remain a perpetual witness of our time."

Solicitor General of Pennsylvania
Benjamin Harris Brewster
Address to the Fairmount Park Art Association
1872

The Civil War Years

From Parlors to the Public

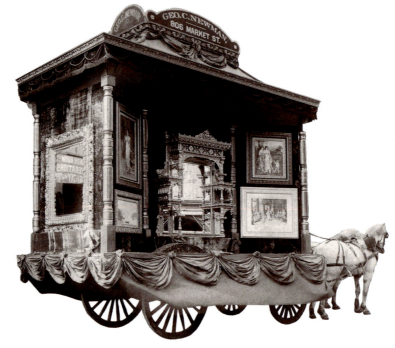

46

Photographer unknown
**George C. Newman's
"Art Cart"** (detail)
photograph 1876

In the middle of the 19th century, artists in the United States were still struggling for recognition and patronage. American sculptors continued to be drawn to Europe for raw materials, recognition, and intellectual stimulation, and American patrons continued to be attracted to foreign artists. Paintings and sculpture were housed in the parlors of the wealthy or exhibited for profit in halls and galleries that charged admission. A unique exception in Philadelphia was the Newman Galleries' horse-drawn "Art Cart," which traveled through the streets of the city in the 1870s. Still, for the most part, sculpture remained available to the few.

Much of the artistic imagery of the period was based on literal and literary traditions. For the headquarters of the Society of the Sons of St. George, a sculp-

ture of *St. George and the Dragon* (relocated to the West River Drive; see **2-27**) was brought from England and installed above the building's pediment. Artists also found a solution to society's widespread resistance to nudity: the creation of allegorical works. The allegory presented an ideal subject based on a figure in classical mythology or the personification of a particular virtue. Thus, the general public was not required to view the sculpture as part of the real world. Hiram Powers' *Greek Slave*, exhibited throughout America in 1848 (now in the collection of the Newark Museum), was considered a work of technical perfection. On view locally at the Pennsylvania Academy of the Fine Arts, its subject was described as "a being superior to suffering, and raised above degradation, by inward purity and force of character." Yet deference to prevailing morality caused the Academy to reestablish special viewing hours for "ladies" and families.

Artist unknown
**St. George and
the Dragon** (detail)
1877 **2-27**

Photographer unknown
**St. George's Hall,
Arch Street at 13th**
photograph c. 1895

**Broadside announcing
the exhibition of
Hiram Powers'
*Greek Slave***
c. 1848

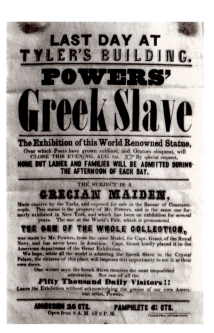

The cause of public morality was also championed by Dr. Wilson Cary Swann when he established the Philadelphia Fountain Society in 1869. Believing that the lack of water for workers and animals led to intemperance and crime, the society provided fountains and watering troughs throughout the city and park so that workers could quench their thirst in public instead of entering local taverns. (By the time the society undertook the construction of the *Swann Memorial Fountain* in 1920, Prohibition and the mass production of the automobile had considerably reduced its activity.)

The expansion of Fairmount Park prompted a dramatic shift in Philadelphia's approach to sculpture. Works of art, commemorative and decorative, were being seen by greater numbers in newly established public settings. At the same

time, the trauma of the Civil War led Americans to seek healing and a collective identity. Naturalism provided what was needed and desired—an effective language through which artists might communicate with the public.

In 1864 local artists found an unusual exhibition opportunity at the U.S. Sanitary Commission Fair, held at Logan Square to raise money for the sick and injured soldiers of the Union Army. Joseph Alexis Bailly contributed 12 commemorative busts. Later, in 1869, his marble figure of Washington was placed in front of Independence Hall (**2-16**). (It was moved indoors to City Hall and replaced by a bronze cast in 1908. See **2-17**.) Like much of the work of its period, Bailly's marble sculpture, though naturalistic, now seems austere and remote.

Before and during the Civil War, an unusual form of public sculpture emerged. In the era of the Underground Railroad (1830–1863), abolitionists used small figures holding lanterns to identify their homes as stations along the route to emancipation. Also known as "Jocko" figures or "hitching posts" (**2-10**), they were symbols of safety and freedom as well as signs of clandestine activity. Jocko Graves was reported to have been a black child who froze to death while faithfully holding the horses of George Washington as he made his legendary crossing of the Delaware River on Christmas night, 1776. Impressed by the child's bravery, it was said, Washington erected a memorial statue of Jocko on his Mount Vernon estate. H. Alonzo Jennings calls the evolution of the Jocko

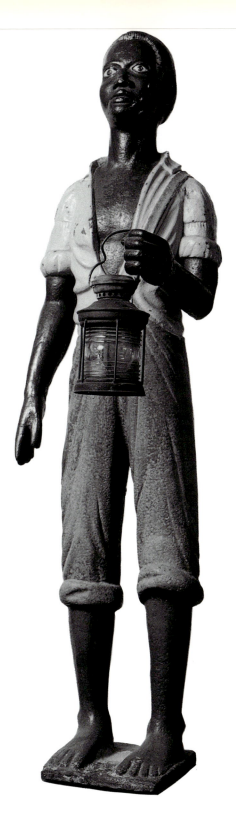

figure from its honorable origins into a decorative lawn jockey one of the great visual distortions of history: "The statue that was dignified and noble in its first appearance has been distorted to the gnomelike caricature we see dotting thousands of lawns throughout America."

In contrast, Edmonia Lewis, considered the first black female sculptor in America, expressed humanistic themes through a neoclassical tradition. Of African and Chippewa Indian descent, Lewis worked in Rome. Her sculpture addressed the social issues of injustice and oppression, and *The Dying Cleopatra* was exhibited at the Centennial Exposition, where it was highly praised. According to William J. Clark, Jr., who reviewed the fine arts section at the Centennial, "The effects of death are represented with such skill as to be absolutely repellent."

The assassination of Abraham Lincoln on April 14, 1865, plunged the nation into deep mourning. Philadelphia, one of the first cities to establish a committee to erect a memorial, embarked upon its first major sculpture competition. Five sculptors were invited to submit designs: Hiram Powers, Thomas Ball, William H. Rinehart, John Rogers, and Randolph Rogers. With the exception of John Rogers, who declined because he preferred to create groups of smaller-scale figures, all of the artists lived and worked in Italy. Rinehart and Powers also declined, Powers explaining that he never entered competitions. Ball and Randolph Rogers competed for the commission, and the committee allowed them considerable freedom, with the one restriction that the figure of Lincoln was to be standing. Rogers' selected design was a

Randolph Rogers
Abraham Lincoln
1871 **2-18**

Edward Kemeys
Hudson Bay Wolves Quarreling Over the Carcass of a Deer
1872 **2-19**

seated figure, however, and he was able to convince the committee that Lincoln's signing of the Emancipation Proclamation was "the great event of his life."

The tradition of naturalism was epitomized by Rogers' monument to Lincoln (**2-18**). Philadelphians responded to the moving portrait and to the artist's attention to the details of fabric, clothing, and chair. Rogers' sculpture of Lincoln is not the standard image of a statesman. It represents a particular act—a "decisive moment," to use the term later applied to 20th-century photography. Similarly, Edward Kemeys selected a decisive moment of confrontation for his *Hudson Bay Wolves* (**2-19**). Along with the attention to detail that characterized naturalism, these artists added the focus of a specific and provocative act.

Lincoln was installed at the entrance to Fairmount Park (now Kelly and Sedgely Drives) and dedicated in 1871 before an enthusiastic crowd of 50,000. Philadelphia was to acquire numerous monuments to the heroes of the Civil War, but these were slow in the making. Though the Fairmount Park Art Association formed a committee to initiate a memorial to Major General George Gordon Meade (**3-10**) three days after his death in 1872, the monument was not installed until 1887. Almost twenty years had passed since Lincoln's assassination when the *Civil War Soldiers' and Sailors' Monument* at Market Square in Germantown (**3-05**) was installed in 1883; and it was not until 1927 that the city placed H. A. MacNeil's *Civil War Soldiers and Sailors Memorial* (**4-19**) along the Parkway.

The Centennial

1876 and the International Influence

Artist unknown
The Closing Ceremonies of the 1876 Centennial Exposition
engraving 1877

By 1876 the United States had survived a bloody Civil War, a shocking presidential assassination, financial instability, and political scandals. Philadelphia, the nation's principal city for nearly a century, entered a period of decline when the center of government was moved to Washington, D.C., and the country's financial focus shifted to New York.

It was through the promotion of arts and culture that the city would eventually regain its status as a center of American enterprise. When Philadelphia was established as the site for the nation's Centennial Exposition, Philadelphians had every reason to hope that the event would restore the city's sense of vitality. Between May 10, 1876, when President Ulysses S. Grant opened the Exposition, and the closing ceremonies on November 10, 1876, almost 10 million people passed through the entrance gates, a number more than 12 times the population of the city at the time. The Centennial proved to be a triumph, focusing national and international attention on Philadelphia.

At the opening of the Centennial Exposition, President Grant and Emperor Dom Pedro of Brazil turned the two master levers of the Corliss Duplex Engine, the largest steam engine in the world, setting in motion hundreds of machines in the 13-acre Machinery Hall. Americans marveled at that immense structure and were dazzled by the fantastic machinery it contained, such as the Cataract, an elaborate display of industrial pumps. The confrontation between mankind and nature, to be explored again and again by 20th-century artists, was foretold by the mechanical marvels of 1876. Throughout the Centennial grounds, a wide-eyed public witnessed a vivid international display and the splendid promise of American art and invention.

Clay, Cosack & Co.
The Corliss Duplex
Engine in Machinery
Hall, Centennial
Exposition
chromolithograph 1876

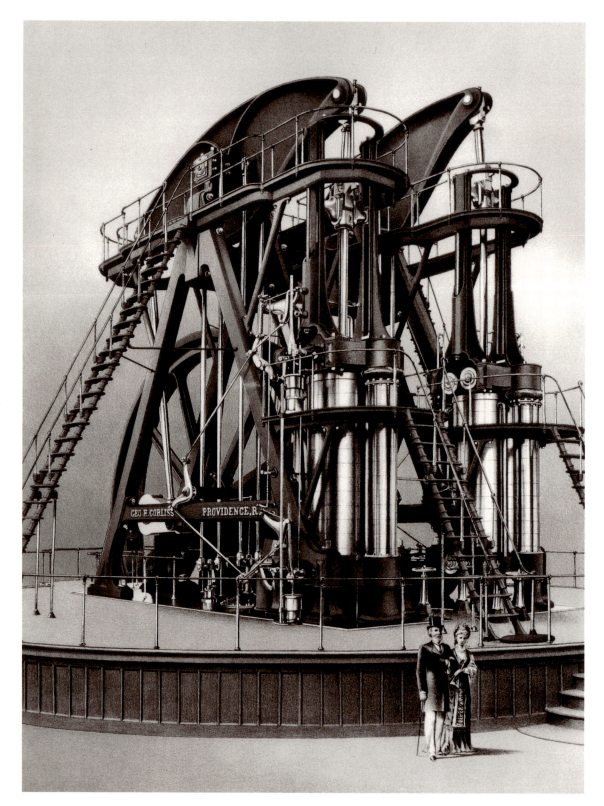

Artist unknown
***The Cataract* in
Machinery Hall,
Centennial Exposition**
engraving 1877

A.M.J. Mueller
Art
c. 1876 **2-22**

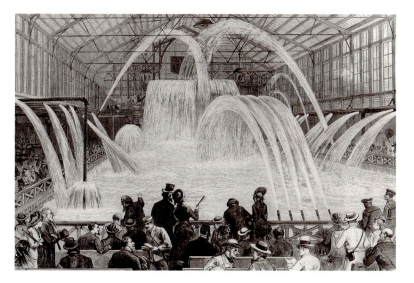

Plans for an elaborate architectural scheme for the Centennial were abandoned in 1874, only two years before the scheduled opening. Filling the vacuum was Herman J. Schwarzmann, a recent immigrant from Austria, who had served as an architect for the commissioners of Fairmount Park. Schwarzmann, who had also helped to plan Fairmount Park and had landscaped the Philadelphia Zoo, presented a proposal for the Centennial Art Gallery (now Memorial Hall) that was quickly accepted. Approval of his design for Horticultural Hall followed. A groundbreaking ceremony was held on July 4, 1874, and architects for the other halls were selected soon after: the Main Exhibition Building, Machinery Hall, the United States Government Building, and Agricultural Hall. These were augmented by numerous foreign, state, and commercial pavilions.

Memorial Hall is the only major Centennial structure that still stands in Fairmount Park. It was also the only fireproof building constructed, as it was intended to remain as a monument to the Centennial in the form of a permanent art gallery. In 1876 the Pennsylvania Museum and

School of Industrial Art was chartered, and Memorial Hall opened as the Pennsylvania Museum of Art in May 1887. The first American art museum in the Beaux-Arts style, it was a model for other museums in the country and, curiously, influenced the design of the Reichstag, the German parliament building in Berlin. Following the Beaux-Arts tradition of using ornamental sculpture, the main cornice features allegorical figures representing *Science* and *Art* (**2-22**). The glass and iron dome, which rises 150 feet above the ground, supports a figure of *Columbia*. (The original work, attributed to the artist A.M.J. Mueller, was damaged by a storm and replaced by a smaller sculpture in 1901.) At each corner of the base of the dome stand colossal figures symbolizing *Industry* and *Commerce* (on the right side of the entrance) and *Agriculture* and *Mining* (on the left). Sixteen eagles originally located on the four corners of each pavilion are, inexplicably, no longer in place.

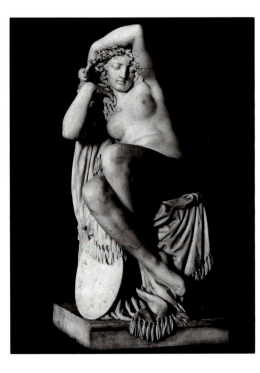

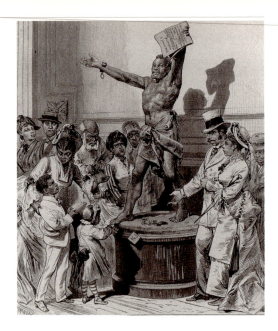

By 1875 it had been determined that Memorial Hall was too small to house the numerous art works expected for the Centennial, and a brick annex was begun. The works of art that were crowded into Memorial Hall and the annex formed the largest and most ambitious exhibition ever seen by the American public. Foreign nations sent representative works, and the U.S. government provided free boat transportation for works sent by American artists living in Europe. Of the 675 sculptures in the Art Department, 325 were Italian. These marble sculptures—prominently placed, meticulously executed, incredibly sentimental, and easily understood—were among the most popular works displayed. American sculptors living in Italy, including William Wetmore Story, Randolph Rogers, and Edmonia Lewis, were represented in the American section by works that were clearly influenced by their Italian

surroundings. Conversely, many European sculptors embraced American themes, as in Francesco Pezzicar's *Abolition of Slavery in the United States* (1863). Because the works exhibited by American-born sculptors were so diverse, just what constituted American art was a matter for debate.

The French influence was embodied by Philadelphian Howard Roberts, who had received rigorous academic training in Paris. His *La Première Pose* (now in the Philadelphia Museum of Art) captured the attention of the public, not only because of its maker's extraordinary technical facility, but also because of its subject, a sensuous nude young woman posing as an artist's model for the first time, eyes downcast. Although Hiram Powers' *Greek Slave* had

Vincenz Bildhauer Pilz
Pegasus
c. 1863 **2-15**

Frédéric Auguste Bartholdi
**Letter to Chairman
Thomas Cochran of
the Committee of**

**Grounds, Plans, and
Buildings for the U.S.
Centennial Exposition**
1876

been shown in 1848 in Philadelphia (see p. 48), the female nude was still objectionable, and *La Première Pose*, although the product of an American, seemed very French indeed. Auguste Rodin, then working in Brussels, made his first American appearance quietly in the Belgian section.

Outdoor sculpture was found throughout the Centennial landscape. The Centennial's Germanic character was influenced, of course, by the chief architect, Schwarzmann. A German artist, Vincenz Pilz, created the two *Pegasus* sculptures in front of Memorial Hall (**2-15**), and Wilhelm Wolff's *Dying Lioness* (**2-21**) was purchased by the Fairmount Park Art Association for exhibition at the Centennial. (It was later placed in front of the Philadelphia Zoo.) Richard Wagner, of all people, composed the "Centennial March," further indication of the Teutonic influence.

The two major French contributions were monumental outdoor works by Frédéric Auguste Bartholdi. For the Centennial, Bartholdi created a cast-iron fountain celebrating light and water. Rising 30 feet on a marble basin 90 feet in diameter, three figures supported a second basin on which a number of gas lamps were suspended. (The fountain was purchased by the U.S. government after the Centennial and is now located in Washington, D.C.) But Bartholdi was also at work on a lighthouse for the Atlantic gateway to America. Light and water were also central to this ambitious project: *Liberty Enlightening the World*, better known as the *Statue of Liberty*. A Centennial commissioner saw the work in progress in Paris and arranged for the colossal arm section to be displayed in

Philadelphia. Forty-two feet high, with a forefinger nearly eight feet long, the hand held a torch that served as an observation tower. In 1876, to raise additional funds for the completion of the Statue, 50 terra cotta models were sold. Of the three extant, the one in the Museum at Drexel University in Philadelphia—the only model in the United States—is in the best condition.

Religious and ethnic groups also erected monuments on the Centennial grounds, five of which are still on public view in Philadelphia. Various societies were prompted to perpetuate the memory of a great deed, a noble character, or a passionately held principle, as in the *Catholic Total Abstinence Union Fountain* (**2-24**).

Photographer unknown
**[Frédéric Auguste
Bartholdi's]
Arm of the Statue of
Liberty**
*photograph 1876 (temporary
installation, Centennial
Exposition)*

56

Caroline S. Brooks
**The Dreaming
Iolanthe
(A Study in Butter)**
1876

The Presbyterians commemorated the *Reverend Doctor John Witherspoon*, the Italian Americans presented a memorial to *Columbus* (**2-23**), the German community unveiled a statue of Alexander von Humboldt, and the Jewish order of B'nai B'rith contributed a monument to *Religious Liberty* (**2-26**). All of the sculptors were trained in France, Germany, or Italy.

Centennial maps and records indicate that the African Methodist Episcopal Church raised funds nationally to honor the Reverend Richard Allen, its founder, with a monument placed near the Government Building. (While city guidebooks published as recently as 1937 list a monument located in Fairmount Park, its current whereabouts are unknown.) A sculptor, Alfred White of Cincinnati, promised delivery in time for a dedication on September 22, 1876, the anniversary of the Emancipation Proclamation. However, the sculpture, described as a neoclassical white marble bust within a Gothic structure bearing biblical figures in relief, was first delayed, then damaged in a train wreck on its way to Philadelphia. This provided an opportunity for the church leaders to consider a more appropriate monument—either a "pure Egyptian obelisk" or a bronze statue of Bishop Allen. With perseverance and dedication worthy of the bishop's spirit, the committee quickly organized the production of a nine-foot-high granite marker. With the rescued marble bust temporarily placed on its top, the monument was dedicated on November 3, 1876, a week before the close of the Centennial. Later that year, as recorded by Charles Wesley, the Reverend John M. Langston proclaimed, "For the first time

in this country, our race erects a monument to the memory of one of its own number."

The Women's Pavilion at the Centennial contained exhibits made and operated by women only. The segregated exhibition of the work of almost fifteen hundred women from 13 countries was unprecedented, and highly controversial. (That same year the National Woman Suffrage Association presented its Declaration of Rights for Women.) Caroline S. Brooks of Arkansas attracted the most attention with her "Butter Lady," a golden *Iolanthe* modeled in butter and displayed in an ice-cooled tin frame. J.S. Ingram in *The Centennial Exposition* described it quite seriously as "beyond all comparison the most beautiful and unique exhibit in the Centennial." Miss Brooks's ephemeral work in the Women's Pavilion may be contrasted with Margaret Foley's enduring marble fountain, placed strategically in the center of Horticultural Hall (**2-25**).

The Centennial stimulated civic pride and an appreciation of artistic expression as work on Philadelphia's elaborate City Hall (**3-01**) began. The citizens of Philadelphia acquired a number of monuments that still stand, and a renewed sense of patriotism ready to be celebrated in bronze and stone.

Monuments to American Ideals

1877–1910

CHAPTER

3

*"Our country is developing a school of art and artists which,
while not too independent to learn what can be and should be learned
from other nationalities, will still be originally and distinctively American."*

Charles J. Cohen on Daniel Chester French
50th Anniversary of the Fairmount Park Art Association
1871–1921

Casting an American Art

From Marble to Bronze

Daniel Chester French
Law, Prosperity, and Power
c. 1880 **3-03**

By the end of the 19th century, Philadelphia was hailed as "the workshop of the world," and the city's industrial economy included the manufacturing of highly specialized goods by skilled craftsmen. Henry S. Tarr's Manufactory at 710 Green Street responded to the public's enthusiasm for white marble in life and death, producing everything from household ornamentation to cemetery monuments (**2-11**). Struthers and Son, Marble, Sand and Stone Work, at 1022 Market Street, provided the stonework for City Hall and the bases for many sculptures; as marble contractors, they executed *George Washington* (**2-16**), now located in Conversation Hall. The Robert Woods Foundry, at 1136 Ridge Avenue, was noted for its metalwork; its workers fabricated the lamps designed by architect Frank Furness for the front of the Pennsylvania Academy of the Fine Arts. Many of Philadelphia's bronze monuments were cast locally by the

Bureau Brothers Foundry, established by Achille Bureau in 1864. The family business thrived under the direction of his sons, Edmund and Edouard, who took over the management in 1888. From their workshop at 21st and Allegheny they advertised the "latest improvements" in art bronze casting.

Continued reverence for the antique and the foreign resulted in the placement of bronze reproduction casts throughout Fairmount Park. In the 1880s and 1890s, works cast from the originals—from earlier periods and distant places—were purchased by the Fairmount Park Art Association or donated to the park through it. These included Antoine Louis Barye's *Lion Crushing a Serpent* (**1-11**) from the Tuileries in Paris, *The Amazon* (**2-08**) and *The Lion Fighter* (**2-12**) from the front of the National Museum in Berlin, and

Daniel Chester French and
Edward C. Potter
**General Ulysses S.
Grant**
1897 **3-18**

Silenus and the Infant Bacchus (**3-08**) from the Louvre. Yet the Art Association had already announced at its annual meeting in 1878 that it would commission new work from American artists, since "art cannot flourish unless supported by proper financial returns."

Although the sculpture most admired by the public at the Centennial Exhibition was carved in marble and shaped by Italian traditions and sentiment, by 1876 the center of influence for sculptors had shifted from Rome to Paris, where it would remain until the middle of the 20th century. American artists, including Augustus Saint-Gaudens and Daniel Chester French, studied at the Ecole des Beaux-Arts. Unlike the Italians, the French sculptors were clay modelers, not stonecarvers, and as a result there was a shift in medium as well as expression among young American sculptors. Modeling in clay facilitated the translation of detail and gesture through the bronze casting process.

Sculptors who worked in marble often handed over a reduced-size clay or plaster model to stonecutters, who would enlarge the model by a mathematical measurement system called "pointing." On some occasions, the artist might ask the stonecutter to leave the last eighth of an inch on the surface of the stone in order to finish the work personally. Most sculptors of the period, however, regarded marble carving as physically demanding labor unrelated to the creative act and best accomplished by professional stonecutters.

Clay modeling and bronze casting, on the other hand, engaged the full creative involvement of the artist, who generally worked with the technicians through the final stages of the casting process. The smooth, idealized interpretation of the marble carver gave way to lively, natural-istic modeling captured in the casting of bronze, a durable material well suited to the renewed American interest in patriotic images for public spaces. (See *Material Pleasures*, pp. 92–93.)

Philadelphians can contrast these media in two works by Daniel Chester French. Among his early commissions were lofty allegorical works that described the functions of federal buildings. *Law, Prosperity, and Power* (**3-03**), commissioned for the U.S. Post Office and Federal Building, idealized the government in a lyr-ical form and material—marble—inspired by the artist's sojourn in Florence. How-ever, a later excursion to Paris certainly influenced his bronze sculpture of *General Ulysses S. Grant* (**3-18**), a collaborative effort with his former pupil, Edward Clark Potter. (French created the figure; Potter, the horse. Although apprentices and assis-tants often worked with sculptors, acknowl-edged collaborations between two artists were rare at this time.) In *Grant* the sculp-tors offer us the personification of the American spirit, captured in the solid, determined gaze and posture of the bronze general on his horse.

Sculptors began to realize that works to be seen outdoors required particular atten-tion to form, surface treatment, and scale. French wrote to the Art Association before beginning *Grant*: "I do not remember if I told you that we can roll our statue out-of-doors and work upon it under the same

62

conditions as the bronze will have." And Frederic Remington said of his *Cowboy* (**3-35**), "I built a studio on my place here [New Rochelle] with a track to run it out on and I find that track of the greatest advantage. I think without it I could never have done the work. The hard lights of indoors are so different from the diffused light of out-doors that it looks like two statues."

French and Potter's *Grant* and Remington's *Cowboy* share the integration of horse and rider and the complexity of form and detail that could only be captured in bronze. When they are seen together, however, it is apparent that, in French's words, "Potter's horse is obedient to the will of his rider," whereas Remington's work is as much a portrait of the horse, stopped short at the brink of a precipice, as it is of his cowboy.

Another Paris-trained artist, John J. Boyle, was born in New York City, but moved to Philadelphia when he was six years old. He started his career in sculpture as a stonecarver and studied at local art institutions until 1877, when he enrolled in the Ecole des Beaux-Arts. Three years later he received a commission from the Fairmount Park Art Association for an Indian group in bronze. By the spring of 1885, he was back in Paris and sent a photograph of the work in progress to the Art Association.

Boyle's *Stone Age in America* (**3-11**) reflected the changing aesthetic attitudes of Paris-trained artists as well as the social concerns of the American public. The American Indian as represented by Boyle is a heroic female figure, a fearless, dignified mother protecting her children. His conception rejects both the popular stereotype of the "naked savage" and the classical, idealized nude. Boyle pursued other American themes in his work and was

Photographer unknown
Plaster model of Alexander Milne Calder's *William Penn*
photograph c. 1890

Photographer unknown
Bronze cast of Alexander Milne Calder's *William Penn* in City Hall courtyard
photograph c. 1893

James L. Dillon
Workers with plaster model of Alexander Milne Calder's *Swedish Matron and Child* for City Hall tower
photograph c. 1890

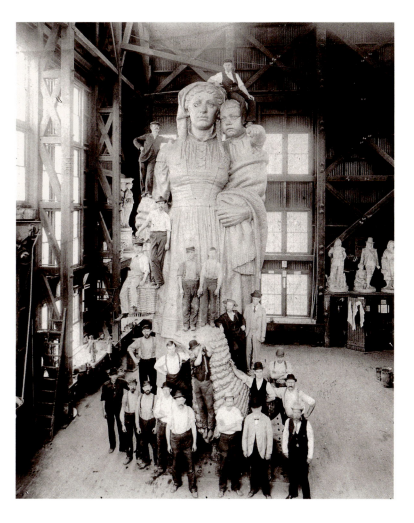

later selected to create a sculpture of Benjamin Franklin (**3-21**), which was originally located in front of the Post Office Building at 9th and Chestnut Streets, a site that once served as the temporary location for *Stone Age.*

In 1888, when Alexander Milne Calder completed the huge plaster model of *William Penn* (**3-02**) for the City Hall tower, there was no foundry in the United States capable of casting the colossal figure in bronze. As a result, the Tacony Iron and Metal Works of Philadelphia was established and awarded the contract for the tower metalwork, including the 30-foot figure of Penn, four 24-foot figurative groups, and four eagles, each with a 14-foot wing span (see *Meet You at the Eagle,* pp. 24–25). Fabricated in 14 sections, *Penn* required almost two years to cast. The bronze sculpture remained on view in the City Hall courtyard until November

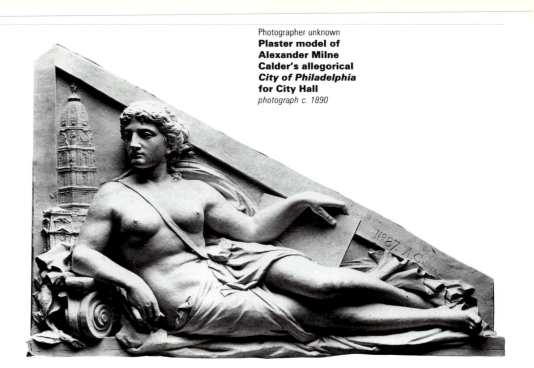

1894, when it was lifted into place, piece by piece, without ceremony.

Calder was born in Aberdeen, Scotland, the son of a tombstone cutter. In the 1860s he studied in Edinburgh, London, and Paris, where he saw the new additions to the Louvre that celebrated the Second Empire style and influenced John McArthur's design for City Hall. Calder then immigrated to Philadelphia and studied with Thomas Eakins at the Pennsylvania Academy of the Fine Arts. As director of the Academy, Eakins instituted the practice of drawing and modeling the figure from life, leading to his forced resignation in 1886 when he created a scandal by removing the loincloth of a male model in the presence of female students. Although Victorian prudery certainly influenced the images considered appropriate for the new American monumental sculpture, a close look at the sculpture on City Hall (**3-01**) reveals a prolific display of nude and scantily draped allegorical figures.

Artists who had studied in Paris returned to Philadelphia to teach, and students could now be trained in the method of the French atelier without leaving

America. In the 1890s Charles Grafly, who as a young man served an apprenticeship in the Struthers stoneyard, returned to become a respected teacher of sculpture at the Pennsylvania Academy, where he too had studied with Eakins. Although Grafly exhibited widely, his extensive use of symbolism, mystical imagery, and exotic references left local audiences bewildered. In a period when public sculpture was motivated by a responsibility to communicate a message or convey a fitting image of a hero, Grafly received few commissions because his work was very personal indeed. He is represented in Philadelphia by three rather conventional works at the *Smith Memorial Arch* (**3-19**) and by his design for the *General Galusha Pennypacker Memorial* (**4-49**). His influence as a teacher drew many sculptors to the Pennsylvania Academy, including Walker Hancock (**4-60, 4-64**), Albert Laessle (**4-05, 4-08**), and Paul Manship (**4-03, 4-62**). Thus the Pennsylvania Academy undertook the training of a new generation of American sculptors.

Renewed Patriotism

Ceremony and Celebration

Frederic Remington
Cowboy
1908 **3-35**

Confidence in the democratic form of government, eroded during the years of civil war, was restored by three world's fairs: the Chicago World's Columbian Exposition in 1893, the Pan-American Exposition in Buffalo in 1901, and the Louisiana Purchase Exposition in St. Louis in 1904. These fairs provided sculptors with opportunities for work, recognition, and future commissions— although much of the sculpture was temporary, made of a "staff" material of straw and plaster.

Many important sculpture commissions of this period were intended for public buildings and were officially endorsed by municipal, state, or Federal agencies. Immortalized and cast in bronze, statesmen, presidents, generals, and soldiers became part of the permanent fabric of growing American cities. In Philadelphia, largely as a result of the early leadership of the Fairmount Park Art Association, private groups and individual patrons com-missioned works for placement in parks, squares, libraries, the Zoo, or wherever people tended to gather in the course of daily life. Soon, local heroes—historic figures, bankers, industrialists, and civic leaders—were honored with monuments funded by private donation or public subscription: *Morton McMichael* (**3-04**), former mayor and the first president of the Fairmount Park Commission; *Tedyuscung* (**3-24**), a Lenni Lenape chief; *Matthias William Baldwin* (**3-31**), the founder of the Baldwin Locomotive Works; *John Christian Bullitt* (**3-33**), a financier and advocate of civic reform; and *Joseph Leidy* (**3-34**), a natural scientist and pioneer in the study of paleontology.

A sculpture commissioned to honor a celebrated individual placed a particular burden on the artist: the public anticipated a physical likeness. The surging popularity

Rudolf Siemering
**Washington
Monument** (detail)
1897 **3-20**

John J. Boyle
Stone Age in America
(below)
1887 **3-11**

of photography gave artists access to a precise record of a contemporary subject's appearance, while etchings, paintings, written descriptions, family interviews, and death masks aided the interpretation of modern and historic figures alike. Before a sculptor was invited to create City Hall's *William Penn* (**3-02**), the Historical Society of Pennsylvania was asked to investigate the founder's costume and appearance. Only after a model of his clothing was prepared did the *Times* of Philadelphia call for a sculptor "to put the man inside" the garments.

Daniel Chester French was aided in his rendering of Grant's uniform by the general's son, Colonel Frederick Dent Grant, who verified that his father wore his cape and overcoat "several inches longer than usual." The German sculptor Rudolf Siemering, in response to the request that the *Washington Monument* (**3-20**) be as "American" as possible, disregarded the engravings of Native Americans that were sent to him and requested photographs taken from life. Dialogue, and often heated debate, inevitably occurred between the commissioning body and the artist. But even when a likeness had been achieved, the artist's skill was challenged by a myriad of criticisms concerning pose, posture, anatomy, action, expression, costume, and scale.

Some of the more adventurous works emphasized an idea or a perception rather

66

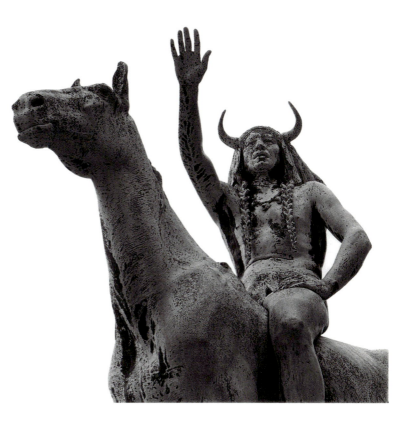

than an individual, even though a particular model may have served to inspire and inform the artist. Saint-Gaudens's *Pilgrim* (**3-29**), based on an earlier work by the artist, altered the appearance of Deacon Samuel Chapin to embody the Puritan tradition in its stern and authoritative posture. The model for Remington's *Cowboy* (**3-35**) was the artist's friend Charlie Trego, a native Pennsylvanian (and later manager of Buffalo Bill's Wild West Show) whom Remington met in Montana. Those who remembered Trego as a Chester County youth declared the sculpture a true likeness. Nevertheless, the *Cowboy* is appreciated for the action, drama, and spirit of adventure conveyed by horse and rider, rather than for the accuracy of its portraiture.

In 1893 Congress created the Dawes Commission to pave the way for an aggressive revoking of Indian land holdings and dissolution of tribal governments. In 1898, under the Curtis Act, tribal laws and courts were abolished, bringing Native Americans under the legal jurisdiction of the United States. Whether inspired by guilt or reverence for the past, Philadelphians during this period commissioned three major works to commemorate the spirit of the American West: Boyle's *Stone Age in America* (**3-11**), Cyrus Dallin's *Medicine Man* (**3-22**), and Remington's *Cowboy* (**3-35**).

Boyle was considered by the Art Association to be "the first sculptor who adequately presented the Indian's case in American Art." Dallin, raised in Utah, was well acquainted with Native Americans, and the critic Lorado Taft pronounced the *Medicine Man* "one of the most notable and significant products of American sculpture." Similarly, in his bronze *Cowboy*, Remington captures the rugged self-confidence of the pioneer. "The fast disappearing Indian and western cowboy should be put in enduring bronze, a record for the coming generations of what once was in America," the art director of *Century Magazine* wrote to Remington.

The unveiling and dedication of such public works were planned to inspire patriotic spirit. The 19th-century tradition of pageantry and spectacle often included bunting, music, speeches, fireworks, and even time off from school or work. Dedication ceremonies were memorable events inviting wide public participation.

In 1887 railroads advertised three-day excursion rates to Philadelphia for the festivities surrounding the unveiling of

Calder's *Meade* (**3-10**) in Fairmount Park. French and American flags were lent by the John Wanamaker department store for the unveiling of Emmanuel Frémiet's *Joan of Arc* (**3-13**) in 1890, when members of the city's French community joined the Art Association for the official dedication of the sculpture. The bilingual ceremony included orations in French and English, and the Girard College Band played the "Marseillaise."

With the advent of electrical utility service, night illumination became a feature of local festivals. The dedication ceremony for Saint-Gaudens's *Garfield Monument* (**3-16**) in May 1896 included a river fete and illuminated pageant. Newspaper accounts describe a "wondrous spectacle" along the Schuylkill: the Girard Avenue Bridge was outlined with thousands of incandescent lights marking every supporting girder; calcium lights defined the railroad bridges; thousands of colored electric lights were placed along the river wall from the bridges to the boathouses, which were themselves outlined with lamps. (The lighting of Boat House Row recalls this effect.) Strings of lanterns were stretched between trees and placed within

Poster announcing
Garfield Monument
river fete
1896

Badges for *Grant*
dedication
1899

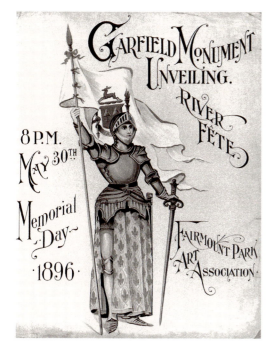

flower beds, and a flotilla, brilliantly lit
with lanterns and colored fires, moved up
the river from the boathouses to a land-
ing in front of the monument. At the
moment of the unveiling, a thousand red
fires were lit along the banks and under
the bridges.

The dedication of French and Potter's
Grant (**3-18**) was postponed when Con-
gress declared war on Spain in 1898. The
next year, a victory celebration was
planned to coincide with the anniversary of
Grant's birth. President William McKinley
attended the ceremony, highlighted by mili-
tary presence and a 17-gun salute hon-
oring the memory of the general. More
than 7,000 people attended, and such was
the demand for seating that badges of var-
ious designations and colors were issued to
identify the reception committee, members
of the Art Association, and the original con-
tributors to the Grant Memorial Fund.

In a pastoral setting in Fairmount Park
at Belmont and Lansdowne Avenues,
friends and family paid tribute in 1905 to
Anthony Drexel, international financier,

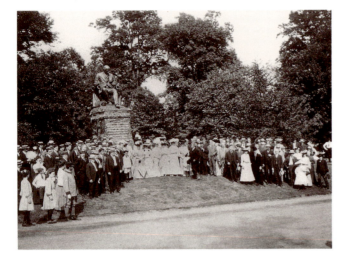

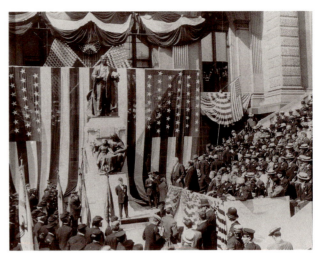

70

founder of Drexel University, and first president of the Fairmount Park Art Association (**3-28**). The sculpture by Sir Moses Ezekiel was unveiled by Drexel's two granddaughters, amid eulogistic tributes and recollections of friendship. It is now located on the Drexel campus.

Following the assassination of President McKinley in 1901, the Philadelphia *Inquirer* initiated a public subscription to raise funds for a sculpture in his memory (**3-36**). It was said that McKinley once remarked that there was "no city I like to visit more than Philadelphia." Charles Albert Lopez began work on the monument, and when he died unexpectedly in 1906, Isidore Konti finished the work from the models that Lopez had created. In 1908 the sculpture was unveiled on the south side of City Hall with great flourish, as much a tribute to the citizenry as to the memory of their leader.

Perhaps one of the most elaborate dedication ceremonies ever held was for Remington's *Cowboy*, attended by a cordon of genuine cowboys led by Wyoming Jack, a famous scout, and a group of Native American men in full warpaint, accompanied by their wives and children. The sculpture was concealed under a huge American flag, and thousands of spectators lined the River Drive and the surrounding hills. Wyoming Jack and He-Dog, a Native American medicine man, loosened the halyards around the *Cowboy*, assisted by two members of the Children's Art Brigade. Established by the Art Association in 1897, the Brigade encouraged the participation of young people in ceremonial events. Remington, however, declined to be present: "No one pays much attention to the sculptor," he wrote to the Art Association.

> *"To give people pleasure in the things they must perforce* use,
> *that is one great office of decoration; to give people pleasure in the things*
> *they must perforce* make, *that is the other use of it."*
>
> William Morris
> **The Lesser Arts**
> *1878*

Arts and Crafts

Another
American Ideal

Henry Mercer
Foyer arch, *Spinning*
(detail)
c. 1904 **3-30**

The Centennial Exposition placed Philadelphia in the center of an international marketplace where art and industry were displayed together. There the ideas of the British design reformers John Ruskin and William Morris gained exposure in the United States. Morris' theories appealed to the democratic impulse in America: "I do not want art for a few, any more than education for a few, or freedom for a few." Linking the arts and crafts, the Philadelphia Museum of Art began in 1876 as the Pennsylvania Museum and School of Industrial Art.

The Aesthetic movement brought "the beautiful" into the daily lives of private citizens with missionary zeal and engaged many of those citizens in the pursuit of beauty for the masses. The Fairmount Park Art Association, established in 1872, was joined by the Graphic Sketch Club, founded by Samuel S. Fleisher in 1899. Fleisher, convinced that all people should have the opportunity for artistic expression

and the appreciation of beauty, established a school in South Philadelphia in the midst of a community of working-class immigrants. Now known as the Samuel S. Fleisher Art Memorial, the nation's first free art school continues to offer cultural opportunities to the city's residents (see p. 110).

The region also nurtured a unique group of artists who developed traditional craft skills. In 1901 the architect William Price established in Moylan, Pennsylvania, the Rose Valley community, committed to the social ideal of improving life through art. *The Artsman*, a journal published by Price from 1903 through 1907, carried the subtitle "the art that is life." Before the community succumbed to bankruptcy in 1909, Price, with his colleague M. Hawley McLanahan, completed the Jacob Reed's

Sons building (now the Barnes and Noble Bookstore), working with Henry Chapman Mercer, who created the tile ornamentation. Its entry arch contains decorative tiles that, in keeping with the building's original function, illustrate the various activities of the clothing industry (**3-30**).

Mercer served as curator of American and prehistoric archeology at the University Museum of the University of Pennsylvania. Returning to his birthplace in Doylestown, Pennsylvania, in 1897, he began a second career by establishing the Moravian Pottery and Tile Works. Mercer's passion for the crafts of the Pennsylvania Germans led him to revive the local clay tradition, and in 1906 he completed the interior paving for the new State Capitol in Harrisburg. The building's 420 tiled mosaics, set irregularly against a background of handmade red tiles, depict the history, achievements, and environment of Pennsylvania's inhabitants, from the symbols and crafts of the Native American Indians (see p. 14) to the 19th-century inventions that changed our lives. "It is the life of the people that is sought to be expressed," Mercer wrote, "the building of a commonwealth economically great, by

the individual work of thousands of hands." He conceived the tile floor as "a great oriental rug," contrasting in color and material with the polished white marble interior of the building. A leader of the Arts and Crafts movement, he founded the Mercer Museum in 1916 to house his pioneering personal collection of American hand-crafted tools. Also at the State Capitol, in the Governor's Reception Room, are early murals by Violet Oakley, a champion of political and social causes who believed that the artist's role included the inspiration and education of society (see p. 104).

A more lighthearted impulse to uplift the American spirit motivated the Dentzel Carousel Company. In its Germantown factory, active at the turn of the century, the Dentzel family employed immigrant craftsmen who produced extraordinary examples of local folk art. A carousel pig attributed to Salvatore Cernigliano (and now in the Philadelphia Museum of Art) was elaborately and lovingly carved and painted. Intended to delight the eye and give joy to the people, the company's work was valued for its quality and imagination.

John LaFarge, credited with reviving American interest in the decorative arts with his mural paintings and stained glass

Attributed to
Salvatore Cernigliano,
Dentzel Carousel Company
Pig Carousel Figure
*1903–1909 (now in
Philadelphia Museum of Art)*

John LaFarge
Apelles (or **Painting**)
c. 1907 **3-32**

windows for Boston's Trinity Church, is represented in Philadelphia by a number of works, including three fused stained glass "tabletop" panels now installed in the Sanctuary of the Fleisher Art Memorial. Originally made for the Edward W. Bok house in Merion, Pennsylvania, the panels—symbolizing art, education, and music—illustrate landmarks in the "ethical development of man."

In response to the growing interest in art for homes and public buildings, the National Sculpture Society was founded in 1893. Its members were among the most important sculptors in America, and they succeeded in their promotion of monumental public art. But the sculpture they produced was not easily absorbed by the American household; it was through the arts and crafts that people were reached—at home, in the workplace, and in schools throughout the nation.

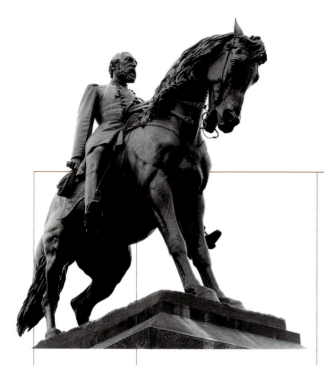

Alexander Milne Calder
**Major General
George Gordon
Meade**
1887 **3-10**

Alexander Stirling
Calder
Sundial (above right)
1903 **3-26**

**Alexander Calder
with model of
*White Cascade***
photograph c. 1976

Philadelphia lore points to a physical and ancestral line of "Calders" along the Benjamin Franklin Parkway: from Alexander Milne Calder's *William Penn* (**3-02**) on top of the City Hall tower, to Alexander Stirling Calder's *Swann Memorial Fountain* (**4-14**) in Logan Circle, to Alexander "Sandy" Calder's *Ghost,* suspended from the ceiling of the Grand Stair Hall in the Philadelphia Museum of Art. Many Philadelphians respectfully and affectionately refer to the sculptures as the Father, the Son, and the Holy Ghost.

Though in memory they are warmly embraced as local art heroes, the Calder family of sculptors endured all manner of rejections in their lifetimes. Sculptor and art historian Lorado Taft, in the 1924 revised edition of *The History of American Sculpture,* barely mentions the Calder name in his discussion of Philadelphia's notable artists. A grand ceremony surrounded the 1887 unveiling of Milne Calder's monument to *General George Gordon Meade* (**3-10**). Yet the artist died in 1923, in his home at 1231 South Broad Street, resentful and bitter because he believed that the architects of City Hall had intentionally positioned his sculpture incorrectly (facing it toward the northeast instead of the south), thus relegating his Penn to "eternal silhouette." This action he attributed to architect John McArthur's successor, who evidently did not care for Calder's work and found it outdated. Penn's face in fact can be seen clearly only in the early morning light.

Calder's son, Stirling Calder, endured the critics' initial coldness toward his allegorical interpretation for the Swann fountain. His grandson, Sandy Calder, was one of the most celebrated artists of this century. Early in his career, however, his "moving sculpture" caused a sensation, and he was often dismissed as a mere toymaker and eccentric. As late as 1957 Salvador Dali acerbically proclaimed, "The least that one can ask of a piece of sculpture is that it should not move."

In a 1949 interview with Gertrude Benson in the *Evening Bulletin,* when his *International Mobile* was exhibited in the Sculpture International Exhibition at the Art Museum, "making Philadelphians gape in awe and wonder," Sandy Calder reminisced about

his family. He had tremendous respect for his grandfather because he worked on such huge sculptures. "Father, of course, belonged to a different generation and thought sculpture should be lovely to touch. He thought my work in wire, especially, too rough and inhospitable to the touch. As a matter of fact, people can't resist touching my mobiles and trying to make them move."

Although their work now seems vastly different, Sandy shared with his grandfather a fascination for the monumental. *William Penn* is thought to be the world's largest cast bronze figure; the 100-foot *White Cascade* (**6-13**) in the Federal Reserve Bank is considered the largest mobile. Watching this mobile, splashed with sunlight and moving slowly through time and space, one realizes that Sandy shared with his father an interest in natural phenomena. Stirling Calder's *Sundial* (**3-26**) in Fairmount Park, for example, interprets the passing of time through the signs of the zodiac and the four seasons.

All three artists worked closely with architects to achieve an integration of art and architecture. One cannot conceive of City Hall without its copious sculpture, and it is impossible to imagine Wilson Eyre's water display for the *Swann Memorial Fountain* without the figures and animals that make up *The Fountain of Three Rivers*. The three sculptors shared an abiding interest in making contact with the public through affectionate, provocative, and conspicuous gestures. Many American cities have proudly placed "a Calder" in a public plaza. Philadelphia boasts three generations of Calders, whose numerous works enhance our outdoor experience of the city and the park.

Alexander Calder
Ghost (above left)
1964 (in Philadelphia Museum of Art)

Alexander Milne Calder
William Penn
1886–1894 **3-02**

Alexander Calder
White Cascade
1976 **6-13**

Alexander Stirling Calder
Swann Memorial Fountain
1924 **4-14**

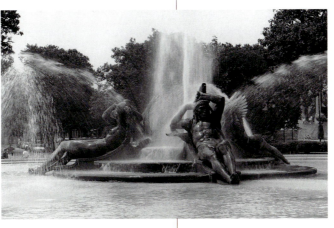

A City Beautiful
The Parkway Plan

MAP OF THE GRAND AVENUE TO THE PARK, PHILADELPHIA.

PLEASE HANG THIS UP FROM THE PUBLIC BUILDINGS TO THE PARK, AS PROPOSED BY C. K. LANDIS, SEA ISLE CITY, N. J.

A CONVENIENT APPROACH TO THE PARK IS A NECESSITY. WHY NOT MAKE IT SOMETHING WORTHY OF THE MAGNIFICENT CITY OF PHILADELPHIA.

C. K. LANDIS, Sea Isle City, N. J.

Charles K. Landis
**Map of the Grand
Avenue to the Park**
1884

The genesis of the "city beautiful" movement was the 1893 Columbian Exposition in Chicago, whose architect, Daniel H. Burnham, also designed the John Wanamaker department store in Philadelphia (1902–1911). The fairground, a showcase for a unified, planned environment, had classical buildings, elaborate sculptural ornamentation, wide boulevards, and broad vistas. In Philadelphia, the influence of this movement resulted in the Benjamin Franklin Parkway.

Yet the Parkway's tumultuous history actually began much earlier. The first known proposal for connecting the city with Fairmount Park was a pamphlet from the press of John Pennington and Son entitled "Broad Street, Penn Square and the Park" (1871): "If the great park, with which we have undertaken to adorn the city, is to be a place of general resort and to benefit *all* of our citizens, it must be brought within reach of all." Pennington's plan advocated connecting the city and the park by the shortest possible route, using trees and landscaping to make the city's avenues "as attractive as those of Paris."

Philadelphia's 1876 Centennial stirred interest in the park, and in 1884 Charles K. Landis, the founder of Vineland, New Jersey, presented another plan in the form of a poster that urged "Please Hang This Up." Landis' plan also recalled the boulevards of Paris, proposing a parkway that "would cut the blocks diagonally which affords a grand opportunity for architectural effects, and for the erection of monuments, statuary and fountains." With foresight, he suggested placing at the terminus the *Washington Monument* (**3-20**), on which the sculptor had just begun work.

Admiration for the French style is not surprising. City Hall, then under construction, was designed in the sumptuously

76

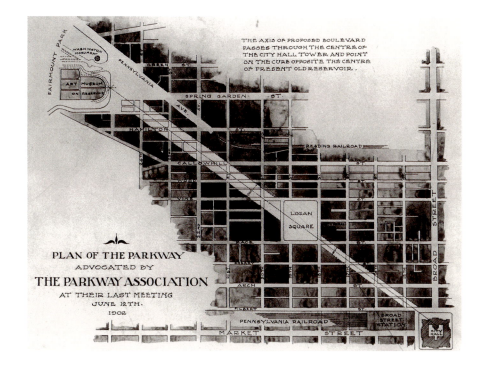

adorned Second Empire manner, promulgated by Napoleon III and exemplified by the Louvre. The unification of sculpture and architecture reached an apogee with the design of City Hall, and its mass provided a starting point for the connection between the city center and the park.

Prominent citizens gathered in 1891 to begin the first serious public campaign for the Parkway, and the next year it was placed on the official maps of the city. The parkway concept was immediately subjected to the struggles and ravages of city politics, but local arts organizations kept the idea alive. In 1900 representatives of various cultural organizations created the Art Federation of Philadelphia. Its Boulevard Committee gave birth in 1902 to the Parkway Association, devoted to the creation of an axial boulevard from City Hall to the Fairmount Reservoir, where an art museum would be located. Alliances with the Fairmount Park Art Association

and the City Parks Association strengthened the movement. The first funds were approved by public vote in 1904. Soon afterward Frederick Crowninshield, president of the Fine Arts Federation of New York, told a Philadelphia audience that New Yorkers had always looked upon Philadelphia as the "Mecca of Art." It was very difficult to get anything done in New York because it lacked public spirit, Crowninshield commented, "but I should think that here you should accomplish pretty much anything."

Finally, in 1907, demolition began based on a modified plan—a diagonal that shifted the axis of the Parkway at Logan Square, negating a full-length vista from City Hall to the terminus. Dissatisfied, the Art Association commissioned the architects Paul Cret, Horace Trumbauer,

Paul Cret,
Horace Trumbauer, and
C. C. Zantzinger
**The Parkway on the
City Plan**
1906

Paul Cret,
Horace Trumbauer, and
C. C. Zantzinger
**Study of a
Compromise Plan**
1907

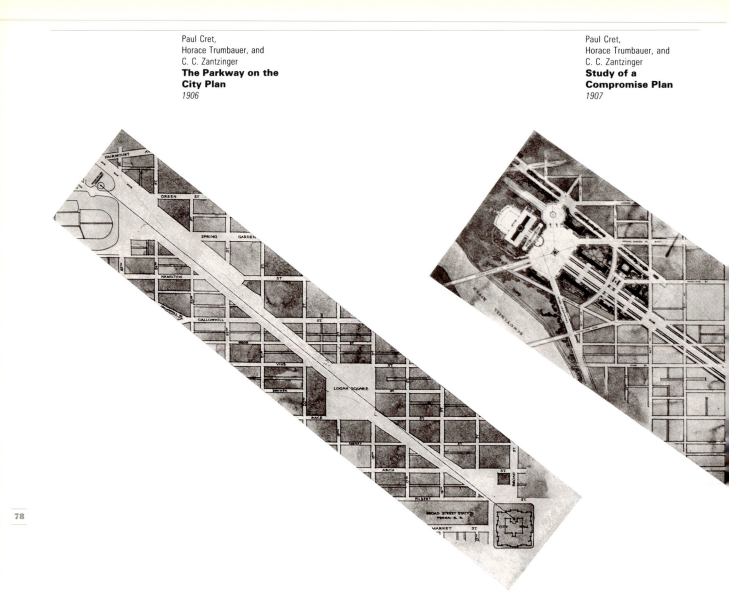

and C. C. Zantzinger to review the plans. Their study bolstered earlier proposals to link the great recreation ground of Fairmount Park to the seat of government, City Hall. The architects observed that the city's severe grid system was appropriate for a small town, but that a growing city required diagonal avenues to link important points, like the great avenues of Washington, D.C., or the Champs Elysées. They recommended a straight line and a full vista from City Hall, and an important point of interest at the terminus—a Municipal Art Gallery or perhaps a viewing plaza. These recommendations

shaped the plan that was placed on the official city map in 1909 and provided the rationale for the dramatic, uninterrupted axis that we experience today (see p. 121).

While the struggle for the Parkway evolved, the city's population swelled, the number of automobiles increased dramatically, and traffic safety and transportation became issues unforeseen in earlier years. Changing perceptions of urban life sparked new speculation about the city of tomorrow. In 1910 George Oakley Totten, Jr., secretary of the American Section of the International Congress of Architects, spoke to the Art Association about "The Influence of Aeronautics on City Building." Totten heralded such

Jacques Gréber
The Parkway Plan
1917

astonishing future roles for aviation as war-
time scouting and reconnaissance, transpor-
tation, commerce, mail delivery, and even
fostering civic improvement by bringing
ill-designed areas of the city into a more
critical view. About aviation machines he
speculated, "Perhaps those no larger than
umbrellas will be sufficiently powerful to
carry one person." Planning had so far
been developmental and incremental, but
new technologies would demand confi-
dence in the power of the imagination.

Realism to
Abstraction

1911–1958

CHAPTER

4

Statues to Sculpture

When Old and New Collide

Auguste Rodin
The Burghers of Calais
1884–1895 (now in Rodin Museum)

Artists and the general public had reached a cultural consensus through the rites of commemoration by the end of the 19th century. The country's heroes, its patriotic ideals, and the universal themes of justice and wisdom were represented through a visual vocabulary understood by many, yet individually interpreted by the artists. Admiration for the past helped to define the nature of truth and beauty, and the role of public art was to reinforce, uphold, and perpetuate commonly held civic values. As Daniel Robbins noted in *200 Years of American Sculpture*, "Only professional sculptors used the term 'sculpture' for their work. Architects, legislators, patrons and public alike referred to sculpture as statues." However, the 20th century was to witness a dramatic shift in the possibilities for public art: from statues to sculpture, from the specific to the general, from

the communal to the personal, and from realism to abstraction.

The artist who set the stage for this transformation was the French sculptor Auguste Rodin, whose expressive interpretation of the human body represented deep social convictions and personal values. In the 1880s, while American artists worked in Paris on many of the idealized civic monuments that were shipped back to the United States, Rodin was challenging convention with his public commissions. In *The Burghers of Calais*, which can be seen in Philadelphia's Rodin Museum, the artist celebrated not an individual but the actions of a group. In this work, the town hero Eustache de St. Pierre was presented standing alongside five companions, neither separate nor elevated according to formal, hierarchical tradition. Despite intense opposition from his patrons, Rodin made a democratic statement by creating a work to be placed at ground level, on the

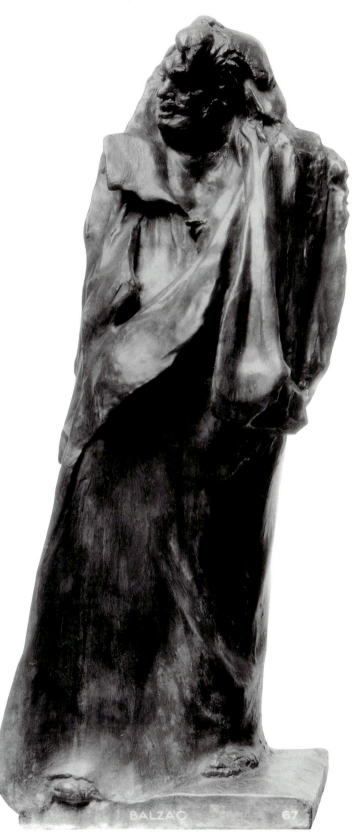

specific site where the six burghers volunteered to die.

The abandonment of the pedestal was revolutionary, suggesting as it did the disintegration of a greater moral authority in favor of the common ground. The pedestal is the sculptor's means of connecting public art to the environment while enabling the work to remain separate from its audience and the pedestrian life of the street. Consider Rogers' *Abraham Lincoln* (**2-18**), installed on a pedestal more than twice as large as the sculpture itself, and the *Smith Memorial Arch* (**3-19**), where the pedestal reaches almost absurd heights as an architectural support, with Generals Meade and Reynolds towering over the park and visible from the River Drives. As society's craving for psychological distance from its heroes has diminished, the scale of the pedestal has declined proportionately.

For the *Monument to Balzac*, commissioned by the Société des Gens de Lettres in 1891, Rodin studied every available representation of the writer and even traveled to the author's home province of Touraine to look at the people there. After many attempts, including nude studies, Rodin finally clothed Balzac in a long, draped garment, knowing that the writer's favorite working clothing was a loose Dominican robe. The exhibition of the sculpture in 1898 caused outrage, and the Société refused to endorse it. (Sentiment had changed by 1939, when the Société installed and dedicated the sculpture in Paris.) Likewise, many objected to the *Burghers'* lack of "monumentality," and

Auguste Rodin
The Gates of Hell (detail)
1880–1917 **4-01**

Auguste Rodin
The Thinker
1902–1904 **4-02**

indeed the work was later to acquire a pedestal and a different location. Rodin had begun the communal dialogue that eventually gave artists a more active role in the conception and placement of public art.

In 1880 Rodin was commissioned to create a bronze portal for a proposed Museum of Decorative Arts in Paris. Although it was originally intended to illustrate scenes from Dante's *Divine Comedy*, Rodin transformed the work over a period of about twenty years into his personal vision of Hell, an organic, sensual, and spiritual expression of mankind's sorrowful destiny. *The Gates of Hell* (**4-01**) was not cast in bronze during Rodin's lifetime (Jules Mastbaum, a Philadelphian, ordered the work cast for the Rodin Museum that he established along the Parkway), but Rodin enlarged *The Thinker* (**4-02**) from its central position on the gates and exhibited it in Paris in 1904 to mixed and passionate critical commentary.

Rodin's *Thinker* was not a monument to Dante, as originally conceived, nor was it a memorial to a particular dead hero or a revered civic leader, but rather a cele-

bration of all artists, intellectuals, and workers. There was speculation that the sculpture was subconsciously autobiographical, symbolizing the artist's working-class roots and quest for life in art, an impression captured poignantly by Edward Steichen's photograph of Rodin and his sculpture. Art historian Albert Elsen suggests, "If Rodin had stated his intentions clearly and without apparent contradiction . . . , it is questionable that *The Thinker* would have become the most well-known sculpture in the world."

In the United States, the influence of Rodin's daring creativity could not be disregarded. Other societal conditions were equally challenging. The advent of the automobile, aircraft, and the skyscraper irrevocably changed creative thinking as artists attempted to address a world in transition. The growth of cities stimulated artists to seek uniquely urban expressions, even as the rise of museums and galleries detached works of art from the public context. Some artists were challenged to seek new forms, while others searched for meaningful content.

"The International Exhibition of Modern Art," held in New York City's

Photographer unknown
Albert Laessle with
Penguins
photograph c. 1917

Albert Laessle
Penguins
1917 **4-08**

Photographer unknown
**Albert Laessle
(center), with live
musk ox, teaching at
the Pennsylvania
Academy**
photograph c. 1904

69th Regiment Armory in 1913 and immortalized as the "Armory Show," advanced the ideas that form could exist independent of content and that art could be an expression of purely aesthetic or personal ideas. It was at the Armory Show that Marcel Duchamp's *Nude Descending a Staircase*, now in the collection of the Philadelphia Museum of Art, confronted prevailing attitudes about painting. Within a few years, Duchamp introduced his "ready-mades"—common, manufactured objects that, taken out of context, called into question prior notions about just what constituted sculpture, removed sculpture from traditional bases, and sent artists out of the studio and into the factory. In the process, the detritus of American culture was scrambled and reassembled, and people began to question the notion of a work of art as a "possession."

The cultural climate in Philadelphia in the early part of the century was perceived by many as inflexible and conservative. In 1923 Albert Barnes exhibited his collection of paintings at the Pennsylvania Academy of the Fine Arts and was furious at the negative reaction of critics and the public.

He retreated to the suburb of Merion, where Paul Cret designed a building to house the collection, and Jacques Lipchitz created the exterior sculptural ornamentation. Barnes's revenge was to deny access to the art community that had rejected him.

In virtually every cultural realm, the old and the new were colliding. The legendary Leopold Stokowski conducted the Philadelphia Orchestra's landmark performance of Igor Stravinsky's *Le Sacre du Printemps* in 1930, with the young Martha Graham as principal dancer. While it was a great success with critics outside Philadelphia, there was local reserve, and even disdain. By 1937 Stokowski had resigned and the more conservative and tactful Eugene Ormandy had been hired.

Philadelphians—and Americans in general—were even less prepared for modern sculpture than they were for modern painting, and the accepted idea of the figure was so deeply rooted in public art that individual experimentation was most unwelcome. Sculpture cost more to

produce, took longer to execute, and was less portable. Because sculpture was so dependent on public and private patronage, each work had to endure long and protracted arrangements before it could be incorporated into the public domain. Not surprisingly, sculpture continued to be less confrontational, less spontaneous, and limited by tradition to representational imagery.

Some artists turned to animal subjects to escape the limitations imposed on the expression of the human body and to counter the dictum of monumentality that insisted on the separation of art from everyday life. The French animaliers, using animals as symbols for real-life drama, had often depicted the bestial side of nature, as in Barye's *Lion Crushing a Serpent* (**1-11**). But by the 20th century, the treatment of animals by American artists had become noticeably tame. Albert Laessle, who studied and taught at the Pennsylvania Academy, devoted his attention to the humor and personality conveyed by animal behavior. Highly individualized and bursting with spirit, his animal sculpture so captured the movement of his subjects that he was often accused of casting from life. Laessle often

visited the Philadelphia Zoo, where he could observe his subjects firsthand. His *Penguins* (**4-08**), installed in front of the Zoo's Bird House, continue to arch their bodies at the same place where the animals captured the artist's attention. Laessle also continued the tradition of using live animals as models for the classes he taught at the Pennsylvania Academy. His sculpture of a billy goat was said to have been inspired by a household pet, and generations of young Philadelphians visiting Rittenhouse Square have vicariously tamed the struggling *Billy* (**4-05**). Laessle's influence can be seen in parks and recreational sites throughout Philadelphia, where frogs, turtles, kangaroos, horses, and other creatures have proliferated.

Other artists developed stylized interpretations that no longer extolled the glorious hero. Sculptor Paul Manship declared: "It is sad to see our streets encumbered with hideous bronze gentlemen in badly modelled frock coats, on ugly pedestals." Manship, in search of an idealized, ornamental, decorative style, was influenced by preclassical works. His sculpture joined

88

ancient mythology with a modern sense of form inspired by elements from archaic Greece, Crete, Rome, India, and Japan. Because of the easy grace and freedom of spirit reflected particularly in his early work, he was much in demand for public commissions. His elegantly draped *Duck Girl* (**4-03**), created in 1911, and his later work, a celestial sphere known as the *Aero Memorial* (**4-62**), created in 1948, represent a range of interests that stretched, but by no means abandoned, academic tradition.

Another challenge to established practice was the revival of the practice of "direct carving." Ironically, this was a reaction against Rodin's custom of using assistants and workers to "translate" his clay models into various sizes and media. Direct carving was increasingly seen as a craft that revealed the true nature of the material, a "subtractive" rather than an "additive" process (see *Material Pleasures*, pp. 92–93). Devoted to the honest and straightforward use of materials, these artists returned to the earlier practices of carving wood and stone, believing that the hand of the artist was as essential to the purity of the work as the eye and mind. The sculptors Robert Laurent, John Flannagan, William Zorach, José de

Creeft, and Koren der Harootian, all represented by works in Fairmount Park, were exponents of this belief. The process of direct carving also had roots in the growing admiration for the working class among artists and intellectuals. What could link the artist and the worker more strongly than the physical labor that carving demanded?

Immigrant sculptors brought European perspectives with them as many relocated to the United States. Freud had embarked on his lecture trips to the United States, and artists too were drawn to the psychological and contemplative. European exposure to African tribal art fostered a growing interest in the mysterious and primordial, and some artists saw the reduction, or abstraction, of the human figure to its fundamental form as an alternative to the overrefined models of the past.

But conservative resistance to abstraction and to the "modern" was unyielding. The role of government in determining the nature of art was dramatically enacted in the 1927 case of Constantin Brancusi (represented by Philadelphia lawyer and art collector Maurice Speiser) versus the United States. The issue was whether Brancusi's polished bronze *Bird in Space* (later known as *Bird in Flight*) was admissible as duty-free art or as dutiable merchandise carrying a 40 percent tariff (along with

other "hardware" and "manufacture of metal" such as kitchen utensils and hospital supplies). On the basis of the Treasury Department's 1916 definition of sculpture as "imitations of natural objects, chiefly the human form . . . in their true proportions of length, breadth, thickness," and the opinion of art "experts" that Brancusi's work "left too much to the imagination," the U.S. Customs Court's 1927 ruling was "Not art." In a landmark Customs Appeal Court decision in 1928, Judge Byron C. Waite overturned the original ruling: "To be art, a work by a recognized sculptor need not bear a striking resemblance to a natural object." Despite the ruling, modern art continued to be vulnerable to the disapproval of customs authorities until 1958, when Congress finally liberalized the law.

Large-scale public commissions generally continued in a traditional mode, even while small-scale or "private" works permitted the modernist influence. Thus, in the first half of the 20th century, public art was not always in step with other aesthetic movements, as the acquisition history of public works in Philadelphia illustrates. Gaston Lachaise immigrated from Paris in 1906 and was well known for his oversized

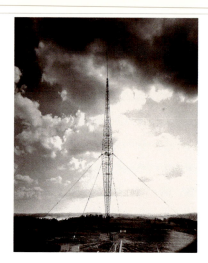

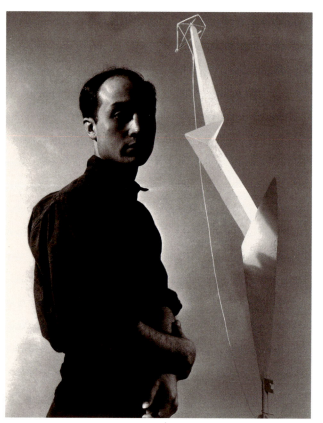

90

and sensual sculptures of his wife, Isabel Nagel, but his more conventional portraits and animal commissions were more appealing to the conservative tastes of American patrons. It was not until 1933 that Lachaise was commissioned by the Fairmount Park Art Association (a sculpture for the Samuel Memorial, unrealized because of his untimely death in 1935), and it was not until 1963 that a second casting of his 1927 *Floating Figure* (**4-20**) was acquired for installation in Philadelphia. Alexander Calder suspended his astonishingly engineered *International Mobile* in the Great Hall of the Philadelphia Museum of Art in 1949, but only in 1965 did the Museum purchase his *Ghost* (1964) for the permanent collection. Isamu Noguchi's monument to Benjamin Franklin was inspired in part by the radio towers that were altering the American landscape, but his drawings were dismissed as too avant garde in 1933. More than 50 years later, *Bolt of Lightning . . .* (**6-41**) was installed at the base of the Benjamin Franklin Bridge.

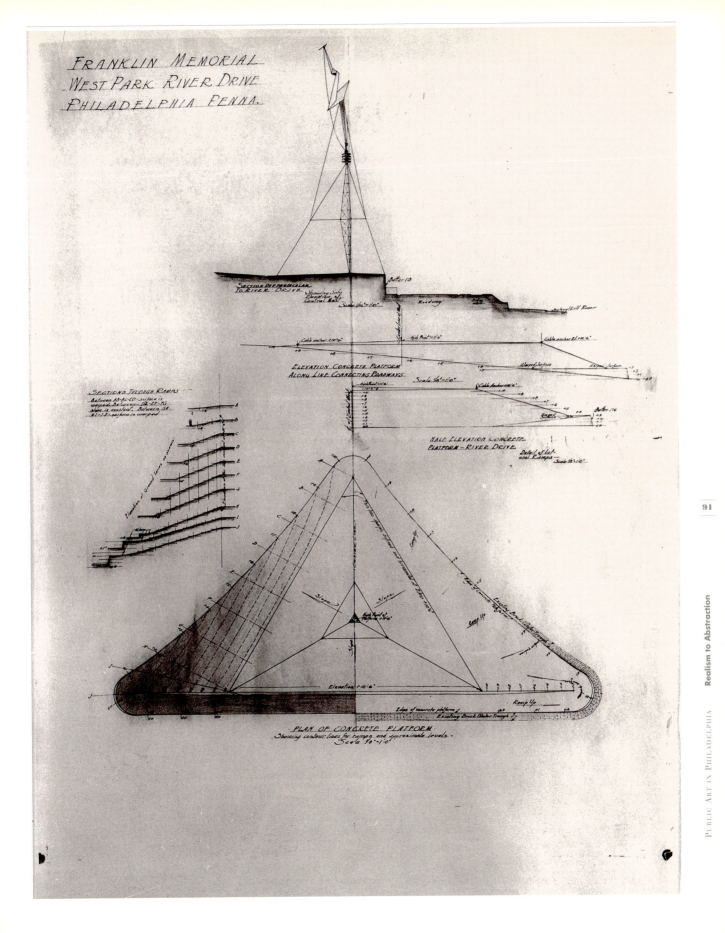

FRANKLIN MEMORIAL
WEST PARK RIVER DRIVE
PHILADELPHIA PENNA.

PLAN OF CONCRETE PLATFORM

Jo Davidson
Walt Whitman
(detail)
c. 1939; cast 1957
4-53

Constantino Nivola
Family of Man
(above right)
1961 **5-02**

92

Joseph C. Bailey
Gift of the Winds
1978 **6-23**

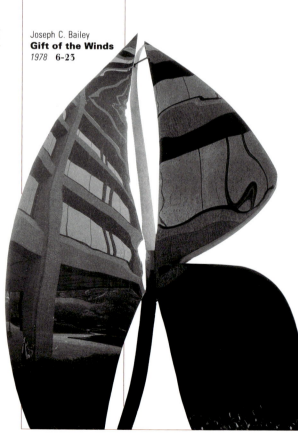

The relationship of the artist to his or her materials has been discussed for centuries. Michelangelo spoke of "liberating the figure from the marble that imprisons it." For Rodin, sculpture was "quite simply the art of depression and protuberance." Michelangelo associated the creation of sculpture with its emergence from the block of stone; Rodin, on the other hand, saw his work as the culmination of the more liquid act of modeling. Thus, the contrast has been made between the *subtractive* process of carving, which removed material, and the *additive* process of modeling, which built and shaped it. Of interest to both artists and observers has been the extent to which the sculptor's "hand" comes into direct contact with the medium, and the artist's regard for the intrinsic qualities of the material of choice.

Modeling is the exact opposite of carving, and it permits the expressive and detailed handling of surface material. In the ancient craft of *cire perdue* or "lost-wax" casting, the object is first formed in wax by modeling, a mold is made, and then the work is "translated" into bronze, ceramic, concrete, or—in recent years—plastics. Modeling has been considered as personal as a signature, as Jacques Lipchitz relates in his autobiography: "Bronze is my first and continuing love because it is so alive, so direct, warm, and fluid. Each piece has my fingerprints all over it."

Wood and stone are the traditional carving materials. The production demands of the 19th century revived the Renaissance practice of handing over a reduced-size model to professional stonecutters, who would enlarge the model by means of a mathematical measurement system called "pointing." By the 20th century, artists had begun to question this practice and revived the use of "direct" carving, doing all the cutting and finishing themselves. The sculptor José de Creeft (*The Poet,* **4-44**) wrote at the age of 88: "If you like stones and carve them, any stone will contain unlimited forms." However, the structural limitations of stone and wood—size, color, grain, density—cannot be forced beyond the natural character of the material. For the carver, these

materials "reveal" themselves, and the artist releases the energy from within. It was Henry Moore who acknowledged the possible interrelationships: "I am by nature a stone-carving sculptor, not a modeling sculptor. I like chopping and cutting things, rather than building up. I like the resistance of hard material. . . . Even now, in producing my bronzes, the process that I use in making the plaster original is a mixture of modeling and carving."

War years inevitably create shortages of certain metals, causing artists to turn to materials that are more readily available. This happened after World War I and during the lean years of the 1920s and 1930s, when the process of direct carving and respect for physical labor also linked immigrant artists to the working class. As artists became less involved with the modeling process, experimental applications and combinations of materials resulted in a new philosophy toward "additive" work—the fabrication of sculpture through welding, forging, construction, or assembly, using materials as diverse as steel and neon lighting. Some artists began to work in industrial settings, exploring new materials on a large scale; others set up studios that resembled factories. In recent years, the historical relationship between artist and technician has been renewed by the challenge of environmental projects that require the close association of creative thinking with technical skill.

John Rhoden
Nesaika
1976 **6-08**

Daniel Chester French
**Law, Prosperity,
and Power** (detail)
c. 1880 **3-03**

**Construction of
*Fingerspan***
photograph 1987
6-55

"There is no abstract art.
You must always start with something."

Pablo Picasso to Christian Zervos,
editor of *Cahiers d'Art*
1935

The Sculpture Internationals

But Is It Art?

E. Quigley
[Carl Paul Jennewein's] *Armillary Sphere* **at first Sculpture International Exhibition**
photograph 1933

Hundreds of works were exhibited, examined, admired, and ridiculed at the three Sculpture Internationals sponsored by the Fairmount Park Art Association in 1933, 1940, and 1949. These exhibitions came about because Ellen Phillips Samuel (1849–1913) left her residuary estate in trust to the Art Association, specifying that the income be used to create a series of sculptures along the Schuylkill River "emblematical of the history of America—ranging in time from the earliest settlers of America to the present era." Mrs. Samuel was a descendant of the earliest Sephardic Jewish settlers in America, and her family life was characterized by a long tradition of patriotism and philanthropy.

Although funds would not become available until the death of her husband, J. Bunford Samuel, in 1929, during his lifetime Mr. Samuel took an active interest in the project and commissioned the Icelandic sculptor Einar Jonsson's *Thorfinn Karlsefni* (**4-09**), with the intention that this

work would begin a sequence of historical sculptures erected at intervals of 200 feet along the river. However, as the art critic Dorothy Grafly later noted, Mrs. Samuel had proposed a 19th-century idea for the 20th century. By the time the last sculpture was dedicated in 1961, the Ellen Phillips Samuel Memorial was as much a monument to the confusion about what constituted modern public art as a tribute to Mrs. Samuel's unprecedented generosity.

When Mrs. Samuel's will was executed in 1907, the site she had selected was a gravel road used primarily by pedestrians. By the time the Art Association received the funds in 1929, the East River (now Kelly) Drive was a blacktop thoroughfare. The committee established to carry out the terms of the bequest abandoned the original idea of a row of portrait sculptures or

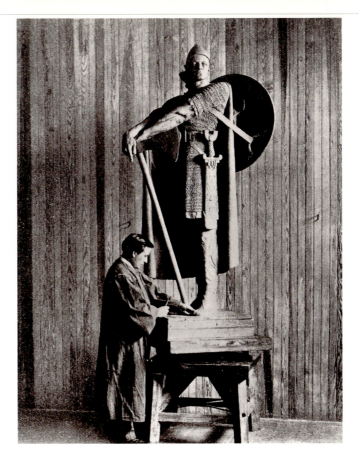

allegorical statuary and agreed that the project should be a more contemporary "expression of the ideas, the motivations, the spiritual forces, and the yearnings that have created America." Paul Cret, a member of the city's Art Jury and a professor of architecture at the University of Pennsylvania, designed a setting of three terraces. Once the central unit had been completed, the Art Association embarked on the ambitious program that would result in the commissioning of works by 16 artists over a period of almost thirty years.

Each terrace was to have an overall theme, the South Terrace representing the settlement of the east coast and the development of the democratic nation; the Central Terrace, America's westward expansion and the extension of liberty through the freeing of slaves and the welcoming of immigrants; and the North Terrace, the spiritual values that have shaped American life (**4-32–4-47**).

In her will, Mrs. Samuel had requested that notices be placed in newspapers around the world, asking for designs and offering to pay shipping costs. In that spirit, the Art Association organized three international exhibitions to permit the Samuel Committee to review the field of contemporary sculpture and select artists who would represent the spirit of the times. For the first Sculpture International exhibition in 1933, the Art Association cooperated with the Philadelphia Art Alliance and the Philadelphia Museum of Art, in whose courtyard, Great Hall, and adjacent galleries the exhibition would take place from May through September. Sculptors around the world were invited to submit photographs of their work for

review, and the Art Association paid for insuring and transporting the selected works.

In a time of worldwide depression, artists found the prospect of exhibition and subsequent commission most desirable. Also appealing was the fact that the sculptors were to be chosen on general merit, rather than as a result of a specific competition. In May 1933, 364 works by 105 sculptors were exhibited, representing the foremost sculptors in America, as well as those from Russia, Germany, France, Romania, England, and Spain. Because of its size, setting, and comprehensive presentation of "classical" and "modern" works alongside one another, newspapers nationwide declared it the most significant American sculpture exhibition of the century. Museum attendance doubled. In the *Public*

Reuben Goldberg
[Aristide Maillol's]
Venus **at second**
Sculpture
International
Exhibition
photograph 1940

Helene Sardeau
The Slave
(below)
1940 **4-37**

John Flannagan
The Miner
1938 **4-34**

Ledger's "straw vote" ballot, newspaper readers chose (in order) Walker Hancock, Carl Milles, Harry Rosin, Alexander Stirling Calder, William Zorach, and Albert Laessle—all of whom would eventually have their work represented in Philadelphia's vast collection of public art. But the Samuel Committee selected none of those artists. Robert Laurent and Maurice Sterne (replacing Gaston Lachaise) were selected to create bronze groupings (**4-32, 4-35**), and John Flannagan, Wallace Kelly, Helene Sardeau, and Heinz Warneke were commissioned to create limestone figures (**4-33, 4-34, 4-36,** and **4-37**). Archipenko, Lipchitz, Maillol, Matisse, and Noguchi exhibited, but these artists—who were to become enormously influential—appeared on neither the popular nor the designated list.

The second Sculpture International exhibition was on view during the summer of 1940. Because of the war, most of the works in the foreign section were on loan from U.S. museums, dealers, and collectors. The Whitney Museum of American Art lent works from its permanent collection for the American section, and others were on loan from government agencies employing artists: the Treasury Department's Fine Arts Section and the Federal Art Project of the Work Projects Administration (originally the Works Progress Administration, WPA). Materials used in the 431 exhibited works ranged from the familiar bronze, marble, and stone to wood, fieldstone, sandstone, cast cement, cast iron, aluminum, and stainless steel. Many artists were developing an interest in "direct carving" as well as experimental assembly. The war had created a shortage

of certain metals, and with decreased financial resources, it is not surprising that artists turned to materials that were more readily available.

Ninety WPA guides wearing blue smocks conducted tours of the exhibition. These previously unemployed workers had been trained to point out that many of the works were created to reveal motion, balance, color, and form. "But is it art?" asked the press. Alexander Calder's two mobiles caused a sensation, hinting at the birth of a new kinetic art form and drawing the curious attention of children while their parents retreated toward something more recognizable. Brancusi's *Miracle*—a smooth white marble form upon which he based his later work, *The Seal*—revolved on a platform just inside the Museum's entrance, posing immediate questions to those entering the building. And, among the artists themselves, there was a lively debate between those who sought an analogical relationship to the natural world in their work and those who sought the pure investigation of form through abstraction.

From the exhibiting sculptors, Wheeler Williams, Harry Rosin, Henry Kreis, and Erwin Frey were selected for the second round of commissions (**4-39–4-42**). Committee member R. Sturgis Ingersoll later acknowledged that for the South Terrace the committee chose more "established" artists than those who had created the works for the Central Terrace. In his opinion, the resulting work was inferior to the first group, "markedly static and

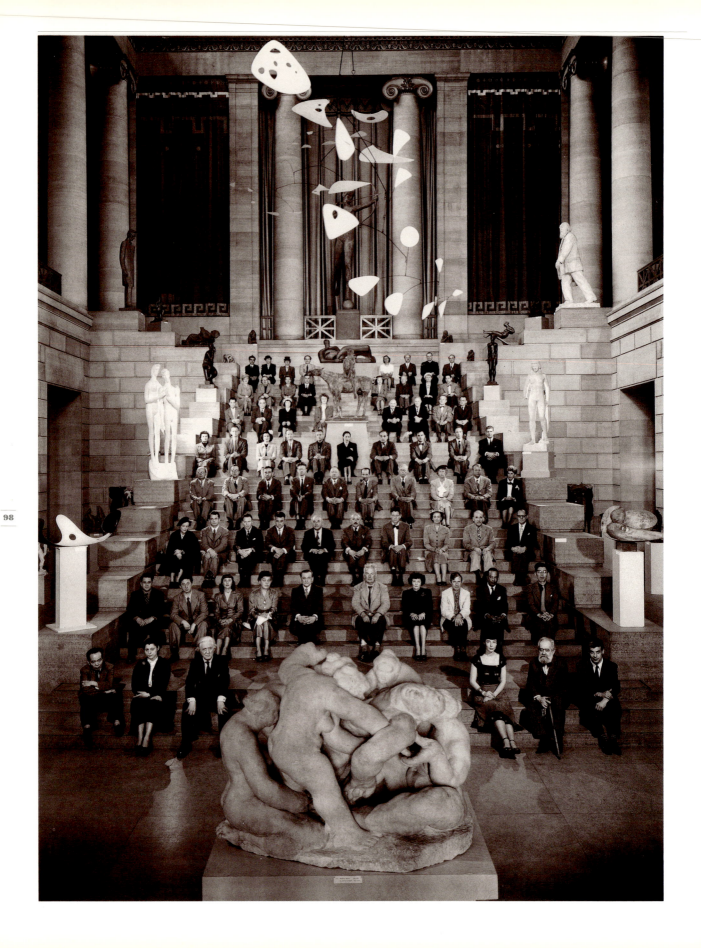

Herbert Gehr
**70 Sculptors Sitting
on the Steps of the
Philadelphia Museum
of Art**
photograph 1949

serious, perhaps too serious, lacking any romantic touch." But those were serious times, and the war may have "inspired a certain solemnity."

Work on the memorial was largely suspended once the United States entered the war. In 1949 the third international exhibition was held to select artists for the third (and last) terrace. Attendance was extraordinary: over 250,000 people came to see the 252 works on exhibition. The event was widely covered in the national press, the caption accompanying a double-page photograph in *Life* magazine calling it "the world's biggest sculpture show." Seventy visiting artists were photographed seated on the grand staircase of the Philadelphia Museum of Art, including gray-haired Alexander Calder seated in the center of the second row, and Jacques Lipchitz, with hands folded, to his left. Said one of the artists, Jo Davidson, "Never had so many sculptors been scrubbed and assembled in one place before." Davidson sits on the first row, second from the right, with his monument to Walt Whitman striding across the upper right of the photograph.

For the first time, the works were officially offered for sale, at prices ranging from $125 to $24,000. The first four sculptures of Revolutionary War heroes commissioned for the Reilly Memorial (**4-56–4-61**) were exhibited, the artists having no doubt been selected as a result of the exposure of their work in the 1940 International. The Art Association pledged an additional $20,000 to purchase works from the exhibition, including Sylvia Shaw Judson's granite *Lambs*, now installed in the Horticultural Center in Fairmount Park; *Reverence* by Wharton Esherick, on view at the Esherick Museum in Paoli; and Gerhard Marcks's *Maja* (**4-31**) on the Art Museum's East Terrace.

An abstract plaster *Cock* by Brancusi, a stone *Reclining Figure* by Henry Moore, and a huge sheet aluminum *International Mobile* by Alexander Calder were created especially for the exhibition. (Ingersoll had hoped that Brancusi's work would be cast in stainless steel by a special formula of the local Budd Company and placed permanently along the Parkway.) Also exhibiting were Georges Braque, Jacob Epstein, Alberto Giacometti, Barbara Hepworth, Jacques Lipchitz, Seymour Lipton, Marino Marini, Pablo Picasso, and David Smith. All were exploring the three-dimensionality of sculpture, departing from the primarily frontal view that had characterized so many earlier works.

The Samuel commissions for four stone figures were awarded to foreign-born artists: Waldemar Raemisch (Germany), Koren der Harootian (Armenia), José de Creeft (Spain), and Ahron Ben-Shmuel (North Africa) (**4-43–4-46**). Jacques Lipchitz, a Russian living in New York, and Jacob Epstein, a New Yorker living in London, received the major bronze commissions (**4-38, 4-66**). The end of the war permitted, and perhaps encouraged, the selection of what Ingersoll called "an artistic League of Nations."

The members of the Samuel Committee faced the issues of their time with responsibility and ingenuity. Issues of site, artist selection, and public opinion were addressed with sensitivity but, perhaps, without commensurate boldness. Although

Peter Solmssen
Jacques Lipchitz with maquette for *The Spirit of Enterprise*
photograph c. 1956

Paul Cret, architect, and various sculptors
Ellen Phillips Samuel Memorial: Central, South, and North terraces
4-32–4-47

the architectural setting and the thematic program were designed to intrude as little as possible on the anticipated sculpture, in the end the imposed restrictions severely limited the artists' creative possibilities. In selecting the artists, the committee felt ethically bound to respect the wishes of its benefactress and maintain the human figure as a reference. The most powerful and successful work, Lipchitz's *Spirit of Enterprise* (**4-38**), is also the one that made the most dramatic departure from the human body. One could even say that its preeminence has grown over the years, contributing to the decision to remove it from its contemporaries and relocate it in 1986 to a more prominent position on the Central Terrace.

Virtually anyone who has contemplated the Samuel Memorial, even in passing, can sense that there is something unsettling about the choice of sculpture. From 1933 to 1949, American culture was being transformed by a depression and a world war. The Samuel Memorial is emblematic of that period of turmoil and transition when artists and patrons were in search of new forms and meaning in an increasingly volatile world.

"What separates us from the animals is the fact that we can send messages down through the generations. . . . We can send greetings to a world unborn. . . . The means by which this is done is art."

Lorado Taft
Public Monuments
1924

Social Consciousness

A National Commentary

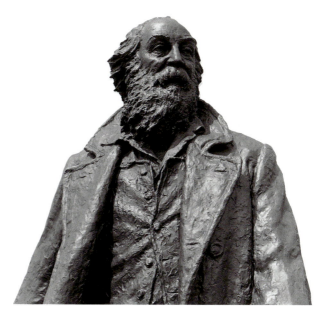

Jo Davidson
Walt Whitman
c. 1939; cast 1957 **4-53**

Public art can send us messages, but only if we understand the language of the sender. At the turn of the century, Americans held firmly to an idealized vision of life, refined and lyrical, and public art reflected that vision. When powerful leaders emerged in finance, industry, and commerce, Philadelphians erected sculptural monuments to celebrate their contributions to the city's growth. Creativity and innovation in the arts, however, continued to be suspect. Many artists trained in Philadelphia left the city to find camaraderie and support elsewhere. Five of the rebellious painters known in New York as "The Eight" or the "Ashcan School"—because their work revealed the less poetic aspects of ordinary life—had attended the Pennsylvania Academy of the Fine Arts. After leaving Philadelphia, they helped to organize the 1913 Armory Show that introduced Post-Impressionism, Cubism, and Abstraction to America.

The population of the city was changing, and so would the messages. A wave of "new" immigration before the First World War dramatically increased the city's foreign-born population, and a great northward migration of African-Americans followed. These new Philadelphians—laborers, artisans, and merchants—all hoped for work, improved living conditions, and community tolerance. The art they inspired reflected dramatic social change and an enthusiasm for the commonplace that echoed Walt Whitman's: "I shall demand a programme of culture, drawn out, not for a single class alone, or for the parlors or lecture rooms, but with an eye to practical life." Whitman's spirit continued to animate public art in Philadelphia, culminating in Jo Davidson's ebullient sculpture (**4-53**).

The country's 1929 financial crisis had widespread effects on cultural life. The

Depression virtually eliminated the patronage, teaching positions, commissions, and sales upon which artists depended for sustenance. Artists were a part of the urban mayhem and were ready—perhaps even desperate—to help to define a new national identity. Social Realism became an art of national commentary. Much like the ecclesiastical art of medieval Europe, this narrative art was able to communicate with a diverse population that was in large measure uneducated.

Among the many Federal programs that addressed the depressed economy, four were directed toward artists. For six months during the winter of 1933/4, the Treasury Department's Public Works of Art Project (PWAP) created jobs for professional artists throughout the country as an experimental emergency measure. Edward Lucie Smith's study of government patronage in the 1930s notes that a driving force behind the establishment of this program was George Biddle, a former Philadelphian and friend of Franklin Roosevelt. "For the first time in our history," Biddle asserted, "the Federal Government has recognized that it has the same obligation to keep an artist alive during the depression as to keep a farmer or carpenter alive; but also that art itself is a necessary function of our social life, and must be fostered during the depression at all times." When it became apparent that the problem of unemployment was long-term, in 1935 the New Deal government set up the WPA Federal Art Project (FAP) for artists already on relief. Paintings, sculpture, and graphic arts were produced,

and artists worked in schools, hospitals, community art centers, and other public places, making art a part of community life—an idea nurtured by John Dewey, who wrote in his landmark *Art As Experience* about the problem of "recovering the continuity of esthetic experience with normal processes of living."

To provide murals and sculpture for Federal buildings, the Treasury Department initiated two art programs in 1935. The Treasury Relief Art Program employed artists on relief, and the Department's Fine Arts Section designated artists by competition, commissioning 1,400 works for post offices throughout the country. All these programs foreshadowed the postwar creation of government agencies to support art and artists: the National Endowment for the Arts, the General Services Administration's Art-in-Architecture Program, and the hundreds of municipal and state arts councils and percent for art programs.

The WPA/FAP is credited with offering artists the most varied opportunities. In the Poster Division's silkscreen workshop in Philadelphia, artists created hundreds of unique, eye-catching posters that urged the public to "Visit the Zoo" or "Work With Care." Julius Bloch, noted for his sensitive portraits, was project head of Philadelphia's program. In an essay written for the WPA in *Art for the Millions*, Bloch recalls the eager interest with which an exhibition held in Philadelphia's subway concourse was received. The WPA also played an important role in supporting the work of African-American artists Dox Thrash and Samuel J. Brown, for whom opportunities had been severely limited.

Edmond Amateis
Drawing for
Mail Delivery
c. 1934

Edmond Amateis
Plaster model for
Mail Delivery
c. 1934

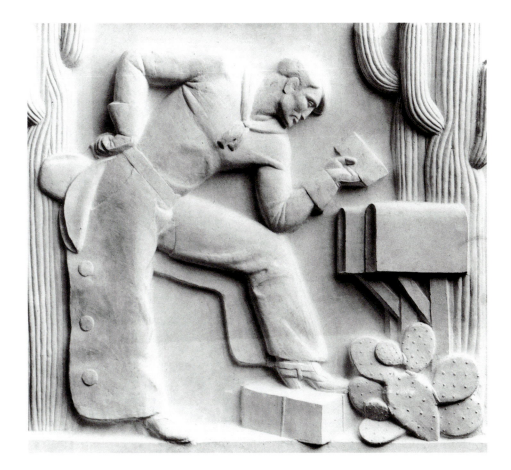

Sculpture produced under the WPA includes Wallace Kelly's *Labor (Unskilled)* (**4-26**) and *N.R.A. (American Youth)* (**4-27**) by Yoshimatsu Onaga; both were exhibited at the 1940 Sculpture International and later installed on the Art Museum's East Terrace.

The Treasury Department's "Section" was not a relief program; artists received contracts for commissioned work and were encouraged to propose subject matter of local cultural and historical significance, fostering the development of American Regionalism. The public and the artists were brought face to face as works of art

were created in post offices throughout America.

In Philadelphia, Edmond Amateis carved four stone panels for the Post Office's William Penn Annex: *Mail Delivery—North, South, East, West* (**4-24**). Artists also worked in North Philadelphia, Spring Garden, Kingsessing, and Southwark post offices. In the Southwark Branch at 10th and Dickinson, positioned to the left of the entrance and awkwardly surrounding a door frame, is Robert Larter's mural *Iron Plantation near Southwark—1800* (**4-52**). The interiors of community post offices were rarely designed to accommodate murals, and the spaces were often broken up by the post-master's door and bulletin boards. Some architects were less than sympathetic: in fact, both the architect and the Section's superintendent insisted on very specific changes in Larter's sketches. On the other hand, Larter cited as "one of the pleasures of the job . . . the interest shown by the spectators." In keeping with Treasury preferences, *Iron Plantation* links local history and industry with a realistic style.

In 1938 a committee of the House of Representatives began to investigate reports of "un-American" elements in the WPA/FAP program. Many artists indeed identified with worker activism and the labor movement, and with the Mexican mural movement, a politically motivated and revolutionary effort. Abstraction, although practiced by few, was considered by the government to be "foreign" and

"subversive." And some artists were suspect for other reasons: in 1937, the Art Association voted to contribute funds to Yoshimatsu Onaga so that he could complete work on his sculpture *N.R.A.*, the Federal government having declared him ineligible for relief on the basis of national origin. These political reactions weakened the FAP, and, along with the Treasury Department's initiative, it was gradually phased out by 1943, when government attention was focused on the Second World War.

The Commonwealth of Pennsylvania served as another government patron. Philadelphia artist Violet Oakley created murals for the Senate Chamber and Supreme Court Room in the State Capitol in Harrisburg. Oakley worked on these murals through 1927 and then went abroad to Geneva, where she was designated the official muralist of the League of Nations. Through the use of powerful female images, her narrative paintings protested

104

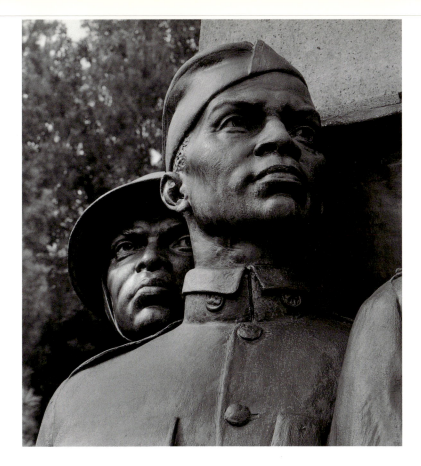

against war, oppression, and slavery. The largest of the Senate Chamber murals, *International Understanding and Unity* is 44 feet long and was painted in her Philadelphia studio without the benefit of assistants. The Supreme Court Room mural series, *The Opening of the Book of Laws* (1917–1927), is an enlarged interpretation of an illuminated manuscript, intended to be "read" by the public. Oakley was active in the suffrage movement and the Women's International League for Peace and Freedom. During World War II, she painted 25 portable altarpieces for the Citizens' Committee for the Army and Navy. Her last major commission in 1949 was *Great Women of the Bible* (**4-63**), for the reception room of the First Presbyterian Church of Germantown.

While Oakley was able to express her passion for human rights through narra-

tive and allegory, the sculptor Antonio Salemme received a less respectful reception. Salemme's *Negro Spiritual*, a nude sculpture of the now-acclaimed performing artist and activist Paul Robeson, was denied placement in the Art Alliance's 1930 Rittenhouse Square exhibition. The Art Alliance's executive committee "expressed their apprehension of the consequences of exhibiting such a figure in a public square, especially a figure of a Negro, as the colored problem seems unusually great in Philadelphia."

It was during this period of tense race relations that J. Otto Schweizer was commissioned with funding from the state legislature to create the state's first monument to black military heroes, who had, since the death of Crispus Attucks, fought with loyalty and courage but without public recognition. The dedication of the *All Wars Memorial to Colored Soldiers and Sailors* (**4-48**) in 1934 was greeted with

Jacques Lipchitz
**Prometheus
Strangling the Vulture**
1943; cast 1953 **4-55**

**Walker Hancock
working on plaster
model for the
*Pennsylvania Railroad
War Memorial***
photograph 1950

more controversy than enthusiasm. There had been heated debate about its location: Parkway placement was rejected by the city's powerful Art Jury, while the black community found the proposed Fitler Square site unworthy. Finally, as a compromise measure, it was placed near Memorial Hall, not far from Calder's *Meade* (**3-10**). In the midst of the controversy, the sculpture itself was hardly discussed in local press accounts. Schweizer's exquisite rendering of the men's portraits, their noble posture, and the impeccable detail of their varied military attire seem to have gone unmentioned, as did the ironic juxtaposition of the towering allegory of Justice, a conspicuously Caucasian female figure.

With the outbreak of war in Europe in 1939, many artists fled to America. Foremost among them was the sculptor Jacques Lipchitz. Born Chaim Jacob Lipchitz in Lithuania, the artist left for France at the age of 19. In the 1930s he sensed the changing political climate in Europe and the rise of Nazism, and began to assert his anguish and alarm through powerful and expressive works based on mythological themes of struggle. His entry in the 1937 International Exhibition in Paris, a 46-foot plaster *Prometheus Strangling the Vulture*, was intended as a prophetic yet

optimistic symbol of the struggle against dark forces. After exhibition in the Grand Palais, the work was moved outdoors, and Lipchitz's darkest fears were realized. A slanderous press campaign against the artist and the sculpture caused the plaster to be smashed into pieces by government authorities. Thereafter Lipchitz lived in fear for his life, fleeing to America in 1941. Fortuitously, a revised plaster version of *Prometheus* was on exhibit at the Pennsylvania Academy of the Fine Arts in 1952 when a fire in Lipchitz's studio destroyed its entire contents. The Philadelphia Museum of Art purchased the plaster, cast the work in bronze, and placed it before the main entrance. There, *Prometheus Strangling the Vulture* (**4-55**), conceived in the shadow of World War II, continues to remind us of the struggle for freedom and democracy, a theme pursued by Lipchitz throughout his life and expressed through his other major works in Philadelphia: *The Spirit of Enterprise* (**4-38**) and *Government of the People* (**5-11**).

The grave realities of the aftermath of World War II required a monument of reconciliation, one that was both somber and stirring. After returning from the war, where he served as a monuments officer, Walker Hancock was commissioned to

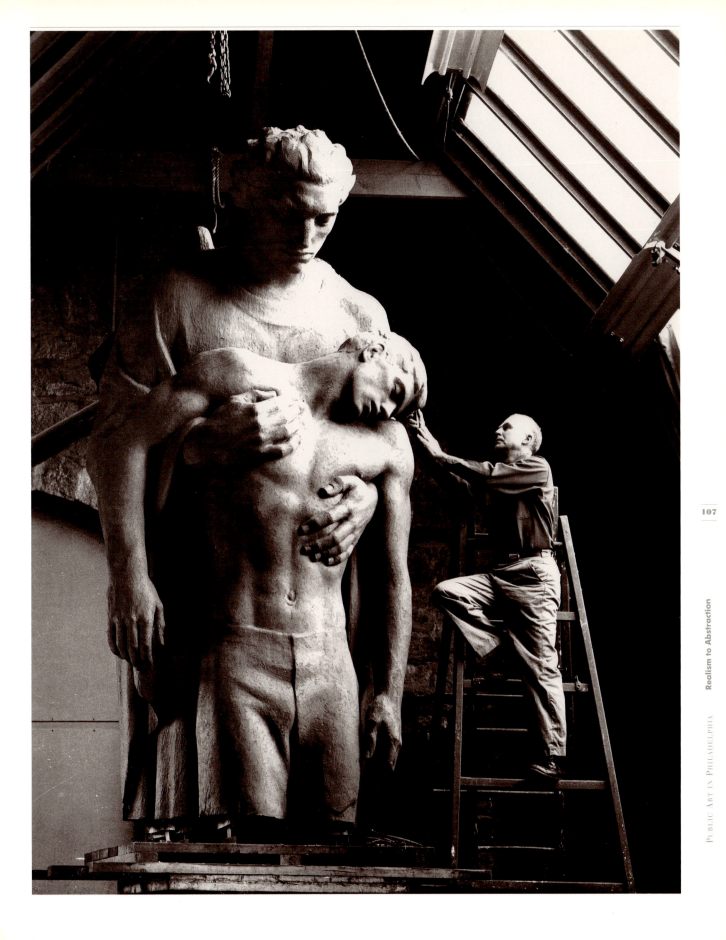

108

create a memorial to the more than 1,300
Pennsylvania Railroad employees who had
died in service. The railroad officials spec-
ified that the work should depict an angel
lifting the body of a soldier. Having experi-
enced the horrors of war firsthand, Han-
cock labored to avoid the melodrama that
such a directive might have suggested. By
capturing, in both spirit and form, the
interdependence of soldier and angel in
the *Pennsylvania Railroad War Memorial*
(**4-64**), Hancock created his finest work, a
dramatic shaft of monumental proportions.

The theme of *Social Consciousness*
(**4-66**) was explored by Jacob Epstein in
response to a request from the Fairmount
Park Art Association. Epstein brought to
the project a humanistic point of view, as
well as an interest in idealized portraiture
and an appreciation for the tribal art of
Africa. His interpretation of the theme
resulted in a sculpture with three parts:
The Great Consoler (or *Compassion*), *The
Eternal Mother* (or *Destiny*), and *Succor* (or
Death). The *Consoler* was intended to rep-
resent "a gentle and saving hand extended
to help the afflicted and downhearted in
the world," the *Mother* expressed eternity
or timelessness, and *Succor* symbolized
both the "mother receiving her manchild"
and "Death receiving mankind." While
Epstein described aspects of this work as
representing "gladness and optimism," the
sculpture bears solemn witness to the
moral underpinnings of the society he was
asked to characterize.

Art and Architecture

Seeking Association

Maxfield Parrish
The Dream Garden
c. 1916 **4-06**

Today it often takes enormous effort to create a harmonious relationship between art and architecture. Earlier in this century, however, artists, architects, and craftspeople were closely associated, and the city nurtured a collaborative approach to building design. Philadelphia's City Hall (**3-01**), completed in 1901, was the first large-scale collaboration between an architect and a sculptor in America. The T Square Club was organized in 1883 to provide a meeting place and forum for architects, historians, sculptors, craftsmen, and manufacturers. By the 1920s, the club's membership included a diverse group of master craftsmen: stained glass and mosaic artisan Nicola D'Ascenzo, ironworker Samuel Yellin, and tilemaker Henry Mercer. Other members were George D. Woodward, who developed Chestnut Hill; Fiske Kimball, architectural historian and director of the Philadelphia Museum of Art; civic leader Eli Kirk Price; and architect Paul Cret.

Cyrus Curtis, publisher of the *Ladies Home Journal*, believed that art had a place in commercial buildings, and for the Curtis Publishing Company's new headquarters he commissioned Louis Comfort Tiffany to transform an oil painting by Maxfield Parrish into a unique and breathtaking mural made of thousands of glass mosaic pieces. Installed in 1916, *The Dream Garden* (**4-06**) greeted Curtis employees each morning as they entered the building.

For the original University Museum building, completed in the 1920s, architect Wilson Eyre engaged the talents of architects, sculptors, and craftsmen. Stained glass and mosaics were created by Nicola D'Ascenzo, with ironwork by Samuel Yellin (see **4-13**) and sculpture by Alexander Stirling Calder. Calder's *Gateposts* (**4-10**)—*Africa, America, Europe,* and *Asia*—symbolized the scope of the

Alexander Stirling Calder
Gate Post
c. 1920 **4-10**

D'Ascenzo Studios
**University Museum
mosaic** (detail)
c. 1920

Photographer unknown
**Metalworkers at the
Samuel Yellin
workshop**
photograph c. 1920–1940

museum's collections, and in doing so described the use and function of the building.

In an early example of "adaptive use" of a building for cultural purposes, Samuel S. Fleisher in 1922 purchased the Romanesque Revival Church of the Evangelist in South Philadelphia as a home for his collections and "a playground for the soul." (His Graphic Sketch Club offered free art instruction next door.) Fleisher dedicated the deconsecrated church to "the patrons of the busy streets of Philadelphia," urging them to "enter this Sanctuary for rest, meditation, and prayer."

The original Church of the Evangelist, built between 1884 and 1886, included interior decoration by the young artists Robert Henri and Nicola D'Ascenzo. In 1929, in memory of his mother, Fleisher commissioned for the Sanctuary an Egyptian-style reredos, or altar screen, by Violet Oakley depicting scenes from *The Life of Moses*. In 1934 he added an iron gate by Samuel Yellin for its portal. Also housed in the Sanctuary were Russian icons and Oriental carpets acquired by his brother, Edwin Fleisher. A three-panel stained glass work by John LaFarge (c. 1909) was added in the 1950s (**3-32,** and see pp. 72–73). (Continuing this tradition, murals have been painted on the school wall adjacent to a community park, and the *Louis Kahn Lecture Room* [**6-33**] by Siah Armajani was installed in 1982.)

The ironworker Samuel Yellin was born in Galicia, Poland, in 1885 and arrived in Philadelphia at the age of 22.

Yellin collaborated with some of the most prominent architects of his time. The immigrant workers he hired specialized in techniques brought from their homelands, and by 1920, 60 forges and 200 men were employed at his workshop at 5520 Arch Street. Although Yellin admired and appreciated the decorative arts of the past, he placed great emphasis on original design: "The work of the old craftsmen is there to be studied for inspiration for one's own creative faculties, and not just to encourage duplicates." The material was a way of expressing his artistry: "I love iron; it is the stuff of which the frame of the earth is made and you can make it say anything you will."

His *Gates and Lighting Fixtures* (**4-13**), created for the Packard Building in 1924, are at once monumental in scale and delicate in execution, functional yet ornamental. The elaborate workmanship does not appear added on to the architecture,

Samuel Yellin
Packard Building *Gate*
(detail)
1923 **4-13**

D'Ascenzo Studios
**Rodeph Shalom
Synagogue mosaic**
1927 **4-18**

Photographer unknown
**Glass workers at
D'Ascenzo Studios**
photograph c. 1930

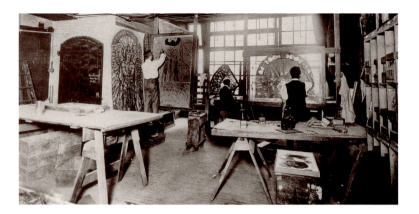

but rather is part of the building design, providing variety, detail, contrast, and scale to the streetscape. The rise of the International style and more simplified architecture signaled the end of that era of ornamentation, and the stature of the Yellin Ironworks declined as well. In recent years, pursuit of the decorative arts has revived interest in Yellin's work.

Ecclesiastical architecture often called upon artisans to add to the spiritual qualities of the building design. The beautiful chapel of the Philadelphia Divinity School (1925–1926) at 42nd and Spruce Streets was designed in the Gothic style by the firm of Zantzinger, Borie, and Medary, with ornamental screens by Yellin and stained glass windows by D'Ascenzo. Rodeph Shalom Synagogue on Broad Street, built in 1927, was designed in the Byzantine style by Frazer, Furness, and Hewitt. The D'Ascenzo Studios executed elaborate exterior mosaics, stained glass in the main sanctuary, and a mosaic floor in the vestibule (**4-18**).

Perhaps the most glorious product of a collaboration between artist and architect is *The Fountain of Three Rivers*, otherwise known as the *Swann Memorial Fountain*

(**4-14**), by Alexander Stirling Calder and Wilson Eyre, Jr. The fountain was originally planned for a site close to City Hall. However, when Jacques Gréber's 1918 Parkway plan proposed a circular treatment of Logan Square with a central ornamental feature, the Philadelphia Fountain Society offered to locate the Swann Fountain at Logan Circle. Eyre and Calder shared a vision of a fountain that would maintain an uninterrupted vista along the Parkway while providing a dramatic focus for the circle. Their vision was realized in the low-lying allegorical river figures coupled with a central water jet and its accompanying sprays. The figures—representing the Delaware, Schuylkill, and Wissahickon rivers—are derived from classical models, but their stylization alludes to the dawning of the Art Deco period. The splendid combination of water, sculpture, and landscape gave us a great civic landmark and an enchanting, human-scale public place.

Celebrating the cadence of the new machine age and repudiating classical styles, the Art Deco movement drew its inspiration from sources as diverse as Cubism and Native American, Egyptian, Assyrian, and Mayan art, with an emphasis on geometric patterns from zig-zags to chevrons. "Streamlining" affected the design of buildings, furniture, jewelry,

Alexander Stirling Calder
**Swann Memorial
Fountain**
1924 **4-14**

Paul Philippe Cret and
Harry Sternfeld
**Design for Remodeled
Philadelphia City
Tower**
1927

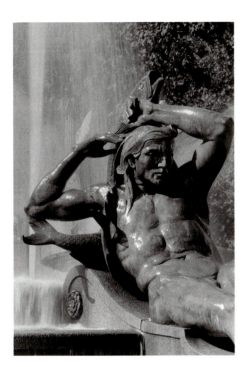

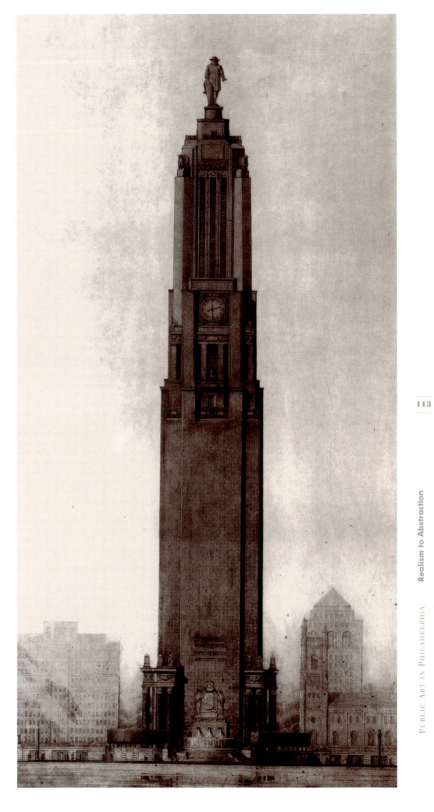

Lee Lawrie with Zantzinger,
Borie, and Medary, architects
**Fidelity Mutual Life
Insurance Company
Building** (detail)
1926–1927 **4-16**

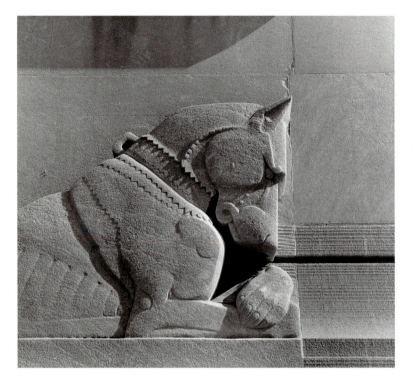

114

trains, and teapots. Perhaps the ultimate gesture of "streamlining" was Paul Cret and Harry Sternfeld's 1927 plan to demolish City Hall, leaving only the tower standing.

The relationship of art to industry was expressed in Philadelphia's commercial architecture. Completed in 1927, the Fidelity Mutual Life Insurance Company Building (**4-16**) was designed in a "modern Classic" style by Zantzinger, Borie, and Medary. Lee Lawrie was responsible for an elaborate sculptural program that was intended to integrate the building's various parts. The figures and animals are allegorical representations of the company's virtues and services, the most prominent being the great Danes, symbols of fidelity.

Sculptors Wallace Kelly and Raphael Sabatini, both former students at the Pennsylvania Academy of the Fine Arts, worked

with architect Ralph Bencker on the design of the N. W. Ayer Building (**4-21**) on Washington Square. The images on this building, completed in 1929, also served to communicate the company's function—in this case advertising. The artists created massive stone carved figures at the top of the building, elaborate bronze doors, and ceilings carved with birds in flight, symbolizing the widespread distribution of information.

Other examples of architecture with descriptive art programs are the WCAU Building (1928) at 1620 Chestnut Street, whose glass tower glowed blue at night when the station was on the air; the School Administration Building (1928–1932) at 21st and Winter, with reliefs over the entrances and historical portraits encircling the tower; and the Drake Hotel (1929) at 1512 Spruce, with ornamental details of dolphins, shells, ships, and globes inspired by the explorer Sir Francis Drake.

Although the Depression limited funds for commercial construction, government buildings were supported through the Federal Treasury Department and the Public Works Administration. The result was a "Federal style"—a 1930s fusion of the classical government style with the decorative commercial architecture of the twenties. Again, architectural sculpture was used to express the purpose of the buildings. Alfred Bottiau's *Wisdom* and *Commerce* (**4-23**), which personified the civic hope for renewed confidence in American industry, framed the entrance to Paul Cret's Federal Reserve Bank. For Harry Sternfeld's Post Office and Federal Building, Edmond

Amateis created *Mail Delivery*, while Donald De Lue's *Law* and *Justice* reflected the building's courthouse function (**4-24**).

Also completed during this period was the Municipal Court (now Family Court) at Logan Circle, which, with the Free Library, was based on buildings of the Place de la Concorde in Paris. An ambitious art program was made possible with Federal assistance: Louis Milione's sculpture for the west pediment, symbolic of juvenile protection, and Giuseppe Donato's figures for the east pediment, which represent family unity. The interior includes murals by Benton Spruance, Walter Gardner, George Harding, Joseph Hirsch, and Alice Kent Stoddard, and stained glass by Nicola D'Ascenzo. Uplifting images of family, work, home, childhood, and education were illustrated throughout the building in a forthright, didactic style.

At the world's fairs of the 1930s, futuristic themes and materials offered an escape into fantasy and introduced the miracles of the modern world. The Chicago World's Fair of 1933 included an elaborate program of architectural ornamentation coordinated by sculptor Lee Lawrie, but is remembered primarily for its dazzling experiments in light and color through the use of neon. The New York World's Fair in 1939, although it too incorporated the work of numerous artists, was distinguished by its extravagant use of newly perfected fluorescent light for the "World of Tomorrow." The capacity for architectural sculpture to communicate civic ideals was diminishing in a culture of technological transition.

In the midst of the Depression, architects George Howe and William Lescaze completed the landmark Philadelphia Saving Fund Society (PSFS) Building (1930–1932) at 12th and Market Streets.

**Lighted sign on PSFS
building**
installed 1930–1932
photograph 1991

Heralding the International style in America, this building was a dominant architectural influence until after World War II, while the lighted sign on its crown established its presence on the city's skyline. Devoid of ornament and surface decoration, the building's architectural design communicated its function, and the role of the artist was irrevocably transformed. The International style emphasized the abstract, industrial character of cities, and sculpture began to mirror architecture instead of decorating it. In both art and architecture, the spirit of artisanry gave way to forms and materials that reflected an age of technology.

In some cases sculpture bore the responsibility of "softening" the hard lines of modern architecture. When the Youth Study Center was proposed for a site along the Parkway in the early 1950s, critics deplored both its style and the placement of such a facility along the city's great avenue. In 1955 the architects placed Waldemar Raemisch's *The Great Mother* and *The Great Doctor* (**4-67**) in front of the building's severe expanse to reconcile the juncture between building and landscape.

The austerity of postwar architecture posed particular dilemmas for artists, and

Ellsworth Kelly's 1957 *Transportation Building Lobby Sculpture* (**4-70**) responded directly to the challenges and limitations of the building's design. It was the first purely abstract public sculpture in the city, one that examined the relationships of geometric shapes and flat color. Commissioned early in the artist's long and distinguished career by architect Vincent Kling, the project was pivotal to Kelly's later work and gave him the opportunity to manipulate a screen of cut shapes, combining control and chance in his selection of elements. It was Kelly's first use of metal, and he participated in the fabrication of the work at the factory of Edison Price, Inc. It was also his first experience working in an industrial setting, a practice subsequently followed by many other artists who began to use industrial materials for large-scale sculpture. "The glass and steel reinforced concrete structures have created a new form and a new space to work upon . . . ," Kelly wrote in 1957. "The monochrome buildings demand color, and the spaces demand an image on a large scale."

Joyce Kozloff
Topkapi Pullman
1985 **6-46**

Maxfield Parrish
The Dream Garden (right)
c. 1916 **4-06**

Since ancient times, paintings and mosaics have enhanced the walls and surfaces of caves, chapels, temples, cathedrals, homes, and palaces. This practice, rooted in virtually every continent and civilization, has been supported by local communities, private patrons, religious institutions, and governments.

In the United States, the National Society of Mural Painters was established in 1895 to expand opportunities for artists and "advance the standards of mural decoration in America." At that time, mural painting was influenced—and often controlled—by architects who commissioned lofty, monumental allegories deemed suitable for public buildings and churches, or by private patrons who sought to ennoble their domestic or business environment. For example, Maxfield Parrish's exquisite Tiffany mosaic, *The Dream Garden* (**4-06**), was commissioned by Cyrus Curtis for the Curtis Building lobby. This tradition is perpetuated in Joyce Kozloff's delightfully intricate *Galla Placidia in Philadelphia* and *Topkapi Pullman* (**6-46**), replete with references to Italian and Turkish mosaics, commissioned by developer

Richard I. Rubin for One Penn Center, the entrance to Suburban Station. Artists working in ecclesiastical settings in Philadelphia have contributed unexpected viewpoints—in the 1940s Violet Oakley, in *Great Women of the Bible* (**4-63**), celebrated the feminine themes of both testaments; in the 1970s Walter Edmunds and Richard Watson, in their *Church of the Advocate Murals* (**6-01**), combined biblical themes with African and American traditions and history.

New opportunities for mural painting were created in the 1930s by the Works Progress Administration and other government programs. Artists were allocated walls in community settings—schools, hospitals, libraries, prisons, and post offices. These programs placed paintings quite literally in the public eye, and the government, with its attendant bureaucratic layers, permitted artists a range of topics under the general heading of American history and industry. Philadelphia post offices were the

recipients of such works as Robert Larter's *Iron Plantation near Southwark—1800* (**4-52**), and a series of murals based on themes of domestic life were commissioned for the Family Court building on Logan Circle. Forty years later, government support through the Art-in-Architecture program for Federal buildings—somewhat less restrictive in content but just as bureaucratic in procedure—resulted in Charles Searles' *Celebration* (**6-03**) and Al Held's *Order/Disorder* and *Ascension/Descension* (**6-10**).

In the 1920s the Mexican muralists José Clemente Orozco, Diego Rivera, and David Alfaro Siqueiros combined Aztec, Catholic, and popular folk images in an expressive form that was aggressively political. The legacy of

the Mexicans would serve as an inspiration for the "people's" mural efforts that began in this country in the 1960s. The social upheavals of the sixties dissolved the "melting pot" ideal, and ethnic pride and neighborhood empowerment gave birth to a community-based mural movement. Hundreds of murals with political and social themes were created throughout Philadelphia in the 1970s. In other cities the movement was impelled by communities or artists; in Philadelphia, efforts were led by the Department of Urban Outreach/Department of Community Programs of the Philadelphia Museum of Art, which hired local artists to offer expertise and coordination to neighborhood groups. Nurtured by institutional support, the murals were created with considerable community involvement in their design or execution, and each project addressed a particular community's concerns or aspirations: in Chinatown, a mural of a fierce red dragon opposed an I-95 highway extension, while a second mural reflected a wistful, bucolic fantasy of flowers and oriental temples; in West Philadelphia, artists brought the inspirational portraits of heroes and heroines—

including Malcolm X, Mary McLeod Bethune, and Aretha Franklin—to the facades of schools and recreation centers. Some communities opted for dramatic abstract images that brought color and identity to neighborhood spaces.

To follow were mural programs sponsored by the Taller Puertorriqueño (**6-51**), the Brandywine Workshop (**6-57**), and the city's Anti-Graffiti Network (**6-47**). Although the various programs have differed in approach, collectively they have produced hundreds of murals and have shared similar goals: to reconnect art to daily life, to engage artists in response to community needs, and to stimulate social and historical consciousness.

Walter Edmunds and Richard Watson
Church of the Advocate Murals
(detail)
1973–1976 **6-01**

Violet Oakley
Great Women of the Bible (above left, detail)
1949 **4-63**

Keith Haring with the CityKids Coalition and the Brandywine Graphics Workshop
We the Youth
1987 **6-57**

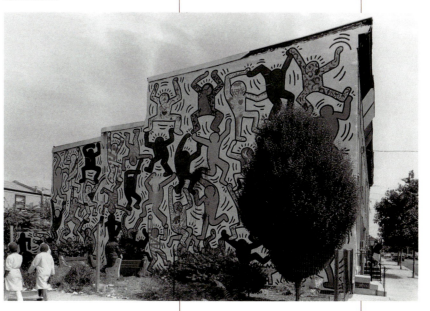

A City Planned

A Strategy for Civic Design

*Model of Parkway
at City Planning
Exhibition*
photograph 1911

hiladelphia was destined to play an important role in the definition and promotion of modern American city planning. Art, architecture, and landscape were united as features of the "city beautiful" in the Parkway plan of 1907. The next 20 years would witness major demolition and construction, and the addition of landscape elements, fountains, and sculpture. Continuing efforts were made to educate the citizenry about this grand plan that would require not only long-term and significant public funding, but the razing of many buildings in the name of beauty.

Modern city planning was in its infancy in 1911 when the Third Annual City Planning Conference was convened in Philadelphia and the first City Planning Exhibition in the nation was held in City Hall, with 900 displays of economic, sanitary, and aesthetic improvements proposed for cities throughout the country. Its central feature was an elaborate 30-foot model of the planned Parkway, seen by thousands of Philadelphians.

A civic body was needed to oversee the aesthetic development of a city beautiful, and a Municipal Art Jury (forerunner of the Art Commission) was urged by the Fairmount Park Art Association and authorized by an act of the state legislature in 1907. But it was not until 1911 that Mayor John E. Reyburn was able to convene a jury of knowledgeable individuals who would consent to serve together. Their initial authority included review of donations, acquisition, and placement of city-owned works of art, and soon expanded to include buildings constructed with public funds and built in or adjacent to Fairmount Park. Under the City Charter of 1919, the mayor served *ex officio* along with eight other members: a painter, a sculptor, an architect, a member of the Park Commission, a business executive,

**Parkway site before
demolition**
photograph 1907

Parkway development
photograph c. 1919

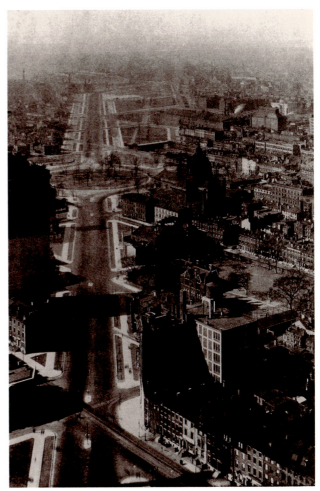

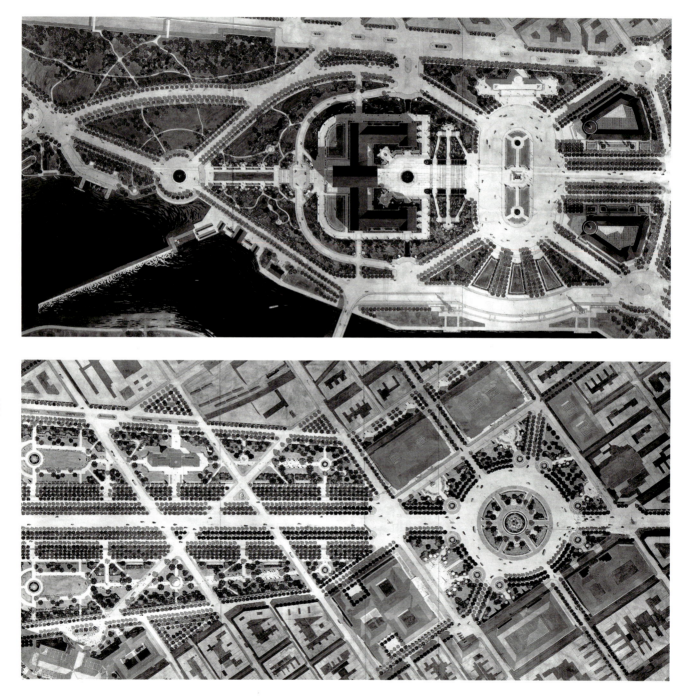

Alexander Stirling Calder
**Swann Memorial
Fountain**
1924 **4-14**

Rudolf Siemering
**Washington
Monument**
1897; relocated 1928 **3-20**

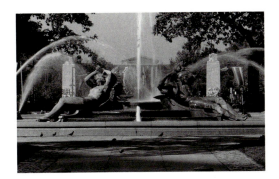

three members from schools of art or architecture, and, in matters pertaining to work under the charge of any city department, the head of that department in a nonvoting capacity.

Under the 1951 Home Rule Charter, the Jury was continued as the Art Commission. A landscape architect was added, reducing the institutional members to two, and the mayor's seat was replaced by that of the Commissioner of Public Property. Added to its duties were the examination of the condition of city monuments and works of art and the establishment of special control areas to limit encroachment and commercial advertising. Collectively, the members of the Art Commission brought considerable experience, expertise, and diversity of opinion to the city's decision-making process, although they would endure political and public criticism over the years. The ongoing debate about the placement of the *Rocky* statue (**6-27**) on the Art Museum's East Terrace is a recent example, with the Commission pitted as the "guardian of good taste" against the "public" (see *Public Art versus Public Taste*, pp. 178–179).

The Art Jury's early intervention aroused interest in aesthetic review throughout Pennsylvania. Prodded by the Fairmount Park Art Association, a State Art Commission was established in 1919, in part to control the proliferation of stock war memorials from ready-made inventories (see *Monuments and Memorials*, pp. 44–45).

A major step toward the realization of the Parkway came in 1911, the year the Art Jury was originally constituted and the Fairmount Park Commission appointed the architectural team of Borie, Trumbauer, and Zantzinger to design the new art museum. Julian Abele was a chief designer in Trumbauer's office and the first black graduate of the University of Pennsylvania's school of architecture. His travels in Greece and France no doubt served him well as he worked on plans for the new art museum and the Free Library building on the Parkway. The Fairmount Park Commission, given new powers of jurisdiction over the Parkway, in 1917 hired the French landscape architect and planner Jacques Gréber to consider the roadways and the siting of buildings. By 1918 demolition was all but complete, and the expanse was fully opened. Gréber's plans—including an extensive proposal for landscape architecture, trees, flowers, fountains, and sculpture—transformed the Parkway from its original conception as an urban boulevard lined with buildings to a tree-lined "broad wedge of green spaces and fresh air." His design converted Logan Square into Logan Circle, where the *Swann Memorial Fountain* (**4-14**) was installed in 1924, and relocated the *Washington Monument* (**3-20**) to the terminus of

the Parkway, a move accomplished in 1928. The *Washington Monument* now sits on the parkway axis with such command and logic that it is difficult to imagine that its bulk was moved from a nearby site.

The Fairmount Park Art Association, in addition to promoting the city planning movement, continued to advocate the commissioning and placement of outdoor sculpture. The *Shakespeare Memorial* (**4-15**) was placed in front of the Free Library near Logan Square in 1926. It was later moved to join the *General Galusha Pennypacker Memorial* (**4-49**) on the Square itself. The two pylons of MacNeil's *Civil War Soldiers and Sailors Memorial* (**4-19**) were located to shape the gateway into the park. In 1928 the *Fountain of the Sea Horses* (**4-17**), a belated Sesquicentennial gift of the Italian government, was placed on the axis behind the art museum, as suggested by Gréber's plan a decade earlier.

With the opening of the Museum of Art in 1928, the Parkway was finally crowned by Philadelphia's glowing, yellow "acropolis." Its capitals, cornices, ceilings, and roof ornaments were enriched by bright colors based on ancient Greek practice. The sculptor Carl Paul Jennewein was engaged by architect Charles Borie to

define and design these polychromatic elements, and his *North Pediment* (**4-25**) was installed in 1933. *The Lion Fighter* (**2-12**) and *The Amazon* (**2-08**) were reunited in 1929 at the base of the Art Museum steps. When the Rodin Museum was completed in 1929, *The Gates of Hell* (**4-01**) and *The Thinker* (**4-02**) joined the Parkway's extraordinary collection of outdoor sculpture.

Looking beyond the Parkway, the Art Association pleaded for improvement of the "disgraceful" condition of the Schuylkill River embankments, pointing out that "those of the Seine in Paris, are, in reality, vast works of sculpture." It envisioned a continuous riverside parkway from Fort Mifflin to Valley Forge. In 1921 Paul Cret proposed a world's fair along the Parkway and the banks of the Schuylkill to celebrate the 150th anniversary of American independence. But City Council voted otherwise, and Philadelphia's Sesquicentennial International Exposition was held in 1926 at a South Philadelphia site that now includes Franklin Delano Roosevelt Park, or "The Lakes." Poor attendance and a huge deficit resulted in a spiritual and financial disaster, but the "Sesqui" is remembered for its elaborate aesthetic lighting effects around the lakes, a mammoth 80-foot *Liberty Bell* illuminated with thousands of lights, and a soaring 200-foot *Tower of Light* visible from great distances. North on Broad Street, 860 floodlights of varied colors washed City Hall.

In 1929 a City Planning Commission was established by ordinance (it would be reconstituted two more times) to address some of the planning functions formerly assumed by the City's Comprehensive Plan Committee, the Fairmount Park Art

William Nicholson Jennings
and John Cardinell,
photographers
Liberty Bell Entrance
**to the
Sesquicentennial
International
Exposition**
*photograph 1926 (temporary
installation)*

Association, and the City Parks Association. Although the stock market crash unhinged the economy that year, Philadelphia had already realized many of the dreams of its visionaries: the Parkway, the Schuylkill River Drives, Roosevelt Boulevard, the Broad Street Subway, and the Benjamin Franklin Bridge, at that time the longest suspension bridge in the world. The WPA supported the construction of roads, paths, and recreational areas in Fairmount Park and new public housing. Walter H. Thomas, architect for the original Robin Hood Dell (1930), served as director and chairman of the Planning Commission's Executive Committee. His comprehensive plan for the city was developed with WPA funds and came to be known in local planning circles as "The Bible." Civic development, he believed, must consider social and recreational needs as well as formal design.

The redevelopment of the area around Independence Hall was next on the agenda. By 1944 the reorganized Planning Commission had in Robert B. Mitchell its first executive director actually trained in city planning. Although the exodus of taxpayers and businesses to the suburbs had begun, this community had never seen anything like the 1947 Better Philadelphia Exhibition (now in the collection of the Civic Center Museum) at Gimbels department store. City planner Edmund N. Bacon, with architect Oscar Stonorov, gave form to civic imagination and demonstrated to Philadelphians what the city could be like 30 years in the future. An elaborate model of center city had movable parts to show new projects; sections would flip over, and the new would instantly replace the old.

Bacon served as executive director of the City Planning Commission from 1949 through 1970. With new powers under the Charter of 1951, the Commission began to carry out the Better Philadelphia concepts. Bacon's years coincided with the Federal government's unprecedented assistance to urban areas, and with center city as a focal point, he planned the long-term development of Penn Center, Independence Mall, Society Hill, and the commercial area of Market Street East.

The architect Louis I. Kahn generated numerous planning studies for Philadelphia, some for the Planning Commission, and others as expressions of his visionary thinking. As a child he attended the Graphic Sketch Club—now the Fleisher

Art Memorial, where the *Louis Kahn Lecture Room* (**6-33**) was created in his memory. Kahn described his early interest in the city:

"The city is a place of availabilities. It is the place where a small boy, as he walks through it, may see something that will tell him what he wants to do his whole life.

"A plan is a society of rooms. The plan of a city is no more complex than the plan of a house, not at all. . . . The city, from a simple settlement, became the place of assembled institutions."

As a young man working in the office of the City Architect, Kahn assisted with the architectural program for the Sesquicentennial. Subsequently, he developed concepts for Penn Center and Market East, landmark traffic studies that explored ideas about streets and patterns of use and movement, and plans for community housing projects. Kahn's goal was to create a structure that derived its form and expression from the human activity that was to take place inside it. His questioning of the International style and his interest in human behavior would have a profound effect on postmodern architecture and postwar urban planning.

To make way for Penn Center, the Broad Street Station and the "Chinese Wall" were demolished in 1953. Bacon's original strategy called for new buildings to be placed on a north-south axis, allowing light to reach a unique landscaped concourse. But the leadership of the Pennsylvania Railroad altered the plan. The new alignment ran east to west, and most of the proposed garden areas were roofed over. The initial cluster of

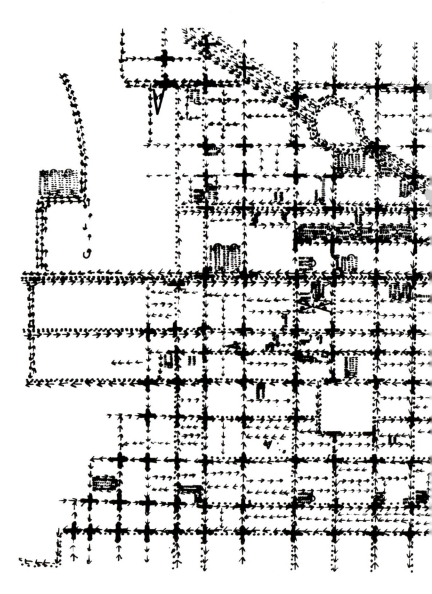

office buildings was executed in an undistinguished modernist style. The absence of building ornamentation and the barren walkways rendered the space less than welcoming. Concern for the pedestrian experience in an increasingly austere architectural environment created an auspicious atmosphere for the legislation that would require the inclusion of public art in new construction.

Louis I. Kahn
Traffic Study, Center City Philadelphia: Project Plan of

Existing Movement Pattern
1952 (original no longer extant)

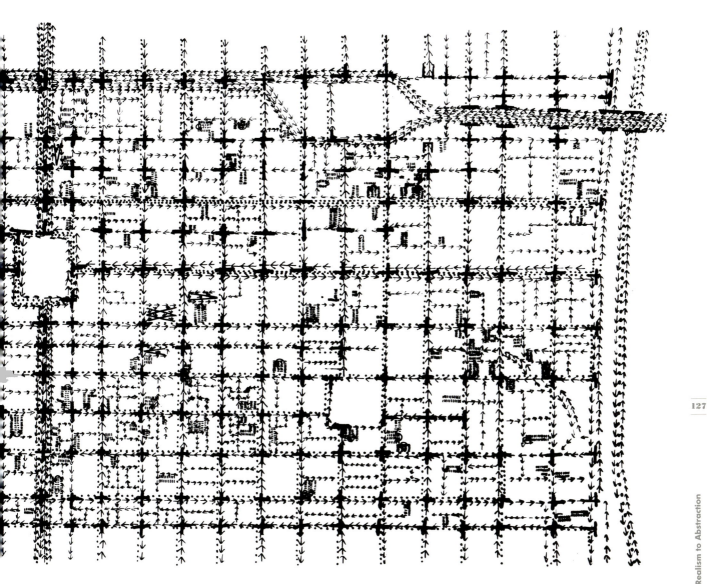

THE THIRD DIMENSION

1959–1975

CHAPTER

5

*"Spread the message that the fine arts must be returned to American architecture;
that sterility and her handmaiden, monotony, must be banished
from our avenues; and that the artist must be returned to the American scene instead of
just having his work hoarded in art galleries and museums."*

Michael von Moschzisker
Address to the National Conference of Editorial Writers in Philadelphia
1958

Percent
for Art

To Humanize
the Urban
Environment

Seymour Lipton
Leviathan
1963 **5-05**

The founders of the Fairmount Park Art Association sought in the mid-19th century to provide an antidote to encroaching industrialism through art in the landscape. Now a new breed of activists would work toward the inclusion of art in new building projects in order to compensate for the disappearance of ornament and information from modern architecture. It was thought that public art on a more human scale might be able to salvage an increasingly bleak public environment. The buildings and walkways at Penn Center seemed to bear witness to this potential.

Through the mechanism of "percent for art" regulations, a percentage of construction funds was to be set aside for fine arts. Philadelphia established two different percent programs in 1959: one for city construction projects, created through an ordinance of City Council, and another for redeveloped property, created through a resolution by the Redevelopment Authority (RDA). Although the two programs were similar in purpose, the city's program was to be carried out by the project architect and approved by the Art Commission; the RDA program gave responsibility to the developer, who by contract sought approval from the RDA's Fine Arts Committee.

Ever since Mies van der Rohe exquisitely juxtaposed a curvilinear figure by Aristide Maillol against the angular planes of his Barcelona Pavilion in 1926, most architects have nourished a deep wish for precisely the same unified and elegant outcome. When, in 1931, the U.S. Commission on Fine Arts recommended that "in all public buildings a sum should be set aside at the beginning for both mural paintings and sculpture as essential parts of the building and not merely as applied

Leonard Baskin
**Old Man, Young Man,
The Future** (detail)
1966 **5-12**

decorations," the need to establish a symbiotic relationship between art and architecture was recognized and expressed in conceptual *and* financial terms. Similarly, the percent for art programs aimed to create an ideal marriage between art and architecture, although there were many forces working against this union. As in life, forced marriages can have happy endings, but often a basic incompatibility produces unfortunate results.

Since 1959, the relationships among artists, architects, public agencies, and the larger social environment have produced public art works of great diversity. A few have been acknowledged as immediate successes, most have taken some time to be appreciated, and some continue to be hotly debated; others have been forgotten, moved, damaged, or destroyed. Much has been learned since the pioneering days of Philadelphia's percent programs.

How Philadelphia established its two landmark percent for art initiatives in 1959 is a little-known but revealing story. Credit is generally given to the two authors of the rulings—Henry W. Sawyer III, a lawyer and city councilman who introduced a bill in City Council, and Michael von Moschzisker, a lawyer, writer, and chairman of the Redevelopment Authority, who, by resolution, added a fine arts clause to the RDA's contracts. In fact, the histories of these enlightened policies reveal the considerable influence of local artists and their advocates.

Sculptor Joseph Greenberg, Jr., lived and worked in Italy from 1949 to 1953,

where he learned from fellow artists that some European cities had initiated percent for art programs as part of their postwar reconstruction efforts. When he returned to Philadelphia, Greenberg discussed the idea with Benton Spruance, a founding member of Artists' Equity, a collective established to represent artists' rights and interests. Raymond Speiser, that organization's legal advisor, offered to help pursue a percent for art program through his colleagues. (Speiser's father had represented Brancusi in the 1927 trial that declared his sculpture "not art." See pp. 88–89). According to Greenberg, Edmund Bacon found the concept interesting but cautioned that it was not a good time to introduce such a measure to City Council. Artists' Equity nevertheless continued to work quietly but persistently behind the scenes, enlisting the help of John Canaday, curator of education at the Philadelphia Museum of Art, who was to become a noted art critic for the *New York Times*.

Raymond Speiser knew Michael von Moschzisker from the days when Speiser was assistant district attorney and von Moschzisker was a criminal lawyer. Speiser and his friend Louis Kahn, the architect, met with von Moschzisker to discuss the work of the RDA. Their interest in a fine arts allocation for new buildings touched a nerve, for von Moschzisker was disenchanted with the plans for Penn Center—"so austere, so drab."

Clark B. Fitz-gerald
Milkweed Pod
1965 **5-10**

Alexander Liberman
Covenant
1974 **5-26**

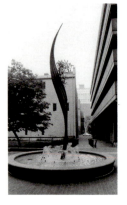

In October 1958 von Moschzisker told the National Conference of Editorial Writers, "Too often in modern buildings, the work of art is an afterthought—a piece of decoration added to fill a space that is felt to be too empty." In March 1959 the RDA passed a resolution to institute a percent for art program, the first such initiative in the nation. An early example of the program's results is Clark B. Fitz-gerald's *Milkweed Pod* (**5-10**), commissioned by Rohm and Haas for its new headquarters in the Independence Mall urban renewal area.

Simultaneously, Greenberg and Spruance carried their idea to Henry Sawyer, city councilman and amateur sculptor. Although he had doubts about its chances, Sawyer introduced the city's percent for art bill in the final months of 1959. On his last day as a councilman, City Council passed the bill by unanimous consent. Because of these collective efforts, the local government began to support public art through its percent ordinance and the RDA's program. Federal sponsorship of works for new government buildings followed. Each of these programs operated somewhat differently from the others.

The RDA's contracts with its redevelopers now included a clause requiring the redeveloper to provide fine arts equal in cost to one percent of construction. This agreement affected housing, office buildings, industrial plants, hospitals, churches, and schools, intending "not only to integrate art and architecture, but to enhance the city and ensure that art could be viewed and appreciated by the passerby—the public whose eye and heart it might hopefully enrich." Ultimate responsibility for the selection of the work (or works) belonged to the developer, although the RDA established a Fine Arts Committee to review proposals, develop policy, and monitor compliance. A full-time fine arts coordinator was appointed to work with the committee and serve as a liaison with developers and artists. The architect's role was less clearly defined and ranged from no involvement to close interaction. "The architects *hated* the idea," von Moschzisker recalled. "They couldn't have disliked me more if I were Prince Charles."

An early RDA objective was to encourage the placement of works appropriate to a specific site, a goal met most dramatically by Alexander Liberman's *Covenant* (**5-26**), which, rather than marking a particular building, unmistakably signals the presence of a central axis on the campus of the University of Pennsylvania. For the developer or corporation, public art offered a singular opportunity to enhance its corporate image—Arlene Love's spellbinding *Face Fragment* (**5-29**), for example, is a uniquely appropriate icon for the Monell Chemical Senses Center.

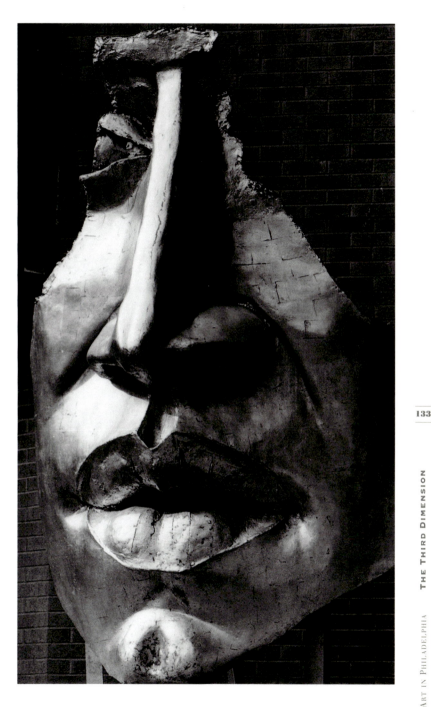

The intent of the city's ordinance, "Aesthetic Ornamentation of City Structures," was similar to the RDA initiative. City procedure lacked coordination, however, and gave the responsibility for selecting the artist to the project architect, with final approval under the jurisdiction of the city's Art Commission. The results depended on the good will of the architect or on the determination of an enlightened administrator. To complicate matters, projects fell under the separate auspices of the Department of Public Property, the Department of Recreation, the Free Library, and the Fairmount Park Commission. More than one ambitious artist regularly visited the various departments to secure numerous commissions. At least one very significant work, Jacques Lipchitz's *Government of the People* (**5-11**), was commissioned under the city's percent for art ordinance, but lack of municipal support for this project almost caused its demise (see pp. 140–142).

The budgets for city projects were generally limited, and contracts were awarded by serendipity. Through sheer luck, connections, or reputation, some local artists received their first commissions from the city, and some were able to work on a large scale for the first time. Works of art found their way to libraries, recreation centers, and health centers. Evelyn Keyser's

Evelyn Keyser
Mother and Child
1964 **5-07**

Harry Bertoia
**Free Interpretation of
Plant Forms**
1967 **5-14**

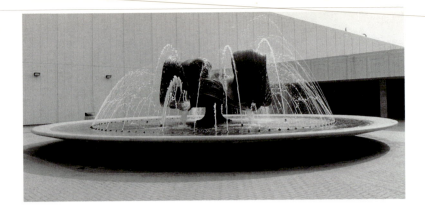

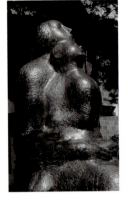

Mother and Child (**5-07**), created for a South Philadelphia health center in 1964, was her first bronze and her first large-scale work. It earned the artist a Citation for Notable Integration of Art and Architecture from the Philadelphia chapter of the American Institute of Architects.

The construction of Philadelphia's new Civic Center offered the opportunity for a major fountain commission for sculptor Harry Bertoia, whose pioneering investigations of new techniques and methods were nationally recognized. Inspired by nature, he explored a wide range of materials, often assembling thousands of small units, in this case metal tubes, to create a dramatic yet delicate presence and mass. The fountain, titled *Free Interpretation of Plant Forms* (**5-14**), exemplifies his interest in natural phenomena, also expressed through the interaction of water with the sculpture. Bertoia's creative intervention brought the sounds and images of nature into a stark plaza to claim and define its center.

In addition to these works produced under local initiatives, Philadelphia gained other works through Federal programs. Art in Federal buildings has been a national tradition since Congress placed Ceracchi's colossal head of Minerva, patroness of American liberty, behind the Speaker's chair in Congress Hall (see p. 22). During the Depression, New Deal art programs commissioned paintings and sculpture for post offices and courthouses across the nation.

The General Services Administration (GSA) has continued this tradition through its policy of spending up to one-half of one percent of the cost of new or renovated buildings for fine arts. Its Art-in-Architecture Program got off to a hesitant start in 1963. Under new selection procedures instituted in 1972, the architect's recommendations regarding the nature and location of the art work were considered by a panel of art professionals appointed by the National Endowment for the Arts (NEA). The panel nominated artists to compete for each project, and the final artist selection was made by the GSA administrator. In 1974 two panels convened in Philadelphia to nominate artists for commissions at local Federal building sites (see p. 102).

Under the influence of the first wave of percent initiatives, the NEA established its Art in Public Places Program in 1967 to provide matching funds for public art projects initiated by communities across the United States. The first major commission funded by this program was Alexander Calder's celebrated *La Grande Vitesse* for Grand Rapids, Michigan. Installed in 1969 to mixed public response, the monumental 43-foot sculpture eventually became a symbol of the revitalization of that city, appearing on everything from sanitation trucks to municipal stationery.

Tony Smith
We Lost
1966 **5-13**

Philadelphia's early encounters with the NEA yielded less ambitious results. In 1967, the Federal agency had contributed toward the purchase of an eight-foot work by Calder through a grant to the City Planning Commission. Now in storage, Calder's *Three Disks One Lacking* (1964) was placed in Penn Center, where, although it was a curious addition, it lacked the scale required for the site. (Some say that from the vantage point of the "lacking" disc, one could crouch down and frame *William Penn* [**3-02**], created by Calder's grandfather.) With this grant Philadelphia also acquired Seymour Lipton's *Leviathan* (**5-05**).

In 1975 the NEA contributed to two sculpture projects at the University of Pennsylvania: Liberman's *Covenant* (**5-26**) for Locust Walk, and *We Lost* (**5-13**) by Tony Smith, a painted steel sculpture sited on the college green. In later years the Art in Public Places Program also supported Claes Oldenburg and Coosje van Bruggen's *Split Button* (**6-31**) on the Penn campus, as well as *Fingerspan* (**6-55**) by Jody Pinto, located along the Wissahickon Creek and commissioned by the Fairmount Park Art Association.

The work of Liberman and Smith, and of many artists during the 1960s, was increasingly minimal and geometric, much like the architecture of the period. Advanced technology and the use of industrial materials provided artists with a new vocabulary totally alien to a public that was familiar with the cast-bronze generals and animals of a bygone era. Having withdrawn to the studio, gallery, and museum, most artists were willing but unprepared to express their private visions in a wider public context. To complicate matters further, many architects viewed their buildings as works of art in their own right, making the inclusion or addition of the work of an artist seem a violation of the architect's sense of pristine order. Moreover, the artist was generally brought into the project after the planning process had been completed and was given the challenge of somehow "beautifying" or "enhancing" the built environment.

The result has come to be called "plop art" or "plunk art"—a product of the uncomfortable process by which artists and architects sought to tolerate each other under the new percent for art laws. Public opinion was largely ignored in this debate, on the theory that public art, like apple pie or prescription medicine, was intrinsically good for us. Meanwhile, artists were often condemned for their assault on public taste, while the underlying aesthetic dilemmas that they were asked to confront continued unabated.

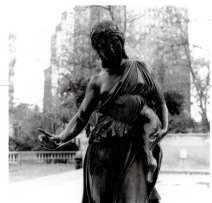

Paul Manship
Duck Girl
1911 **4-03**

George Segal
**Woman Looking
Through a
Window** (above right)
1980 **6-28**

136

Gaston Lachaise
Floating Figure
1927 **4-20**

Philadelphia's enduring interest in the figure has been influenced by the legacy of the Pennsylvania Academy of the Fine Arts and characterized by relentless controversy over nudity. When portrait painter Robert Edge Pine brought the first plaster cast of an antique statue to the United States in 1784, he was unable to exhibit the *Venus de Medici* in public because it "outraged the prevailing sense of decency." Charles Willson Peale fought a "running battle with prudery" at the Academy, and when it officially opened to the public in 1806, an exhibition of plaster casts of nude statues from the Louvre prompted officials to set aside Mondays for "ladies only" and modestly drape the statues on that day. The Society of Artists condemned the public exhibition of nude casts as "extremely indecorous and altogether inconsistent with the purity of republican morals."

Even as William Rush's *Water Nymph and Bittern* (**1-07**) was installed prominently in Centre Square in 1809, it was being criticized for the nymph's provocative pose and clinging drapery. When Hiram Powers' *Greek Slave* was exhibited at the Academy in 1848, "ladies' days" were again instituted, and by 1886 Thomas Eakins had resigned his post at the Academy after a furor over the use of nude male models. At the official opening of the State Capitol in Harrisburg in 1911, George Grey Barnard's huge, symbolic marble nudes in front of the building were ordered draped in deference to public morality. The Bellevue Stratford Hotel was censured that year by the Purity Society for displaying in the lobby two marble nudes by the noted sculptor William Whetmore Storey.

While abstraction gripped the art world in the 20th century, the figure continued to define and dominate artistic expression in public art. Figurative public art endured an

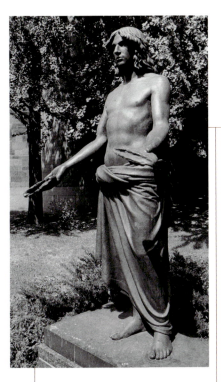

exceedingly slow transformation, as artists privately pursued a vocabulary of the modern while the public held tightly to 19th-century traditions. Paul Manship's winsome *Duck Girl* (**4-03**) represents a departure from the heroic figure to a decorative, stylized image. The sculpture at the Samuel Memorial, commissioned between 1933 and 1950 (**4-32–4-47**), embodies various approaches to the figure: from the clumsy but persistent struggle to release the modern figure from the boundaries of stone, to the expressive thrust of Jacques Lipchitz's gutsy bronze *Spirit of Enterprise* (**4-38**).

The influence of modernism ultimately resulted in figurative sculpture that was less narrative and more illusory. Gaston Lachaise's *Floating Figure* (**4-20**) leaves the allegorical figure

behind, radiating a boldly sensual, expressive fantasy. By the 1960s, Leonard Baskin was exploring memory and the unconscious in his *Old Man, Young Man, The Future* (**5-12**). As public art pursued less idealized goals, artists created images of the routine, everyday, and common man. Even Walter Erlebacher's seemingly classical *Jesus Breaking Bread* (**6-06**) is life-size, human, and installed at pedestrian scale—a departure from the ecclesiastical tradition that visualized Christ as larger than life, divine, and ethereal. In recent years artists have engaged the figure to examine social and psychological phenomena as well as formal issues of scale and placement. The environment created by George Segal in his *Woman Looking Through a Window* (**6-28**) relies on its ambiguity to convey multiple meanings and associations; and Joel Shapiro's *Untitled* (**6-44**) is an extraordinary fusion of the figurative and the abstract, precariously balanced with only one foot grounded in reality.

Leonard Baskin
Old Man, Young Man, The Future
(detail)
1966 **5-12**

Walter Erlebacher
Jesus Breaking Bread (left)
1976 **6-06**

Joel Shapiro
Untitled
1984 **6-44**

*"How does one judge a work of art?
My method is probably unconventional. If I look at a painting
or a piece of sculpture and my arteries jump,
I know at least for me it is good and will be rewarding."*

R. Sturgis Ingersoll
Recollections of a Philadelphian at Eighty
1971

Patrons
and Participants

Urban Design
Issues

Carl Milles
Playing Angels
1955 **4-65**

The percent programs dramatically expanded the opportunities for art in public places. Prior to this time, the Fairmount Park Art Association had been the primary patron and advocate for public art in Philadelphia. It now sought new ways to contribute to the civic environment, encouraging, but not duplicating, the efforts of others.

In 1960 a wide range of projects typified the Art Association's unique interest in the juncture of art, landscape, and planning. The Samuel Memorial along East River (now Kelly) Drive was nearing completion, Lipchitz's *Spirit of Enterprise* (**4-38**) was being cast, the gilding of *Joan of Arc* (**3-13**) was in progress, Manship's *Duck Girl* (**4-03**) was brought out of storage and placed in a pool in Rittenhouse Square, the siting of Davidson's *Walt Whitman* (**4-53**) had just been determined, and Warneke was at work on his colossal *Cow Elephant and Calf* (**5-03**) for the Zoo. Always mindful of an opportunity to add to the city's "collection," the Art Association purchased significant works by Milles, Moore, Miró, and Nevelson, before the cost of such works had escalated and well before the artists had achieved general public acceptance and wide international recognition.

Three projects undertaken by the Art Association illustrate the difficulties and possibilities of patronage in the 1960s and 1970s. It initiated a national competition for the design of a monumental sculpture fountain for the site later known as John F. Kennedy Plaza. The civil rights movement, the assassinations of John F. Kennedy and Martin Luther King, and a heightened awareness of community activism suggested new directions for commemorative sculpture, and the Art Association responded. And, in perhaps its greatest civic gesture, it "saved" Lipchitz's *Government of the People* (**5-11**) after the city abandoned the project in 1972.

The fountain competition epitomized the problems of placing a major work of art in the public domain in the 1960s. In 1964 the Art Association was approached by the Mayor's West City Hall Plaza Committee and asked to organize a competition to select a design for a fountain that would mark the southeastern terminus of the Benjamin Franklin Parkway. The site and its underground garage had been designed by architect Vincent Kling with a concrete circular basin and granite rim to accommodate a fountain, and it was anticipated that the winning entry would be awarded a contract by the city. At the time, the one great mile from the Art Museum to City Hall contained five major fountains. The competition was to provide the sixth—a public amenity that would captivate the eye as well as refresh the urban dweller with the sights and sounds of water.

Since the work would inevitably be compared with the nearby Swann fountain, the organizers took care to address this issue in the competition invitation. "It is not mandatory that the solid forms, or form, be representational sculpture," they boldly announced, "but," they continued with reserve, "they shall not be forms which only a few persons could relate to and admire." The competition was advertised nationally. There were approximately 1,000 inquiries, and 194 competitors fulfilled the complex and challenging submission requirements.

The distinguished jury included architects I. M. Pei and Charles R. Colbert, sculptors Jacques Lipchitz and Theodore Roszak, and Philip Price, then president of the Art Association and

member of the Art Commission. There were five prize winners and five honorable mentions, and the ten submissions were exhibited in the new Bell Telephone building at 16th and Arch, adjacent to the site. Dr. Evan Turner, newly appointed director of the Philadelphia Museum of Art, addressed the disappointing results of the competition. To commission a fountain that would endure as one of the great works of our time, he suggested, the city should have been more courageous—it should have persuaded a few major sculptors to enter a competition, compensating them for their efforts. "So I ask each of you: is the first prize in the competition as satisfactory a solution of the problem as was hoped for?" The answer to his question can be seen in the result. The Art Association asked Kling to design a jet fountain with the idea of adding sculpture later, but this was not to be. The water display was dedicated to the memory of Ellen Phillips Samuel.

Paul Keene and
Neil Lieberman
**Martin Luther King
Freedom Memorial**
(details)
1971 **5-19**

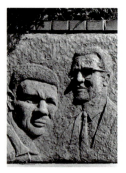

The development of a new approach to planning through community design was more fruitful. Through the Architects' Workshop, volunteer architects, planners, engineers, and students provided architectural and planning assistance to those who wanted professional help but could not afford it. In 1970 Augustus Baxter, the Workshop's executive director, encouraged the Art Association to support projects in the inner city—new tot-lots and vest pocket parks that "need aesthetic ornamentation as much as Fairmount Park ever will." As a starting point, Baxter pointed to a community group in West Philadelphia that had collected funds for a park dedicated to the memory of Martin Luther King.

Within the year, the Art Association was in touch with the Reverend Leonard Smalls of the 59th Street Baptist Church. The community had already started to build the small park, and some planting and paving had been completed. As work progressed, the Art Association funded the sculpture and the completion of its setting. Originally planned to memorialize Dr. King, the *Martin Luther King Freedom Memorial* (**5-19**), by artists Paul Keene and Neil Lieberman, developed to include five bas-relief panels dedicated to others involved in the civil rights movement: Ralph Abernathy, Violet Liuzzo, Medgar Evers, Malcolm X, John and Robert Kennedy, Michael Schwerner, Andrew Goodman, James Chaney, and a group of Alabama children killed in the bombing of a Sunday school. The panels were

installed with consideration for the overall park design, creating a memorial that was both inspirational and useful to the neighborhood. As an extension of the church, the "lock-key" park design was itself innovative—a facility for which the community provides its own security.

Jacques Lipchitz extended his ebullient spirit to the minds and souls of Philadelphia's citizens when he conceived *Government of the People* (**5-11**) for the plaza of the new Municipal Services Building. Commissioned in 1966 in response to the city's percent for art ordinance, the sculpture has an intriguing social, aesthetic, and political history.

Lipchitz had great affection for Philadelphians and thought of himself as the city's "pet sculptor." Art Association trustee R. Sturgis Ingersoll met Lipchitz in 1941, shortly after the artist fled France. When fire destroyed the contents of his studio in 1952, it was Ingersoll who "scurried" to find the funds to purchase the plaster of *Prometheus* (**4-55**) and have it cast in bronze for placement in front of the Art Museum. Ingersoll recalled in his autobiography that the purchase "set Jacques spiritually and materially on his feet," while Lipchitz in his autobiography wrote, "Before I came to this country, I thought America was a place without trees and only stupid things. When I met Ingersoll, I knew that America too had such people as we have in France: people who love art and really love artists."

Lipchitz was originally approached through the project architect, Frederick G. (Fritz) Roth, of Vincent G. Kling & Partners. With Ingersoll's encouragement, Lipchitz accepted the city commission. In

**Plaster model of
Lipchitz's *Government
of the People***
photograph c. 1973

1967 the Art Commission enthusiastically approved the preliminary model, and the next year agreements were signed for the casting. As early as 1970 there was concern about whether the city could fund the completion of the sculpture, and the Art Association trustees agreed to contribute $18,500 to meet this need. Little did they know what financial obligations the future had in store.

Lipchitz had translated the preliminary model into a full-size plaster by March 1972. The following month the city reassessed its finances, speculated that available funds would not cover the cost of casting, and terminated its option to complete the project. Work on the sculpture was halted, although the city expressed a willingness to sign over its equity to the Art Association or another private group.

The public believed that the newly elected Mayor Frank Rizzo cut off funds for the casting because he disliked the sculpture himself, was worried that public disdain for it would reflect poorly on his tenure, and wanted to avoid any perceived violation of the public purse. He did, however, agree to the sculpture's placement on the plaza if the city did not have to pay for it. Commenting freely on the plaster model to reporters and talk show hosts, he created a media brouhaha. "I looked at it, and I tried to be fair," he said. "It looked like some plasterers had dropped a load of plaster."

As Philadelphians debated the aesthetic merits of the sculpture, a major exhibition of Lipchitz's work opened at the Metropolitan Museum of Art in New York. Lipchitz's death a year later, in May 1973, at the age of 82, left unfulfilled the dream

141

THE THIRD DIMENSION

PUBLIC ART IN PHILADELPHIA

of one of the world's most accomplished sculptors. In the small Italian town of Pietrasanta, at the Fonderia d'Arte Luigi Tommasi, the full-scale plaster model of a 30-foot monument for the city of Philadelphia awaited its fate. The Art Association had already begun to entertain thoughts of commissioning a major, heroic sculpture for the Bicentennial celebration, "symbolic in character, reflecting the accomplishments of our Democracy and our aspirations for the future." When Lipchitz died, the trustees of the Art Association agreed to make every effort to carry out the project—his largest and most profound work, and one of the last ideas he developed. As a tribute to family life and democracy, it seemed a fitting symbol for the nation's 200th anniversary. The sculpture would be cast in Italy, transported to Philadelphia by freighter, and installed in the Municipal Services Plaza in time for the Bicentennial.

By 1974 the Art Association had signed agreements with the city, the architects, and the Lipchitz estate. There were constant increases in cost due to escalation of wages (imposed by the Italian government), rises in the cost of bronze, shipping expenses, and fluctuations in the value of the lira. By the time the sculpture was installed, the Art Association had contributed almost three times the city's initial expenditure.

When the base for the sculpture was begun in 1975, the city asked the Art Association to include the names of Mayor Rizzo, City Representative Hillel Levinson, and Public Property Commissioner Robert Silver on the pedestal. The trustees were shocked; apart from the mayor's initial reaction to the sculpture, it was the Art Association's policy never to inscribe works of art with the names of public officials. The reasoning seemed particularly strong in this case, since several city administrations had been associated with the project. The trustees refused.

Work continued at the Tommasi foundry, where 155 separate molds were required, and casting and assembly took 20 months. Then there were unanticipated developments. The sculpture was 2.5 feet wider than planned, causing transportation problems in Italy. There was also last-minute concern that the sculpture was overweight. The pedestal and substructure were designed to hold 18 tons. The actual weight of the sculpture and armature was estimated at 20 to 22 tons, necessitating reinforcement of the original foundation.

Government of the People was dedicated on primary election day, April 27, 1976, as a gift to the city. Art Association President C. Clark Zantzinger, Jr., heartily thanked the city for its cooperation and dedicated the sculpture to the people of Philadelphia. It was accepted by City Representative Levinson for an absent mayor, called "powerful" and "impressive" by city officials, and "astonishing" and "magnificent" by the press. Lipchitz's widow, Yulla, presented to the city the tools that Lipchitz used for working on the monument. Then Lipchitz's recorded voice filled the air: "I believe in the capacities and potentialities of the human being, and I would like to exalt them in every one of my works." Lipchitz's masterly sculpture succeeded in expressing the essence of democratic government—boldness, strength, struggle, and unity of purpose.

*"My idea was to make a new kind of sculpture,
less dependent on gravity, which could be seen in at least three positions and be
effective in all of them; a sculpture which you could understand
more completely because you knew it better."*

Henry Moore to John Hedgecoe, in
Henry Spencer Moore
1968

Innovations

New
Materials
and New
Concepts

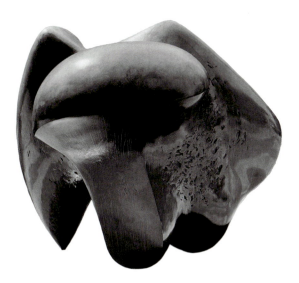

Henry Moore
**Three-Way Piece
Number 1: Points**
1964 **5-09**

Adeeper understanding of three-dimensionality began to emerge as creative achievements in painting and sculpture were slowly incorporated into American public art in the sixties and seventies: the fragmented object of the cubists, the evocation of the nonrational by the surrealists, the technological orientation of the constructivists, and the dynamic energy of the expressionists. Public art was also being affected by societal changes, including the availability of new materials and new technologies, the advent of large-scale civic development and concern for open public space, the promise of new sources of public and private funding for urban renewal, and the desire to reach out to diverse communities. However, the central modernist belief in the autonomy of the work of art—the idea that the work exists unto itself—had kept abstract public art out of the mainstream of American daily life.

The definition of abstraction evolved in two ways. Abstraction might derive from the artist's personal observations of the natural world, or it might be based upon nonobjective principles, with forms not intended to be referential. Appearing either biological or technological, round or linear, soft-edged or hard-edged, sculpture began to assume novel forms. The role of the viewer was powerfully transformed—mentally and physically—from passive observation to active participation. Seen from different vantage points in the outdoors, sculpture became less a study of mass and more an experience of space. The work of art not only revealed something about itself and its maker; it also affected, and sometimes transformed, the viewer's understanding of the space and elements surrounding it. Robinson Fredenthal's sculptures for 1234

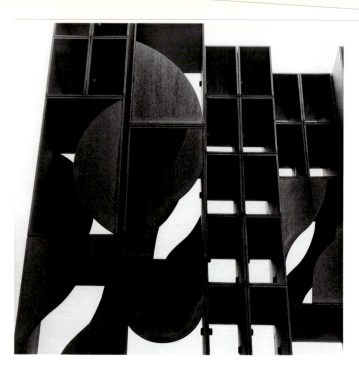

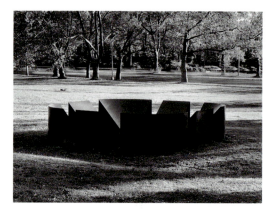

Market Street (**5-25**), while based on the geometry of the tetrahedron, create new architectural and perceptual relationships. Speaking about his exhibition "Elbow Room" at the Philadelphia Colleges of Art, he commented, "My work shouldn't be viewed as an object. I'm after a feeling that's the result of an experience. It can only be understood after you've gone all the way around it."

Duchamp had introduced through his "ready-mades" the idea that sculpture could take almost any form (see p. 86). Indeed, during the 20th century, the public witnessed the greatest innovations in sculptural technique to occur in centuries. Sculptors began to apply the methods of construction to their increasingly abstract works. An interest in collage, the putting together of disparate materials, paved the way for a new kind of "assembled" sculpture. A work could now be constructed of incredibly diverse elements to form a unified whole, as in Nevelson's weathering steel *Atmosphere and Environment XII* (**5-16**). New materials and forms

demanded a new approach to subject matter, and Nevelson is an example of an artist who developed a personal language through the constructed association of form, detail, and rhythm.

Interest in pure abstraction led some sculptors to create "minimal" works: structurally simple, systematic, geometric forms, such as Robert Morris' *The Wedges* (**5-18**). "Simplicity of shape does not necessarily equate with simplicity of experience. Unitary forms do not reduce relationships. They order them," Morris explained. Because these geometric works had no hidden messages, artists thought that they would be appealing as outdoor sculpture. But the public, accustomed by this time to search for the "meaning" in art, had little patience for and understanding of an art derived from the rational.

An interest in "biomorphic" abstraction, the use of forms that have some basis in reality, characterized the works of Barbara Hepworth and Henry Moore. Hepworth was known as the artist who "put the hole in modern sculpture." She took much of her inspiration from the rocky coasts of Cornwall, as in her *Rock Form* (**5-08**). Moore collected nature's fragments—pebbles, rocks, and bones—

Barbara Hepworth
Rock Form
1964 **5-08**

Robinson Fredenthal
Water, Ice, and **Fire**
(detail)
1973 **5-25**

Joan Miró
Lunar Bird
1966
(now in Philadelphia
Museum of Art)

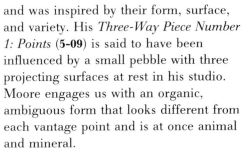

and was inspired by their form, surface, and variety. His *Three-Way Piece Number 1: Points* (**5-09**) is said to have been influenced by a small pebble with three projecting surfaces at rest in his studio. Moore engages us with an organic, ambiguous form that looks different from each vantage point and is at once animal and mineral.

Perhaps more easily understood, yet more deeply disconcerting, was the sculptors' exploration of the power of the unconscious. Engaging the inner reaches of the mind and the world of dreams and fantasies, artists sought a vision that could be both personal and universal. Joan Miró's *Lunar Bird* was purchased by the Fairmount Park Art Association and is on loan to the Philadelphia Museum of Art until another public location can be determined. Inspired by visions and reveries, *Lunar Bird*, with its strange appendages and phantasmal posture, is an example of the artist's whimsical yet enigmatic alternative universe. "For me a form is never something abstract; it is always a sign of something," Miró explained. "It is always a man, a bird, or something else."

For Jean Dubuffet, the naive, raw power of the art of children, prisoners, and mental patients represented a journey to the subconscious beyond dreams and fantasies. Dubuffet raged against conventional notions of aesthetics and beauty. *Milord la Chamarre* (**5-24**) is a jittery combination of sculpture and drawing, at once charming in character and frenetic in form. The title of the work translates roughly to "My Lord in the Fancy Vest," but its local designation as "the Mummer" probably has more to do with its clamorous spirit than with its attire. Developer Jack Wolgin reached adventurously beyond the decorous when he selected *Milord* to satisfy the percent for art requirement for Centre Square.

Despite the new opportunities for permanent installations of public art, there was still an urgent need to create conditions in which artists could experiment, place their ideas before the public, and engage the participation of new audiences outside the galleries and museums. To accomplish this, new organizations were created while existing institutions ventured into uncharted territory. The Arts Council, a free-wheeling, volunteer organization sponsored by the Young Men's/Women's Hebrew Association, staged the first Philadelphia "happening" (by Allan Kaprow) and introduced Claes Oldenburg at his first local appearance in an exhibition in the early 1960s. The Institute of Contemporary Art (ICA) was established in 1963 at the University of Pennsylvania solely to explore and present the art of our time. In 1970 the Philadelphia Museum of Art created its Department of Urban Outreach (later known as the Department of Community Programs) to extend the experience of art to community residents and to draw new audiences to the Museum through highly visible public art programs, installations, and events.

The ICA's daring "Art for the City" (1967) sought to give artists an opportunity to think beyond the traditional gallery environment and audience while encouraging city officials to consider contemporary art for public projects. Four black, starkly geometric pieces by Tony Smith were placed on the new Municipal Services Plaza; of these, *We Lost* (**5-13**) was later purchased

Rafael Ferrer
**Deflected Fountain
1970, for
Marcel Duchamp**
*1970 (temporary work,
Philadelphia Museum of Art,
East Terrace)*

for the University of Pennsylvania campus. A flashing optical work by Josef Levi was placed in the subway station at 15th and Market, and geometric constructions in steel were located outdoors in such public places as the plaza at Society Hill Towers and Penn Center. Edmund Bacon, who assisted the placement of the works, suggested that the exhibition cast the artist in a new role, that of contributor and participant in the life of the city. Still, his introduction to the exhibition catalogue anticipated the uneasiness with which the works would be viewed by the general public: "There is no doubt that this action will result in a collision because the artist and the people have allowed themselves to stray far apart."

The social climate of the sixties and seventies led some artists to reject the idea of permanence, and the possibilities for art in public places widened to incorporate the experimental and the temporary. These artists ventured beyond constructed elements into the use of more ephemeral materials such as hay, leaves, air, water, and ice, creating gallery "installations" and "happenings." This "conceptual" view of art would generate a new aesthetic language, also drawing upon an experiential and interdisciplinary view of communications, film, music, theater, and dance. Rafael Ferrer, born in Puerto Rico and a longtime resident of Philadelphia, was an intrepid explorer in this new territory. For the first Earth Week "Peace" exhibition, he executed *Deflected Fountain 1970, for Marcel Duchamp* on the East Terrace of the Philadelphia Museum of Art. Standing in the fountain, Ferrer physically deflected the stream of water with his body on Tuesday and Thursday afternoons at one o'clock for the duration of the exhibition. "With this piece I have reduced the elements involved to a minimum. It is the simple execution of a task," Ferrer wrote. But he was far from being a "minimal" artist. Ferrer's seminal work was loaded with reference. As a memorial to Duchamp, it made a connection to one of this century's most important and enigmatic artists. (Duchamp's *Large Glass* is housed in the Museum in front of a glass door in direct

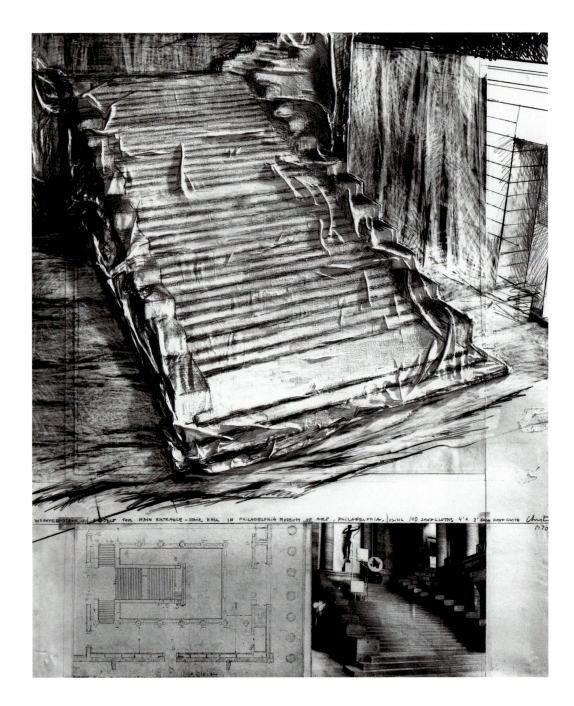

Gene Davis
Franklin's Footpath on Benjamin Franklin Parkway
1972 (destroyed 1976)

alignment with the fountain.) As an intervention, the work drew attention to an artist's ability to alter the environment, in this case with his body. As a conceptual work, *Deflected Fountain* was the result of the artist's thinking process, documented in greater detail in the Museum exhibition. The "Peace" exhibition was also the occasion of the artist Christo's wrapping of the Museum's main stairway, an event that drew international attention to the Museum and the city.

The Art Museum, through the Department of Urban Outreach, began to seek out artists to create unique temporary works for the Museum's outdoor environment. "There aren't many paintings you can stand on," said Gene Davis upon the completion in 1972 of *Franklin's Footpath*, a huge street painting (76 by 414 feet—larger than a football field) located at the northwest end of the Benjamin Franklin

Parkway and visible from the Museum's terrace. Davis was a Washington, D.C., painter known for his investigations in line and color, and *Franklin's Footpath* consisted of 80 colored stripes in 15 hues, each 11½ inches wide. Local artists Don Kaiser and Clarence Wood enlisted the help of public school students in painting six miles of stripes using 800 gallons of paint. Davis never considered the work permanent and was particularly interested in its gradual transformation through weathering and public use. (It was prematurely destroyed in 1976 to make way for a Bicentennial pavilion.)

Rockne Krebs's *Sky-Pi* (or *Sky Bridge Green*), a pioneering laser installation, was commissioned by the Museum and sponsored by the Greater Philadelphia Cultural Alliance for its Philadelphia Festival '73. Every evening for three weeks, two argon laser beams were projected from the Museum. Reflected off mirrors positioned on the Museum's terrace, the rays traveled more than a mile along the Parkway to City Hall. Krebs, an innovator in the use of light and lasers for environmental installations, used the technology as an artistic tool, much like a pencil, and his structural "drawing" articulated the physical design of the Parkway and its many associations, including the linking of three generations

of works by the Calder family (see *Three Generations of Calders*, pp. 74–75). The Washington critic Benjamin Forgey spoke on the opening night with a man who arrived at the Museum Terrace after having walked the entire length of the Parkway in the rain. When asked what he thought about the installation, the man replied, "It's like walking into heaven."

In December 1974, the Museum of Art turned its inside outward. Fifteen thousand handmade cardboard pinhole cameras of unique design filled an entire portal in the West Foyer. The mass of neatly stacked triangular cameras dwindled as visitors took them home to become part of Phillips Simkin's *Displacement Project II*. Each participant made a single photographic exposure of his or her choice, recording some aspect of the environment. Returning to the Museum, they developed the photograph in a specially constructed darkroom, and the resulting

Rockne Krebs
Sky-Pi (or **Sky Bridge Green**)
1973 (temporary installation, Benjamin Franklin Parkway)

Sam Gilliam
Seahorses
1975 (temporary installation, Philadelphia Museum of Art)

images became part of an exhibition that grew as the number of cameras decreased. The "displacement" was physical, photochemical, and conceptual. Art in this case was the substance of the community rather than an object contained within it. Simkin's unrelenting interest in human interaction has since stimulated a wide range of ingenious, witty, and elaborately conceived projects (see *An Urban Laboratory*, pp. 152–153) and a singular and unorthodox vision of public art.

For the Philadelphia Festival in 1975, the Museum commissioned Sam Gilliam's *Seahorses*, a draped fabric installation. Gilliam was known for his adventurous work with color and fabric, but he had never tackled a project on this scale. His grand civic decoration adorned the two exterior Museum walls facing the Parkway and City Hall. Six immense swags of painted cotton duck fabric glistening with metallic

colors were hung by (existing) bronze rings, calling attention to some rarely observed classical details of the building. *Seahorses* evolved from Gilliam's idea that the bronze rings that circle the Museum building were like those used to tie seahorses to Neptune's temple. In fact, the Museum had been draped with fabric swags for the Sculpture International in 1949, but this new installation and the new public art were unlike anything Philadelphians had ever seen before.

151

THE THIRD DIMENSION

PUBLIC ART IN PHILADELPHIA

Pat Lasch
Wilhelmina's Window
1981 (temporary installation)

Charles Fahlen
InSites '85 (above right)
1985 (temporary installation)

Amy Cohen
Cautiously Optimistic: A Progressive Ritual
1984 (performance work)

Our rich tradition of outdoor bronze commemorative sculpture has led to the presumption that public art should be physically permanent and spiritually timeless. Yet we now know that even "enduring" bronze is subject to the ravages of time and the environment, and the "hero on a horse" may be unknown to a subsequent generation. In recent years, the public process that creates permanent works of art—with its committees, bureaucracies, and caveats—has often resulted in work that is mundane and unremarkable, failing to challenge either the capacity of the artist or the interest of the public. Temporary public art, like work in a scientific laboratory, can strive to be daring, exploratory, exciting, participatory, and, sometimes, controversial. When Charles Willson Peale opened the nation's first museum in the 18th century, he set up the polarity between art that is presented in an institution and art that is encountered in the street.

Artist Phillips Simkin's projects invite public participation in nontraditional settings.

His work overflows with humor, insight, multiple meanings, and possibilities that arouse the spirit as well as the intellect. For Simkin's *Human Puzzle,* orchestrated on the Parkway for the 1976 Bicentennial celebration, 76 people wearing pieces of a giant foam jigsaw puzzle worked cooperatively and playfully to complete a 40-foot gray disk. His subsequent *American Enterprise Series,* begun in 1984, comments on American entrepreneurship. At The Gallery shopping mall in Market East, for example, Simkin directed the cultural activities of 10 students from the Philadelphia Colleges of the Arts. Operating as *ACME Inc.* (1985)—"Arts and Cultural Maintenance Engineers Implementing New Creations"—the students used the commercial environment as an alternative public art space for new and changing special events and performances.

The Institute of Contemporary Art's "ICA Street Sights" created opportunities for artists to reach a wide audience and exhibit in unorthodox settings, such as the five imposing display windows at John Wanamaker's department store. Pat

Lasch's *Wilhelmina's Window* (1981)—a bakery-like installation that included ornate confectionery sculptures made of black, gray, white, purple, and red pigments—was in part an homage to her father, a master baker from whom she learned the art of pastry decoration. For "ICA In Transit" (1980–1981), local photographers provided images of Philadelphia that were reproduced as placards and installed in over a thousand SEPTA buses and elevated trains.

Amy Cohen's *Cautiously Optimistic: A Progressive Ritual* (1984)—a choreographed procession of 50 giant hand-crafted fruits, vegetables, and cheeses through Philadelphia's Italian Market—was not solely a parade of giant victuals. Cohen, a painter, playwright, and mask-maker, paid tribute to the community by engaging more than one thousand participants and spectators. The spectacle culminated in a

ceremonial event, with a
sermon delivered by a giant,
"deified" artichoke: "Alone we
are merely fruits, vegetables
and cheeses but together we
form a salad." Cohen estab-
lished the Foundation for
Public Performance in 1987 to
support original multidiscipli-
nary productions of social and
cultural significance, and for
her work she received a

Women's International League
for Peace and Freedom Award
in 1988.

InSites '85 was a collabora-
tive installation on the Munic-
ipal Services Building Plaza by
Lynn Denton, Charles Fahlen,
and Marie Gee. Sponsored by
the city's Office of Arts and
Culture, the project gave artists
an opportunity to transform a
central public space and
encourage interaction among its
users. Into this vast plaza,
which people generally pass
through rather than linger in,
Fahlen introduced park ele-
ments: potted trees, water, and
sculpture fragments. Denton
imported tree fragments from
the park and created sheltered
areas, and Gee created struc-
tures that echoed the adjacent
architecture.

The same plaza was the
site for the installation of
Christopher Janney and Joan
Brigham's *STEAMSHUFFLE:* Phila-
delphia, sponsored in 1987 by

the Office of Arts and Culture
and the University City Science
Center. Combining steam,
sound, and poetry by Emmett
Williams, *STEAMSHUFFLE* inter-
acted with pedestrian traffic.
Walking past a series of
upright glass panels etched
with the poetic text triggered a
photocell beam that activated a
jet of steam, a succession of
electronically composed sounds,
and, at night, strobe lights.
STEAMSHUFFLE aroused interest
and curiosity during the day,
and gathered people like a
magnet at night, when the area
is usually deserted. Discussion
on the plaza had people won-
dering whether the "hot air"
was symbolic of what went on
inside the government
building.

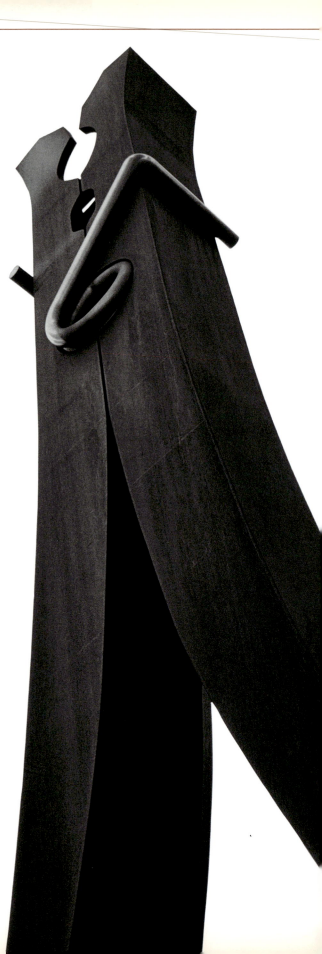

A Sense of
Place
Since 1976

155

CHAPTER

6

"*Public art and architecture share the same culture,*
yet architecture is not here to house public art, nor is public art here
to enhance or alter architecture."

Siah Armajani
Site: The Meaning of Place in Art and Architecture
1983

Art and the Built Environment

Toward a Reconnection

Claes Oldenburg
**Percent for
Art Proposal**
c. 1972

The relationship of public art to society changed radically when artists moved away from the creation of discrete objects in order to seek interrelationships between public experience and the physical environment. This movement was encouraged in part by an increase in government funds, which was itself intended to counter a general disregard for the public environment. Meanwhile, the "social architecture" and advocacy planning of the 1960s, embodied by the movement begun in Philadelphia by the Architects' Workshop, was eclipsed by postmodern "signature" architecture. Architecture as art was promoted; architecture as advocacy was not.

In the 1980s, artists began to respond more like architects and planners, and architects to behave more like artists. Although their approaches to culture, meaning, space, and perception remain fundamentally different, there appears to be a growing interest on the part of some artists and some architects in addressing the public environment. Percent for art programs called attention to the need to advance this relationship beyond the obligatory placement of a work of art. One of Claes Oldenburg's preliminary designs for Centre Square, a gigantic percent sign, wryly comments on this issue.

During the 1980 Federal Abscam trials, the sacrosanct status of art and architecture in Philadelphia was confirmed in a most incongruous context. "Those who worry about public art in the city may be pleased to know that one of the few regulations that our public officials did not promise to bend, fix, subvert, or otherwise sully during their Abscam escapades was one that requires 1 percent of building costs to be spent on art," reported architecture critic Thomas Hine. Hidden cameras recorded City Councilman Harry P.

Joel Shapiro
Untitled
1984 **6-44**

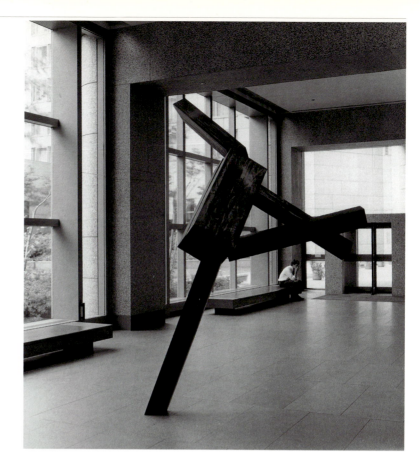

Janotti telling FBI agents that the fictitious hotel-building sheik whom they represented would have to comply with the percent for art regulation because it was written in the City Charter. According to the former councilman, "the percent"—a local colloquialism—was something unavoidable that you tripped over on the way to a public swimming pool or that assaulted you on your way into a government building. Animated, if uninformed, discussion about the percent ranged from the sarcastic to the profane.

Contemporary public art began as a gesture to relieve the monotony of buildings through controlled contrast, often using the art as a Band-Aid. This fix-it approach precluded any tenable interaction between artist and architect. The pursuit of accommodation—to the site and to the audience—was impeded when the artist was not involved in the early stages of a project but was later expected to command a vast space with limited financial resources. And a nagging, often hyperbolic, distrust between artist and architect remained. Artists were concerned that their work would be controlled by the architect and dominated by the architecture, and architects feared that their buildings would be sullied by the art. Out of this conundrum grew a variety of approaches designed to reconnect art and architecture, many of them initiated and asserted by public agencies: a more conscientious consideration of the placement of art in public buildings and spaces; a search for new and contemporary community symbols and markers; renewed interest in the integration of crafts and the decorative

arts; greater cooperation, and even collaboration, between artists and architects; and, alternatively, the design of an entire environment by an artist.

Since the 1970s, Robert Irwin has created work "in response" to a specific site, situation, or location, identifying four categories for site-related public art: site dominant, site adjusted, site specific, and site conditioned/determined. "People still think that they want objects," he observed. Irwin's unrealized 1982 proposal for the Fairmount Park Art Association's "Form and Function" project—an elaborate marble *Philadelphia Stoop* in the center of City Hall courtyard—was a somewhat unexpected response, but his stoop was more than a mere object. It was symbolic of the community's repossession of the courtyard (used as a parking lot by the

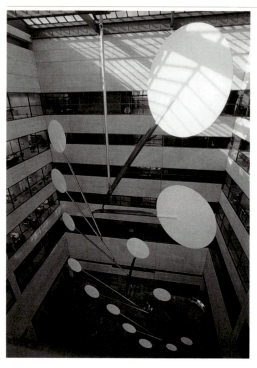

Alexander Calder
White Cascade
1976 6-13

Brower Hatcher
**Starman in the
Ancient Garden**
1990 6-62

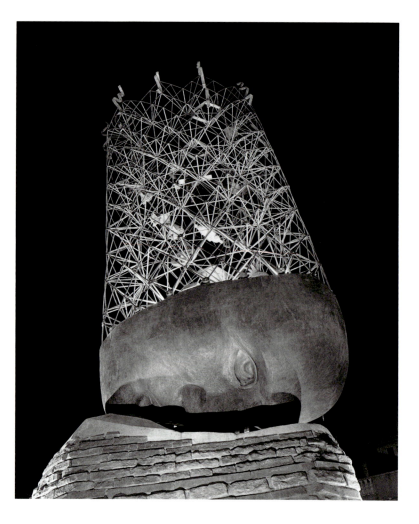

158

sheriff's buses), as well as a monument to
the habits and materials of Philadelphia's
neighborhoods.

According to Irwin's definition, site
dominant works are "recognized, under-
stood, and evaluated by referencing their
content, purpose, placement, familiar
form, materials, techniques, skills, etc."
Public monuments, historical figures, and
works that have emerged from museums
and galleries are in this category.

Site adjusted sculpture responds
directly to the formal elements of scale
and placement but is developed and
fabricated in the studio or workshop. An
example is Joel Shapiro's *Untitled* (**6-44**) in
the lobby of One Logan Square. Invited
to propose a sculpture specifically for the
completed lobby, Shapiro presents
the viewer with an endlessly dynamic 360-
degree impression of a figure in space.
Alexander Calder's breathtaking *White
Cascade* (**6-13**) is another example, the
result of Calder's particular interest in the
tension and movement of elements
through time and space. Adjusted to the
scale of the immense, skylighted East
Court of the Federal Reserve Bank, the
mobile is considered the largest in the

world, and was Calder's last major work before his death in 1976.

Site specific work is conceived with the particular location in mind, and is clearly distinguishable yet inextricably connected to the site. Brower Hatcher's *Starman in the Ancient Garden* (**6-62**) at 9th and Walnut Streets effectively determines the plaza rather than contributing to it. The work cannot be relocated without altering its design, intent, and meaning. Site conditioned/determined work, according to Irwin, "draws all of its cues (reasons for being) from its surroundings." In this case, the observer plays an active, pivotal role: "What appeared to be a question of object/non-object has turned out to be a question of seeing and not seeing." Some aspects of the *Columbia Subway Plaza* (**6-48,** and see p. 163) can be understood in this context: the physical requirements of the site, the relationships created by the station building and its symmetrical stairways, and the need for a symbolic entry into the Temple campus. A variety of visual elements, including order, symmetry, alignment, and function, influenced and determined the design of the space. Irwin's observations help to define the variety of approaches to the creation and understanding of contemporary public art.

The nation's Bicentennial in 1976 provided the occasion for a number of local ceremonial dedications that celebrated the connection between art and architecture in government buildings. Lipchitz's *Government of the People* (**5-11**) was dedicated at the Municipal Services Plaza (see pp. 140–142). Nevelson's *Bicentennial Dawn* (**6-02**) was dedicated in January 1976, the "dawning" of the Bicentennial, in the

James A. Byrne Federal Courthouse. The extravagant dedication, culminating with fireworks over Independence Hall, was attended by First Lady Betty Ford, government officials, and arts professionals. The ceremony honored an ambitious work by one of this country's most distinguished sculptors and demonstrated to Jack Eckert, the new administrator of the General Services Administration, the community's support for the Art-in-Architecture Program. He had been hounded by complaints from congressmen and taxpayers who saw the program as costly and expendable. (In fact, the allocation for Nevelson's work amounted to a mere eleven-hundredths of one percent of the total building construction costs.) Donald Thalacker, then the director of the Art-in-Architecture Program, recorded artists' comments in *The Place of Art in the World of Architecture.* Nevelson described her 29 painted wooden columns arranged in three groups as part of her continuous search "for a new seeing, a new image, a new insight, a new consciousness. This search includes the object as well as the in-between places—the dawns and the dusks, the objective

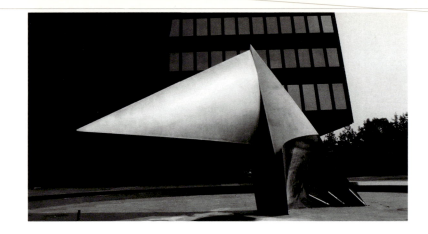

world, the heavenly spheres, the places between the land and the sea."

A year later, in 1977, there was another dedication of Federal projects by Charles Searles, Al Held, and David von Schlegell. The theme, "Celebrations: Buildings, Art and People," was suggested by Searles's mural *Celebration* (**6-03**). The mural, in turn, was inspired by a joyous North Philadelphia community festival in which the artist once participated. To create a year-round focus for the plaza between the Byrne and Green buildings, von Schlegell combined water with sculpture in *Voyage of Ulysses* (**6-21**): "My intention is to heighten the experience of the whole place . . . so the object mediates between the person and the place and isn't just a thing, an end in itself." Held's two murals, *Order/Disorder* and *Ascension/Discension* (**6-10**), occupy a staggering stretch of 180 feet in the lobby of the Social Security Administration's Mid-Atlantic Program Center. The paintings can be viewed from a distance through the building's glass windows or experienced by walking "through" them.

Nevelson, Searles, Held, and von Schlegell were commissioned after building plans were in place. Therefore, the projects' success relied heavily upon the selection panel's ability to suggest artists who would be challenged but not restrained by the fixed architectural program. The resulting works enable the individual to have a personal encounter in a series of ponderous civic spaces.

In other cities, works commissioned under this program were less well received. In Baltimore, for example, a group of Federal judges protested against the placement of George Sugarman's *Baltimore Federal*, arguing that the work could cause injury to pedestrians and would be a magnet for vandals, explosives, and terrorists. The judges enlisted the support of the U.S. Marshals, the Baltimore police department, and the FBI. After an outrageous media blitz and a public hearing where the sculpture had more supporters than detractors, the work was installed and welcomed with an outpouring of public enthusiasm. It was the Art-in-Architecture Program that came under attack during the controversy over the removal of Richard Serra's *Tilted Arc* in New York City. After the destruction of the work in 1989, the GSA eliminated its interagency agreement with the NEA. Its updated guidelines place greater emphasis on local citizen involvement and artist/architect collaboration.

The search for new civic symbols has led artists to reconsider earlier, traditional monuments that had addressed a wide audience through the expression of shared beliefs and value systems. Contemporary society is simply too large and too pluralistic to allow us to assume that all images will mean the same thing to all people. Today, according to R. H. Fuchs, "the

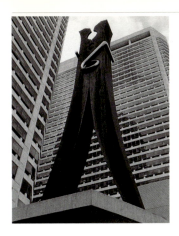

Claes Oldenburg
Clothespin
1976 **6-04**

Claes Oldenburg
**Design for a Colossal
Clothespin Compared
to Brancusi's *Kiss***
1972

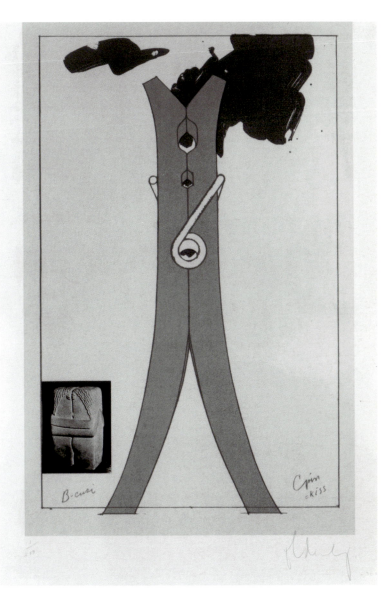

great monument is, instead of a cold recollection of the past, an intersection of art and (contemporary) life. . . . The product of this marriage is an icon which collects meaning instead of projecting it. At this level lies the achievement of Claes Oldenburg's monuments."

Oldenburg's *Clothespin* (**6-04**) in Centre Square was inspired by a commonplace item of mass production. With its elegance of form at a monumental scale, it combines both abstract and realistic elements. Oldenburg has said that his public sculpture, in recent years created in collaboration with his wife, Coosje van Bruggen, "has to have the capacity for surprising you and renewing itself and changing in your imagination. When we do a sculpture, we try to load it up with a lot of possible ideas and directions for content." The public quality of contemporary public art comes from *layers* of agreement about what it is and what it means. The community can begin with general agreement that the work is, say, a huge clothespin. A smaller group may see it as a study in contrasting materials, as a statement about joining and tension, or as a comment on authority. Cartoonist Tony Auth has suggested that the *Clothespin* might support an invisible clothesline to hang all of City Hall's dirty linen. Others may decide that the steel clip forms a commemorative "76" or that the two elements are engaged in a kiss, symbolic of the city of brotherly love. As did the artist, museumgoers might associate it with Brancusi's stone sculpture *The Kiss*.

Venturi and Rauch,
Architects and Planners
Ghost Structures
1976 **6-05**

John Rhoden
Nesaika
1976 **6-08**

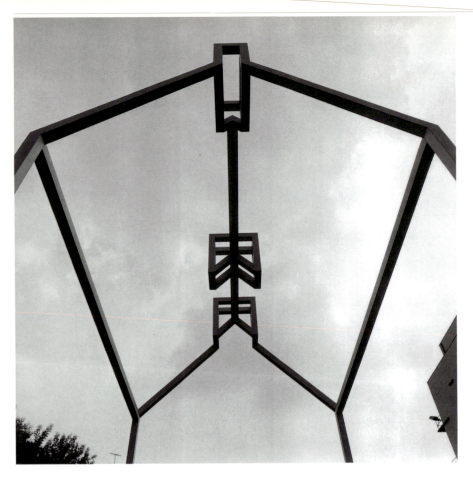

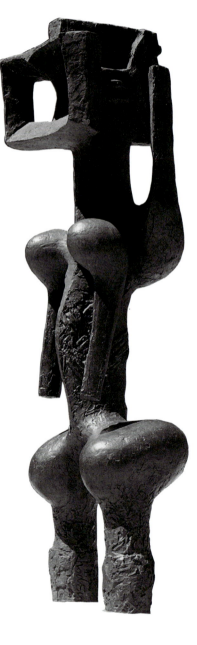

162

Attitudes about monumentality were
forever altered by Oldenburg's witty anti-
monumental commentary. Maya Lin's
moving *Vietnam Veterans Memorial* (1982)
in Washington, D.C., is a very different
example of this change in thinking. Sunk
into the earth, more like a wound than a
sentinel, Lin's memorial represents alterna-
tive possibilities for public monuments—
from the vertical to the horizontal, from
the masculine to the feminine, from a "sig-
nature" to something that more closely
resembles an intimate conversation. By
placing the names of the dead in chrono-
logical rather than alphabetical order, Lin
created a unique situation as well as a
civic monument. The act of locating a
name on the wall has made a visit to the
memorial a shared public and private
experience.

The *Ghost Structures* (**6-05**) in Franklin
Court, designed by the architectural firm
of Venturi and Rauch, also take the form
of monumental sculpture. So little

Richard Fleischner, with
Mitchell/Giurgola Architects
and Harriet Pattison and
Richard Glaser Landscape
Architects
**Columbia Avenue
Subway Plaza**
1986 **6-48**

Barbara Neijna
Total Environment
1986 **6-52**

remained of Benjamin Franklin's original house and print shop that the architects decided to create two "ghost" buildings that suggest the outlines and placement of the structures. Marking the site often discussed by Franklin in his correspondence, the *Ghost Structures* derive their meaning from their analogous characteristics: the buildings are implied rather than fully described.

In some cases, the work of art relates most strongly to the building's use and context, acting as a symbolic marker. John Rhoden's *Nesaika* (**6-08**), in front of the Afro-American Historical and Cultural Museum, suggests both the African and the American aspects of the museum's mission. Rhoden describes the work as "neo-African," a transformation of African aesthetics into an American sculptural language.

The relationship of object to site continues to be examined through diverse working relationships between artists and architects. In some cases, a shotgun marriage is determined by the commissioning agency, or the artist is selected by a panel that includes the architect, or the architect may be selected by the artist, or a "team" of self-selected arts professionals is designated. Sometimes the artist designs the total environment with the support of design professionals. No particular approach can guarantee the quality or success of the result.

The *Columbia Subway Plaza* (**6-48**) was a productive collaboration among artist (Richard Fleischner), architects (Mitchell/Giurgola Architects), and landscape architects (Harriet Pattison and

Richard Glaser). In contrast, Barbara Neijna's proposal for an environment at Independence Place (**6-52**) was incorporated into the construction plans for the apartment complex, but the relationship was not collaborative. The artist designed the entry to the building, the three-dimensional elements in the plaza, including a 60-foot light column, as well as the landscaping, lighting, walkways, and seating.

Attention to pattern, color, decoration, and historic reference on the part of postmodern architects has reintroduced a claim on the streetscape that bodes well for the involvement of artists. Moreover, the revival of an interest in crafts has been a natural consequence of a renewed interest in art that is also functional or decorative. Philadelphia's early crafts tradition had continued in the first half of this century with the work of Yellin, Mercer, and others (see pp. 71–72). Modernism, however, drew a clear distinction between the artist and the artisan: one dedicated to the cerebral and conceptual, the other to the physical and material. The presence in Philadelphia of two of the most active crafts galleries in the country—the Helen Drutt Gallery and the Snyderman Gallery—along with the Clay Studio and The Fabric Workshop, has once again blurred these distinctions and created avenues for the exhibition, creation, and architectural integration of crafts and the decorative arts.

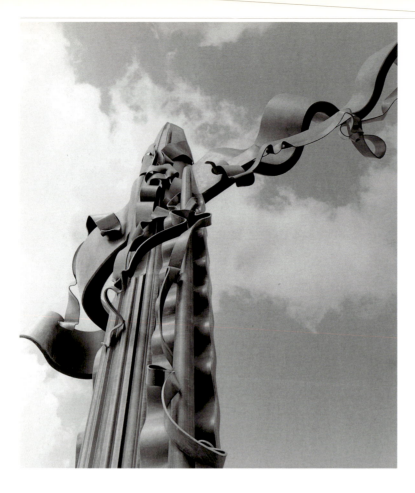

Albert Paley
Synergy
1987 **6-56**

Ray King
**Aurora Window,
Canopy,** and **Sconces**
1989 **6-58**

The Redevelopment Authority antici-
pated this resurgence by creating a new
but short-lived fine arts provision in 1976.
Projects whose costs exceeded $200,000
could use one-half of one percent for fine
arts and the other half "for decorative
architectural features" such as grills,
grates, and landscaping. Gates and grills
for center city residential developments in
Washington Square West were among
the works produced during that period,
including a modest effort by Albert Paley
for houses in the 100 blocks of Pine and
Lombard. (In 1979 the Authority re-
scinded this modification, believing that
some developers had abused it by using
percent for art funds for elements that
were a normal part of the building's
design.) By 1987, when Paley's installation
of colossal pylons, *Synergy* (**6-56**), drama-
tically marked the entrance to the
Museum Towers in Franklintown, atti-
tudes toward the work of the craftsperson
had changed considerably.

Ray King's *Aurora* (**6-58**) is an impres-
sive departure from his early stained glass
windows. (Two of these were installed in
the Old Pine Community Center in 1976.
See p. 173.) *Aurora* includes a glass
window treatment, a canopy over the
entranceway, two six-foot bronze sconces,
and eight small sconces. King's work ties
the Cosmopolitan apartment complex to
the surrounding 19th-century architecture,
unifies the building's exterior, and
provides distinctive lighting at night, identi-
fying the building, in the developer's
words, "as related but unique to the area."

With a shift in emphasis from object
to site, artists are seeking ways to make
public space more conceptually interesting,
more perceptually engaging, more useful,
and more inviting.

*"The creation of art in public places requires the eye of a poet,
the ear of a journalist, and the hide of an armadillo. By intention or consequence,
this work illuminates the relationship between the institutions that
shape and define American life and the people they serve."*

Richard Posner
Intervention and Alchemy: A Public Art Primer
1990

In the Public Context

Public Art and Public Life

Robert Indiana
LOVE
c. 1976 **6-07**

When works of art found a neutral, protected isolation in museums and galleries, they were all but deprived of any immediate connection to everyday life. When architects—and public art programs—plucked those sequestered objects from their sanctuaries, it was no wonder that early outdoor installations of sculpture, stripped of function and devoid of organic, contextual relation to a site, were often condemned as private art for public spaces. Such works attracted many unflattering comparisons. Art historian Harriet Senie reminds us that Henry Moore remarked, "I don't like sculpture used as costume jewelry, which is what happens when it is pinned onto a building." Even the most exquisite object appeared oddly displaced when stationed on a pedestal in front of a building like some kind of gatekeeper. "Usually the art stands to one side," Thomas Hine has said, "like someone who has been invited to a party and doesn't know why."

From this sense of incongruity emerged a reconsideration of public art. As artists explored ideas for works that would respond to the physical conditions of a particular site, they began to consider the site's social, cultural, and historical characteristics as well. In recent years there has been a movement toward public art that is useful, invites participation, respects the environment, and reflects the social history of its location—art having much in common with the work of William Rush, the consummate civic artist of the early 19th century (see p. 27).

As cultural commentators, artists have a longstanding tradition of seeking out the paradoxical and calling the public's attention to it. Robert Indiana's *LOVE* (**6-07**) grew out of the Pop-art movement, which satirized American popular culture and its wholesale devotion to consumerism

George Segal
**Woman Looking
Through a Window**
1980 **6-28**

through the advertising media. Ironically, his *LOVE* paintings of the 1960s were among the most widely reproduced artistic images of the 20th century—on a Museum of Modern Art Christmas card, on innumerable unauthorized gold pendants and T-shirts, and on a special Christmas stamp that sold 330 million copies. (The artist received the standard $1,000 fee.) Philadelphia acquired its three-dimensional version in 1976, when it was placed prominently in John F. Kennedy Plaza to advertise the "City of Brotherly Love," a meaning assigned to it by its location and audience. Indiana, who has since pursued a wide range of artistic interests, has been burdened by the early success of *LOVE*, held hostage by the very consumerism he sought to comment upon: "I'm really not looking forward to painting *LOVE*s for the rest of my life."

As the business world began to invest and trade in art as a commodity, and as the political arena began to treat public art as an environmental remedy, some artists sought to revive the idea of art as a means to illuminate perception, unconsciously evoking the Native American tradition of connecting the spiritual and natural worlds. Other artists were influenced by the European tradition that created memorable urban places—the same tradition that, in Philadelphia, produced the *Washington Monument* (**3-20**), City Hall (**3-01**), and the *Swann Memorial Fountain* (**4-14**).

Out of this dialectic emerged a new form of site specific public art that aspired to be more democratic and interactive, less esoteric, and, above all, responsive to its surroundings.

If anything is emblematic of the discord of contemporary society, it is the alienation and isolation of the individual in daily life. Some artists have reacted to this condition by invoking it, as George Segal did with *Woman Looking Through a Window* (**6-28**), who peers with lifeless anonymity at passers-by. Other artists present deliberately provocative imagery to counter the monotony and impersonality of the street. Oldenburg's giant *Clothespin* (**6-04**) is a metaphor for the disjuncture between art and everyday life.

Another response to the apparent separation of public art from those it was intended to benefit was "Form and Function," a program initiated in 1980 by the Fairmount Park Art Association. Artists were invited to propose public art projects that would be utilitarian, site specific, and integral to community life. An important objective was to integrate art into the public context through *use* as well as *placement*. For the Art Association there was also a strong desire to respond to the needs of a changing city as well as to accommodate the expressions of individual artists.

A Matrix for a New Approach to Public Art was designed to help participants establish a common point of reference. Since the artists did not begin with a preconceived form or location but rather with a

Rosalie Sherman
Eastwick Farm Park
1983; expanded 1985
6-35

A Matrix for a New Approach to Public Art

Locations	Functions	Applications
Street corners	Rest, shelter	Newsstands, kiosks
Bridges	Recreation, play	Bus shelters
Pedestrian tunnels	Security, safety	Outdoor lighting
Vacant lots	Mapping, guiding	Street furniture
Subway entrances	Community focus	Land reclamation
Shopping centers	Community identity	Pavilions
Community centers	Human experience	Playgrounds
Recreational spaces	Ecological consciousness	Walkways
Highway underpasses	Meditation, reflection	Plazas
Community parks	Observation	Performing spaces
Riverfronts	Meeting	Meeting rooms
Parking lots	Connection	Amphitheatres

Penny Balkin Bach, 1980

set of principles, the process was one of exploration, definition, observation, testing, participation, and reflection. Each artist attempted, in a personal way, to give meaning and identity to a place. Each probed for the *genius loci*, or "spirit of the place," a venerable concept that recognizes the character of a site and the impression it makes on the mind.

The ensuing proposals expanded the definition of the new public art. Proposals that ranged from lighting to the design of community parks were submitted by artists and architects including Dan Flavin, John Hejduk, Robert Irwin, Barry Le Va, Sol LeWitt, Martin Puryear, Robert Wilson, and Mitchell/Giurgola Architects. To encourage community dialogue, many of the proposals were exhibited as ideas in progress at the Pennsylvania Academy of the Fine Arts. The project was greeted by civic leaders with cautious enthusiasm.

The first proposed works to be installed (in 1982) were Rafael Ferrer's *El Gran Teatro de la Luna* (**6-32**) and Siah Armajani's *Louis Kahn Lecture Room* (**6-33**). Red Grooms's *Philadelphia Cornucopia* was carried out that same year as an independent project by the Institute of Contemporary Art. Richard Fleischner's proposal for the new campus of Community College was thwarted when the site plans were unexpectedly changed, although his concepts were later realized through a fruitful collaboration with Mitchell/Giurgola Architects for the *Columbia Subway Plaza* (**6-48**). Jody Pinto's *Triple Tongue Pier* was slowly transformed, and the resulting *Fingerspan* (**6-55**) was installed along the Wissahickon Creek in 1987. Installation of Martin Puryear's *Pavilion* is anticipated. Scott Burton's proposal for an "outdoor living room" in Palmer Park, although unrealized, had a major influence on his subsequent work.

Other artists also began to consider functional possibilities. Rosalie Sherman created a series of benches in the shapes of cows, sheep, and border collies for *Eastwick Farm Park* (**6-35**) as the result of a competition sponsored by the Redevelopment Authority. "I took my grandfather, who is 99, to see a lot of the sculpture around town, and then I took him to see mine," she commented to Thomas Hine. " 'At least you can sit on yours,' he told me."

167

A Sense of Place

PUBLIC ART IN PHILADELPHIA

Rafael Ferrer
**El Gran Teatro de la
Luna**
1982 6-32

Siah Armajani
**Louis Kahn Lecture
Room**
1982 6-33

168

"Public art is oratory," said Rafael
Ferrer when *El Gran Teatro* (**6-32**) was
installed in Fairhill Square—whereas
works created for galleries, museums, and
private collections are more like novels or
poems. Ferrer's "tropical crown" sits on a
utility building that was designed as a
public lavatory but locked up shortly after
construction. The artist's intervention
reclaimed the structure by creating a focal
point in the park for gathering and celebra-
tion. The business community along the
nearby *Bloque de Oro* helped advertise the
work's dedication, which was attended by
a spirited and diverse group of community
residents, government officials, and art
aficionados.

Public art can also have meditative
qualities. Siah Armajani wanted to create a
work for a school and asked simply that
the space be "useful and used." When he
learned that Louis Kahn had attended the
Fleisher Art Memorial as a child, he was
moved to create the *Louis Kahn Lecture
Room* (**6-33**) there. This is not a memorial
to Kahn per se, nor is it a monument, nor

does it resemble the architect's work. Ar-
majani described it as a tool for education,
listening, and gathering, inspired by
Kahn's maxim, "The room is not only the
beginning of architecture; it is an exten-
sion of self." Kahn's memory is the source,
rather than the subject, of the room. The
small space is simple and open, but rich
with detail. A yellow glass transom etched
with one of Kahn's drawings calls atten-
tion to the light cast into the room, a
quality about which the architect was pas-
sionate. On the cornices, Armajani placed
wooden letters quoting Kahn: "Schools
began with a man under a tree who did
not know he was a teacher, discussing his
realizations with a few who did not know
they were students."

Public art is realized when it takes its
place in its setting, but it is "actualized"—
caused to fully exist—when it is experi-
enced and interpreted by the public. Many
artists working in the public context value
and encourage the communication of mul-
tiple meanings. Pinto's weathering steel
Fingerspan bridges a precipitous gorge
along the Wissahickon Creek (**6-55**). The
artist described the experience of *Fin-
gerspan* as an act of "passing through the

finger so that the public becomes the
muscle or the bone marrow." Whereas
most bridges are seen as linear embodi-
ments of mathematical concepts, she
notes, *Fingerspan* also has symbolic and
expressive content. Its abstract form may
well contribute to public interest: it sug-
gests realism, although it is not a figurative
sculpture. Pedestrians interviewed at the
site have their own views: "I keep waiting
for birds to pour out of it," declared one
hiker. Another observed, "The first image I
got was that of a covered wagon. . . . The
articulation of the finger's joints is an intel-
lectual delight, something you have to
notice and appreciate rather than
something that hits you right away." When
it was dedicated in the fall of 1987, at a
sumptuous and lighthearted community
feast of apples prepared in every
conceivable way, it was difficult to imagine
that the project had been vehemently
opposed as unnecessary and intrusive by a
few residents in a nearby neighborhood.

Alan Sonfist
Rising Sun
1983 **6-39**

Giuseppe Penone
**Una Biforcazione e
Tre Paesaggi**
1986 **6-53**

Herb Parker
**Transient Earth
Structure**
*1986 (temporary installation,
Horticultural Center)*

The astonishing beauty and variety of the American landscape have inspired generations of artists, and many again seek a more reverent bond with the natural world through a reconnection with ritual, magic, mythology, and archeology. Alan Sonfist's *Time Landscape* (1965–1978), in the midst of lower Manhattan, recreated a precolonial forest by planting species of trees that grew before the European settlement of North America. In North Philadelphia, Sonfist's interest in natural phenomena is the basis of *Rising Sun* (**6-39**), a series of wall projections that function as a solar calendar.

George Rickey's *Two Lines* (**6-24**), a stainless steel kinetic sculpture installed at the sylvan Morris Arboretum, dramatizes the symbiotic relationship between man and nature. Its graceful "blades," activated by the wind and shimmering in the sun, bring human invention in direct contact with natural forces. In contrast, Giuseppe Penone's *Una Biforcazione e Tre Paesaggi* (**6-53**) combines plants, water, and images of the human figure to bring the elements of nature indoors, alluding to a landscaped environment in the midst of the bustling lobby of the Sheraton Society Hill hotel.

In recent years artists have examined the relationship of art and nature within the protected boundaries of the Arboretum of the Horticultural Center in Fairmount Park. In 1986 the Fairmount Park Commission, the city, and the Cheltenham Art Center sponsored "A Celebration of Art and Nature," inviting 25 artists to create works that would respond "visually, conceptually or spiritually" to the site. Herb Parker's *Transient Earth Structure* consisted of a series of columns and a temple structure of excavated earth and sod. Returned to the environment at the completion of the project with no trace of its existence remaining, this process was the artist's "metaphor for the continuum of systems within the natural order." The installations were diverse: some were displayed in high contrast to the natural environment, and others were almost imperceptible. Many artists used landscape materials—grass, trees, earth—presented

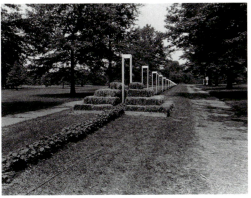

in relation to the natural elements of wind
and light. Throughout the Arboretum
there were unexpected placements of
shrinelike elements and suggestions of
ritual activity.

The next year "Alliance in the Park"
invited nine artist/architect collaborations.
Interest in spatial relationships and the ter-
ritorial mapping of fields of human activity
characterized the results. Warren Angle
and Charles Duncan's *Measure and Profile*
created an inviting walkway that connected
the Arboretum's entrance and pool on an
axis with the Japanese House. Eight hun-
dred feet of blooming red flowers were
punctuated by white wooden posts and hay
bales, which served as a "measuring
device" for the 10-foot drop in the land.

Twenty-five large-scale works were
commissioned for "Altered Sites" in 1988.
Artists added artificial elements and trans-
formed natural ones. Mei-ling Hom's
Going Green was a 60-foot arched pas-
sageway constructed of perforated copper
tubing. It bestowed a delicate arc of mist
that reflected the captured sunlight on a
trellis of radiant morning glories. Through
the efforts of "Sculpture Outdoors," the

Arboretum continues to be transformed
periodically by installations that respond to
the natural environment.

"Site specific" was a term that at first
related to the physical elements of a partic-
ular location. Increasingly, artists have
been seeking out the socio-cultural history
of a site, becoming researchers, commenta-
tors, satirists, or raconteurs. Pioneering
this approach was Red Grooms, whose
large-scale environmental works of the
1960s and 1970s, *City of Chicago* and
Ruckus Manhattan, celebrated the complex-
ities and ironies of urban American life.
Born in Nashville, Grooms has said that
his main childhood influences were Holly-
wood movies, circuses, and the Cavalcade
of Amusement at the Tennessee State
Fair. He works in a highly personalized,
idiosyncratic form that he calls a "sculpto-
pictorama" or "sculptural novel."

Grooms's *Philadelphia Cornucopia*, a
wacky environment filled with figures
and scenes from Philadelphia's past and
present, was created in 1982 in commemo-
ration of Philadelphia's 300th birthday.

Red Grooms
**Philadelphia
Cornucopia:
Washington's Ship
of State**
1982 (temporary installation)

Red Grooms
**Philadelphia
Cornucopia: Victorian
Life Drawing Class**
1982 (temporary installation)

Red Grooms
**Philadelphia
Cornucopia: Peale
Dining in the Ribcage
of a Mastodon**
1982 (temporary installation)

Grooms began his work with research at the Historical Society of Pennsylvania, but his curiosity about Philadelphia's social and cultural history took him on many walks and into conversations with local residents. *Cornucopia*'s frenzied, kaleidoscopic vision of Philadelphia was seen through the eyes of an artist with a keen sense of historic tradition and a mastery of vernacular expression. Grooms offers a full palette of images for interpretation, dishing out an astutely comic and ironic view of his subjects. Symbolically spilling out of a giant horn of plenty, a huge papier-mâché figure of George Washington stands on the deck of a ship of state equipped with wheels like a parade float. Joining him on the vessel are Thomas Jefferson and Ben Franklin, with a buxom Martha Washington as the ship's figurehead. Three-dimensional vignettes present witty commentary on local personalities and landmarks, from Charles Willson Peale dining in the ribcage of a mastodon to a Victorian life-drawing class at the Pennsylvania Academy of the Fine Arts.

Juxtaposed against Philadelphia's contemporary skyline are a diminutive Rocky Balboa, the 76ers led by Julius Erving, and the strutting Mummers.

After exhibition at the ICA, an ad hoc citizens' group raised funds to purchase *Cornucopia* for the city. It was temporarily installed at the Visitor Center at Independence National Historical Park and then at the 30th Street train station through 1989. The work, now in storage, is part of the collection of the Port of History Museum.

Andrew Leicester's *Riverwalk at Piers 3 and 5* (**6-61**), installed in 1990, draws its inspiration from the city's maritime history and nautical mythology. Along an 800-foot stretch of Delaware Avenue, a series of mermaids, figureheads, and dock horses allude to the lore of the water. These images are anchored to the north by a metal *Lightship* structure, derived from the historical *Atlas*, a floating shipyard derrick, and to the south by *Hulk*, an evocation of

Andrew Leicester
Riverwalk at Piers 3 and 5 (detail)
1990 **6-61**

Larry Rivers
Philadelphia Now and Then (detail)
1983 **6-37**

Red Grooms
Philadelphia Cornucopia: On the Schuylkill (detail)
(below)
1982 (temporary installation)

Gerald Nichols
Painted Relief
c. 1976 **6-09**

an abandoned ship, which forms an observation deck with a view of the river. A weathervane, turquoise ceramic fish, impressions of tools, and glazed nautical knots offer a delightful array of waterfront allusions.

The use of historical and cultural material varies dramatically from one artist to another. Larry Rivers' *Philadelphia Now and Then* (**6-37**) in the Food Hall walkway of Gallery II, Richard Haas's mural (**6-36**) at 2300 Chestnut Street, and Red Grooms's *Philadelphia Cornucopia* all include scenes from Philadelphia's past and present and allusions to local heroes and events, including a familiar rowing scene along the Schuylkill from Thomas Eakins' painting. But Rivers gives us only a suggestion on his sketchlike tiles, Haas presents the scene with pastel elegance, and Grooms has fish literally jumping out of the water.

Eakins' painting also appears transformed in a painted relief by Gerald Nichols in the gymnasium of the Old Pine Community Center, begun in 1976 (**6-09**). Friday Architects & Planners invited the

community to help select three other works of art as part of the RDA's percent program: Charles Fahlen's howling coyote, accessible to children on a second-floor landing; a fabric hanging by Virginia Jacobs in the stairwell; two small stained glass windows by Ray King; and Nichols' relief. For the floor of the community room, architect David Slovic designed a seven-color tile pattern with the look of an Oriental rug. For the exterior courtyard pavement, he designed a gridwork in which alternate blocks would be available for mosaics. Then about two hundred community volunteers—including well-known local artists Sam Maitin and Isaiah Zagar—created the mosaic patterns. The goal was to create a participatory public art process that would link the architecture with the community's interests.

**Twin sisters posing
for *Community
Mural***
photograph 1977

Clarence Wood and
Don Kaiser with
community residents
Community Mural
1977 **6-20**

There are times when the community and the artist intersect in an expressive, participatory, and mutually enriching way. The products of this convergence often take the form of murals, mosaics, and community gardens: the materials are relatively inexpensive, the results are swift and gratifying, and there are political and cultural precedents for such activity (see *A Legacy of Murals*, pp. 118–119). Public art that is initiated at the community level is characterized by spontaneity and inclusiveness because it generally occurs by invitation, not by resolution. Community arts projects combine the desire for neighborhood beautification with an understanding of the political realities of urban life. But behind virtually every such project there is an artist who works with extraordinary energy to seek out the untapped creativity within the neighborhood.

In Philadelphia, public art in the neighborhoods received an unlikely boost from the creation in 1971 of the Museum of Art's Department of Urban Outreach/ Department of Community Programs. Through its mobile art programs, community education facilities, contemporary art events, community-oriented exhibitions, and environmental art projects, the department was dedicated to developing imaginative and flexible ways to make the encounter with art a more familiar experience. For more than ten years, artists Clarence Wood and Don Kaiser worked with community groups, by invitation, to develop environmental art projects, including over one hundred murals that became symbols of community change and local

Charles Searles
Playtime
1983 **6-38**

Kent Twitchell with the
Anti-Graffiti Network
**Julius Erving
Monument**
1989 **6-59**

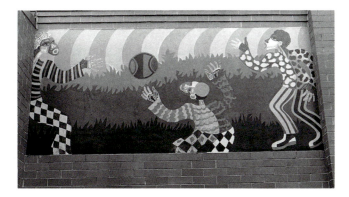

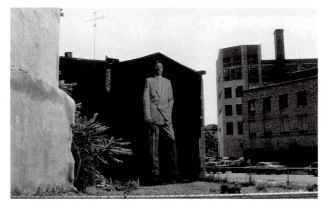

empowerment. In addition to "reclaiming" community walls, the program employed young and minority art students who helped to carry out the designs that emerged from neighborhood arts workshops. In some cases, the community became part of the subject for the wall; in South Philadelphia, twin sisters posed for inclusion in their neighborhood mural (**6-20**). After the termination of the Museum department, the city-sponsored Philadelphia Anti-Graffiti Network began its mural program in 1984, involving young people in the rejuvenation and development of their communities. Under the leadership of artist Jane Golden, and with the participation of numerous professional artists, hundreds of neighborhood murals have been painted.

Images of African-American leaders began to appear on the facades of schools and community centers in direct response to the aspirations of young people. The

community arts programs of the seventies dramatically expanded the iconography available for pubic art. Charles Searles's *Playtime* (**6-38**), commissioned by the Department of Recreation for a city playground, is an absorbing, spontaneous expression of family life with a profusion of strong colors and patterns that suggest African textiles. By the eighties, the image of Julius Erving (Dr. J.)—local sports hero, former Fairmount Park commissioner, and public-spirited leader—could be found in *Philadelphia Cornucopia*, on a mural by Los Angeles artist Kent Twitchell (**6-59**), who worked with the Anti-Graffiti Network, and in a sculpture by Barney Bright at the Spectrum.

Lily Yeh with community
residents
**Ile-Ife Park: The
Village of Arts and
Humanities**
1986–ᅠ (work in progress)

Since 1986 Lily Yeh has been the artist, project director, heart, and soul of *Ile-Ife Park: The Village of Arts and Humanities* (**6-50**). North Philadelphia residents have helped to create a community park that includes murals, sculpture, and plantings. With the support of Arthur Hall, founder of the Afro-American Dance Ensemble and the Ile-Ife Center, Yeh began a modest project that has grown with her enthusiasm and dedication. Participants in the Village of Arts and Humanities have included hundreds of neighborhood children and adults, artist and student volunteers, and other community-oriented organizations: the Painted Bride Art Center, Philadelphia Green, the Philadelphia Anti-Graffiti Network, and the Clay Studio.

The nonprofit Brandywine Graphic Workshop has sponsored a number of community-based public art activities. "Philly Panache" enlisted artists to paint illusionary shutters, curtains, and plants over the sealed windows of abandoned properties. In 1987 the Workshop sponsored Keith Haring's mural *We the Youth* (**6-57**) in South Philadelphia, produced with help from local children.

Ideally, civic buildings, like parks and murals, ought to embody the fusion of art and public life. The city initiated a promising public art program in 1987 for its proposed criminal justice center. Not since

Keith Haring with
the CityKids Coalition
and Brandywine Graphics
Workshop
We the Youth
1987– (work in progress)
6-57

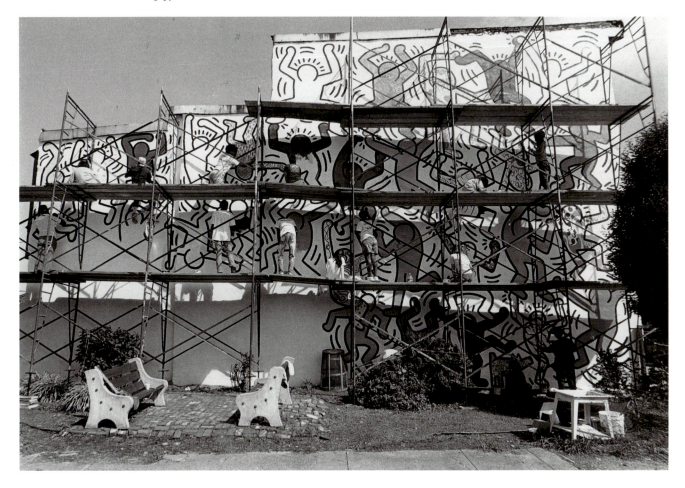

the design of City Hall (**3-01**) had artists been invited to pursue an ambitious art program that would be integral with the design of a major civic building. The six artists selected by competition for this unrealized project—Cynthia Carlson, Houston Conwill, Nefertiti Goodman, James Phillips, Richard Posner, and Phillips Simkin—intended to add the resonance of history, messages of hope, and reflections on the justice system itself, as in Posner's proposal for the jury assembly room. His *People's Court* included a pair of bronze chairs: a human-scale "Ceremonial Seat of Power" and a

larger, abstract "Symbolic Juror's Chair." Inspired by the old Pennsylvania political adage "How you stand depends upon where you sit," the larger chair would be perceived as a chair *only* from the ceremonial seat. Seen from any other place in the room, it would "disassemble" and appear to be an abstract sculpture.

Art in the public context has the potential to encourage individual insight and interpretation. Information and knowledge are public; understanding and perception are private. At this uneasy borderline, public art creates the potential for personal discovery and private contemplation by infusing public spaces with meaning and content.

Public Art versus Public Taste

Augustus Saint-Gaudens
Diana
1892 **3-14**

Alexander Stirling Calder
Swann Memorial Fountain (below right)
1924 **4-14**

An adage promises, "Those who have stones thrown at them in one generation have monuments built by the next." Public art provokes different responses from different people at different times. Often there is initial skepticism about a public work because it is new and startling, or because it violates conventional standards of beauty and propriety. Even the most democratic and informative public process cannot ensure uniform acceptance or appreciation. In 1974, for an article in *Philadelphia Magazine,* Jim Quinn polled gallery owners, collectors, and artists to determine the city's 10 "best" and 10 "worst" sculptures. When some works appeared on both lists, he concluded: "There are not ten works of public art that a reasonably knowledgeable group of people can agree are good in the city of Philadelphia." Because taste is personal and changing, it helps to search for more objective criteria: the meaning of the work, the reason it was commissioned, its relationship to its site, the artist's intention, or the place of the work in the evolving history of art and culture. Controversy is not always a matter of elite taste versus the masses.

When the sketch model for Frederic Remington's *Cowboy* (**3-35**) was inspected in 1907, one trustee of the Fairmount Park Art Association protested against the "inartistic" position of the foreleg and the "disagreeable" pose of the horse. Emmanuel Frémiet intended *Joan of Arc* (**3-13**) to illustrate the small physique of the 15th-century warrior, as indicated by the armor of the period. But critics complained about the diminutive figure in relation to the ungainly horse she commanded; the public wondered how a monumental feat could be accomplished by a girl so small; and a member of the selection committee complained that the horse "has hardly the nervous action of a fat cow." Any departure from the conventional dignity of the equestrian monument was suspect.

At the dedication of *Joan of Arc* in 1890, the Honorable Samuel Gustine Thompson praised that work but complained that "most of the works of art placed in public parks are made to represent destruction in some form or other. In such works we see the lion, the king

Emmanuel Frémiet
Joan of Arc
1890 **3-13**

*"We felt we had no choice, even though we may not have liked the pictures.
We learned that art doesn't have to be pretty."*

Anthony Eckstein, juror,
on the acquittal of director Dennis Barrie and the Cincinnati Contemporary Art Center
on obscenity charges stemming from the Robert Mapplethorpe exhibition
1990

*"As long as art is the beauty parlor of civilization,
neither art nor civilization is secure."*

John Dewey
Art As Experience
1934

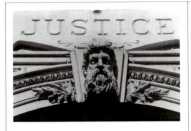

of the forest, with his prey in his grasp ready to destroy it; we see the tiger about to spring on his unconscious victim; we see fierce wolves in a death struggle for food; we see the savage seeking to drive off the wild beast intent upon destruction; we see the gladiators in mad contortion striving to crush out life. . . . Far better it would be that these works in public places should represent subjects that will tend to advance and elevate the public mind."

In 1892 the architect Stanford White commissioned Augustus Saint-Gaudens's *Diana* (**3-14**) for the tower of New York's Madison Square Garden. When the building was demolished in 1925, the nude goddess of the hunt was placed in storage until 1932, when it was brought to Philadelphia by the Art Association for installation in the Grand Stair Hall of the Philadelphia Museum of Art. The Reverend Mary Hubbert Ellis, a "crusader against pornography,"

tried to prevent the entry into the city of a statue that was "brazen, ungarbed and unfit for public view."

Alexander Stirling Calder's use of allegorical figures to represent the city's three rivers was criticized as too subtle for the average person, and State Supreme Court Justice Robert von Moschzisker complained that he himself had no idea what the *Swann Memorial Fountain* (**4-14**) meant. The artist replied, "The meaning of works of art is just as mysterious as life itself. . . . There are lots of things in life we do not understand; art is no exception." In 1945, Strothers Burt judged City Hall (**3-01**) "one of the largest, most expensive, and ugliest city halls ever conceived by the mind of man; a monstrosity of bad taste, inconvenience, and graft."

One of the city's most unusual and highly publicized controversies was the ongoing debate over the permanent placement of Thomas Schomberg's *Rocky* (**6-27**) on the steps of the Museum of Art. The *Inquirer*'s *Today Magazine,* in its 1982 cover story "The Fight that Rocky Lost," presented the dispute as a showdown: "Rocky (The Statue) vs. The Guardians of Good Taste (a/k/a The Art Commission)." Although the debate began as a populist issue that pitted the

Artist Thomas
Schomberg and
Sylvester
Stallone with
model for *Rocky*
photograph 1980

Alexander Milne Calder
City Hall details
(left)
1873–1893 **3-01**

common folk against the cultural elite, by the time it was renewed in 1990, people had the opportunity to hear many points of view and form their own opinions. A KYW-TV telephone poll recorded 57% for keeping the sculpture at the Art Museum and 43% for removal, while a *Daily News* telephone poll reported 53% for removal and 47% for keeping. No matter what the ultimate decision was, approximately half the people polled would be disgruntled—a compelling reason to search for other criteria to determine the fate of public art in Philadelphia.

*"We are what we make ourselves.
The art of the future will be what we have become."*

Vincent Scully
Architecture, Sculpture, and Painting:
Environment, Act, and Illusion
1981

Why Public Art?

Recent Developments and Future Directions

Artist unknown
Nandi
c. 1500
(Madras, India)
6-16

The world is enriched by what we now call "public art." Painting, sculpture, and the decorative arts have interpreted, enhanced, and animated our landscape, public spaces, and cities since prehistory: the early pictographs of the Native American cultures, the friezes of the Parthenon in classical Greece, the exquisite bronze plaques of the Royal Palace in Benin, Michelangelo's frescoes for the Sistine Chapel, Rush's wood carvings for the Fairmount Waterworks, Calder's sculpture for Philadelphia's City Hall, Yellin's ironwork, and Oldenburg's monuments. In every period of history, in every corner of the world, under the best and worst of circumstances, artists have reflected upon their civilization. Art in public places is a reminder of the spirit of the culture that created it. Governments and public officials come and go, but the art remains as a

cultural legacy. The image of the artist as an alienated, isolated, introspective being is new to this century and, even today, generally erroneous. Many contemporary artists are more engaged, reflective, participative, and community-minded than their immediate predecessors. Given the opportunity, they can offer meaning, content, definition, detail, contrast, insight, or continuity to the public environment.

The International Sculpture Garden at Penn's Landing offers some historical clues to the integration of the artist's work into community life. Under the auspices of the Fairmount Park Art Association, a group of significant objects from other cultures were installed at the waterfront, symbolic of the international nature of the port and the diversity of human achievement through time. *Nandi* (**6-16**), a symbol of Shiva, was originally placed opposite the Shiva temples in India; two pre-Columbian *Spheres* (**6-14**) are thought to have

been used for religious or astronomical purposes in Costa Rica; stone *Water Spouts* (**6-15**) from Indonesia derive a spiritual dimension from their placement at ritual bathing pools; a carved *Central Post* (**6-18**) supported the roof of a dwelling on the northwest Pacific coast; and two carved stone figures (**6-17**) represent scholar-officials of a local Korean court. While our own diverse society does not share a unified religious tradition, the role of the artist as a poetic interpreter of spirit, myth, and ritual is one that might offer identity and tranquility.

Artists whose work is guided by a curiosity about the relationship of art to public life can contribute to a revitalization of our public space and a reevaluation of our public culture. Without second-guessing the results, we need to seek out artists and thinkers who are engaged in their work as well as dedicated to the world we share.

Creating a fertile climate for the development of ideas is the first step toward improving our public environment. This often involves a degree of risk-taking. For example, in 1980 the Fairmount Park Art Association commissioned a proposal from the architectural firm of Venturi, Rauch and Scott Brown for Philadelphia's 1982 tricentennial. It resulted in a plan for *Penn's Light*, a light sculpture symbolic of

the Quaker Inner Light. The architects proposed a circular installation of 14 searchlights directed into the sky at Belmont Plateau in Fairmount Park, on an axis with the Parkway and City Hall. To test the plan, searchlights were placed in the Park, and observers gathered at City Hall tower to see the results—a disappointingly faint fan emanating from behind the Art Museum, weakened by the ambient city light. Ironically, the beams were dramatically visible from the northern suburbs, drawing curious suburbanites to the Park. Although the technical problems were never solved—because the project was not commissioned—the experience fueled the firm's interest in the use of light. Years later project architect Steven Izenour wrote, "We couldn't have done it if we hadn't learned from Penn's Light which then became Ben's Light." He was referring, of course, to the *Benjamin Franklin Bridge Lighting* (**6-54**), designed by the firm of Venturi, Rauch and Scott Brown.

Venturi, Rauch and
Scott Brown
**Benjamin Franklin
Bridge Lighting** (or
Ben's Light)
1987 **6-54**

Along these lines, the Foundation for Architecture's "City Visions" international design competition (1986) sought creative ideas that would contribute to a more livable city. Louise Schiller's plan to thread a *Ribbon of Gold* throughout the city was selected in part because it could be implemented—and, indeed, plantings of black-eyed Susans and other yellow flowers have been initiated, "a link from neighborhood to neighborhood," in Schiller's vision, helping the city to see itself as a whole. A range of suggestions—some pragmatic, others conceptual, and a few ethically thought-provoking—were examined. *Four New Squares and a Garden for Every House*, submitted by Patrice Lynch and Brian Wait, was a strong graphic response to the need to extend Penn's original city plan by creating four new squares and centers of communal activity—two on Broad Street and two on Market.

Inspired by these entries, in 1988 the Foundation for Architecture joined with the city to sponsor a design competition, "Visions for Penn's 5th Square in 2001." In anticipation of the building's centennial year, this project sought creative design ideas for the ground level of City Hall and Penn Square. At a public forum, civic leaders were invited to express their thoughts about City Hall as a public living room. The jury observed, however, that before any creative ideas could be considered, a few basic steps were necessary, among them restoring and cleaning the building, improving the lighting, and introducing an aggressive maintenance program. A number of submissions suggested public art projects that would symbolically involve citizens: Marvin Verman proposed that each neighborhood sponsor a competition to design a neighborhood flag to be installed around Penn Square; Mierle Ukeles suggested inviting each child beginning school in the year 2001 to make a "stepping stone," a tile set into a ring around City Hall, with an annual ceremony that would reunite the participants and their families.

Patrice Louise Lynch
and Brian Wait
**Proposal for *Four New
Squares and a Garden
for Every House***
1986

In 1985 the Office of the City Representative explored the possibilities of "lighting up" Philadelphia and establishing light as an artistic signature for the city. With record speed and enthusiastic community support, Venturi, Rauch and Scott Brown was selected by competition to implement a unique computerized lighting system for the Benjamin Franklin Bridge. Simultaneously, the Art Association saw an opportunity to study the potential for creative urban lighting. It proceeded in the spirit of Laszlo Moholy-Nagy, who declared in 1939, "Great technical problems will be solved when the intuition of the artists will direct the research of engineers and technicians."

The study explored creative means to increase residents' and tourists' sense of security, encourage mobility and enjoyment of the city's resources after dark, punctuate the city's sculptural and architectural treasures, increase local pride in neighborhoods and commercial districts, and use advanced technologies to reflect the much-sought-after image of a forward-thinking city. It was hoped that artists would offer new visions for how public art can create public space. David Ireland, Leni Schwendinger, Phillips Simkin, Mierle Ukeles, and Krzysztof Wodiczko were chosen to focus and extend Philadelphia's history of aesthetic illumination.

With the support of the city's cultural community and municipal government, enhanced by the private sector and fed by the contributions of individual creators and visionaries, one would think that public art would be firmly set on a track toward civic betterment. In fact, complex, demanding, and entirely unforeseen questions have arisen surrounding the creation of public art.

What happens when a sculpture is moved out of context? When the Bell Atlantic Company remodeled its ground floor, it donated Joseph Greenberg, Jr.'s *Heroic Figure of Man* to the Fairmount Park Commission. Greenberg had created the bronze for the building in 1963,

Henry Moore
**Three-Way Piece
Number 1: Points**
1964 **5-09**

attempting, as he recounted, "to find a compromise between the ideas of the architect and those of the executives of the company. Afterward, I regretted having done it." Greenberg informed the Commission that an open park setting would be inappropriate because the sculpture was designed to be viewed from the front of the building, and that he would prefer not to be represented by such an untypical example of his work. The Park Commission honored the artist's request that the sculpture be sold as scrap metal. (Later an arts advocate who saw the work about to be melted attempted to "save" it from its fate.) As the city and its architecture evolve, other works in public spaces will inevitably be victims of a changing environment.

Should a work of art be moved to a "better" location? The answer depends in part on whether it was created specifically for its current site and whether it relies on this connection to maintain both its meaning and the artist's intentions. Consider Remington's *Cowboy* (**3-35**). We know from correspondence that Remington visited Fairmount Park in 1905 with his foundry representative, selected a site, and posed a horse and rider there.

Remington considered the surrounding wooded environment, the elevation of the rock that acts as the sculpture's base, and the view from the East River Drive. The site played an integral role in his aesthetic decisions, and although the use of Kelly Drive has changed over time, the environment surrounding the sculpture has not. In order to relocate the work, it would be necessary, at the very least, to replicate the precipice upon which the horse and rider are poised in frozen action. A more practical alternative is to create a parking area for those who want to look at the work at their leisure.

The recent relocation of Moore's *Three-Way Piece Number 1: Points* (**5-09**) from a concrete plaza to a grassy mound along the Parkway allows the work to be seen, to great advantage, in a natural setting. Unlike the *Cowboy*, this sculpture was not created with a particular site in mind. Rather, the work exemplifies Moore's general interest in the observation of nature. When the sculpture was removed from Kennedy Plaza, alternative sites were carefully evaluated. Using the traditional "pointing" system (see p. 61), a mock-up was created by sculpture students from the University of Pennsylvania. The replica was then studied and photographed at nine locations before the new one was determined.

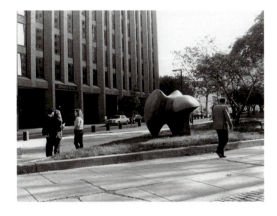

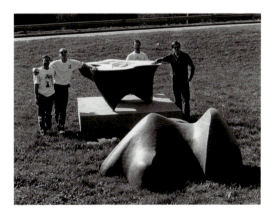

What happens when public art is in private hands? The Redevelopment Authority requires that private developers who build on Authority land spend one percent of their construction costs for fine arts. Although the Authority has generally assumed that the art is inseparable from the site, when buildings are sold the new owner may view the art as a commodity that can be sold, exchanged, or relocated. This position was tested when Centre Square changed ownership and the new corporate entity decided to refurbish the interior atrium that housed Dubuffet's *Milord la Chamarre* (**5-24**). When rumor spread that the work was to be put up for sale (its market price had increased appreciably since its original purchase), the RDA obtained a court order to prevent its removal. In the end, the work remained on site in the public domain, but was relocated. Such works, although purchased by the developer, constitute a civic "collection" and exist primarily because of governmental actions that require public placement.

What happens when the civic environment is inhospitable to public art? One cannot help but wonder if contemporary sculpture gardens are, in part, a response to the obstacles and challenges presented by demanding urban situations. Urban art is subject to governmental review, vandalism, scrutiny, and public derision. For

Phillips Simkin
Public Center for the Collection and Dissemination of Secrets
1973 (temporary installation, 30th Street Station)

Jenny Holzer
Signs
1987 (temporary installation, the Bourse)

the artist, there is a definite advantage to working in a landscaped environment that—despite its natural changes—resembles a neutral museum space. Like their counterparts in Europe, and like Storm King in New York and Brookgreen Gardens in South Carolina, Philadelphia's Morris Arboretum and the Abington Art Center have established sculpture gardens that provide alternatives to public art in urban settings.

Will public art stand the test of time? Community enthusiasm or passivity notwithstanding, public art in the outdoor environment is also subject to the daily ravages of pollution, corrosives, vandalism, and neglect. Philadelphia has the highest concentration of acid rain and pollution in this region, and concern for the condition of the city's bronze and marble sculpture has stirred civic associations to raise funds for sculpture conservation projects (see *Preserve and Protect*, pp. 190–191).

The difficulty of reconciling old and new has never been more apparent as we struggle to preserve the images of the past and simultaneously urge artists to respond to a dizzying, rapidly changing present. Today, even as we move toward a global community through telecommunications and technology, our daily interactions have become, lamentably, less interpersonal. Artists reflect on our estranged, image-saturated society in different ways, some by exploring alternative uses of media, and others through reconsideration of the content and material presence of their work.

Phillips Simkin's persistent interest in communications systems prompted his *Public Center for the Collection and Dissemination of Secrets* (1973). Inspired by the Watergate bugging, Simkin, with the assistance of Bell Telephone, installed 20 specially wired phones in the middle of 30th Street Station as part of the Institute for Contemporary Art's "Made in Philadelphia" project. The installation lured passers-by to record a secret and be in turn rewarded by hearing someone else's anonymous communication.

For the 1987 project "Independence Sites: Sculpture for Public Spaces," Jenny

Nam June Paik
Video Arbor
1990 **6-63**

Stephen Antonakos
Neons for
Buttonwood
1990 **6-60**

Holzer installed two-color light-emitting diode (LED) *Signs* under the clocks at the east and west interior entrances of the Bourse. Her invented texts, aphorisms that comment on contemporary life, caused controversy when the site's management expressed concern that the audience might confuse Holzer's messages with those of the commercial establishments. The ambiguity of her language, and the *Signs'* placement, calls attention to the anonymity of her work, but unlike Simkin's *Public Center*, Holzer relies on the cerebral rather than the emotional.

The computer was used as a tool to distribute the 250,000 tiles that make up the *Commuter Tunnel Mural* (**6-43**). Software developed to analyze chromosome patterns was applied to this end. Jennifer Bartlett's *In the Garden* (**6-29**) represents the essence of computer technology: the organizing and ordering of information. Bartlett presents a huge painting that is then disassembled and reintroduced throughout a building, creating the sense of an integral whole from many scattered parts.

Stephen Antonakos' *Neons for Buttonwood* (**6-60**) transforms commercial technology through the use of abstract imagery. For his startling *Video Arbor* (**6-63**), which frames the entrance to the One Franklin Town apartments, Nam June Paik intends to reconcile nature and technology—a goal "central to the problem of humanity." Two video programs pulsate: one of juxtaposed views of Philadelphia, the other a simulated world of transformed fish, flowers, and birds. His use of video in an outdoor installation comments on the ironic insulation of public life by television. The retreat from the civic realm into the world of media and commerce has provoked artists to try to reinvent the public experience through public art.

Another reaction to the rift between nature and technology has been the development of an ecologically minded approach to public art. The reckless materialism of our society has stimulated, in art and in life, a desire to reconnect with the natural world and reexamine romantic longings. Some artists use recycled materials in their work; others call attention to

the management of our resources. Even the form of public art is subject to reconsideration. *Sleeping Woman,* completed in 1991, is a distinctly antimonumental collaborative work by poet Stephen Berg and visual artist Tom Chimes in celebration of mankind and nature (**6-64**). Berg's line of text, written specifically in response to its site in Fairmount Park, emerges on the surface of a 1,000-foot stretch of the retaining wall that separates the Schuylkill River and the grass bank of Kelly Drive. Monumental in scope, but intimate in scale, the line of text rises out of the stone, invisible from the Drive, in what the artists call a "legible whisper."

We have always lived in a multicultural, pluralistic community, although only recently have we begun to define what that has meant in societal terms. Increasingly, public art has dared to address issues of race, gender, and power. Opportunities for public art ought to expand to reflect the city's rich cultural diversity. The power of art to invoke this vitality was underscored by Joan Logue's temporary installation, *Video Portrait Gallery* (1990), in the Portrait Gallery of the Second Bank of the United States as part of "The Electrical Matter" festival. Video closeups of civil rights activist Rosa Parks and United Farm Workers leader Cesar Chavez represented those who have been excluded from the bank's collection—women and people of color. In addition, Logue documented eight Philadelphia women

who now work in professions with which Benjamin Franklin was associated, including printer, postal worker, and firefighter.

Who is the "public" for public art? In a pluralistic society, all art cannot appeal to all people, nor should it be expected to do so. Varied public opinion is an inevitable consequence of public presentation, and it is a healthy sign that the public environment is acknowledged and not ignored. To some degree, every public art project is an interactive process involving artists, architects, design professionals, juries, community residents, civic leaders, politicians, approval agencies, funding agencies, and construction teams. The challenge of this communal process is to *enhance* rather than limit the artist's perspective.

What is the "art" of public art? As our society and its modes of expression evolve, so will our definitions of public art. Materials and methods will change to reflect our contemporary culture. The selection process, guided by professional expertise and public involvement, should be designed to seek out the most imaginative and productive affinity between artist and project. Likewise, the artist ought to demonstrate a commitment to respond to complex conditions with invention, skill, and perseverance. Until public art is understood as an integral part of the public context—in physical, social, and cultural terms—it will continue to be expected, unrealistically, to make up for deficiencies in architecture and planning. What is needed is a commitment to courage, boldness, and cooperation, not compromise.

Why public art? Public art is part of our historic continuum, part of our evolving culture, and part of our collective memory. It reflects and reveals our society and contributes to our material culture. As artists respond to the conditions of our time, reflecting an inner vision to the outside world, they become the diarists of our public experience. Philadelphia's rich tradition of public art reveals our cyclical longing for public expression: the spiritual roots of Native American culture, the utilitarian needs of the colonial period, the patriotism and civic glorification of the 19th century, the planning instincts of the industrial era, and the 20th-century pursuit of originality and invention. Whether historic or contemporary, realistic or abstract, monumental or human-scale, public art is a metaphor for our time and place.

J. Otto Schweizer
**All Wars
Memorial to
Colored Soldiers
and Sailors**
*1934; before (above)
and after 1984
conservation by
Steven Tatti* **4-48**

Alexander Milne Calder
William Penn
(above right)
*1886–1894; photograph
of 1987 conservation
(cleaning with water
under pressure) by
Moorland Studios*

The condition of outdoor monuments is an international problem of enormous proportions, affecting the Parthenon in Athens, the Sphinx at Giza, and numerous monuments in Rome that have remained under scaffolding for many years. Philadelphia's outdoor sculptures are visible victims of a changing environment. Pollution, vandalism, and neglect threaten our irreplaceable artistic and cultural inheritance. When historians referred to Philadelphia as the "Athens of the Western World," little did they realize that what contemporary Athens would share with today's Philadelphia would be the disintegration of our collective material culture.

The deterioration of bronze and marble, once thought to be "enduring" materials, is caused by both acid rain and airborne chemical pollutants. Because of prevailing wind patterns, Pennsylvania receives the most acidic precipitation in the nation. Acid rain is created when sulfur dioxide and nitrogen oxide (both primarily from coal-burning electric power plants) mix with moisture in the atmosphere. Airborne pollutants, in the form of minute and microscopic particles, are caused primarily by car emissions. Acid rain corrodes the surface of bronze sculpture, increasing the danger of structural failure and giving the works a streaked and unsightly appearance; particle deposits can cause pits in the bronze; and marble eventually dissolves in an acidic solution.

In 1982 the Fairmount Park Art Association initiated a landmark conservation program with the generous support of the Pew Charitable Trusts. A select group of the city's works of historic and artistic significance received initial treatment and continue to receive annual maintenance. Each spring, under the guidance of a professional conservator, the sculpture is inspected, grime and graffiti are removed, the work is washed, and a protective wax coating is applied. Treated works include *Abraham Lincoln* (**2-18**) at the entrance to Kelly Drive and the *All Wars Memorial to Colored Soldiers and Sailors* (**4-48**) near Memorial Hall. The uniform coloration provided by the wax allows the

Friends of Clark Park, a civic organization in West Philadelphia, raised funds for the repair and reinstallation of *Dickens and Little Nell* (**3-12**) after vandals tore Nell from her pedestal.

When *The Wrestlers* (cast c. 1885) was stolen from its pedestal in front of Memorial Hall in 1991, the public was outraged—showing that people do care about our cultural treasures. The new challenge, led by the city's Art Commission, is to maintain an ethical balance between preserving the treasures of the past and commissioning, and assuring the continued care of, new works for the future.

sculpture to be "read" by the viewer, revealing surface details once obscured by the variegated corrosion.

With funds raised by the nonprofit William Penn Restoration Committee, Alexander Milne Calder's *William Penn* (**3-02**) was restored in 1987 as part of the City Hall tower renovation. This set the stage for the renovation of the *Swann Memorial Fountain* (**4-14**), and the Friends of Logan Square Foundation raised more than $2 million to install new plumbing, electrical, and lighting systems and to refurbish the pool and the surrounding walkways. The rededication in June 1990 was led by local Girl Scouts, who made the first major contribution to restore the fountain's turtles and frogs with $25,000 from the proceeds of cookie sales. In January 1990, as part of the renovation of the Benjamin Franklin National Memorial, the William B. Dietrich Foundation supported the conservation of the massive marble sculpture of *Benjamin Franklin* (**4-51**), which was gently cleaned by professional conservators using baking soda and de-ionized water. The

Catalog

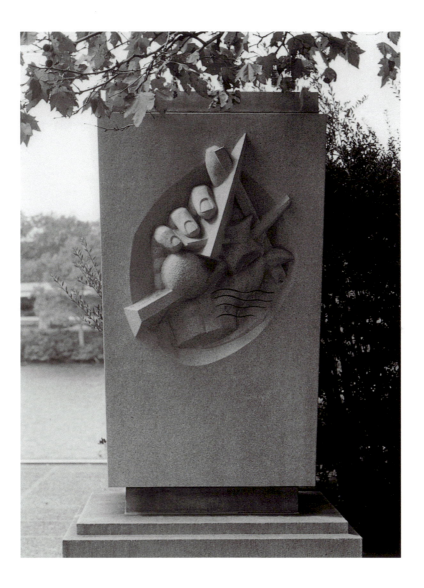

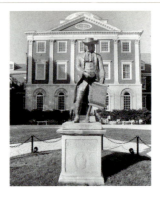

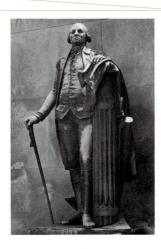

1

1-01

Attributed to John Cheere (active before 1739; d. 1787)
William Penn
c. 1774
Lead, on granite base. Height 6′
(base 3′6″)
Pennsylvania Hospital, Pine Street
Garden (installed c. 1804)
Pine Street between 8th and 9th Streets

Following a visit to Lord Le Despencer's estate in Buckinghamshire, England, Benjamin Franklin wrote that his friend "has lately erected at Wycombe . . . a noble statue of William Penn . . . holding in his hand a scroll." When Le Despencer's successor redesigned the grounds of West Wycombe, he sold the statue for old metal. John Penn, grandson of William Penn, came upon the work in a junk shop in London, and purchased it for his house at Stoke Poges before presenting it to Pennsylvania Hospital. It arrived in Philadelphia in 1804. Originally designed to be placed on top of a house with head facing downward, it no doubt influenced Alexander Milne Calder in the planning of his figure for City Hall (**3-02**).

1-02

Francesco Lazzarini (d. 1808)
Benjamin Franklin
1789
Marble. Height 8′2″
The Library Company of Philadelphia
(interior)
1314 Locust Street
For access call 546 3181
See p. 22

1-03

Jean Antoine Houdon (1741–1828)
George Washington
Marble original c. 1790; cast c. 1922
Bronze, on granite base. Height 6′7½″
Washington Square (installed 1954)
Walnut Street between 6th and 7th Streets

Jean Antoine Houdon came to America with Benjamin Franklin in 1785 to model a full-figure sculpture of George Washington. Then considered one of the finest sculptors in Europe, he had recently completed a bust of Franklin, who was serving as ambassador to France. The statue of Washington was to be the first monumental sculptural effort of the new nation, of "finest marble and best workmanship." The original clay model was completed in 1788; the stone was carved between 1788 and 1791; and the statue was set on its pedestal in the Virginia State House in 1796. This later casting is one of three in existence. It was donated to the Philadelphia Museum of Art by John McIlhenny in memory of his father, and given to the Fairmount Park Commission in 1954, when it was installed in Washington Square.

1-04

Giuseppe Ceracchi (1751–1802)
Minerva as the Patroness of American Liberty
1792
Terra cotta, bronze patina. Height 5′6″
The Library Company of Philadelphia
(interior)
1314 Locust Street
For access call 546 3181
See p. 23

1-05

Claudius F. Le Grand and Sons
Eagle
1797
Mahogany. Height 8′
First Bank of the United States
120 South 3rd Street
See pp. 24–25

1-06

William Rush (1756–1833)
Comedy and **Tragedy**
1808
Pine. Height 7′6½″
Philadelphia Museum of Art (interior)
Benjamin Franklin Parkway
For access and admission fee call 763 8100
See p. 26

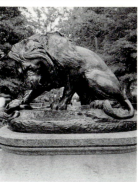

1-07

William Rush (1756–1833)
Water Nymph and Bittern (or
**Allegory of the Schuylkill
River**)
Pine original 1809; cast 1872
Bronze. Height 7'6¾"
Philadelphia Museum of Art (interior)
Benjamin Franklin Parkway
For access and admission fee call
763 8100
See p. 27

1-08

William Rush (1756–1833)
George Washington
1814
Pine, painted white. Height 6'1"
Second Bank of the United States,
Portrait Gallery (interior)
420 Chestnut Street
For access call 597 8042
See pp. 12–13

1-09

William Rush (1756–1833)
Justice and **Wisdom**
1824
Pine. Height: Wisdom 7'8¾";
Justice 7'9¼"
Pennsylvania Academy of the Fine Arts
(interior)
Broad and Cherry Streets
For access and admission fee call
972 7600
See p. 29

1-10

William Rush (1756–1833)
The Schuylkill Chained (above)
and **The Schuylkill Freed**
Spanish cedar originals c. 1825;
casts 1980
White fiberglass. The Schuylkill Chained:
height 3'3½"; width 7'3½"; depth
2'2½". The Schuylkill Freed: height
3'5½"; width 7'3½"; depth 2'6½"
Fairmount Waterworks, North and South
Entrance Houses (casts installed 1989)

As the Fairmount Waterworks
expanded in the 1820s, a wonder
of contemporary engineering and
a famous public garden, the
city's Watering Committee de-
cided to embellish the site with
emblematic sculpture. The mem-
bers did not have to look far for
an artist, for William Rush, the
foremost American sculptor of
his era, served on the committee.
 Rush designed two sculptures
to be placed atop the entrance-
ways to the new Fairmount mill-
house, where visitors descended
for a dramatic view of the
gigantic water wheels churning
below. The male figure, *The
Schuylkill Chained*, was origi-
nally known as *Allegory of the
Schuylkill River in Its Improved
State*—a title that gives a clearer
idea of Rush's intentions. The
female figure was originally
called *Allegory of the Waterworks*.
The allegory of the "improved"
river draws on traditional repre-
sentations of river gods, but
Rush's wild old man with
flowing beard—the arms scarcely
restrained by the chains of civic
improvement—has a unique
energy and strength. Around the
figure the waters gush out in
many directions. Beside his feet
is an American eagle, wings out-
spread. The female figure forms
a sharp contrast. This classical
young woman holds one graceful
hand above a water wheel as if
to demonstrate its elegance and
power. Behind her, a large vase

represents the Fairmount reser-
voir. Even her platform of bolted
steel indicates the artifice of
civilization.
 Since 1937, Rush's Spanish
cedar originals have been in the
Philadelphia Museum of Art. In
1980, in conjunction with the ren-
ovation of the Waterworks,
copies were cast in white fiber-
glass—a project of the Fairmount
Park Art Association. When the
casts were installed on the refur-
bished entrance houses in 1989,
Rush's Schuylkill allegories took
their intended place once again.

1-11

Antoine Louis Barye (1796–1875)
Lion Crushing a Serpent
1832
Bronze, on granite base. Height 4'6"
(base 3'2")
Rittenhouse Square (installed 1892)
Walnut Street between 18th and 19th
Streets

Although his contemporaries criti-
cized his style and his choice of
animal subjects, Barye is today
esteemed as the founder of the
Parisian animaliers. He worked
at a time of widespread hope that
the government could be made
more liberal and responsive, and
his choice of bronze over marble
and use of animals as symbols
for human emotions were both
considered radical. The political
symbolism of the lion of mon-
archy crushing the evil serpent
was applauded by Louis Phil-
ippe, who made Barye a knight
of the Legion of Honor in 1833.
Later Barye was appointed pro-
fessor of zoological drawing at
the Museum of Natural History,
where Auguste Rodin studied
with him.
 F. Barbedienne, whose
foundry cast the *Lion*, interested
Thomas Hockley of the Fair-
mount Park Art Association in
the sculpture. Hockley circulated
subscription books in 1885, and
six years later payment was made
for a cast of the work.

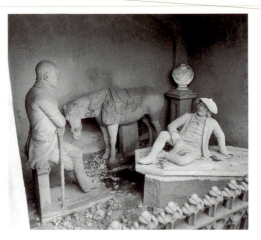

2

Laurel Hill Cemetery

3822 Ridge Avenue
(Huntingdon Street to Allegheny Avenue)
For access to cemetery and office hours
call 228 8200

Founded in 1836 in what was then a rural area, Laurel Hill became Philadelphia's first garden cemetery (see pp. 36–40). Over the generations it has provided sites for a magnificent variety of tombs and monuments, many with elaborate sculptural ornamentation. The works listed here are only a small sample of the cemetery's sculptural riches.

Because the cemetery covers 95 acres and its roads and paths are complicated, visitors should consult the map posted at the office door or inquire in the office for a copy of the map and brochures.

2-01

James Thom (1802–1850)
Old Mortality
c. 1836
Limestone. Sir Walter Scott: height 6'.
Old Mortality: height 3' (base 1'6").
Pony: height 4'2"
North Laurel Hill, small building near
entrance gate

The title character of Sir Walter Scott's novel *Old Mortality* is an aged peasant who travels from one churchyard to another to perform the pious act of recutting the faded names of Scottish Covenanters on their tombstones. In James Thom's sculptural group at Laurel Hill Cemetery, Scott sits on a grave marker to talk with the old man, who has interrupted his work on the tomb beneath him. Between the two figures stands *Old Mortality*'s weary pony.

Thom, a Scot, first gained renown with sculptures representing Tam o' Shanter and Souter Johnnie, characters from the poetry of Robert Burns. By the mid-1830s he had turned to Scott's novel for inspiration; and when he emigrated to America around 1836, he had completed the *Old Mortality* figure, the pony, and a plaster cast of Scott. The pony broke in transit, but Thom soon repaired and completed the group for the new cemetery at Laurel Hill, a suitable setting for a work about mortality and remembrance.

2-02

John Notman (1810–1865)
Sarah Harrison Tomb
1850
Marble. Height 6'8"; width 5'2";
depth 9'3"
South Laurel Hill—Section 7, Lot 7–16
See p. 38

2-03

Joseph Alexis Bailly (1825–1883)
Francis E. Patterson Monument
1862
Marble, on granite base. Height 5'4";
width 2'11"; depth 2' (base 4'8")
Central Laurel Hill—Section K, Lot 38–51
See p. 39

2-04

Joseph Alexis Bailly (1825–1883)
William E. Cresson
1869
Bronze, on granite base. Height 5'2½"
(base 5'2")
North Laurel Hill—Section W, Lot 284
See p. 39

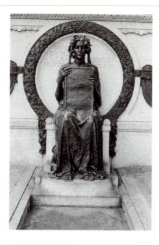

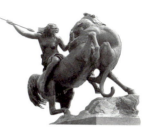

2-05

Attributed to D. Kornbau
William Mullen Tomb
c. 1880
Marble. Height 15'; width 6'10";
depth 5'10"
South Laurel Hill—Section 15, Lot 39

William Mullen (1805–1882) was a jeweler, dentist, and philanthropist. A false accusation in his boyhood and a close brush with jail left him with a lifelong sympathy for the wrongfully incarcerated. As state prison agent, he helped to free (by his own estimate) over 50,000 people.

Beside the standing figure of Mullen is a replica of the Moyamensing Prison, with an open gate from which a woman prisoner has just emerged, freed by Mullen's efforts. She sits on the step before the gate. On top of the prison stands a winged figure with a horn, presumably the angel Gabriel. Above the prison gate a head of Christ is carved in relief. These elements may be allegorical as well as biographical: the female figure can be interpreted as the soul, released from its earthly prison through the intervention of Christ.

Although this monument bears the name of a local monument maker, D. Kornbau, both the overall design and the portrait sculpture of Mullen may be by Albert E. Harnisch (b. 1843). According to a newspaper report, the tomb was erected "some years" in advance of Mullen's death; some accounts say that the entire monument was exhibited at the 1876 Centennial.

2-06

Alexander Milne Calder (1846–1923)
William Warner Tomb
1889
Granite. Height 7'8"; width 7'6";
depth 5'4"
Central Laurel Hill—Section J, Lot 74

William Warner made a fortune in the coal business and donated much of it to charity. His handsome tomb was carved by the first member of the famous Calder family of sculptors, Alexander Milne, who by then had nearly completed his massive sculptural program for City Hall (**3-01, 3-02**).

Unlike the Mullen tomb (**2-05**), Warner's is reticent about the man's life and accomplishments. It offers instead an elegantly simple religious symbol: a draped female form opens the sarcophagus to allow the soul— partially seen as a face and wings—to escape in the midst of a swirling cloud.

2-07

Alexander Stirling Calder (1870–1945), sculptor
Zantzinger and Borie, architects
Henry Charles Lea Tomb
1911
Bronze, on granite structure. Height: monument 7'6"; figure 5'5"
North Laurel Hill—Section S, Lot 36

The historian and reformer Henry Charles Lea (1825–1909) rests below a monument adorned with the figure of Clio, the muse of history. The bronze figure is the work of the second of the Calders, Alexander Stirling, who throughout a long career contributed enormously to Philadelphia's public sculpture (see **3-26, 4-10, 4-14,** and **4-15**).

The tomb's granite backdrop forms part of a retaining wall on a picturesque hillside above Kelly Drive. This classical stone structure, which provides an austere setting for Calder's sculpture, was designed by the firm of C. C. Zantzinger and C. Louis Borie, Jr., who later collaborated on the Fidelity Mutual Building (**4-16**) and the Philadelphia Museum of Art. The tomb, suggests architectural historian George Thomas, "might be considered a summa of Philadelphia's funereal monuments, combining a significant architectural composition with an important piece of sculpture commissioned for this purpose. Like the best local monuments, it is personalized, biographical, and readily understandable."

2-08

Auguste Kiss (1802–1865)
Mounted Amazon Attacked by a Panther
c. 1837; cast 1929
Bronze. Height 11'3" (base 17')
Philadelphia Museum of Art (installed 1929)
Benjamin Franklin Parkway

Mounted Amazon Attacked by a Panther is the work of Auguste Kiss, a student of Christian Rauch. Caught in the midst of the attack, the figures convey the violence and emotional tension of the moment. The *Amazon* was installed in 1837 at the steps of the newly built National Museum in Berlin, standing alone for several years until Albert Wolff, another student of Rauch's, completed a companion piece, *The Lion Fighter* (**2-12**). The Fairmount Park Art Association acquired the plaster casts for both works in 1889.

The decision to commission only American art (see p. 61) prompted the Art Association to present the *Amazon* to Harvard's Germanic Museum. However, once construction began on the new Museum of Art, the Art Association arranged to cast another copy to sit across from *The Lion Fighter*.

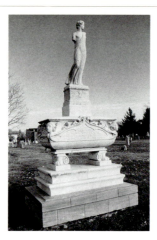

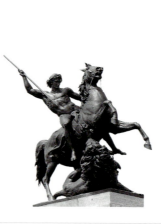

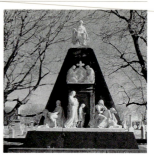

2-09

Artist unknown
Gas Jet Eagle
c. 1848
Iron. Height 5'9"; width 8'4"
Atwater Kent Museum (interior)
15 S. 7th Street
For access call 686 3630
See pp. 24–25

2-10

Artist unknown
Lantern Holder (or **Jocko Figure**)
c. 1850–1870
Painted cast iron, on wood and cement base. Height 4' (base height 1'7½"; width 2'5")
Charles L. Blockson Afro-American Collection
Temple University, Sullivan Hall (interior)
13th and Berks Streets
For access call 787 6632
See p. 49

2-11

Henry S. Tarr Manufactory
Mary Hirst Tomb
c. 1858
Marble. Height 13'
Cathedral Cemetery
48th Street and Lancaster Avenue
For access call 477 8198

During her life Mary Adele Cochran Hirst (1823–1858) seems to have been best known as a wife and daughter. Her husband, William Lucas Hirst, served as city solicitor and as legal advisor to the Roman Catholic diocese of Philadelphia. Her father, Captain Stephen Cochran, was a commander of the U.S. naval fleet at Tripoli. In death, however, Mrs. Hirst achieved a distinction separate from her family, for her tomb is thought to be one of the finest in the First Empire style in the United States. Above the ornamental sarcophagus rises a winged, draped figure that suggests a classical goddess, perhaps Nike, goddess of victory. The tomb was created by the Henry S. Tarr Manufactory on Green Street, which helped to satisfy the city's voracious demand for marble ornamentation.

2-12

Albert Wolff (1814–1892)
The Lion Fighter
1858; cast 1892
Bronze. Height 14' (base 17')
Philadelphia Museum of Art (relocated 1929)
Benjamin Franklin Parkway

The original *Lion Fighter* sits as a companion piece to Auguste Kiss's *Amazon* (**2-08**) on the steps of the National Museum in Berlin. The Fairmount Park Art Association purchased the original plaster casts for both works in 1889 and placed them in Memorial Hall for public viewing. This bronze was cast locally by the Bureau Brothers for exhibition at the 1893 Columbian Exposition in Chicago. When returned to Philadelphia, it was installed on a "jutting rock" on East River Drive. It was moved to the steps of the Philadelphia Museum in 1929.

Albert M. Wolff was born in Mecklenburg, Germany, and began his studies with the renowned artist Christian Rauch at the age of 17. Wolff became known and respected for the garden sculpture he created for Sans Souci in Potsdam.

2-13

Joseph Alexis Bailly (1825–1883)
Benjamin Franklin
c. 1860
Marble. Height 10'6" (base 2'9")
Public Ledger Building (interior; installed 1978)
6th and Chestnut Streets
For access call 925 6000
See p. 32

2-14

Guillaume Geefs (1805–1883), sculptor
Firm of Napoleon LeBrun, architects
Gardel Monument
c. 1862
Marble, on stone structure. Height 23'2"
Mount Vernon Cemetery
Ridge and Lehigh Avenues
For access call 299 6038

To design his wife's monument—at a burial site that he would eventually share—the wealthy Philadelphian Bertrand Gardel hired the architectural firm of Napoleon LeBrun, who had contributed to the designs of the Academy of Music and the Cathedral of Saints Peter and Paul. Guillaume Geefs, sculptor to the king of the Belgians, was commissioned to provide the sculpture. Geefs modeled his work on the famous pyramid-shaped tomb of Archduchess Maria Christina in the Church of the Augustinians in Vienna. On the lower level, three life-size female figures represent Europe, Asia, and Africa. The boy with a torch and key is Genius. On the central level, above the pyramid's door, kneeling figures of Hope and Faith support a medallion bust of Mrs. Gardel. On top of the monument sits America, a robed woman with a wreath of immortality to crown the deceased.

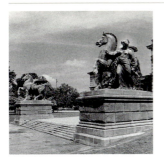

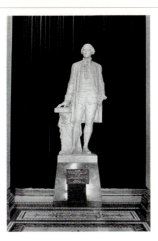

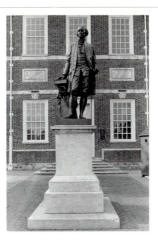

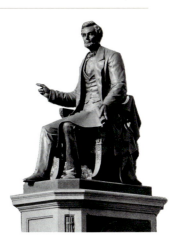

2-15

Vincenz Bildhauer Pilz (1816–1896)
Pegasus
c. 1863
Bronze. Height 16'
Memorial Hall, Front Entrance (installed 1876)
North Concourse Drive east of Belmont Avenue, West Fairmount Park

Two figures of Pegasus accompanied by the muses *Erato* (love poetry) and *Calliope* (epic poetry) were designed by Vincenz Pilz for the Imperial Opera House in Vienna (1861). Once installed high upon the building, the sculptures were thought to be out of scale and were removed, with the firm order from the Austrian government to melt them down. Fortunately, the foundry obtained permission to sell the sculptures instead, and they were purchased by Robert H. Gratz, a Philadelphia businessman. Gratz offered the winged horses to the Fairmount Park Commission, and in the year of the Centennial Exposition, they were installed in front of Memorial Hall.

2-16

Joseph Alexis Bailly (1825–1883)
George Washington
1869
Marble. Height 8' 6" (base 2' 11")
City Hall, Conversation Hall (interior; reinstalled 1983)
Penn Square, Broad and Market Streets
For access call 686 2250

2-17

Joseph Alexis Bailly (1825–1883)
George Washington
Marble original 1869; cast 1908
Bronze. Height 8' 6" (base 6' 8")
Independence National Historical Park
Chestnut Street between 5th and 6th Streets

The son of a cabinetmaker, Joseph Bailly was born in Paris in 1825. Little is known of his early training, but he fled from France during the 1848 uprising, apparently after shooting his commanding officer. After traveling throughout the United States, Bailly settled in Philadelphia in 1850, where he joined the faculty of the Pennsylvania Academy of the Fine Arts.

George Washington was installed in front of Independence Hall in 1869. To protect the marble from the weather, it was moved in 1908 to a balcony above City Hall's north vestibule, while a bronze replica was installed on the original site. When Conversation Hall was restored in 1983, the marble sculpture was placed in a central position in one of City Hall's grand public spaces. Bailly's monument to the Reverend John T. Witherspoon, erected by the Presbyterian Church for the Centennial Fair, stands on the east slope of Memorial Hall in Fairmount Park.

2-18

Randolph Rogers (1825–1892)
Abraham Lincoln
1871
Bronze, on granite base. Height 9' 6" (base 22' 6")
Kelly Drive at Sedgely Drive

Philadelphia's Lincoln Monument Association, chaired by Mayor Alexander Henry, was formed on May 22, 1865, and in a little over a year raised $22,000 to commission a memorial. Randolph Rogers has rendered Lincoln in the naturalistic style that was prevalent in mid-19th-century portraits. Seated, with quill in hand, Lincoln is shown just having signed the Emancipation Proclamation.

Rogers was born in Waterloo, New York, but spent most of his childhood in the frontier town of Ann Arbor, Michigan. At 20 he went to New York City and found work as a dry goods clerk while pursuing his work as an artist. According to the art historian Lorado Taft, an "impromptu exhibition of . . . several figures and a bust of Byron" was so well received that his employers financed his first trip to Italy. He studied with Bartolini in Florence and in 1851 joined a well-established community of American artists in Rome. His first public commission was a portrait of John Adams for the Mount Auburn Cemetery in Cambridge, Massachusetts, but he is also known for the nine relief panels, entitled *Columbus Doors*, that he designed for the U.S. Capitol.

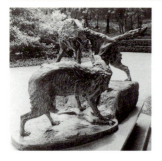

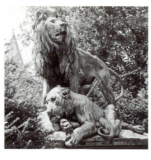

2-19

Edward Kemeys (1843–1907)
Hudson Bay Wolves Quarreling Over the Carcass of a Deer
1872
Bronze. Height 4' 2" (base 2' 6")
Philadelphia Zoological Gardens, near Wolf Woods (relocated 1956)
34th Street and Girard Avenue
For access and admission fee call 243 1100

Born in Savannah, Georgia, and educated in New York, Edward Kemeys served as captain of artillery in the Union army during the Civil War and later with the Engineer Corps in Central Park before embarking on his artistic career. While in New York, he studied modeling and was fascinated by the energy and emotional tension found in animal interaction. His works are considered distinctly American, portraying animals in a direct, naturalistic style.

His group of two wolves fighting over a carcass was the first official acquisition of the newly established Fairmount Park Art Association. Kemeys used the money earned from the commission not to visit Paris, which was the center of sculptural activity at that time, but to travel into the American wilderness. He visited Paris after the Centennial celebration in 1876, but did not like the "approach" or the "caged animals" that he found in the ateliers there.

2-20

Edward Stauch (b. 1830)
Night
1872
Bronze. Height 5' 8"
Horticultural Center grounds (relocated c. 1976)
North Horticultural Drive, West Fairmount Park

Little is known about the sculptor of *Night*, Edward Stauch. Funds for the purchase—the first gift to the Fairmount Park Art Association—were contributed by Edwin N. Benson, a founding member of the board. The work was presented to the Fairmount Park Commission in 1872 and was originally located at George's Hill in West Fairmount Park. The sculpture was relocated when the new Horticultural Center was built. Other works in Philadelphia attributed to Rauch include a bust of George Bacon Wood at the American Philosophical Society and one of Friedrich Schiller at the German Society.

2-21

Wilhelm Franz Alexander Friedrich Wolff (1816–1887)
The Dying Lioness
1873; cast 1875
Bronze, on granite base. Height 5' 9" (base 4')
Philadelphia Zoological Gardens entrance (installed c. 1877)
34th Street and Girard Avenue

Having won a first prize at the Vienna International Exhibition (1873), the model for *The Dying Lioness* caught the attention of Herman J. Schwarzmann, master architect for the Centennial Exposition in Philadelphia, who shared his discovery with the Fairmount Park Art Association. The emperor of Germany had already been promised the first casting of the piece for the Imperial Garden in Berlin, and he granted the Art Association permission to purchase a second casting. Upon arrival in Philadelphia, it was exhibited outdoors at the 1876 Centennial.

The artist was the younger brother of Albert Wolff, sculptor of *The Lion Fighter* (**2-12**) and was known for his powerful and allegorical renderings of animals. The Fairmount Park Art Association's *Annual Report* (1876) praises his depiction of "the maternal instinct, stronger than death . . . ; over the mother and the whelps stands the lion, the prominent figure of the group, who roars defiance, grief and rage."

2-22

A.M.J. Mueller (b. 1847)
Art, Science, Industry, Commerce, Agriculture, Mining, and **Columbia** (on dome)
c. 1876
Painted bronze. Columbia: height c. 20'
Memorial Hall
North Concourse Drive east of Belmont Avenue, West Fairmount Park
See p. 53

2-23

Artist unknown
Columbus Monument
1876
Italian marble. Height 10' (base 12')
Marconi Plaza (relocated 1976)
South Broad Street between Oregon and Bigler Streets

Italian residents of the city raised the funds for a memorial to Christopher Columbus for the 1876 Centennial. On the anniversary of his first landing, October 12, the Italian Societies dedicated this statue of the explorer "in commemoration of the first century of American Independence." Columbus stands with one hand on the globe, an anchor at his feet, as if prepared to begin yet another voyage. The pedestal on which he stands depicts his first sighting of the coast and ultimate landing, along with inscriptions and the coats-of-arms of Italy and the United States.

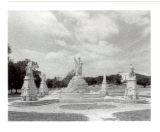

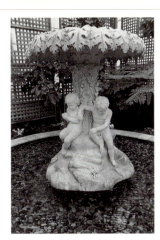

2-24

Herman Kirn (d. after 1911)
Catholic Total Abstinence Union Fountain
c. 1876
Marble. Fountain diameter 40'. Moses: height 15'
North Concourse Drive and States Street, West Fairmount Park

Following the Civil War, an international temperance movement spawned a number of organizations. The Catholic Total Abstinence Union of America, over half of whose members were Pennsylvanians, built a fountain for the nation's Centennial in Philadelphia. The fountain is designed in the shape of a Maltese cross, with nine-foot figures at its exterior points representing three prominent Catholics of the Revolutionary era—Commodore John Barry, Archbishop John Carroll, Senator Charles Carroll—and the contemporary temperance preacher, Father Theobald Mathew. These 16-ton figures loom over drinking fountains, while the central figure, Moses, gestures toward the heavens, the source of all water. All are encircled by a wall with medallions that depict other prominent Catholics who participated in the American Revolution, including George Meade (grandfather of the Civil War general), Lafayette, Thaddeus Kosciuzko, and Chief Orono of the Penobscot Indians.

Kirn came to the United States as a child but returned to his native Germany to study with Carl Steinhauser. After creating this fountain, he moved back to Philadelphia, where he worked as a restorer for the Fairmount Park Commission and later carved *Toleration* (**3–06**).

2-25

Margaret Foley (c. 1827–1877)
Centennial Fountain
1876
Marble, in fountain base. Height 5' 8"
Horticultural Center (interior; relocated 1976)
Horticultural Drive, West Fairmount Park
For access call 685 0107

Under a leafy, umbrellalike basin sit life-size figures of three nude children. While one boy blows a horn, a girl seems to debate whether to try the pool below, and a second boy extends one foot to test the water. This intricately carved marble fountain sculpture, created for the Centennial Exposition, marked the culmination of Margaret Foley's career.

Raised in Vermont, Foley left home to become a "female operative" in the textile mills of Lowell, Massachusetts. She also taught school to support herself while she developed her skill as a sculptor. She eventually realized her dream of going to Italy, where she set up a studio and gained "large and merited celebrity," according to the *Art-Journal* of 1871. But major commissions were hard to come by for a female artist. The *Centennial Fountain*, her major project of the 1870s, was originally intended for a site in Chicago, but after the great Chicago fire of 1871 the commission was withdrawn. Foley then carved the sculpture in marble for display in the horticultural building at the Centennial. Always in poor health, she died in Italy within a year.

In the 1950s, when the original Horticultural Hall was damaged by a hurricane and taken down, the fountain went into storage. In 1976 it was reinstalled in a new Horticultural Center for the nation's Bicentennial.

2-26

Moses Jacob Ezekiel (1844–1917)
Religious Liberty
c. 1876
Marble. Height 12' (base 14' 6")
55 North 5th Street (relocated 1984)

The complex iconography of *Religious Liberty*, whose cap is adorned with 13 gold stars, was described by the artist in the Roman newspaper *Il Diritto*: "[*Religious Liberty*] represents Republican Freedom, in the figure of a woman eight feet high holding in her left hand the laws of equality and humanity, and symbols of victory; in her right, the genius of Faith raising the burning torch of religion. . . . The crown of laurel, the instrument of the American Constitution, the colossal eagle crushing the serpent (the symbol of tyranny) typify the glory and the power of the country of Washington."

Ezekiel was born and raised in Richmond, Virginia. He moved to Berlin in 1869 to study at the Royal Art Academy and in 1873 was awarded the Michel Beer Prix de Rome but deferred the scholarship for a year in order to work on *Religious Liberty*, his first major commission, sponsored by the American chapter of the Jewish charitable organization B'nai B'rith. His concern for perfecting the piece, as well as his insistence on exhibiting it first in Rome, where he had set up studios, prevented *Religious Liberty* from arriving in Philadelphia in time for the Centennial. It was dedicated on Thanksgiving Day, November 30, 1876, in Fairmount Park. The monument was relocated by the B'nai B'rith in 1984 to a site near the National Museum of American Jewish History and the Liberty Bell.

2-27

Artist unknown
St. George and the Dragon
c. 1876
Bronze, on stone and concrete bases. Height 8' (bases 6' 6")
West River Drive at Black Road (relocated 1975)

The legend of St. George, the patron saint of England, relates that he rescued a princess by slaying a dragon. Besides serving as a national symbol, the figure of St. George has often appeared in religious contexts to represent the Christian hero's victory over evil.

On West River Drive St. George and his sharp-toothed foe can be seen in the midst of battle. Already pierced in the chest by a lance, the dragon rakes the frightened horse's belly with its claws as it snarls defiance at the hero. This forceful bronze once topped the headquarters of the Society of the Sons of St. George, a group formed to assist English people in distress in America (see p. 47). But in 1901 the society moved, the building was demolished, and the sculpture's location after that is unknown—until about 1935, when the work was placed in storage in the basement of the Museum of Art. In 1975, rescued from storage, the sculpture was installed at its present site in time for the Bicentennial. Although records indicate that the bronze cast was made in Birmingham, England, the artist's identity remains a mystery.

Nearby stands Frederick Johann Heinrich Drake's statue of *Alexander von Humboldt* (1871), donated by the "German citizens of Philadelphia to commemorate the Centenary of the Republic."

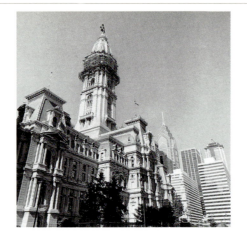

3-01

Alexander Milne Calder (1846–1923), sculptor
John McArthur, Jr. (1823–1890), architect
City Hall
1871–1901; sculpture 1873–1893
Penn Square, Broad and Market Streets

City Hall was conceived as the tallest building in the world. (By the time it was completed, however, it had been surpassed by the Eiffel Tower and the Washington Monument.) Designed in the ornate Second Empire style used for the Louvre, it was built amid a swirl of political controversy. Critics called it "the tower of folly" and "the marble elephant." Nevertheless, in 1957 a committee of the American Institute of Architects declared City Hall "perhaps the greatest single effort of late nineteenth-century American architecture."

Covering four and a half acres of Penn Square, City Hall remains today the tallest masonry-bearing building in the world. The domed tower rises over 547 feet above the ground. Most remarkably, the exterior and interior contain over 250 works of sculpture, principally attributed to one man, Alexander Milne Calder.

In the earliest drawings the building had little or no sculpture; the artistic program seems to have evolved as the work progressed. The external facades of the central pavilions follow the pattern shown in the accompanying table. The archway entrance in the north central pavilion led to the chambers of the Select and Common Councils; hence, many of the sculptures on that facade relate to Philadelphia's government and history. William Penn's face in the keystone recalls the original government; the spandrel figures of a pioneer and an Indian suggest the city's early history; the figures symbolizing Liberty,

Fame, and Victory refer to the achievements of a wise legislature. The east central pavilion, where the entrance served the mayor's office, follows a similar theme. Since the south central entrance led to the law courts, that facade emphasizes law and its associated functions and virtues. On the west central archway, through which prisoners were brought for trial, the sculpture offers a keystone face of Sympathy and reminds the accused of the value of Repentance, Prayer, and Meditation.

The central pavilions also have a geographic theme: the north bears images of Europe; the east, of Asia; the south, of Africa; and the west, of America. Sculptures within the entryways reinforce the various themes of the facades; for instance, the northern entrance continues its celebration of Philadelphia's government and history with interior images of Suffrage, Education, Navigation, Commerce, and Poetry.

On the tower, below the dominating figure of *William Penn* (**3-02**), stand four colossal bronzes, each 24 to 26 feet tall. At the southern corners—facing the area where Swedes had settled before Penn's arrival—are a Swedish man with his son and a Swedish woman with a child in her arms and a lamb at her feet (see p. 63). At the northern corners stand representatives of the region's Native Americans, a man with his dog and a woman with her child. Between these sculptures, facing north, south, east, and west, are four giant bronze eagles.

In the crypt below the tower, the column capitals are carved with figures representing the races of humankind, and animal heads on the walls symbolize the continents. Elsewhere in the building are sculptures representing the seasons, the elements, virtues and vices, heroes, arts and sciences, trades and industries. As the city's Historical Commission declared in 1981, City Hall is "as much a work of art as an architectural and engineering wonder."

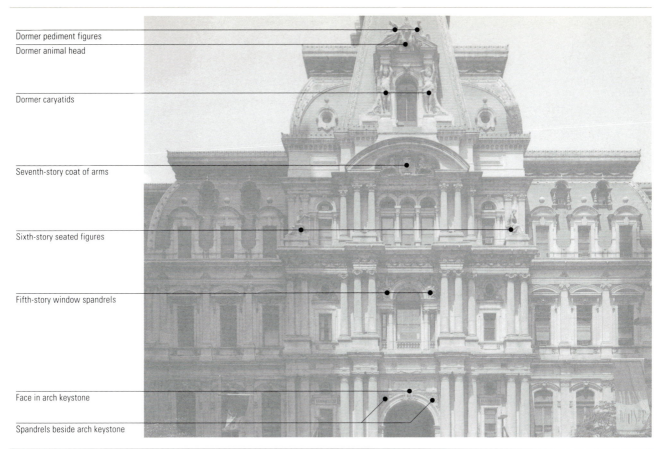

Dormer pediment figures

Dormer animal head

Dormer caryatids

Seventh-story coat of arms

Sixth-story seated figures

Fifth-story window spandrels

Face in arch keystone

Spandrels beside arch keystone

City Hall's Central Pavilions:
Symbolism of the External Sculpture

	North central pavilion	East central pavilion	South central pavilion	West central pavilion
Allegorical theme	Philadelphia government and history	Philadelphia history and attributes	Justice	Rehabilitation of lawbreakers
Continental theme	Europe	Asia	Africa	America
Main elements top to bottom				
Dormer pediment figures	Europeans	Asians	Africans	Americans
Dormer animal head	Horse (Europe)	Elephant (Asia)	Camel (Africa)	Buffalo (America)
Dormer caryatids	Vikings	Asians	Africans	Native Americans
Seventh-story coat of arms	Philadelphia	Philadelphia	Pennsylvania	Philadelphia
Sixth-story seated figures				
Left	Fame	Industry	Law	Prayer
Right	Victory	Peace	Liberty	Meditation
Fifth-story window spandrels				
Left	Liberty	Science	Executive power	Admonition
Right	History	Art	Judicial power	Repentance
Face in arch keystone	William Penn	Benjamin Franklin	Moses (Lawgiver)	Sympathy
Spandrels beside arch keystone				
Left	Pioneer	Engineering	●	Hope
Right	Native American	Mining	●	Justice and Mercy

● The images in the south central archway spandrels seem to pertain to agriculture or harvest, but their symbolic significance is unclear.

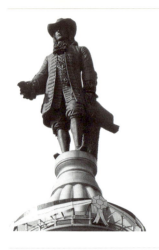

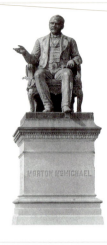

3-02

Alexander Milne Calder (1846–1923)
William Penn
1886; cast 1892
Bronze. Height 36' 4"
City Hall Tower (installed 1894)
Penn Square, Broad and Market Streets

Although William Penn must have known he would loom large in the region's history, it is doubtful that he imagined himself more than 36 feet tall and weighing over 53,000 pounds— the proportions of Alexander Milne Calder's colossal statue on top of City Hall tower. Calder's Penn holds in his left hand a copy of the Charter of Pennsylvania; with his right, he seems to gesture in friendship in the direction of Penn Treaty Park, the site of his legendary treaty with the Lenni Lenape Indians.

In John McArthur, Jr.'s early plans for City Hall, the tower was capped by a symbolic figure of Justice, but by 1872 the sketches showed Penn in that position. It was not until 1886, however, that Calder began work on the statue. He progressed from a three-foot clay model to a full-size version. At each stage John Cassani and other Calder assistants translated the clay model into plaster. In 1890 the casting process began, and Calder's Penn became the tallest and heaviest statue ever to be cast in bronze.

"What we want," Calder said, "is William Penn as he is known to Philadelphians; not a theoretical one or a fine English gentleman." But one academician immediately put a dent in the work's realism by noting that the seal on the charter belonged not to King Charles II (the monarch who had granted it) but to Queen Victoria. After the last piece of the sculpture was set in place on November 28, 1894, a more important controversy erupted. Calder protested that

the statue faced the wrong way. He had intended it to face south, and he claimed that architect William Bleddyn Powell, McArthur's successor, had turned it northeast out of spite. In fact, early drawings showed the statue facing northeast, toward Penn Treaty Park, a historically appropriate position reinforced by Calder's Indian figures on the northern side of the tower.

Over the years *Penn* became a symbol of Philadelphia, and it remained the dominant point in center city's skyline because of a "gentlemen's agreement" that no skyscraper would be built higher than the brim of Penn's hat. Thus, a single work of art exerted a profound influence on the city's architectural development. In 1986 the gentlemen's agreement was finally broken, but "Billy Penn" continues to command the long vistas of Broad Street and the Parkway.

3-03

Daniel Chester French (1850–1931)
Law, Prosperity, and Power
c. 1880
Marble. Height 16' (base 2' 6")
South George's Hill Drive north of Mann Music Center, West Fairmount Park (relocated 1938)

Daniel Chester French was born in Exeter, New Hampshire, a member of an established New England family. When he was 23 years old, he created a highly praised *Minute Man* for Concord, Massachusetts. After completing his studies in Europe, French received a number of federal commissions.

Law, Prosperity, and Power was originally carved for the Post Office Building at 9th and Chestnut Streets. When the building was destroyed in 1937, the work was given to the city and relocated to Fairmount Park. French is best known in Philadelphia for his statue of *General Ulysses S. Grant* (**3-18**), a later work in the artist's mature style.

3-04

John H. Mahoney (1855–1919)
Morton McMichael
c. 1881
Bronze, on granite base. Height 6' 7" (base 6' 10")
Lemon Hill Drive, East Fairmount Park

Morton McMichael served as mayor of Philadelphia from 1866 to 1869 and led an active political life until his death in 1879. He was born in Bordentown, New Jersey, and studied law while working as a journalist and editor on such magazines as the *Saturday Evening Post*. He was elected president of the Fairmount Park Commission when it was formed (1867) and retained that office until his death. Funds for this commemorative statue were collected through public subscription. John Mahoney, a former tombstone carver from Indiana, was awarded the commission—his first.

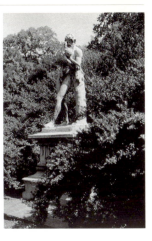

3-05

John Lachmier (dates unknown), sculptor
James H. Windrim (1840–1919), architect
**Civil War Soldiers' and
Sailors' Monument**
1883
*Granite and bronze. Height: figure 9′6″;
total 35′*
Market Square
*Germantown Avenue between Church
and School House Lanes*

In community after community,
citizens banded together to com-
memorate the Civil War with
sculptural monuments. In the
Germantown area, Ellis Post
Number 6 of the Grand Army of
the Republic joined with a local
citizens' committee to sponsor a
monument of considerable gran-
deur. Atop the column stands
John Lachmier's figure of a mus-
tachioed soldier, rifle in hand.
The imposing structure below,
with its wreath, pyramids of
carved cannon balls, and bronze
plaques, was designed by Phila-
delphia architect James Windrim
and built by local contractor
Thomas Delahunty, who had
already completed war monu-
ments for towns from Florida to
Iowa. Around the base lie can-
nons, mortars, and other military
relics. The site itself is signifi-
cant, for it marked the center of
the British line at the Battle of
Germantown in 1777.

In 1900 the memorial was
enhanced with ornamental stone
posts and bronze Roll of Honor
plaques, the work of John
Massey Rhind (see **3-19, 3-23,
3-24,** and **4-12**). Two more
plaques, added after the Ellis
Post transferred ownership to the
city in 1914, contain additional
names of Civil War veterans and
death dates as late as 1934.

3-06

Herman Kirn (d. after 1911)
Toleration (or **William Penn**)
1883
Marble. Height 9′8″ (base 4′3″)
*East Bank of Wissahickon Creek below
Walnut Lane Bridge*
Fairmount Park

Herman Kirn executed the *Cath-
olic Total Abstinence Union Foun-
tain* (**2-24**) for the Centennial
and this rendering of William
Penn for the Park. The work's
title no doubt reflects the Quaker
beliefs that Penn espoused. The
figure looms over the Wissa-
hickon Valley, where Lenni
Lenape Indians formerly wan-
dered.

Directions by car: Park on
Hortter Street where it meets
Parkline Drive in Mount Airy.
Walk left on wooded path off
Parkline Drive, down a hill (five
minutes). Statue is on the right,
across and overlooking Wissa-
hickon Creek.

3-07

John Rogers (1829–1904)
**Major General John Fulton
Reynolds**
1884
*Bronze, on granite base. Height 12′
(base 10′)*
City Hall, North Plaza
Penn Square, Broad and Market Streets

Major General John Fulton
Reynolds was killed by a sharp-
shooter's bullet at Gettysburg in
1863. Over 18 years after his
death, Joseph Temple of Philadel-
phia offered $25,000 toward a
sculpture to commemorate the
fallen Pennsylvanian and the
state's participation in the Civil
War. The artist selected, John
Rogers, was well known for his
parlor sculptures, popularly
known as "conversation group-
ings." He had never attempted a
sculpture of this scale before,
but, after some hesitation, began
to study the anatomy of horses
and to collect information about
the general. His intention was to
"represent General Reynolds in
front of the battlefield as he was
on the first day of Gettysburg.
The horse is startled and shying
away from the noise and danger
in the direction he is looking,
while the General is pointing to
the same spot and giving direc-
tion to his aides at his side."

3-08

Attributed to Praxiteles
**Silenus and the Infant
Bacchus**
4th century B.C.; cast 1885
Bronze. Height 6′1″ (base 4′3″)
*Kelly Drive north of Fairmount Avenue
(installed 1885)*

Silenus and the Infant Bacchus is
attributed to Praxiteles, whose
fondness for satyrs is evident in
this rendering of Silenus. Often
depicted as elderly, obese, and
intoxicated, here the chief of the
satyrs is young, lithe, and hand-
some. He holds in his arms his
foster son, Bacchus, who is des-
tined to become the god of wine.
Taken from the original in the
Louvre and cast by the Barbe-
dienne Foundry in Paris, the
work was purchased by the Fair-
mount Park Art Association.

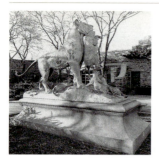

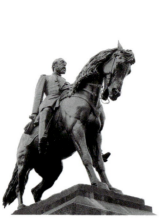

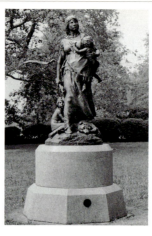

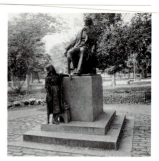

3-09

Auguste Cain (1822–1894)
Lioness Carrying to Her Young a Wild Boar
1886
Bronze, granite base with plantings. Height 7' 6" (base 3')
Philadelphia Zoological Gardens, Rare Mammal House entrance (relocated 1950)
34th Street and Girard Avenue
For access and admission fee call 243 1100

Auguste Cain was born in Paris, and his work followed in the tradition of Antoine Louis Barye (see **1-11**). The *Lioness* was exhibited in the French Salon of 1886 before its acquisition by the Fairmount Park Art Association. Before its installation at the Philadelphia Zoo, the *Lioness* had been moved twice. It was relocated to the foot of Lemon Hill from its original site on the river drive because, a contemporary newspaper said, its "realistic pose . . . terrified many horses, that in other respects were fearless."

3-10

Alexander Milne Calder (1846–1923)
Major General George Gordon Meade
1887
Bronze, on granite base. Height 11' 6" (base 12')
Lansdowne Drive north of Memorial Hall, West Fairmount Park

Major General George Gordon Meade commanded the Pennsylvania Reserves at the Battle of Gettysburg. He briefly served as military governor for the Georgia district during Reconstruction, and then returned to Philadelphia to serve as a commissioner of Fairmount Park. Meade was directly responsible for the layout of the park and designed many of its drives, walks, and bridle paths.

Following Meade's death, the Fairmount Park Art Association initiated its first major project—a campaign to finance an appropriate memorial. Jay Cooke's September panic of 1873, along with competition for funds and attention from the Centennial celebration, slowed the fund-raising process. Finally, spearheaded by Mary McHenry, the Meade Memorial Women's Auxiliary Committee raised the balance, and a competition to select an artist was initiated.

In 1881 Alexander Milne Calder won the competition. Calder, who had been studying under Thomas Eakins at the Pennsylvania Academy of the Fine Arts, based his rendering of Meade on his own memory, photographs, and the recollections of family members and friends. Over thirty thousand people watched Meade's grandsons unveil the statue on October 18, 1887.

3-11

John J. Boyle (1851–1917)
Stone Age in America
1887
Bronze, on granite base. Height 7' 6" (base 4' 2")
Near Samuel Memorial (relocated 1985)
Kelly Drive north of Boat House Row

The descendant of generations of Irish stonecutters, John J. Boyle apprenticed to that trade but took classes in drawing at the Franklin Institute. At the Pennsylvania Academy of the Fine Arts, he studied with Eakins and Bailly. He left Philadelphia in 1877 to study at the Ecole des Beaux-Arts and returned three years later to open his own studio.

That year he received his first major commission—a Chicago patron's request for a group of Indian figures. *An Indian Family*, exhibited in his studio before being shipped to Chicago, came to the attention of the Fairmount Park Art Association, which resolved to give Boyle a commission for an Indian grouping for the park. Anthony Drexel noted in the Art Association's 16th annual report, "The group has awakened deep interest in those who care to perpetuate in bronze, types of American Indians. In the near future, there will be few living representatives of that once powerful race. We may now preserve in enduring form characteristic pictures of their life and lineaments which will enhance in value and rarity as time advances."

Relocated from the Sweetbriar Mansion area to a grassy plot south of the Samuel Memorial (**4-32, 4-47**), *Stone Age* takes its place among other sculpture "emblematic" of American history.

3-12

Frank Edwin Elwell (1858–1922)
Dickens and Little Nell
1890
Bronze. Height: Little Nell 5' 4"; Dickens 6' 8½" (base 6' 8½")
Clark Park (installed 1901)
43rd Street and Chester Avenue

Originally commissioned by the Washington newspaper publisher Stilson Hutchins, *Dickens and Little Nell* pays tribute to the ever-popular but tragic heroine of *The Old Curiosity Shop*. When the publisher was unable to pay for the completion of the work, Frank Edwin Elwell returned the money and took the work to England in the hope of finding a buyer. Instead, he discovered that Dickens' will prohibited any "monument, memorial or testimonial, whatever. I rest my claims to remembrance on my published works and to the remembrance of my friends upon their experiences of me." Elwell returned to America to exhibit the work at the World's Columbian Exposition of 1893, where it was awarded two gold medals. After four years of negotiations, the Fairmount Park Art Association purchased the sculpture in 1900 and installed it in Clark Park in 1901. After vandals damaged the sculpture in 1989, the Friends of Clark Park raised funds for its repair (see *Preserve and Protect*, p. 191).

A prolific portrait sculptor, Elwell was raised in Concord, Massachusetts. Like Daniel Chester French (see **3-03, 3-18, 3-19**), he studied with Abigail May Alcott, the sister of Louisa May Alcott.

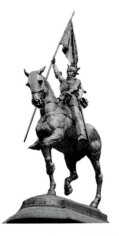

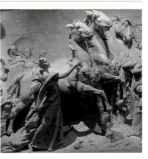

3-13

Emmanuel Frémiet (1824–1910)
Joan of Arc
1890
Gilded bronze, on granite base. Height 15' (base 8' 4")
Kelly Drive at 25th Street (relocated 1960)

The French government commissioned Emmanuel Frémiet to design a monument to Joan of Arc for the Place des Pyramides in Paris. Frémiet had earned a reputation as an animalier in the tradition of Antoine Louis Barye (see **1-11**). For the memorial to the French heroine, he studied 15th-century French armor and dress in order to convey the figure within her historical context.

In 1889 members of the French community in Philadelphia, with the aid of the Fairmount Park Art Association, commemorated their centennial by purchasing a statue of Joan from Frémiet. The contract with the sculptor stipulated that there would be only three editions of the work: the one in Paris, one in Philadelphia, and one in Nancy. A site was selected on the eastern approach to the Girard Avenue Bridge, and on November 15, 1890, the work was unveiled with extensive fanfare (see p. 68). In 1960 the Art Association gilded Philadelphia's cast and placed it near the Philadelphia Museum of Art.

3-14

Augustus Saint-Gaudens (1848–1907)
Diana
1892
Copper sheeting. Height 15' 4½" (base diameter 1' 6")
Philadelphia Museum of Art, Grand Stair Hall (interior; relocated 1932)
Benjamin Franklin Parkway
For access and admission fee call 763 8100
See p. 179

3-15

Henry Jackson Ellicott (1847–1901)
General George McClellan
c. 1894
Bronze, on granite base. Height 14' 6" (base 10')
City Hall, North Plaza (relocated 1936)
Penn Square, Broad and Market Streets

George McClellan was born in Philadelphia in 1826. He left the University of Pennsylvania in 1842 to continue his education at West Point Academy. Though trained as an engineer, he was best known for his military activities during the Civil War. He had a reputation as a brilliant but sometimes overly cautious general, one who inspired loyalty and confidence in his men.

The memorial to the general was commissioned by the Grand Army of the Republic and given to the city of Philadelphia. The artist, Henry Jackson Ellicott, completed equestrian statues and memorials for cities throughout the country.

3-16

Augustus Saint-Gaudens (1848–1907)
James A. Garfield Monument
1895
Bronze, on granite pedestal. Height 19' 6"
Kelly Drive south of Girard Avenue Bridge; across from Samuel Memorial

Following the assassination of James A. Garfield, the 20th president of the United States, the Fairmount Park Art Association established a fund to create a fitting memorial. The second monument to be commissioned by the Association, it proved a challenge. Garfield had not been a colorful president during his short term, nor outstanding as a soldier, congressman, or teacher.

Augustus Saint-Gaudens was selected for the commission in 1889. The artist came to America with his family from Dublin in 1848. He apprenticed to a stone cameo cutter at 13 and took evening classes in art and drawing. In 1867 he entered the Ecole des Beaux-Arts in Paris and supported himself by continuing to cut cameos. He spent three years in Rome before returning to New York, where he established a studio.

Early sketches indicate that the Art Association's committee wanted a standing figure on a pedestal, but Saint-Gaudens preferred to bring the scale of the work down to the viewer and to its "natural environment." Working with his long-time associate, the architect Stanford White, the artist selected the site on East River Drive. The unveiling was accompanied by parades, a flotilla, and naval and military ceremonies (see p. 69).

3-17

Karl Bitter (1867–1915)
Progress of Transportation
1895
Cast plaster. Height 12'; length 30'
30th Street Station (interior; relocated 1933)
30th and Market Streets

The architect Frank Furness hired Karl Bitter to design five reliefs for the exterior of the Pennsylvania Railroad's Broad Street Station. When the station was demolished in 1952, only this panel, which had been moved 20 years before to 30th Street Station, was saved.

The mural depicts the "Spirit of Transportation," embodied by a figure of a woman seated in a horse-drawn carriage and surrounded by allegorical figures. To her right, historical modes of transportation are represented by a wagon drawn by oxen; to her left is the future in the form of a steam locomotive, a steamboat, and an airship (though the Wright brothers would not fly at Kitty Hawk for another eight years).

Bitter was born in Vienna, where he had studied stone carving and then sculpture at the Academy of Fine Arts until called to military service. After serving one of the three mandatory years, he came to America in 1889, attracted, like many European artists, by the demand for decorative and ornamental work for buildings and monuments.

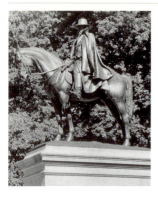

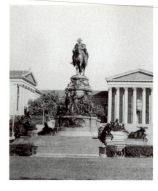

3-18

Daniel Chester French (1850–1931)
Edward C. Potter (1857–1923)

General Ulysses S. Grant
1897
Bronze, on granite base. Height 14′6″
(base 16′4″)
Kelly and Fountain Green Drives

Four days after the death of General Grant in 1885, the Fairmount Park Art Association formed a committee to create a fund for erecting an appropriate memorial. By January of the following year, almost $13,000 had been collected. Seven artists were invited to prepare sketch models. Daniel Chester French, who was awarded the commission, requested that a former student, Edward C. Potter, work with him. Potter had previously collaborated with French and was particularly interested in the modeling of horses.

French depicted Grant "surveying a battlefield from an eminence and . . . intent upon the observation of the forces before him. The horse is . . . obedient to the will of his rider. We endeavored in the figure of Grant to give something of the latent force of the man, manifesting itself through perfect passivity."

The model was completed in 1893 and then enlarged to one and a half times life size in Potter's studio in Enfield, Massachusetts. Casting at the Bureau Brothers Foundry began in 1896. The sculpture was dedicated on April 27, 1899, the 77th anniversary of Grant's birth.

3-19

Smith Memorial Arch
1897–1912
Bronze and limestone
North Concourse Drive, West Fairmount Park

Equestrians:
• *Major General Winfield Scott Hancock*—John Quincy Adams Ward (1830–1910)
• *Major General George B. McClellan*—Edward C. Potter (1857–1923)

Figures:
• *Major General George Gordon Meade*—Daniel Chester French (1850–1931)
• *Major General John Fulton Reynolds*—Charles Grafly (1862–1929)
• *Richard Smith*—Herbert Adams (1858–1945)

Busts:
• *Admiral David Dixon Porter*—Charles Grafly (1862–1929)
• *Major General John Hartranft*—Alexander Stirling Calder (1870–1945)
• *Admiral John A. B. Dahlgreen*—George E. Bissell (1839–1920)
• *James H. Windrim, Esquire*—Samuel Murray (1870–1941)
• *Major General S. W. Crawford*—Bessie O. Potter (Vonnoh) (1872–1955)
• *Governor Andrew Gregg Curtin*—Moses Jacob Ezekiel (1844–1917)
• *General James A. Beaver*—Katherine M. Cohen (1859–1924)
• *John B. Gest, Esquire*—Charles Grafly (1862–1929)
• *Two Eagles* and *Globes*—John Massey Rhind (1860–1936)

Richard Smith, a Philadelphian who had made his fortune as a founder of electroplate and type, bequeathed a half million dollars to build a monument to

Pennsylvania's naval and military heroes of the Civil War. He left the design and construction to the architect James H. Windrim and the selection and supervision of sculptors to the Fairmount Park Art Association. In 1897 a call to artists attracted 59 entries, and 13 artists, among the most distinguished sculptors of the time, were selected. Two were women, and four were Philadelphians. Only two had not been trained in the French school: Moses Jacob Ezekiel (see **2-26, 3-28**) had studied in Berlin, and Samuel Murray (see **3-34**) had been a student of Thomas Eakins.

The 15-year project ran into a number of unforeseen problems. The Art Association offered each artist $1,800 for modeling the portrait busts—an average of the estimates submitted by the sculptors—which proved acceptable to all finalists except John J. Boyle. Boyle declined the commission, and Charles Grafly accepted it in his stead. More sculptors were lost along the way. When William Ordway Partridge's figure of Major General Reynolds was repeatedly rejected by the committee, he resigned. This commission too passed to Grafly, giving him three works on the colossal monument. The equestrian statues of Hancock and McClellan further delayed the completion of the memorial. John Quincy Adams Ward was in poor health, and Paul Wayland Bartlett was overcommitted. Disappointment with Bartlett's work caused the Art Association to engage Edward Potter (see **3-18**) in 1909.

The *Smith Memorial Arch* was finally completed in 1912 without fanfare, no doubt because enthusiasm had waned over the years. One of the most ambitious monuments of its period, it remains today as a gateway to West Fairmount Park.

3-20

Rudolf Siemering (1835–1905)

Washington Monument
1897
Bronze and granite. Height 44′
Benjamin Franklin Parkway at Eakins Oval
(relocated 1928)

The State Society of the Cincinnati of Pennsylvania was founded at the City Tavern in Philadelphia on October 4, 1783, to commemorate those who had fought together during the War of Independence and assist members or their families. On Independence Day in 1810, the Pennsylvania Society resolved "to establish a permanent memorial of their respect for the memory of the late father of his country, General George Washington."

Funds for the monument accumulated slowly, but in 1881 a final contract was signed with Professor Rudolf Siemering of Berlin. Siemering was born in Königsberg in 1835 and studied there before moving to Berlin in 1858. Siemering quickly gained an international reputation for his monumental sculpture, and was working on the Leipzig War Monument when the Society of the Cincinnati contacted him.

For this commission, Siemering was particularly concerned that the figures be accurate in features and dress. He modeled Washington's face from a copy of a mask made during the late general's life and asked for photographs and prints: "I desire to make the monument a typical American one, and request you to take photographs, and to select, if possible, for each figure a person to serve as type. . . . The photographs must not be retouched but show nature with all 'incidentals.'" Siemering used his distinctive baroque style to depict Washington within the context of the general's country and his times. The monument is "constructed" in three zones or

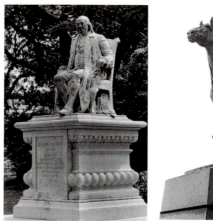

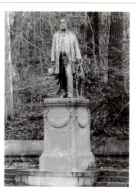

levels, each representing a different concept: Washington (the hero) sits at the top; allegorical figures depicting his time are on the middle level; and on the lowest level are the flora and fauna of his country with representative human figures.

Following extended negotiation concerning the site and the artist's expressed interest in having the sculpture gilded (the suggestion was ultimately rejected), the monument was unveiled on May 5, 1897, at the Green Street entrance to Fairmount Park. The event was celebrated nationally, and William McKinley presided over the dedication ceremony. When the Benjamin Franklin Parkway was completed in 1928, the monument was moved to its terminus in front of the Philadelphia Museum of Art.

3-21

John J. Boyle (1851–1917)
Benjamin Franklin
1899
Bronze, on granite base. Height 6′9″
(base 11′)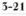
University of Pennsylvania
Blanche Levy Park (relocated 1939)
Between 34th and 36th Streets, Locust and Spruce Streets

When commissioned by Justus C. Strawbridge to create a statue of Franklin, John J. Boyle was one of the most prominent sculptors in Philadelphia. Boyle based his rendering of Franklin on extensive research. The portrait was based upon a bust by Jean Antoine Houdon, though Boyle's Franklin is a younger man. The fur-trimmed cape (surtout) was a popular garment of Franklin's time.

The statue was given to the city of Philadelphia by Strawbridge and installed in front of the Post Office at 9th and Chestnut Streets. In 1938 the city donated it to one of the many institutions that Franklin had helped to found: the University of Pennsylvania.

3-22

Cyrus E. Dallin (1861–1944)
The Medicine Man
1899
Bronze, on granite base. Height 8′
(base 8′6″)
Dauphin Street west of 33rd Street, East Fairmount Park

While the young Cyrus Dallin was working in one of his father's mines in Utah, some of the miners discovered a bed of soft white clay, from which he modeled two life-size heads. His work attracted attention and financial support. While living in Paris, Dallin encountered Buffalo Bill's Wild West Show and began to produce works that glorified the American Indian. *The Medicine Man*, one of four Indian sculptures that he executed, was purchased by the Fairmount Park Art Association. At the dedication ceremony in 1903, Francis LaFlesche, a distinguished Native American scholar, spoke about the representation of the holy man: "In many of the religious rites the priest appeared in such a manner. The nudity . . . typifies the utter helplessness of man, when his strength is contrasted with the power of the Great Spirit, whose power is symbolized by the horns upon the head of the priest."

3-23

John Massey Rhind (1860–1936)
Henry Howard Houston
1900
Bronze, on granite base. Height 9′6″
(base 7′2½″)
Lincoln Drive and Harvey Street

Henry Houston (1820–1895) acquired his fortune while organizing the freight operation for the Pennsylvania Railroad. He purchased large tracts of land on the outskirts of the city and developed some small communities, including Chestnut Hill. Houston bequeathed a large section of his property, the Wissahickon Heights, to the Fairmount Park Commission. To commemorate the gift, the commissioners asked John Massey Rhind to design a fitting statue.

The son of a prominent Scottish sculptor, Rhind executed architectural and monumental sculpture in Philadelphia (see **3-19, 3-24,** and **4-12**) and throughout the world in the realistic style popular at the time.

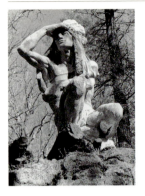
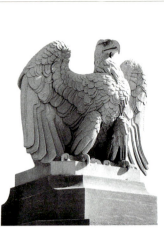
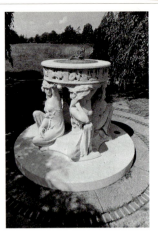

3-24

John Massey Rhind (1860–1936)
Tedyuscung
c. 1902
Limestone, on rock base. Height 12'
Forbidden Drive near Rex Avenue Bridge
Wissahickon Valley, Fairmount Park

The Lenni Lenape chief Tedyus-
cung (c. 1700–1763) represented
his people during meetings with
colonial authorities. When a
wooden statue of Tedyuscung
originally sited in the Wissa-
hickon Valley began to decay, it
was removed to the Germantown
Historical Society, and Mr. and
Mrs. Charles W. Henry commis-
sioned John Massey Rhind to
create a replacement. The
Lenape leader sits on top of
Indian Rock, thought to be the
meeting place of the Delaware
Council, of which his tribe was a
part.

Directions by car: Take Ger-
mantown Avenue northwest and
turn left onto Willow Grove,
right onto Seminole, then left
onto Rex Avenue in Chestnut
Hill. Park on Rex Avenue, which
narrows to a walking path. Walk
downhill on blacktop path to a
foot bridge. Turn right onto a
wooded path, going up a steep
hill (five minutes). Stay to the
left of the path. The statue over-
looks the Wissahickon.

3-25

Adolph Alexander Weinman (1870–1952)
Eagles
1903
Granite. Height 5'; width 6' each
*Market Street Bridge at the Schuylkill
River (installed 1967)*

Adolph Alexander Weinman was
born in Carlsruhe, Germany, in
1870. When he was 10 years old,
his widowed mother brought him
to New York, where he later
apprenticed with a carver of
wood and ivory. In the evenings,
he studied at Cooper Union and
frequented the Art Students
League. Weinman was interested
in medallic as well as sculptural
art and is known for designing
the 1916 dime and half-dollar.

The architectural firm of
McKim, Mead, and White hired
Weinman to design ornamental
figures for the Pennsylvania Sta-
tion Building in New York City
(1903). Using Milford pink
granite from Massachusetts, he
also carved 14 eagles for the
roof, each weighing 5,500
pounds, and 8 smaller eagles of
Knoxville marble. When the sta-
tion was demolished in 1963,
four of the large eagles were
given to the Fairmount Park Art
Association. They were installed
four years later on the Market
Street Bridge.

3-26

Alexander Stirling Calder (1870–1945)
Sundial
1903
Marble. Height 4' 1" (base 6")
*Sunken Garden, Horticultural Center
grounds*
*North Horticultural Drive, West Fairmount
Park*

Alexander Stirling Calder
designed this sundial in his dis-
tinctively decorative style in
1903, soon after completing his
studies at the Ecole des Beaux-
Arts. The adaptation of natural
forms suggests the influence of
the Art Nouveau movement. As
described in the *Public Ledger* on
January 29, 1905, "The dial is
supported by four figures of
young women grouped around
its edge, who represent the four
seasons. Each figure holds an
apple bough aloft. By this is sug-
gested the opulence of the year,
which each season foresees in
turning her head expectantly
toward the season before her,
whose place she is eventually to
usurp." A foreboding inscription
on the base continues the refer-
ence to the passage of time:
"Watch therefore for ye know
not what hour your hour doth
come."

3-27

August Gaul (1869–1921)
Eagle
1904
*Bronze. Height 6' 2"; length 9' 10";
width 3' 3"*
*John Wanamaker's Department Store
(interior)*
13th and Chestnut Streets
For access call 422 2000
See p. 24

3-28

Moses Jacob Ezekiel (1844–1917)
Anthony J. Drexel
1904
*Bronze, on marble base. Height 8' 4"
(base 9' 8")*
Drexel University (relocated 1966)
*Market Street between 32nd and 33rd
Streets*

John Henry Harjes, a former
business partner, commissioned
Sir Moses Jacob Ezekiel to exe-
cute a memorial to the Philadel-
phia philanthropist Anthony
Drexel. Ezekiel had created mon-
umental and commemorative
sculptures for patrons worldwide
and was knighted by three mon-
archs. He was the first American
to receive the Prix de Rome and
later established a studio in the
historic Baths of Diocletian. His
first commission, *Religious Lib-
erty* (**2-26**), was shown at the
1876 Centennial.

The sculpture of Drexel, cast
in Germany, was unveiled on
June 17, 1905, at Belmont and
Lansdowne Avenues (see p. 70).
In 1966 it was moved to the
Drexel University campus and
installed near the library.

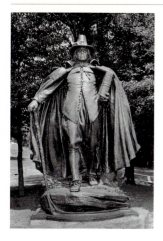

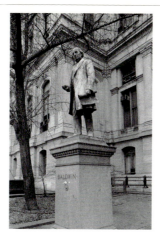

3-29

Augustus Saint-Gaudens (1848–1907)
The Pilgrim
1904
Bronze, on fieldstone base. Height 9' 1"
(base 1' 7")
Kelly Drive at Lemon Hill Drive (relocated 1920)

Augustus Saint-Gaudens was one of the most influential and successful artists of the late 19th century (see **3-16**). *The Puritan*, the first version of *The Pilgrim*, was commissioned by Chester W. Chapin as a monument to Deacon Samuel Chapin (1595–1675). The New England Society of Pennsylvanians asked Saint-Gaudens to make a replica for Philadelphia. For the later commission, Saint-Gaudens made some changes in the figure's dress and face: "For the head in the original statue, I used as a model the head of Mr. Chapin himself, assuming that there would be some family resemblance with the Deacon, who was his direct ancestor. But Mr. Chapin's face is round and Gaelic in character, so in the Philadelphia work, I changed the features completely, giving them the long, New England type, besides altering the folds of the cloak in many respects, the legs, the left hand, and the Bible." *The Pilgrim* originally stood on the South Plaza of City Hall.

3-30

Henry Chapman Mercer (1856–1930)
Title Unknown (Foyer Arch)
c. 1904
Terra cotta tile
Entrance to Barnes and Noble Book Store (ceiling)
1424–1426 Chestnut Street

Southeastern Pennsylvania was home to many artisans and craftspeople at the beginning of the 20th century. One such artisan, Henry Chapman Mercer, changed his professional direction after receiving a degree in law from the University of Pennsylvania. Mercer was intrigued by archeological studies of early cultures. When illness forced him to resign his position as curator of the University Museum, he began to collect hand-crafted tools native to the Bucks County area. He planned at first to revive the art of the Pennsylvania German potters, but the clay in his region proved too porous. He founded instead a tile works, basing his designs on motifs taken from Pennsylvania German stove plates. As the business grew, Mercer adapted designs from other cultural sources and produced tile for clients throughout the country (see p. 72). This foyer arch was originally commissioned by Alan H. Reed of the Jacob Reed's Sons Store, and the tiles express themes related to the garment industry: pattern making, spinning, shearing sheep, Indian weaving, and tailoring.

3-31

Herbert Adams (1858–1945)
Matthias William Baldwin
1905
Bronze, on granite base. Height 8'
(base 10' 8")
City Hall, North Plaza (relocated 1936)
Penn Square, Broad and Market Streets

Matthias Baldwin, businessman, inventor, and philanthropist, was born in Elizabethtown, New Jersey, in 1795. He was apprenticed to the Woolworth Brothers of Philadelphia—manufacturers of jewelry—and later established his own manufacturing business. As early as April 25, 1831, Baldwin exhibited a model locomotive with two cars at the Peale Museum. In 1832 he established the Baldwin Locomotive Works and sold more than 1,500 "improved" steam locomotives until his death in 1866.

This commemorative statue of Baldwin was a gift of Burnham Williams and Company, proprietors of the Baldwin Locomotive Works, to the city of Philadelphia through the Fairmount Park Art Association. It was originally placed at Broad and Spring Garden Streets, on a grassy plot overlooking the locomotive factory. The artist, Herbert Adams, was born in Vermont, studied in Paris for five years, and taught at the Pratt Institute in Brooklyn.

3-32

John LaFarge (1835–1910)
Art, Education, and Music:
Apelles (or **Painting**)
Sabia Muni Sitting Under the Bo Tree (or **Wisdom**)
Pan and Nymph (or **Music**)
c. 1907
Three cloisonné (fused) stained glass panels. Height 5' 5"; width 2'
Samuel S. Fleisher Art Memorial (interior; installed 1955)
709–721 Catharine Street
For access call 922 3456
See p. 73

3-33

John J. Boyle (1851–1917)
John Christian Bullitt
1907
Bronze, on granite base. Height 9' 10"
(base 5' 1")
City Hall, North Plaza (relocated 1936)
Penn Square, Broad and Market Streets

John Christian Bullitt, born in Kentucky in 1824, came to Philadelphia in 1849 and quickly established a successful legal practice. He entered into the politics of the city, identifying with the Whig party until its dissolution in 1852, and later with the Democratic party. Bullitt constructed the first modern office building in the city on 4th Street north of Walnut and was one of the founders of the Fourth Street National Bank. A delegate to the state Constitutional Convention in 1873, Bullitt drafted the City Charter of 1885, the "Bullitt Bill," intended to increase the mayor's authority within the city government. Following his death in 1902, the citizens of Philadelphia commissioned John J. Boyle (see **3-11** and **3-21**) to design a memorial.

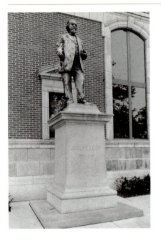

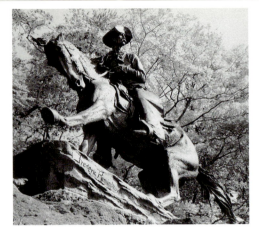

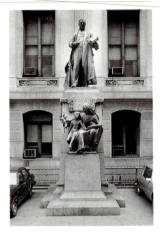

3-34

Samuel Murray (1870–1941)
Joseph Leidy
1907
Bronze, on granite base. Height 8' 6"
(base 10')
Academy of Natural Sciences (relocated 1929)
19th Street and Benjamin Franklin Parkway

Joseph Leidy was born in Philadelphia in 1823 and later studied medicine and anatomy at the University of Pennsylvania, where, in 1853, he was elected professor of anatomy. Recognized as the foremost American anatomist of his time, Leidy served as president of the Wagner Free Institute of Science and of the Academy of Natural Sciences. Following his death in 1891, a group of "public spirited citizens" resolved to erect a statue to his memory. Samuel Murray, at work on *Commodore John Barry* for a Philadelphia site, was awarded the commission. He represented Leidy "in a sack coat because Dr. Leidy scorned the dictates of fashion and was always carelessly attired."

The sculpture was unveiled on the west plaza of City Hall in 1907. When the plaza was cleared for the construction of the Broad Street subway, *Leidy* was moved to the Benjamin Franklin Parkway.

3-35

Frederic Remington (1861–1909)
Cowboy
1908
Bronze, on natural stone base. Height 12'
Kelly Drive north of Girard Avenue Bridge, Fairmount Park

Frederic Remington went west to Montana in 1880 to become a cowboy. Having grown up in Ogdensburg, New York, and briefly attended the Yale School of Art—where he earned a reputation as a football player—Remington found his inspiration in the West, in the interaction of the cowboy and his horse. In 1886 he returned to New York and produced illustrations of the western frontier for numerous publications. He continued his studies at the Art Students League and began to work in oils and modeling clay. An 1893 newspaper account describes Remington's precise rendering of his subjects in the midst of action: "He had a positive genius for fact. His eye caught with the celerity and certainty of the shutter all the lens of the camera saw and much more besides."

In March 1905 the president of the Fairmount Park Art Association suggested that a statue of a cowboy be commissioned for the park. Remington was apparently intrigued by the prospect of a large-scale work. He drove through Fairmount Park and finally selected a site: a rock ledge jutting out over East River Drive. The Philadelphia *Daily News* described the *Cowboy* on June 18, 1908: "The horse has been running at full speed and has almost reached the brink of a precipice before his rider has seen it; he has stopped his steed just at the edge. The study of anatomy of the man and the horse is a remarkable one, mad action brought almost to a dead rest."

This was to be Remington's only large-scale bronze. He died the year after its installation.

3-36

Charles Albert Lopez (1869–1906)
Isidore Konti (1862–1938)
William McKinley
1908
Bronze, on granite base. Height 9' 6"
(base 14' 6")
City Hall, South Plaza
Penn Square, Broad and Market Streets

A public subscription to erect a memorial to President William McKinley was initiated by the *Philadelphia Inquirer* three days following his assassination on September 14, 1901. The Fairmount Park Art Association announced a design competition: 38 models were submitted, and that of Charles Albert Lopez was chosen. Lopez was born in Metamora, Mexico, but came to New York as a young man. He studied with John Quincy Adams Ward in New York City and later at the Ecole des Beaux-Arts in Paris. Lopez showed great promise, but he died unexpectedly after completing the working models for the McKinley sculpture. Isidore Konti, born in Vienna and known for his decorative monumental work, was selected to complete it.

McKinley is depicted giving a speech. Sitting at his feet, Wisdom instructs a youth.

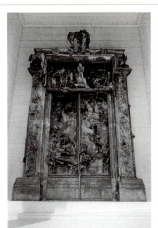

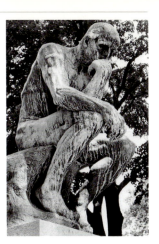

4

4-01

Auguste Rodin (1840–1917)
The Gates of Hell
1880–1917
*Bronze, on concrete base. Height
20' 10¾"; width 13' 2"*
*Rodin Museum entrance (installed 1929)
Benjamin Franklin Parkway between 21st
and 22nd Streets*

Writhing in anguish or unful-
filled desire, the figures on *The
Gates of Hell*—more than 180 of
them in all—seem to struggle to
free themselves from swirling
masses of material. Begun in the
year Rodin turned 40, this
intensely passionate work occu-
pied him for the next 10 years
and at intervals thereafter for the
rest of his life. The son of a Pari-
sian civil servant, Rodin attended
a government art school but
failed three times to gain admit-
tance to the prestigious Ecole des
Beaux-Arts. During his long,
uproarious career, he was blasted
for his audacity, sensuality, and
devotion to realism rather than
standard notions of beauty. The
theme for *The Gates of Hell*
derives from Dante's *Inferno*, but
Rodin incorporated dozens of
figures that have no strict par-
allel in the poem. For artistic
inspiration he drew on Michelan-
gelo's sculpture and Ghiberti's
Gates of Paradise in Florence.

The identifiable borrowings
from Dante include the *Three
Shades*, spirits of the dead who
stand atop the frame and point to
the sufferings below. Directly
below them sits *The Thinker* (see
4-02). About two-thirds of the
way down the left door are
Count Ugolino and his sons, who
endured starvation in a tower
until the boys died, at which
point Ugolino ate their flesh. Just
beneath these figures are the
flowing, straining forms of the
famous lovers Paolo and Fran-
cesca. In the right-hand door
jamb, at the very bottom, kneels
a bearded man thought to be

Rodin himself, with a small
attendant figure that may repre-
sent the fruits of his imagination.
At the bottom of each door is a
tomb, a reminder of the temporal
entrance to Hell.

Many of Rodin's most famous
free-standing sculptures began as
small figures on the gates or
grew out of experiments with the
massive project. But the gates
themselves were never cast in
bronze during Rodin's lifetime.
When Jules Mastbaum decided
to establish the Rodin Museum
in Philadelphia, he ordered two
bronze casts of the gates, one for
his museum and the other for
the Musée Rodin in Paris. The
first cast came to Philadelphia,
where architects Paul Cret and
Jacques Gréber incorporated it
into the design of the museum's
entrance.

4-02

Auguste Rodin (1840–1917)
The Thinker
1902–1904
*Bronze, on limestone base. Height 6' 7"
(base 6' 5")*
*Rodin Museum entrance walk (installed
1929)
Benjamin Franklin Parkway between 21st
and 22nd Streets*

One of the world's most widely
recognized sculptures, *The
Thinker* began as a representa-
tion of the poet Dante for
Rodin's *Gates of Hell* (**4-01**). In
1889 Rodin exhibited a version
that he titled *The Thinker, the
Poet* and identified as a fragment
of the *Gates*. By 1902–1904,
when he created the enlarged ver-
sion, the figure had come to rep-
resent the power of creative
thought. "I conceived another
thinker," Rodin explained, "a
naked man, his fist against his
teeth, he dreams. The fertile
thought slowly elaborates itself
within his brain. He is no longer
dreamer, he is creator."

Funds were raised to pur-
chase the large version for the
city of Paris. When the sculpture
was installed in front of the Pan-
théon in 1906, Rodin interpreted
it as a "social symbol." "It magni-
fies," he told a reporter, "the
fertile thought of those humble
people of the soil who are never-
theless producers of powerful
energies." In later years it may
have acquired additional mean-
ings for him. When his wife
died, he had a cast of *The
Thinker* placed on her grave at
Meudon, in front of the facade of
a ruined chateau that he had pur-
chased and installed there. Rodin
was buried at the same site a few
months later. Philadelphia's
Thinker, a cast of the 1902–1904
version, stands before a replica of
the Meudon facade.

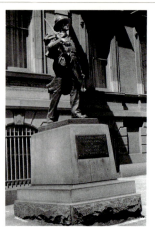

4-03

Paul Manship (1885–1917)
Duck Girl
1911
Bronze, on limestone base. Height 5' 1"
(base 2' 8")
Rittenhouse Square, Children's Pool
(relocated 1956)
Walnut Street between 18th and 19th
Streets

The *Duck Girl* was first exhibited in 1914 at the Pennsylvania Academy of the Fine Arts, where it won the Widener Gold Medal. The Fairmount Park Art Association purchased one of two casts from the artist and installed *Duck Girl* in Cloverly Park, at Wissahickon and School House Lane, in 1916. Damaged and moved to storage in 1956, it was rescued by the Rittenhouse Square Improvement Association and relocated to the square, where it continues to delight the visiting public. Poised in a Greek dress, the figure draws on classical imagery, as is characteristic of Manship's earlier works. His later *Aero Memorial* (**4-62**) stands in Logan Square.

4-04

Henry Kirke Bush-Brown (1857–1935)
Spirit of '61
1911
Bronze, on granite base. Height 8' 10"
(base 6')
Union League of Philadelphia
140 South Broad Street

A successor to the Gray Reserves, which originated in 1822, the First Regiment Infantry of the National Guard of Pennsylvania was the first to be called to action following the attack on Fort Sumter. *Spirit of '61* shows a First Regiment soldier marching in full uniform, a unique rendering at the time of its execution. The statue was commissioned for the 50th anniversary of the regiment in 1911. It was installed on Broad Street in front of the Union League until an appropriate location could be found in Fairmount Park. A site was never selected, however, and the work was deeded to the Union League on the regiment's centennial anniversary.

Henry Kirke Bush-Brown executed a number of equestrian sculptures, including *Major General George Gordon Meade* (1896) at Gettysburg.

4-05

Albert Laessle (1877–1954)
Billy
1914
Bronze, on granite base. Height 2' 2"
(base 1' 10")
Rittenhouse Square (installed 1919)
Walnut Street between 18th and 19th
Streets

Billy, inspired by and rendered after a family goat, was one of many animal studies that Albert Laessle created. Laessle was born in Philadelphia, and attended the Spring Garden Institute, Drexel Institute, and the Pennsylvania Academy of the Fine Arts. His work portrayed animals so realistically that—according to his own recollections—Laessle was once charged by fellow students with casting directly from life. He silenced his critics by making a similar sculpture in wax, a material that could not be easily cast.

Billy was given to the city of Philadelphia by Eli Kirke Price II through the Fairmount Park Art Association. A later sculptural group of *Pan, Dancing Goat,* and *Duck and Turtle Fountain* (c. 1928) stands in a park in front of the Walt Whitman Center, in Camden, New Jersey.

4-06

Maxfield Frederick Parrish (1870–1966)
The Dream Garden
c. 1916
Glass mosaic. Height 15'; width 49'
Curtis Building lobby (interior)
Washington Square at 6th Street
For access call 238 6450

Born in Philadelphia, Maxfield Parrish received no formal art training as a youth. However, with the guidance and inspiration of his father, he began to draw at an early age. He entered Haverford College intending to study architecture, but left after three years to study at the Pennsylvania Academy of the Fine Arts. Parrish worked in a range of forms, from magazine illustration to murals, and his use of color and imagery was distinctive. Publisher Cyrus Curtis commissioned the Tiffany Studios to create *The Dream Garden* from an original painting by Parrish (see pp. 109, 118). The mural is the second largest Tiffany mosaic in the world.

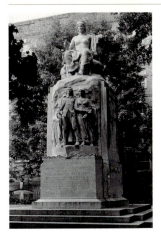

4-07

Albert Jaegers (1868–1925)
Pastorius Monument
1917
Marble, on marble and granite base.
Height 27'
Vernon Park
Germantown and Chelten Avenues

Even when memorials are created to commemorate historic events, national sentiment does not necessarily remain consistent. This monument to the founding of Germantown in 1683 by Francis Daniel Pastorius was funded by a special act of Congress and by the German-American Association, and it has been hidden from view twice because of popular opposition. The artist, Albert Jaegers, was himself German-born. His commissions included the von Steuben memorial in Washington, D.C., and statuary at the Customs House in New York City.

Unveiling festivities for the *Pastorius Monument* were postponed because of the U.S. entry into World War I. Anti-German sentiment caused the government to dissolve the German-American Alliance, and the monument was encased in a large box by the War Department until its dedication in 1920. When the United States entered the Second World War, the monument was "boxed" again and remained concealed until the war ended.

4-08

Albert Laessle (1877–1954)
Penguins
1917
Bronze, on marble base. Height 2' 1"
(base 3' 1")
Philadelphia Zoological Gardens, Bird
House entrance
34th Street and Girard Avenue
For access and admission fee call
243 1100

Albert Laessle's small animal groupings are unique in their realistic yet lively portrayal. The artist had easy access to animal models, since his studio was close to the Philadelphia Zoo. The *Penguins* were first exhibited at the Pennsylvania Academy of the Fine Arts in 1918. One of four casts was purchased by the Fairmount Park Art Association and installed at the entrance to the Bird House in the Zoo. The next year Laessle's bronze *Billy* (**4-05**) was installed in Rittenhouse Square.

4-09

Einar Jonsson (1874–1954)
Thorfinn Karlsefni
c. 1918
Bronze, on granite base. Height 7' 4"
(base 5' 7")
Kelly Drive north of Boat House Row
near Samuel Memorial

In the spirit initiated by his wife, Ellen Phillips Samuel (see p. 94), J. Bunford Samuel commissioned this sculpture of the Icelandic hero Thorfinn Karlsefni. Karlsefni is said in the saga of Eric the Red to have visited America's shores as early as 1004. The artist, Einar Jonsson, was born near Reykjavik to a peasant family and studied at the Royal Academy in Copenhagen.

4-10

Alexander Stirling Calder (1870–1945)
Gate Posts and Fountain
c. 1920
Marble and granite. Height: Africa
6' 4"; America, Europe, Asia 5' 7";
fountain 9' 7"
University Museum courtyard
33rd and Spruce Streets
See p. 110

4-11

Beatrice Fenton (1887–1983)
Seaweed Girl Fountain
c. 1920
Bronze, on marble plinth. Height 5' 1"
Horticultural Center (interior; relocated
1976)
North Horticultural Drive, West Fairmount
Park
For access call 685 0107

Edwin F. Keene of the Stetson Hat Company approached the Fairmount Park Art Association in 1921 with the offer to donate this figure "completely mounted in the pool." The *Seaweed Girl Fountain* work was accepted and installed along Sedgely Drive in Fairmount Park that same year. Almost forty years later, the Association commissioned the artist to add to it, and Fenton created two groups of angel fish swimming through a coral reef. The fish were stolen in 1974, and the figure was later relocated to the Horticultural Center, where it joins Margaret Foley's *Centennial Fountain* (**2-25**).

Beatrice Fenton was born and raised in Philadelphia. With the encouragement of Thomas Eakins, a family friend, she studied at the School of Industrial Art (now the University of the Arts) and later at the Pennsylvania Academy of the Fine Arts. The fanciful liveliness of her sculpture can also be seen in the *Evelyn Taylor Price Sundial* in Rittenhouse Square.

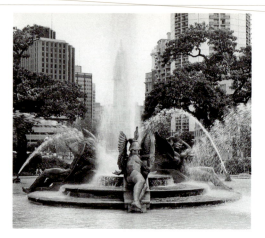

4-12

John Massey Rhind (1860–1936)

John Wanamaker
1923
Bronze, on granite base. Height 8'6"
(base 7')
City Hall, East Plaza
Penn Square, Broad and Market Streets

Schoolchildren donated $50,000 in pennies to help finance this memorial to one of the most celebrated merchants of the industrial era. Within a few months of John Wanamaker's death, enough funds had been raised to commission the well-known sculptor John Massey Rhind (see **3-19**, **3-23**, and **3-24**). Wanamaker (1838–1922) had pioneered such retail concepts as "one price only" and "your money back if not satisfied." When his two-acre emporium at 13th and Market, known as the Grand Depot, opened in time for the 1876 Centennial, it was thronged by marveling crowds. The Depot was the first store to be lit by electricity. Between 1902 and 1910, Wanamaker replaced it with the building that occupies the site today.

Rhind's statue faces the store. When the unveiling took place on Thanksgiving Day, 1923, Leopold Stokowski led the police band and thousands of Philadelphians in a rendition of the national anthem. The inscription, however, is a simple and modest one, identifying Wanamaker by name, dates, and the title "Citizen."

4-13

Samuel Yellin (1885–1940)

Gates and Lighting Fixtures
1923
Iron. Gate: height 33'; width 21'
Packard Building
15th and Chestnut Streets

Like other traditional arts, ironworking declined in the late 19th century. But in the early years of the new century, Philadelphia's Samuel Yellin led a wrought-iron revival that influenced many architects as well as artists and craftspeople. Yellin's work ranged from small locks, keys, lamps, and boxes to massive gates, grilles, and ornamental screens. The ten-ton gates at the Packard Building are a fine example of his larger commissioned works. Yellin's exterior lighting fixtures are also still in place, although his grilles have been removed.

Other examples of Yellin's work in Philadelphia include gates and doors at the Curtis Institute of Music (18th and Locust Streets), the old Lea & Febiger Building (600 South Washington Square), St. Mark's Church (1625 Locust Street), the Rosenbach Museum and Library (2010 Delancey Place), the University of Pennsylvania Museum (33rd and Spruce Streets), and the Fleisher Art Memorial (700 block of Catharine Street).

4-14

Alexander Stirling Calder (1870–1945), sculptor
Wilson Eyre, Jr. (1858–1944), architect

Swann Memorial Fountain
(or **The Fountain of Three Rivers**)
1924
Bronze figures on granite bases in fountain pool. Height 11' (bases 5'2");
pool diameter 124'
Logan Circle
Benjamin Franklin Parkway at 19th Street

Surrounded by the swirling traffic of the Parkway, three bronze Indians recline among soaring jets of water. Created as a memorial to Dr. Wilson Cary Swann, these handsome fountain sculptures represent Philadelphia's three main waterways: the Delaware and Schuylkill Rivers and Wissahickon Creek.

Swann (1806–1876) was the founder and president of the Philadelphia Fountain Society. His wife, Maria Elizabeth Swann, bequeathed funds to the Society to erect "a large and handsome fountain" in his honor. In 1917, architect Wilson Eyre persuaded the Fairmount Park Commission to provide a site in the newly designed Logan Circle. For his collaborator, Eyre chose Alexander Stirling Calder, whose works graced public places throughout the city (see **2-07**, **3-26**, **4-10**, and **4-15**). Calder set to work on the sculptural ensemble that he called *The Fountain of Three Rivers*. Borrowing the time-honored allegorical motif of a reclining nude river god, he adapted it to the region's geography and Native American history.

The figure representing the Wissahickon is an Indian girl leaning modestly on her side against an agitated, water-spouting swan. There is a subordinate classical reference to Leda and the swan, but the motif also resulted from Calder's inability to resist a pun on Dr. Swann's name. For the larger Schuylkill River, he created the figure of a mature woman holding the neck of another swan. The largest river, the Delaware, became a powerful Indian male—evidently a member of the Lenni Lenape or Delaware tribe—who reaches above his head to grasp his bow as a leaping fish sprays water over him. For the fountain's center Eyre designed a geyser that shot 50 feet into the air, and he staggered or interlaced the other jets and sprays for maximum visual effect. Fittingly, the fountain opened to the public on a hot July day in 1924. To the music of the police band, ten thousand people danced the tango in the surrounding streets.

In the decades thereafter, Calder and Eyre's work became justly famous, but the underlying technology proved less successful than the aesthetics. Maintenance lagged, and many of the jets became dribbles; lights went out and the pool was cracked—until the late 1980s, when the Friends of Logan Square Foundation raised funds for the fountain's restoration (see *Preserve and Protect*, pp. 190–191).

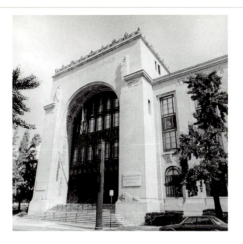

4-15

Alexander Stirling Calder (1870–1945)
Shakespeare Memorial
1926
*Bronze, on black marble base. Height 6'
(base 14' 2")*
Logan Square (relocated 1953)
*Benjamin Franklin Parkway between 19th
and 20th Streets*

John Sartain approached the
Fairmount Park Art Association
in 1892 with a proposal to raise
funds through public and private
subscription for a monument to
Shakespeare. By 1917 funds
were in place, and Alexander Stir-
ling Calder was commissioned.
The original site in front of the
Free Library was carefully
selected by representatives of the
Art Association and the Shake-
speare Memorial Committee,
with additional input from
Parkway architects Gilbert McIl-
vaine, Paul Cret, and Jacques
Gréber. The sculpture was cast
by the Roman Bronze Works and
dedicated on Shakespeare's
birthday in 1926. It depicts two
figures representing Comedy and
Tragedy. Hamlet is shown
leaning his head against a knife,
while Touchstone, the jester, sits
at his feet, his head rolled back
in laughter. A quotation from *As
You Like It* is inscribed on the
base: "All the world's a stage and
all the men and women merely
players."

4-16

Lee Lawrie (1887–1963), sculptor
Zantzinger, Borie and Medary, architects
**Fidelity Mutual Life
Insurance Company
Building**
1926–1927
Limestone, bronze, and other materials
Pennsylvania and Fairmount Avenues

Gilt squirrels and pelicans, huge
stone reliefs of human figures,
small suns and moons, and the
classical Graces—all these and
more adorn one of the city's
finest Art Deco structures, the
Fidelity Mutual Building. The
architectural team included C. C.
Zantzinger and C. Louis Borie,
who also collaborated on the
Museum of Art. The artist, Lee
Lawrie, was already noted for his
sculpture on the Nebraska State
Capitol and Gothic cathedrals in
New York; later he contributed
many of the reliefs at Rockefeller
Center.

The elaborate sculptural pro-
gram symbolizes key features of
human life and suggests the pro-
tective value of the insurance
that Fidelity Mutual provided. At
the main portal on Fairmount
Avenue, two guardian dogs,
emblems of fidelity and of the
company itself, watch sternly.
Overhead, rising out of the lime-
stone columns, are giant male
and female forms: a father figure
(*Fidelity*) on the left, with a
spade as his token; a mother
(*Frugality*) on the right, with a
child in her arms. At the figures'
bases are smaller symbols: for
the father, a sheaf of grain and a
horn of plenty; for the mother, a
cradle and a "gift tree." Else-
where, friezes, reliefs, and
mosaic panels present the
"twelve labors" and the "seven
ages" of humankind, the cycle of
time, and many symbols of
"home and protection" and "the
hazards of life." Crowning the
entrance tower is an ornamental
gilt crest with marvelous figures

of squirrels, opossums, owls, and
pelicans, which represent, respec-
tively, the virtues of thrift, protec-
tion, wisdom, and charity.

The portal at the corner of
26th Street and Pennsylvania
Avenue repeats the same motifs.
Here, though, the male figures
atop the column on the left repre-
sent *Friendship*, while the smaller
sculpture at the base shows Wil-
liam Penn and an Indian bearing
tokens of friendship. The female
figure on the right, holding an
hourglass, symbolizes *Prudence*.
Below her, oddly, is Ben
Franklin in his most famous but
imprudent activity—flying his
kite in a storm.

4-17

Attributed to Christopher Untenberger
Fountain of the Sea Horses
Original c. 1740; replica c. 1926
Travertine. Height 10' 8"; figures 4' 9"
*Aquarium Drive west of Azalea Garden
(installed 1928)*

This fountain is a replica of the
Fontana dei Cavalli Marini in
the Villa Borghese Gardens in
Rome. A gift to the United States
from the Italian Government, the
fountain arrived too late to be a
part of the 1926 Sesquicenten-
nial celebration. It was sent to
America in 76 pieces and assem-
bled by Italian craftsmen upon
its arrival in 1928. Later the foun-
tain's mechanical system deterio-
rated, and it was refurbished as a
Bicentennial project with the
assistance of the Philadelphia
Chapter of the Sons of Italy.

4-18

D'Ascenzo Studios, mosaic and stained
glass artisans
Simon and Simon, architects
Rodeph Shalom Synagogue
1927
Mosaic tile and stained glass
615 North Broad Street
See p. 112

217

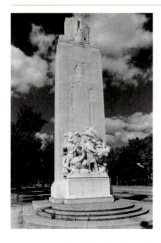

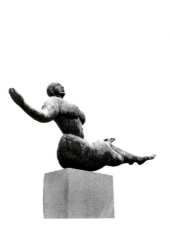

4-19

Hermon Atkins MacNeil (1866–1947)
Civil War Soldiers and Sailors Memorial
1927
Marble, on granite bases. Height 40'
Benjamin Franklin Parkway and 20th
Street (relocated 1954–1955)

In the midst of fighting World War I, Philadelphia chose to commemorate the Civil War. Funds were appropriated by the city, and Hermon Atkins MacNeil was selected for the commission.

MacNeil was born in Massachusetts and worked in Paris. Returning to the United States, he was among the first American artists to look to his native terrain for sculptural subjects, particularly the American Indian. He traveled in the Southwest and won numerous awards for his renderings of Native Americans.

These two pylons—one depicting sailors, the other soldiers—were intended to stand as gates to the "Parkway Gardens." They were moved to accommodate the construction of the Vine Street Expressway, but still mark the entry to the park from the city.

4-20

Gaston Lachaise (1886–1935)
Floating Figure
1927
Bronze, on marble base. Height 4' 3¾";
width 8' (base 8')
Society Hill Town Houses courtyard
(installed 1963)
Locust Street between 2nd and 3rd
Streets

Gaston Lachaise introduced a certain vitality and sensuality into American sculpture. Born in Paris, he attended the Ecole des Beaux-Arts. Lachaise described the institution as a place where "he learned to make sweet nothing compositions and soulless reminiscences of the classics." An encounter with an American woman, Isabel Nagle, changed his life. He followed her to America in 1906 and later married her. In New York, he assisted in the studio of Paul Manship and then opened his own studio.

In Lachaise's blatantly sexual imagery, rendered through the exaggeration of the female form, the influence of prehistoric art is marked. The original *Floating Woman* was cast in 1927 and installed in the Museum of Modern Art in New York. A second casting was secured in 1963, with the help of R. Sturgis Ingersoll, for the Society Hill Town House Development, designed by I. M. Pei and sponsored by the Alcoa Corporation and the Redevelopment Authority.

4-21

J. Wallace Kelly (1894–1976) and
Raphael Sabatini (1898–1985), sculptors
Ralph Bencker (1883–1961), architect
N. W. Ayer Building
1929
Limestone, bronze, and other materials
210 West Washington Square

Like the Fidelity Mutual Building (**4-16**), the Ayer Building is a leading example of the integration of figurative sculpture and commercial architecture. In the late 1920s, N. W. Ayer & Son was Philadelphia's best-known advertising agency, and the sculptural program of its new Art Deco headquarters was designed to illustrate the goals and achievements of the advertising profession.

The most spectacular elements are far above street level. In the setback of the top three stories, emerging from subtly tapering limestone columns, rise eight monumental figures, two on each side of the building. With open books in hand, they represent the creative mind and truth as expressed through advertising. These figures were carved in situ, the sculptors working on scaffolds high above the ground. Adjacent to the giant figures are smaller carved reliefs between the window levels. Nearer the street, more reliefs in metal or limestone appear between or below some of the windows. On the ornate bronze doors facing Washington Square, robed figures engage in speaking, writing, typing, painting, and printing. The lobby's dominant motif of birds in flight indicates the power of advertising to spread its message to the far corners of the world. This motif is stated most strongly in the elevator court, where a massive bronze by J. Wallace Kelly stands below a relief of winged birds at ceiling level.

J. Wallace Kelly and Raphael Sabatini were both Philadelphia sculptors. Kelly went on to create many other works in the city (see **4-26, 4-33, 4-47,** and **4-56**), and Sabatini taught at Temple University's Tyler School of Art. In collaboration with architect Ralph Bencker, they helped to create the style known as "automat" or "jazz-modern."

4-22

Beatrice Fenton (1887–1983)
Boy with Baseball (above)**, Boy with Football, Girl with Ball, Girl with Doll**
1931
Limestone, on granite and brick bases. Height 5′3″ (bases 14′2″)
The Children's Hospital of Philadelphia cafeteria courtyard (interior; relocated 1974)
34th Street and Civic Center Boulevard
For access call 590 1000

Beatrice Fenton designed these gateposts for the entry of the Children's Hospital building on 17th and Bainbridge Streets. The pensive children are much less lively than Fenton's usual subjects. In 1974, when the hospital relocated to West Philadelphia, the gateposts were moved to the new location.

Fenton's *Seaweed Girl Fountain* (**4-11**) is in the Horticultural Center. Fenton taught at the Moore College of Art, from which she received an honorary degree in 1954.

4-23

Alfred Bottiau (1889–1951)
Wisdom and **Commerce**
1932
Marble reliefs. Height 5′9½″; width 7′6″ (each)
Federal Reserve Bank
Chestnut Street east of 10th Street

Although the Depression reduced the use of architectural sculpture, the tradition survived in many Federal buildings of the 1930s. Paul Cret's Federal Reserve Bank (now occupied by the Pennsylvania Manufacturers' Association) offers a prime example of the role of sculptural relief in the "Federal style." Facing each other on either side of the main entrance are marble reliefs by French sculptor Alfred Bottiau, who had worked with Cret on earlier projects in Philadelphia and France. On the left is *Wisdom*, a seated woman who holds a figure of Athena Parthenos, the virgin goddess of wisdom. Opposite her sits a male figure, *Commerce*, with a sheaf of wheat in his right hand and the tools of industry cradled in his left arm. Beyond him a sailing ship plies the seas. Together these two figures speak for the sagacity of the Federal Reserve System—a much-needed affirmation during the Depression years.

4-24

Federal Courthouse and Post Office
1934–1940

Edmond Amateis (1897–1981)
Mail Delivery: North, South, East, West (*East* and *West* above)
Donald De Lue (1897–1988)
Justice and **Law**
Louis Milione (1884–1955)
State Shields

Harry Sternfeld (1888–1976), architect
Granite and limestone
9th Street between Market and Chestnut Streets

Like the neighboring Federal Reserve Bank (see **4-23**), Harry Sternfeld's Courthouse and Post Office building illustrates the Federal style of the 1930s. Here, however, the sculpture is more rugged and robust. Flanking the main entrances on the 9th Street side are four granite reliefs by Edmond Amateis, titled *Mail Delivery: North, South, East, West*. The boldly carved figures symbolize the indefatigable efforts of postal workers at the geographic extremes of America. An African-American at a rural mailbox surrounded by palm trees, bananas, and a pineapple represents the South (specifically the Panama Canal Zone, according to Amateis). A parka-clad Eskimo with a dog sled stands for the arctic North; a mailman in cowboy attire with a backdrop of desert plants, for the West; and a postal worker in traditional uniform, for the East.

At the entrances on Market and Chestnut Streets, the sculptural program reflects the building's function as a courthouse. Donald De Lue's intense, stern, muscular figures of *Justice* and *Law* have been compared to the popular style of American regionalist painters like Thomas Hart Benton. *Justice* wears no blindfold in De Lue's interpretation; rather, the figure stares unblinkingly toward Law, a formidable patriarch. Equally muscular eagles, as well as symbolic stars and bars, add to the force of the allegory.

Above the post office windows along the 9th Street facade, Louis Milione carved *State Shields* to represent each of the 13 states in the circuit of the federal district court.

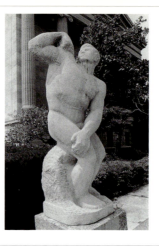

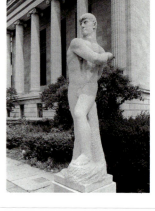

Philadelphia Museum of Art
Benjamin Franklin Parkway

East Terrace

The sculptures installed on the East Terrace of the Philadelphia Museum of Art derive from the International Sculpture Exhibitions of 1940 and 1949 (see pp. 94–100); they were purchased by the Fairmount Park Art Association, donated to the museum, or placed there on indefinite loan (also see *Prometheus Strangling the Vulture* [**4-55**], p. 227). Overlooking the East Terrace is the museum's north pediment, where the architects realized their goal of integrating classical sculpture with the architecture.

4-25

Carl Paul Jennewein (1890–1978)
North Pediment
Completed 1932
*Polychrome terra cotta. Height 12';
width 70'*

Carl Paul Jennewein's sculptures for the north pediment draw their content and their technique from ancient Greece. The colored glazing on the terra cotta figures reflects methods used in Greek architectural sculpture over two thousand years ago, and the 13 figures represent gods, mortals, and beasts from classical mythology. The theme is that of sacred and profane love. Zeus, ruler of the gods, is the central figure. Immediately to the right, from the viewer's perspective, is Demeter, here presented as the protector of marriage, holding the hand of the child Triptolemus, whom she rescued from a mortal illness. Next are Ariadne, Theseus slaying the Minotaur, and the beast Python. Beside Zeus to the viewer's left stand Aphrodite, goddess of love, and her son, Eros, Hippomenes in the form of a lion, Adonis, Nous (the mind), and Eos, goddess of the dawn, who is turning away from the Owl, the bird of night.

Jennewein, a native of Germany, emigrated to New York in 1907. A gifted classical sculptor, he was particularly interested in combining sculpture with architecture. The figures were fabricated by the Atlantic Terra Cotta Company, and the colorist was Leon V. Solon, author of *Polychromy* (1924). John Gregory (see **4-50**) designed a similar, unrealized group for the south pediment; a model remains in storage.

4-26

J. Wallace Kelly (1894–1976)
Labor (Unskilled)
1933–1936
*Limestone, on concrete aggregate base.
Height 7' 1½" (base 2' 6¾")*

With his massive arm flexed, J. Wallace Kelly's prototypical laborer suggests the hard work, muscle, and energy that were needed to build American industry. The sculpture can also be seen as a tribute to the working men and women who struggled for economic survival during the Depression. A product of the WPA (see pp. 97, 102–103), the brawny figure was placed on loan at the Art Museum in 1937 and was exhibited at the 1940 Sculpture International.

Kelly, a native of Secane in Delaware County, moved to Philadelphia as a child. In addition to the Ayer Building (**4-21**), his public commissions included works for both the Samuel and the Reilly Memorials (**4-33**, **4-47**, and **4-56**).

4-27

Yoshimatsu Onaga (1890–1955)
N.R.A.
c. 1933–1937
*Limestone, on concrete base. Height
7' 1" (base 2' 6")*

Like his good friend Wallace Kelly, Yoshimatsu Onaga was employed by the WPA. But the $400 he received as his payment for this work was only enough to buy the four-ton block of limestone. For nearly four years he worked on his heroic statue of an American athlete, taking odd jobs to support himself and sleeping in Kelly's studio. In praising his dedication to the work, a newspaper article described him as "a glorious fool."

Onaga, born in Japan, came to the United States in 1911. His *N.R.A.*, which was included in the 1940 Sculpture International, is on indefinite loan to the Museum. The title refers to the National Recovery Administration, one of the "alphabet" agencies created during the Depression. An alternative title is *American Youth*.

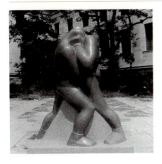

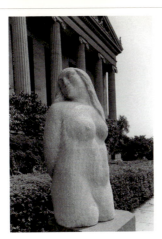

4-28

Ahron Ben-Shmuel (1903–)

Boxers

1937

Coopersburg granite, on concrete base. Height 5' 1½" (base 3' 1½")

Ahron Ben-Shmuel's study of two boxers in a clinch, exhibited at the 1940 Sculpture International, was installed on the Art Museum's East Terrace in 1958, on loan to the Park Commission from the artist. In 1982, during the controversy over the *Rocky* sculpture (**6-27**), *Boxers* was cited as evidence that the city's art establishment had no prejudice against boxing as a subject for art.

Ben-Shmuel, born in North Africa and raised in New York, started carving at an early age, using wood scraps and bits of stone from demolition sites. Eventually he apprenticed in a stoneyard and earned money by reproducing other sculptors' models in stone. His study of ancient and primitive art confirmed his conviction that direct carving in "resistant" material was the basis of sound sculptural technique. Two decades after he completed *Boxers*, he carved *The Laborer* for the Samuel Memorial (**4-46**).

4-29

Simone Brangier Boas (1895–1981)

Woman

c. 1940

Tennessee marble, on granite base. Height 3' 10" (base 2' 4")

The idealized figure of a woman glances over her shoulder as if something has just caught her attention. This sculpture by Simone Boas appeared in the 1940 Sculpture International and later was donated by the artist to the Fairmount Park Commission. It was installed on the Museum's East Terrace in 1962.

Boas studied in her native France with sculptor Antoine Bourdelle and in the United States with William Zorach before settling in the Baltimore area. In 1938 her work was included in the first New York exhibition of the Sculptors Guild, a group who believed that form should derive naturally from material.

4-30

Maria Martins (1900–1973)

Yara

c. 1942

Bronze, on limestone base. Height 6' 11" (base 2' 7")

Often known simply by her first name—as she signed herself on *Yara*—Maria Martins considered a career as a pianist but in her twenties took up painting and sculpture instead. Married to a diplomat, she lived in cities around the world, immersing herself in the study of local artistic techniques. To this international exposure she added a strong attachment to her native Brazil, and many of her early sculptures were evocations of its forests.

Yara was exhibited in plaster at the 1940 Sculpture International, and two years later the bronze cast was given to the Museum by an anonymous donor. The fishlike forms at the base and the droplets running down the figure's back and legs suggest that the work was originally intended as a fountain centerpiece.

4-31

Gerhard Marcks (1889–1981)

Maja

1942

Bronze, on marble base. Height 7' 4" (base 2' 4")

Many visitors to the 1949 Sculpture International considered Gerhard Marcks's *Maja* the most significant work on display. It was purchased by the Fairmount Park Art Association (a second cast is owned by the City Art Museum of St. Louis).

Marcks, a native German, was associated with Walter Gropius's famous Bauhaus from 1919 to 1925. When the Nazis came to power in 1933, Marcks was directing the Academy of Arts and Crafts in Halle. When he tried to protect a Jewish woman student from persecution, he was dismissed from his post. Many of his works were confiscated from German museums and included in a touring exhibit of "degenerate" art; later they were melted, burned, or auctioned off for foreign currency. But Marcks continued to work in Germany, concentrating on small creations that could easily be concealed. After World War II he received many commissions for war memorials and ecclesiastical sculptures.

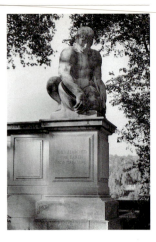

Ellen Phillips Samuel Memorial
1933–1961
Kelly Drive south of Girard Avenue Bridge

Despite the cars that buzz past on Kelly Drive and the legions of runners and bicyclists who use the paths in summertime, the Samuel Memorial remains a contemplative site, as Ellen Phillips Samuel intended (see p. 100). It is a place for reflecting on the nation's evolution and the people and ambitions that have molded America.

Central Terrace
Construction of the Memorial began with the Central Terrace, where two large bronze monuments and four complementary figures in limestone express the twin themes of America's westward expansion and the new nation's welcome to immigrants from other lands. Occupying the center of the terrace is *The Spirit of Enterprise* (**4-38**), the massive bronze that was originally commissioned for a site in the North Terrace.

4-32
Robert Laurent (1890–1970)
Spanning the Continent
1937; installed 1938
Bronze, on granite base. Height 9′2″ (base 3′)

Spanning the Continent, Robert Laurent's interpretation of American migration westward, became the first sculpture installed at the Samuel Memorial in 1938. Art critic Dorothy Grafly characterized the work as an expression of "rugged individualism"; the man and woman are "taking the continent in their stride, wheel between them, and ax in hand." Laurent was born in the Breton region of France, but at the age of 11 his budding talent was discovered by the American art critic and painter Hamilton Easter Field, who brought the young artist to the United States and supervised his education. In his adopted country, Laurent became a pioneer in the revival of direct carving in wood and stone.

4-33
J. Wallace Kelly (1894–1976)
The Ploughman
1938
Limestone, on limestone base. Height 5′1″ (base 5′7″)

"Land and gold," wrote the Samuel Memorial committee, "were probably the most basic urges" that propelled Americans westward across the continent. To represent the pioneers who sought new land to settle, the committee asked J. Wallace Kelly to create *The Ploughman*. Kelly was a native of the Philadelphia area who taught at Haverford College and other local schools. Like his sculpture on the East Terrace of the Art Museum (**4-26**), *The Ploughman* is a dignified celebration of human labor.

4-34
John B. Flannagan (1895–1942)
The Miner
1938
Limestone, on limestone base. Height 5′ (base 5′6″)

Opposite *The Ploughman*, John Flannagan's *Miner* commemorates the thousands of Americans who journeyed west in search of instant (and generally illusory) wealth. Flannagan, born in North Dakota, was one of America's preeminent stone carvers. "My aim," he once wrote, "is to produce a sculpture feeling as direct and swift as a drawing, a sculpture with such ease, freedom and simplicity that it hardly feels carved."

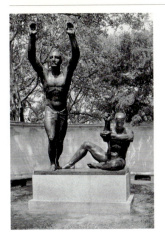

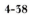

4-35

Maurice Sterne (1878–1957)
Welcoming to Freedom
1939
*Bronze, on granite base. Height 13′ 4″
(base 3′ 1″)*

Originally the Memorial committee selected Gaston Lachaise to create the bronze group symbolizing "the welcoming of the oppressed from all lands." But when Lachaise died in 1935 after completing only a quarter-scale model, Maurice Sterne was commissioned to take his place. Sterne, a Russian-American who had been one of Robert Laurent's early teachers, was a painter, printmaker, and sculptor known for the controlled poise of his works. His *Welcoming to Freedom* presents two male figures, one standing with arms raised in welcome, the other seated and gesturing in solidarity.

4-36

Heinz Warneke (1895–1983)
The Immigrant
1940
*Limestone, on limestone base. Height
5′ 9″ (base 5′ 6″)*

Opposite *The Slave* is Heinz Warneke's representation of *The Immigrant*. Born in Germany, Warneke himself became an immigrant to the United States at the age of 28. Well known for his animal sculptures, such as *Cow Elephant and Calf* (**5-03**), he also created monumental human figures for a number of public sites, including government buildings in Washington, D.C. In contrast to the enthusiasm expressed in Sterne's *Welcoming to Freedom*, Warneke's *Immigrant* is a rather melancholy figure. Taken together, the works by Sterne, Sardeau, and Warneke suggest both the promise and the difficulties of American freedom.

4-37

Helene Sardeau (1899–1968)
The Slave
1940
*Limestone, on limestone base. Height
5′ 5″ (base 5′ 6″)*

"Spiritually," the Samuel Memorial committee wrote, "there is an association between the freeing of the slaves and the welcoming [of immigrants] to our shores." Thus the committee members commissioned a figure of an unshackled slave to accompany Sterne's *Welcoming to Freedom*. Sculptor Helene Sardeau, born in Belgium, emigrated to the United States as a child. She also collaborated on murals and reliefs in Mexico City and Rio de Janeiro with her husband, the painter George Biddle.

4-38

Jacques Lipchitz (1891–1973)
The Spirit of Enterprise
1950–1960
*Bronze, on granite base. Height 10′ 5″;
length 14′ 10″ (base height 4′ 8″)*

For the Samuel Memorial, the trustees of the Fairmount Park Art Association imagined a large bronze representing America's "Constructive Enterprise"—"the vigor, the power of harnessed nature, or the strength of men harnessing nature and making it conform to their uses and desires." The commission was granted in 1950 to Jacques Lipchitz. After numerous studies, the casting in 20 separate pieces began. In 1960 the massive bronze, now called *The Spirit of Enterprise*, was installed in the Memorial's North Terrace. It was moved to the Central Terrace in 1986 to increase its visibility from Kelly Drive.

Lipchitz's powerfully optimistic treatment reflects his lifelong idealism. The muscular pioneer surges forward, one hand shading his eyes as he scans the horizon, the other holding a caduceus. Echoing his movement is a great eagle, wings outstretched. The link with *Prometheus Strangling the Vulture* (**4-55**) is apparent, and many have been tempted to symbolically connect the two: here, the eternal battle has ended, and man and bird are united in a common purpose. Lipchitz was particularly pleased by the inscription quoting the quintessential American optimist, Theodore Roosevelt: "Our nation, glorious in youth and strength, looks into the future with fearless and eager eyes, as vigorous as a young man to run a race."

 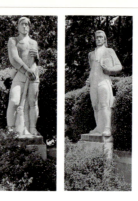 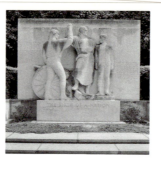 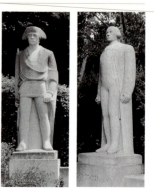

Ellen Phillips Samuel Memorial

South Terrace

After the second Sculpture International in 1940, the committee selected four sculptors to express the governing themes of the new South Terrace—the settlement of the east coast and the emergence of the United States as an independent, democratic nation. The two principal groups were carved as reliefs, and the other four sculptures as free-standing figures.

4-39

Wheeler Williams (1897–1972)
Settling of the Seaboard
1942
Limestone, on granite base. Height 12' 1" (base 3')

To celebrate the earliest settlers Wheeler Williams carved a relief of four figures: a young man; a woman, who dramatically gestures toward the distance; the infant in her arms; and an Indian sitting peacefully alongside. Williams, a native of Chicago who trained as a sculptor and architect, was an experienced monument-maker who had created works for bridges, post offices, and other public and private sites. R. Sturgis Ingersoll, a member of the Memorial committee, later described *Settling of the Seaboard* as a "somewhat conventional statement," yet it is notable as the only representation of a Native American among the sculptures originally commissioned for the Memorial.

4-40

Harry Rosin (1897–1973)
The Puritan and **The Quaker**
1942
Limestone, on granite bases. Height 8' 4" (bases 4' 7")

The standing figures by Harry Rosin were intended to represent major spiritual forces in the settling of the seaboard. Rosin approached the project with a dual purpose: to create sculptures that were historically accurate and at the same time to make them intelligible to the general public. For Rosin, a native Philadelphian who taught for more than three decades at the Pennsylvania Academy of the Fine Arts, these sculptures were the first of many public commissions in the Philadelphia area; his later works included *Mr. Baseball* (**4-69**) and the sculpture of John B. Kelly on Kelly Drive.

4-41

Henry Kreis (1899–1963)
The Birth of a Nation
1943
Limestone, on granite base. Height 12' 1" (base 3')

In the words of the Memorial committee, the second principal relief in the South Terrace was to be "an expression of the agreement among the American people to make and abide by their own laws, free of outside control." The commission was awarded to Henry Kreis, who had emigrated from Germany in 1923. A former assistant to Paul Manship (see **4-03, 4-62**) and Carl Paul Jennewein (see **4-25**), Kreis created sculptures for public buildings in many American cities. As the committee suggested, Kreis avoided such well-worn visual symbols as the Liberty Bell and the signing of the Declaration of Independence. Instead, his monument shows three male figures of varying ages, signifying the agreement of young and old to forge a self-governing republic.

4-42

Erwin Frey (1892–1967)
The Revolutionary Soldier and **The Statesman**
1943
Limestone, on granite bases. Height 8' 4" (bases 4' 8", 4' 6")

Military might and political intelligence, twin necessities of the new republic, are the subject of Erwin Frey's two figures. Frey was a professor at Ohio State University who had worked as an assistant to Augustus Saint-Gaudens (see **3-16, 3-29**) and Herbert Adams (see **3-19, 3-31**). Although the Memorial committee suggested that the revolutionary soldier be "the tattered veteran of a Valley Forge winter," Frey's figure is respectably dressed and of a serious, resolute demeanor matching the statesman's.

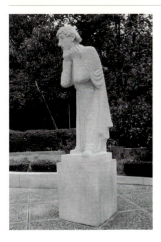

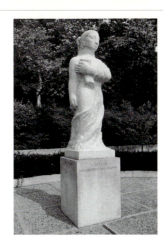

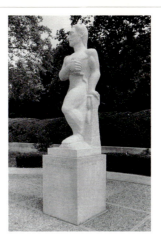

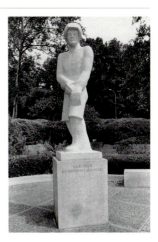

Ellen Phillips Samuel Memorial

North Terrace

The development of the North Terrace inaugurated the final stage of the Samuel Memorial. Here, the intention was to express not historical periods or movements, but rather the "inner energies" that shaped the nation. Two major bronze groups were to represent "social conscious-ness" and "constructive enter-prise," and the commissions were offered to Jacob Epstein and Jacques Lipchitz. As Epstein and Lipchitz progressed, it became apparent that their two massive monuments would not fit com-fortably in the same terrace. Thus, Epstein's *Social Conscious-ness* (**4-66**) was installed at the west entrance of the Museum of Art. Lipchitz's *The Spirit of Enter-prise* (**4-38**) served as the center-piece of the North Terrace until in 1986 it was moved to the Cen-tral Terrace.

4-43

Waldemar Raemisch (1888–1955)
The Preacher
1952
Granite, on granite base. Height 8′ 2″
(base 3′ 10″)

Hands cupped near his chin as he speaks, *The Preacher* is an emblem of the religious figures who have "guided our ways." In a letter to the Art Association, artist Waldemar Raemisch referred to this figure as "The Exhorter." Raemisch, who fled to the United States from Nazi Ger-many, later created the bronze groups for Philadelphia's Youth Study Center, *The Great Mother* and *The Great Doctor* (**4-67**).

4-44

José de Creeft (1884–1982)
The Poet
1954
Granite, on granite base. Height 8′ 6″
(base 3′ 10″)

The writer who helps to shape the imagination of the country is represented in José de Creeft's sculpture of a draped poet clutching his writings to his breast. Even before emigrating to America from Spain in the late 1920s, de Creeft had established a substantial reputation as a carver of wood and stone. *The Poet* was his first major public commission in the United States; a few years later, he created a bronze *Alice in Wonderland* for New York's Central Park.

4-45

Koren der Harootian (1909–)
The Scientist
1955
Granite, on granite base. Height 8′ 6″
(base 3′ 10″)

To balance the spiritual and emo-tional energies of *The Preacher* and *The Poet*, the Memorial com-mittee commissioned a figure to represent the scientific impulse that has spurred the nation's intellectual and technological development. The sculptor, Koren der Harootian, was a native of Armenia who had escaped the turmoil of the Near East and the Russian Revolution. Two decades after completing *The Scientist*, der Harootian cre-ated *Meher*, a sculpture of a leg-endary Armenian folk hero; this work was installed at the west entrance driveway of the Art Museum.

4-46

Ahron Ben-Shmuel (1903–)
The Laborer
1958
Granite, on granite base. Height 8′ 6″
(base 3′ 10″)

America's mental and spiritual energies would have had little impact without physical energy as well; thus Ahron Ben-Shmuel was commissioned to commemo-rate the working men and women who helped to build the nation. Born in North Africa, Ben-Shmuel grew up in New York, where he trained as a stone-cutter. Another of his granite carvings in Philadelphia is *Boxers* (**4-28**).

4-47

J. Wallace Kelly (1894–1976)
Titles Unknown: Eye and **Hand** (relief panels)
1959
Limestone, on granite base. Height 6′ 3″
(base 2′ 1″)
See pp. 192–193

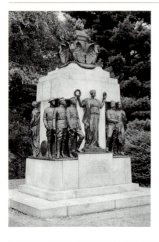

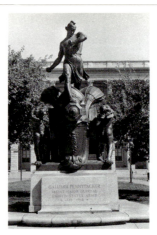

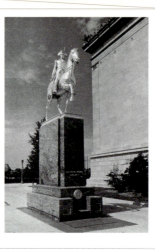

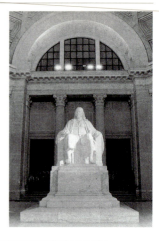

4-48

J. Otto Schweizer (1863–1955)
All Wars Memorial to Colored Soldiers and Sailors
1934
Bronze and granite. Height 21' 6";
width 17'; depth 13'
Lansdowne Drive near Memorial Hall
West Fairmount Park

In 1927 the Pennsylvania legislature decided to erect a memorial to the black military men who had served the United States in wartime, and funds were appropriated to construct "a lasting record of their unselfish devotion to duty." After considerable dispute about the location (see p. 105), officials agreed on a site in West Fairmount Park.

The commission was awarded to J. Otto Schweizer. Born in Zurich, Schweizer studied in Germany and Italy before emigrating to the United States. Working out of a studio in Philadelphia's Tioga neighborhood, he became a specialist in monumental works, many of which were commissioned for sites in Pennsylvania. His bronze of General Peter Muhlenberg stands near the west entrance of the Museum of Art. He also created a massive sculpture of revolutionary general Friedrich von Steuben for Valley Forge and six statues of Civil War generals for the memorial park at Gettysburg.

At the top of the *All Wars Memorial*, Schweizer placed a "torch of life," surrounded by four American eagles. Below stands an allegorical figure of Justice, holding symbols of Honor and Reward. To the left and right are groups of black soldiers and sailors, both officers and enlisted men. Allegorical figures at the rear of the monument represent the principles for which American wars have been fought.

4-49

Albert Laessle (1877–1954); initial concept by Charles Grafly (1862–1929)
General Galusha Pennypacker Memorial
1934
Bronze, on limestone base. Height 10' 8"
(base 4')
Logan Square
19th Street and Benjamin Franklin Parkway

Galusha Pennypacker, a native of Chester County, Pennsylvania, became at age 22 the youngest general to serve in the Civil War. After the Civil War he served in the South and on the western frontier before retiring to Philadelphia. The General Pennypacker Memorial Committee sponsored this monument in collaboration with the State Art Commission. The basic concept was developed by Charles Grafly, an instructor at the Pennsylvania Academy of the Fine Arts who had studied at the Ecole des Beaux-Arts in Paris. In addition to his sculptures for the Smith Memorial (**3-19**), he had created a massive statue of General Meade for Washington, D.C. But Grafly died before the Pennypacker Memorial could be completed. The project was taken over by his student Albert Laessle, who was already known in Philadelphia for his *Billy* (**4-05**) in Rittenhouse Square and his *Penguins* (**4-08**) at the Zoo. In keeping with the Beaux-Arts tradition, the monument portrays the youthful general in classical costume. With energetic determination the figure strides forward on top of a gun carriage flanked by two tigers.

4-50

John Gregory (1879–1958)
General Anthony Wayne
1937
Gilded bronze, on base of Cold Spring rainbow granite. Height 12' (base 13' 6")
Philadelphia Museum of Art, East Terrace
Benjamin Franklin Parkway

"Mad Anthony" Wayne, Pennsylvania's foremost military hero of the Revolutionary War, led the bayonet attack on the fort of Stony Point and played a major role in the battles of Brandywine and Germantown and the siege of Yorktown. In 1893, nearly a century after his death, the Pennsylvania Society of Sons of the Revolution decided to commemorate the general with a monument. Another four decades passed before the society accumulated enough funds to commission the statue by John Gregory.

An Englishman by birth, Gregory came to the United States at the age of 14. At 20 he was employed as an office worker by the sculptor John Massey Rhind (see **3-19, 3-23, 3-24,** and **4-12**). The exposure to art provided a turning point, and Gregory soon enrolled in art school. After a dozen years as a student and sculptor's assistant, he won the Prix de Rome for study at the American Academy in Rome. He became one of the most honored sculptors of his era.

4-51

James Earle Fraser (1876–1953)
Benjamin Franklin
1938
Seravezza marble, on rose aurora marble base. Height 12' 6" (base 8' 4½")
Franklin Institute (interior)
20th Street and Benjamin Franklin Parkway
For access call 448 1329

James Earle Fraser was once called the nation's "most famous unknown sculptor." He is often recognized by his works—the buffalo nickel and a prodigious number of public monuments—rather than by his name. Fraser grew up on the American plains and studied in Paris in his late teens and twenties. His work was shaped by this combination of rugged Americanism with the classical sculptural tradition.

His *Benjamin Franklin*, a gift to the Franklin Institute from William L. McLean, was carved from 30 tons of Italian marble and rests on a 92-ton base of Portuguese marble. The artist described the pose: "I have conceived Franklin a massive figure, tranquil in body, with latent power in his hands, but with an inquisitive expression in the movement of his head and the alertness of his eyes, ready to turn the full force of his keen mind on any problem that concerned him."

4-52

Robert E. Larter (c. 1912–1970)
**Iron Plantation near
Southwark—1800**
1938
Oil on canvas. Height 7' 5"; width 15'
Southwark Branch Post Office (interior)
925 Dickinson Street
For access call 462 3136

During the Depression, Federal art programs employed thousands of artists from diverse backgrounds. Sometimes the works they created are referred to generically as "WPA art," but the Works Progress Administration was not the only agency involved. The Southwark post office mural by Robert Larter, a Yale graduate, was commissioned by the Treasury Department's Section of Fine Arts, which sponsored art works for post offices and federal buildings throughout the country (see pp. 102–104). Opposite *Iron Plantation* Larter painted *Shipyards at Southwark—1800* on a wall that is now out of public view.

4-53

Jo Davidson (1883–1952)
Walt Whitman
c. 1939; cast 1957
*Bronze, on granite base. Height 8' 6"
(base 4')*
*Broad Street and Packer Avenue
(installed 1959)*

*Afoot and light-hearted I take to
the open road, / Healthy, free, the
world before me, / The long
brown path before me leading
wherever I choose.*

So begins Walt Whitman's "Song of the Open Road," and the bronze by Jo Davidson captures the spirit of the free-striding American bard. This is a second cast from a plaster original exhibited at the New York World's Fair in 1939 and the 1949 Sculpture International in Philadelphia.

Davidson made a career of portrait sculptures; his subjects included Woodrow Wilson, Mahatma Gandhi, John D. Rockefeller, and Gertrude Stein. In developing his sculpture of Whitman, Davidson created a life-size clay figure with an armature of movable parts that he could twist and bend until he found the right pose. "I wanted Walt afoot and lighthearted," he explained in his autobiography, echoing the words of the poem; "I had to make a sure Whitman, a singing Whitman." In later years this portrait remained one of Davidson's favorites, perhaps because he himself looked much like Whitman and shared the poet's salty appreciation of life. Philadelphia's cast was commissioned by the Fairmount Park Art Association as a gift to the city. It stands near the approach to the Walt Whitman Bridge, only a few miles from the home in Camden where the poet spent his last years.

4-54

Municipal Court (now Family Court)
1931–1941

Giuseppe Donato (1881–1965)
East Pediment
1940

Louis Milione (1884–1955)
West Pediment
1940

*John T. Windrim, architect, succeeded by
W. R. Morton Keast*
Indiana limestone. Height 10'; width 43'
1801 Vine Street
See p. 115

4-55

Jacques Lipchitz (1891–1973)
**Prometheus Strangling
the Vulture**
1943; cast 1953
*Bronze, on bronze plinth and stone base.
Height 8'; length 7' 8" (plinth height
5¼"; base height 3' 3")*
*Philadelphia Museum of Art, Parkway
Entrance, East Terrace steps*
Benjamin Franklin Parkway

Moved by a sense of pity and justice, the Titan Prometheus stole fire from the gods and made a gift of it to the first humans. For this transgression, Zeus had him chained to a high rock in the Caucasus, where a giant bird of prey pecked at his vitals. He remained imprisoned there for eons until freed at last by Hercules. So runs a familiar version of the Greek myth. In Jacques Lipchitz's version, however, Prometheus literally takes matters into his own hands. The massive bronze presents the Titan broken free of his chains, strangling the bird that has tormented him. The sculpture is directly symbolic, expressing the ongoing struggle between good and evil, humanity and intolerance.

Born in Lithuania, Lipchitz migrated illegally to Paris at the age of 18 and by his mid-twenties was a leading sculptor of the Cubist movement. As the political situation in France grew more ominous, Lipchitz, as a Jew, had to confront the implications of the rise of Nazism. His work changed in theme and technique as he strove to express a more complex, darker vision of the world.

In 1939, Lipchitz and his wife fled Paris; two years later they arrived in New York, where the sculptor soon managed to rebuild his career. In 1952, his 1943 plaster sculpture of *Prometheus* won the George D. Widener Gold Medal in an exhibition at the Pennsylvania Academy of the Fine Arts. The Philadelphia Museum of Art quickly purchased the plaster and arranged for Lipchitz to supervise its casting in bronze. At that time the purchase represented the Museum's largest payment for a work by a living sculptor. Now Lipchitz's *Prometheus*, with its intense one-eyed stare, continues the eternal battle on the Museum steps. Lipchitz's other major public works for Philadelphia are *The Spirit of Enterprise* (**4-38**) and *Government of the People* (**5-11**).

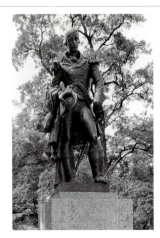
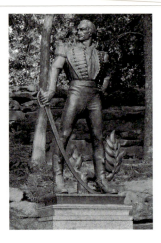
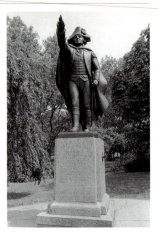

William M. Reilly Memorial
1938–1961
Terrace northwest of the Philadelphia Museum of Art

In his will of 1890, General William M. Reilly of the Pennsylvania National Guard established a trust fund for the purpose of creating monuments to Revolutionary War heroes. In 1938, when the fund reached the necessary level, the trustees set the project in motion, and four bronze statues were installed by 1947. Although Reilly had requested a site near Independence Hall, the larger-than-life figures were placed instead on the terrace northwest of the Art Museum. C. Louis Borie, Jr., one of the architects of the museum itself, designed the granite bases. The first four sculptures commemorated Montgomery, Pulaski, von Steuben, and Lafayette, volunteers from other lands who "threw themselves into the cause of emancipating the colonies from the yoke of British tyranny." The statues of Jones and Greene were added later.

4-56
J. Wallace Kelly (1894–1976)
General Richard Montgomery
(c. 1946)
Bronze, on granite base. Height 9′6″ (base 8′)

Philadelphian J. Wallace Kelly, who was already responsible for a number of other public sculptures in the city (**4-21, 4-26, 4-33,** and **4-47**), completed the first of the Reilly monuments, a tribute to a general whose career was both spectacular and short. Born in Ireland, Richard Montgomery served with the British army in America during the French and Indian War. In 1772 he emigrated to the American colonies, and when the Revolutionary War broke out he was commissioned a brigadier general. In the Canadian campaign of 1775 he quickly captured the cities of St. John's and Montreal. He then joined forces with Benedict Arnold to attack Quebec, and in that unsuccessful assault Arnold was wounded and Montgomery died in the field.

4-57
Sidney Waugh (1904–1963)
General Casimir Pulaski
c. 1947
Bronze, on granite base. Height 9′4″ (base 7′6″)

Opposite the Montgomery monument is a stern, sword-wielding portrait of General Casimir Pulaski, a Polish nobleman who served under George Washington. After distinguishing himself in the Battle of Brandywine, Pulaski set up an independent cavalry corps, Pulaski's Legion, in Baltimore. The corps was sent to fight in the South, where Pulaski was killed during the siege of Savannah. The sculptor, Sidney Waugh, was himself a much-decorated veteran of World War II. As an artist, Waugh was known for his architectural sculpture on Federal buildings in Washington, D.C., and his friezes on the Buhl Planetarium in Pittsburgh.

4-58
Warren Wheelock (1880–1960)
General Friedrich von Steuben
c. 1947
Bronze, on granite base. Height 9′6″ (base 7′7″)

A Prussian military expert, Friedrich von Steuben joined the American forces as inspector general in 1778. After helping to instill discipline and professionalism in the troops at Valley Forge, von Steuben led his own command in the siege of Yorktown. Unlike Montgomery and Pulaski, he survived the war and, on a congressional pension, lived the rest of his life in upstate New York. Warren Wheelock, a volunteer in the Spanish-American War, taught himself sculpture after an early career as a commercial artist and teacher. By the time of his commission for the Reilly Memorial, he had created sculptures of Lincoln, Washington, Walt Whitman, and Babe Ruth.

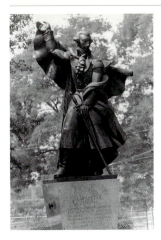

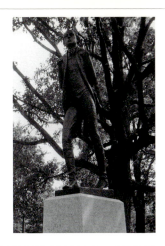

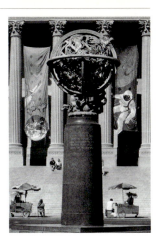

4-59

Raoul Josset (1899–1957)
Marquis de Lafayette
c. 1947
Bronze, on granite base. Height 10' 5"
(base 7' 6")

The most famous of the foreign volunteers in the Revolutionary War was the Marquis de Lafayette, a French nobleman who sailed for America at the tender age of 20 to offer his military services free of charge. Commissioned a major general, he joined Washington's staff and took part in the Battle of Brandywine, the long winter at Valley Forge, and the campaign of Rhode Island. After a brief return to France, he helped to defeat General Cornwallis in Virginia. In later years the new nation showed its gratitude by granting him large tracts of land in Louisiana and Florida. The flamboyant Lafayette is portrayed in a dynamic pose by Raoul Josset. Though born in New York, Josset was educated in Paris, and in the aftermath of World War I he created war memorials throughout France. He became well known for his monumental sculptures at the Chicago World's Fair (1933) and the Texas Centennial Exposition (1936).

4-60

Walker Hancock (1901–)
John Paul Jones
1957
Bronze, on granite base. Height 9' 5"
(base 7' 8")

Born in Scotland, John Paul Jones commanded a merchant ship at 22, but after killing a sailor during a mutiny he fled to America to escape prosecution. When the Revolutionary War began, he quickly attained the rank of captain in the Continental navy and became celebrated for raids along the coasts of England and northern Ireland, especially for the 1779 battle in which he captured the British ship *Serapis*. During this encounter, when the British commander called on the Americans to surrender, Jones supposedly retorted, "I have not yet begun to fight."

Walker Hancock is a former chairman of the sculpture department at the Pennsylvania Academy of the Fine Arts. Art historian Beatrice Gilman Proske praised his *John Paul Jones* for its "striking impression of the doughty seaman's character." Hancock also created the *Pennsylvania Railroad War Memorial* (**4-64**).

4-61

Lewis Iselin, Jr. (1913–)
General Nathanael Greene
c. 1960
Bronze, on granite base. Height 9' 3"
(base 7' 1")

Nathanael Greene is the only native-born hero to be honored in the Reilly Memorial. Scion of a Rhode Island Quaker family, he served in the battles of Trenton, Brandywine, and Germantown. During the winter at Valley Forge he was appointed quartermaster general, in which capacity he helped to improve the supply system. Late in the war he commanded forces in the South that drove the British back toward the coast at Charleston. For this campaign he became known as "the man who saved the South." Lewis Iselin, Jr., created sculpture for the U.S. military cemetery in Suresnes, France, after World War II, yet his contemplative figure of Greene is perhaps the least martial of the sculptures in the Reilly Memorial.

4-62

Paul Manship (1885–1966)
Aero Memorial
1948
Bronze, on granite base. Height 8'
(base 9' 8")
Logan Square (installed 1950)
20th Street and Benjamin Franklin Parkway

The bronze sphere opposite the main entrance of the Franklin Institute is dedicated to the aviators who died in World War I. Inscribed with the Latin names of constellations and planets, the *Aero Memorial* illustrates the signs of the zodiac in a style that recalls both classicism and Art Deco.

The artist, Paul Manship, was a leading figure in American sculpture for several decades. Profoundly influenced by classical Roman and archaic Greek art, he received many major sculpture awards in the United States and abroad, and his famous *Prometheus* dominates Rockefeller Center in New York. *Duck Girl* (**4-03**) in Rittenhouse Square is one of his early works.

The idea for the *Aero Memorial* was conceived by the Aero Club of Pennsylvania, which donated modest funds for this purpose to the Fairmount Park Art Association in 1917. Fundraising took many years, and the work did not begin until 1939, when the Art Association contacted Manship. The idea of a celestial sphere was finally approved in 1944. Manship had already executed a number of similar spheres, including one for the Woodrow Wilson Memorial at the League of Nations in Geneva.

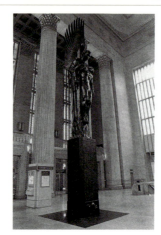

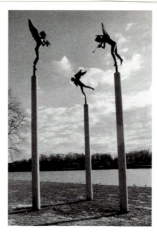

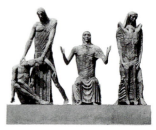

4-63

Violet Oakley (1874–1961)
Great Women of the Bible
1949
Oil on canvas, attached to plaster. Height
c. 25'; width c. 20'
First Presbyterian Church of Germantown
(interior)
35 West Chelten Avenue
For access call 843 8811

In the mid-1940s Mrs. W. Beatty
Jennings, wife of the former
pastor at the First Presbyterian
Church in Germantown, con-
tacted Violet Oakley about
painting a mural of the Annunci-
ation for the reception hall of the
Pastoral Aid Society. When
Oakley discovered that this
society was the women's organiza-
tion of the church, she persuaded
the group to sponsor an entire
series of murals focusing on "the
great women forerunners and fol-
lowers of Christ." Completed in
1949, the murals are collectively
known as *Great Women of the
Bible*. In addition to the Annunci-
ation, the paintings illustrate the
Adoration of the Magi, Eve
beguiled by the serpent, and
other themes from the Old and
New Testaments. One scene, Eve
at the feet of Mary, is taken from
Dante's *Paradiso*. Stylized trees
bear the names of the "army of
women" Oakley culled from both
testaments; direct ancestors of
Christ are inscribed on the
trunks, while others are named
on the boughs.
 Born and raised in northern
New Jersey, Oakley studied in
New York, Paris, and England
before moving with her family to
Philadelphia in the 1890s. She
created murals for the State Cap-
itol (see p. 104), and her *Life of
Moses* is in the Sanctuary of the
Fleisher Art Memorial (see
p. 110).

4-64

Walker Hancock (1901–)
**Pennsylvania Railroad War
Memorial**
1950
Bronze, on black granite base. Height 39'
(base 2')
30th Street Station (interior)
30th and Market Streets

Commissioned to honor Pennsyl-
vania Railroad employees who
died in World War II, Walker
Hancock's heroic bronze presents
the Archangel Michael, angel of
the Resurrection, lifting a lifeless
soldier in his arms. The angel's
great wings point directly upward
as he frees the youth from the
flames of battle. The high col-
umns of 30th Street Station form
a dramatic backdrop, and the
pedestal bears the names of all
1,307 railroad employees who
perished in the war. Many
people recall the sculpture from
the early scenes of the film
Witness.
 After studying in his native
St. Louis and later at the Penn-
sylvania Academy of the Fine
Arts, Hancock built a national
reputation for garden sculpture,
portraits, and sculpture inte-
grated with architecture. During
World War II he served with an
overseas military unit concerned
with fine arts and archives.
When the hostilities ended, he
brought considerable personal
feeling to the creation of war
memorials. He contributed three
angels of victory to the tower of
the Lorraine American Cemetery
in Saint-Avold, France, but his
best-known angel is the compas-
sionate Michael of 30th Street
Station. The poet Robert Frost
voiced his admiration for this
monument. Hancock also fash-
ioned the statue of John Paul
Jones for the Reilly Memorial
(**4-60**).

4-65

Carl Milles (1875–1955)
Playing Angels
c. 1950
Bronze, on concrete bases. Height 7'
(bases 20'–23')
Kelly Drive at Fountain Green Drive
(installed 1972)

Three slim angels concentrate
raptly on their music as they
hover above the grass along Kelly
Drive. The work of Swedish-born
artist Carl Milles, they are casts
from a group of five originals
from the Millesgarden in Stock-
holm, where they overlook that
city's harbor.
 Apprenticed at an early age
to a cabinetmaker in Stockholm,
Milles began to study art in night
school. At 22 he left for Paris
and earned a precarious subsis-
tence by hawking souvenirs and
working for a coffinmaker until
he became an assistant to the
sculptor Auguste Rodin.
 Milles' style combined conser-
vative, pictorial elements with a
poetic and popular spirit. His
characteristically slender figures
often have a childlike innocence
and vulnerability that make them
immediately appealing to the
public. Originally all five casts of
the *Playing Angels* were intended
for a private site in Philadelphia.
When the plans dissolved, one
angel went to Kansas City and a
second to Falls Church, Virginia;
the remaining three were pur-
chased by the Fairmount Park
Art Association.

4-66

Jacob Epstein (1880–1959)
Social Consciousness
1954
Bronze, on granite base. Height 12'2"
(base 2'3")
Philadelphia Museum of Art, West
Entrance
Benjamin Franklin Parkway

The Eternal Mother, seated with
arms outstretched, casts a stern,
sorrowful look at visitors who
enter the west doors of the
Museum of Art. Flanking her,
The Great Consoler reaches down
to comfort a stricken youth, and
Succor (or *Death*) supports a
young man who bends backward
to embrace her shoulders. The
entire group by Jacob Epstein,
known as *Social Consciousness*,
suggests not only the tenderness
and sympathy of humankind but
also the affliction that makes
these virtues necessary.
 Born in New York, Epstein
moved to London as a young
man. One of the first Westerners
to develop a deep appreciation of
"primitive" and traditional art,
he displayed a particular interest
in images of maternity and fer-
tility. But his career was punctu-
ated by controversy, and his
public commissions often
prompted such adjectives as
"ugly," "vulgar," and "vile."
 The commission for *Social
Consciousness* came from the Fair-
mount Park Art Association,
which wanted to include in the
Samuel Memorial a work
expressing the American ideal of
brotherhood (see p. 108). But as
Epstein's massive sculpture took
shape, the artist and the Art Asso-
ciation realized that the planned
site in the Samuel Memorial
could not accommodate it.
Installed instead at the west
entrance of the Museum in 1955,
Social Consciousness has upheld
Epstein's reputation for contro-
versy. Some critics complain that
the figures look unnatural; others

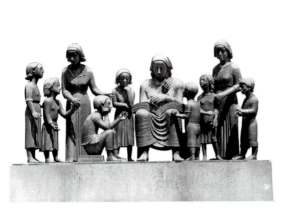

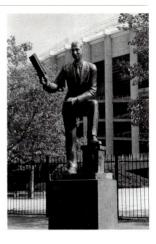

object to the lack of strong visual unity among the three groups. Still others praise the work's amalgamation of Western and Eastern influences and its "hieratic" stylization, which suggests a timeless emotion. It could be argued that the very awkwardness of the figures emphasizes the precariousness and suffering of the human condition.

4-67
Waldemar Raemisch (1888–1955)
The Great Mother (above) and
The Great Doctor
1955
Bronze, on concrete bases. Maximum height 11'4" (bases 3'); width c. 20' (each group); depth 5'
Youth Study Center
20th Street and Benjamin Franklin Parkway

The southwestern facade of the Youth Study Center, a juvenile detention facility designed by the architects Carroll, Grisdale and Van Alen, presents a large expanse of unadorned wall at each end. For the lawn in front of these blank areas, the architects commissioned sculptures by Waldemar Raemisch to represent the "spirit of juveniles." In each of the two groups, a seated, central figure is surrounded by idealized compositions of children and attending adults. The central figures symbolize a universal Mother and a Doctor or Healer, respectively—allegorical expressions of the care, comfort, and guidance that adults can offer to children. From a distance each group blends into a whole, almost as if the figures were carved in relief on the building itself.

A refugee from Nazi Germany, Raemisch taught at the Rhode Island School of Design. *The Great Mother* and *The Great Doctor* were his last works, for he died suddenly as he supervised their casting at a foundry in Rome. Raemisch also created *The Preacher* for the Samuel Memorial (**4-43**).

4-68
Joseph J. Greenberg, Jr. (1915–1991)
Bear and Cub
1957
Black granite. Height 3'7" (base 11")
Philadelphia Zoological Gardens, near Bear Country exhibit
34th Street and Girard Avenue
For access and admission fee call 243 1100

More approachable than the average bruin, and even more durable, the mother bear and her cub were commissioned for the Philadelphia Zoo by the Fairmount Park Art Association. These supple forms in black granite represented the first major commission for local sculptor Joseph Greenberg.

Born in Philadelphia, Greenberg studied at Temple University's Tyler School of Art with Raphael Sabatini (see **4-21**). After a stay in Italy in the early 1950s, he returned to Philadelphia, where he began to experiment with works in fiberglass and reinforced plastic. As *Bear and Cub* attests, Greenberg was equally skilled in more traditional media. He also created a limestone gorilla, chimpanzee, and orangutan for the Zoo, and his sculptures appear in schools, recreation centers, and other public and private sites throughout Philadelphia. He helped persuade local officials to establish the city's landmark percent-for-art program (see pp. 131–132).

4-69
Harry Rosin (1897–1973)
Mr. Baseball
1957
Bronze, on granite base. Height 7'6" (base 5'6")
Veterans Stadium (relocated 1972)
Broad Street and Pattison Avenue

For old-time Philadelphia baseball fans, there is only one "Mr. Baseball," and the sculpture at Veterans Stadium presents him in a characteristic pose: impeccably dressed, one foot on the dugout step, gesturing with his scorecard as he looks out to the field. Connie Mack, born Cornelius McGillicuddy, managed the Philadelphia Athletics for half a century, and when he died in 1956 a committee was formed to create a memorial to him. Funds were raised by appeals to baseball fans across the country.

The committee selected the Philadelphia sculptor Harry Rosin, already known for his contributions to the Samuel Memorial (**4-40**). Rosin had begun his artistic career by working for Samuel Yellin, the master craftsman in wrought iron (see **4-13**); later he studied sculpture with Charles Grafly at the Pennsylvania Academy of the Fine Arts (see **3-19, 4-49**). Rosin's affectionate tribute to Connie Mack was installed in 1957 across from the old baseball stadium at 20th Street and Lehigh Avenue. Over the years it suffered from neglect—"visited more by pigeons than by people," according to one newspaper account—until in 1972 it was moved to the new stadium in South Philadelphia.

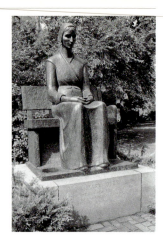

4-70

Ellsworth Kelly (1923–)
**Transportation Building
Lobby Sculpture**
1957
Anodized ⅛" aluminum. Height 12';
width 64'; depth 1'
6 Penn Center (interior)
17th Street between Market Street and
John F. Kennedy Boulevard
For access call 563 3356

One hundred and four panels of
aluminum, arranged in four rows
on a double-bar grid, form the
abstract composition that
stretches across the lobby of 6
Penn Center. Twenty-eight of the
irregular panels are anodized
blue, red, black, or yellow, and
these colored pieces are distrib-
uted with a studied randomness
across the whole, creating an inter-
play of light, color, and shape.

Along with *Seven Sculptural
Screens in Brass*—a series of
dividing walls installed in the
building but later removed—the
*Transportation Building Lobby
Sculpture* was commissioned for
the site by architect Vincent
Kling. The work was the first
sculptural commission for Ells-
worth Kelly, and Philadelphia's
earliest example of abstract
public art (see p. 117).

The site imposes many restric-
tions on the work, and the sculp-
ture has been criticized for its
complex and cramped relation-
ship to the architecture. It is diffi-
cult to find a good angle, from

either outside or inside the
building, to see the sculpture as a
whole. But Kelly no doubt under-
stood the site's limitations, and he
may well have intended the sculp-
ture to be seen in tantalizing bits
and pieces. "I've always been inter-
ested in fragmentation, in aper-
tures, doors and windows," Kelly
told an interviewer in 1973.
"When you look through them,
that fragmented view changes as
you move, and you get a series of
different pictures."

5-01

Sylvia Shaw Judson (1897–1978)
Mary Dyer
1960
Bronze, on granite base. Height 6' 11"
(base 1' 9½")
Friends Center (installed 1975)
15th and Cherry Streets

Mary Dyer, a "Comely, Grave
woman, and of a good Per-
sonage," was hanged in Boston
in 1660, a martyr to her Quaker
belief in freedom of religion. Her
execution created an uproar, and
King Charles II ordered the
colony of Massachusetts Bay to
cease its persecution of Quakers.
Although John Greenleaf Whit-
tier recounted Dyer's story in
"The King's Missive," it was not
until 1945 that Massachusetts
planned a public monument.
Sylvia Shaw Judson, a Quaker
sculptor who had trained at the
Art Institute of Chicago and
studied in Paris, received the
commission and later arranged
with the Fairmount Park Art
Association for a second cast to
be placed in Philadelphia. In
1975 the sculpture, then in
storage, came to the attention of
H. Mather Lippincott, architect
of the new addition to the
Society of Friends complex.
Placed on long-term loan to the
Friends Center, the work was
installed as part of the Redevelop-
ment Authority's Fine Arts
Program.

Judson portrays Dyer in a
quiet moment, sitting on a bench
during a Meeting for Worship,
her hands in her lap and her
head lowered. Simplicity of style
reinforces the aura of quiet deter-
mination.

5

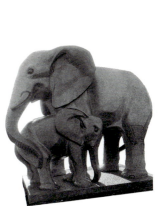

5-02

Constantino Nivola (1911–1988)
Family of Man
1961
Concrete and sand. Height 10' 6";
width 18' 3" (each of two reliefs)
University of Pennsylvania
Entrance to Van Pelt Library, near
Blanche Levy Park
Between 34th and 36th Streets, Locust
and Spruce Streets

While building sand castles with
his children on a Long Island
beach, the Sardinian artist Con-
stantino Nivola conceived a new
kind of sculpture: bas-reliefs that
would be molded in damp sand
and then cast in concrete. Both
Family of Man and *Dedicated to
the American Secretary* (**5-17**)
result from this innovative tech-
nique.

Nivola trained in masonry
and ornamental stucco work
before winning a scholarship to
the Institute of Art in Monza,
Italy. He had a lifelong interest
in the relationships among art,
architecture, and landscape.
Moving to the United States in
1939, he established himself as a
painter, graphic designer, and
sculptor.

Typically his bas-reliefs
include a multitude of abstract
forms that suggest images from
the human and natural world.
For many observers they also
bring to mind a collection of
ancient artifacts. Because parti-
cles of sand adhere to the surface
during the molding process, the
reliefs have an intriguing grainy
texture that changes gradually
over time. *Family of Man*, two
separate reliefs facing outward
on either side of the Van Pelt
Library's front steps, was commis-
sioned by the University of Penn-
sylvania.

5-03

Heinz Warneke (1895–1983)
Cow Elephant and Calf
1962
Granite. Height 11' 4" (including base);
length 12' 3"
Philadelphia Zoological Gardens, near
main entrance
34th Street and Girard Avenue
For access and admission fee call
243 1100

Years ago a traveler on the train
from New Haven to Washington
glanced out the window as his
car passed the Philadelphia Zoo.
"Just look," he exclaimed to his
wife, "at that mother elephant
left wandering about loose at this
hour with her calf. What in the
world do the Zoo people mean?"

This story was gleefully
related in a letter by sculptor
Heinz Warneke, who was respon-
sible for the apparent transgres-
sion. Warneke's *Cow Elephant
and Calf*, a life-size, 37-ton mon-
olith, stands near the Zoo's main
entrance. It is considered the
largest free-standing single-block
sculpture in the United States.
The immense block of stone—a
gray Bergan granite that simu-
lates an elephant's hide—was
quarried and rough-cut at the
small Norwegian town of Larvik.
The final carving was done by
Oslo stonecutters guided by
Warneke.

As indicated by his commis-
sion for *The Immigrant* (**4-36**) in
the Samuel Memorial, Warneke
was a highly respected sculptor.
In the early 1940s he carved the
work for which he is best known
in Pennsylvania, the *Nittany Lion*
on the Penn State campus in
State College.

5-04

Henry Mitchell (1915–1980)
Impala Fountain
1962–1963
Bronze. Height 20'; pool 68' by 34'
Philadelphia Zoological Gardens
34th Street and Girard Avenue
For access and admission fee call
243 1100

In front of the Rare Animal
House, ten streamlined bronze
impalas, caught in the instant of
flight from an unseen predator,
leap high over the jets of a black
granite fountain, while a mother
impala and calf stand, apparently
unaware of any danger, at the
pool's edge. These sculptures are
the work of Henry Mitchell, an
Ohio native who became one of
Philadelphia's best-known
animal sculptors. *Impala Foun-
tain* is considered the finest
achievement of Mitchell's career.
Mitchell's *Hippo Mother and
Baby* was also commissioned by
the Zoo. Other works at outdoor
sites around the city include
Winged Ox and Column at
Thomas Jefferson University;
Running Free, a sculpture of
three exuberant horses at Drexel
University; and *Courtship, Henry
M. Phillips Memorial Fountain*,
in the East Terrace of the Art
Museum. As the art critic
Edward Sozanski remarked,
Mitchell's animals are "user-
friendly"; many were designed as
play sculptures, and all empha-
size the joyful and gentle side of
nature. Often, as in his impalas,
Mitchell made extensive use of
"negative space"—holes to indi-
cate the animals' recessive areas
or fur patterns.

5-05

Seymour Lipton (1903–1986)
Leviathan
1963
Nickel silver on Monel metal, with
granite base. Height 3' 4½" (base
7' 10½")
Penn Center Plaza (installed 1969)
16th Street between Market Street and
John F. Kennedy Boulevard

Leviathan is the sea monster
mentioned in the Bible, often
identified with the whale or croc-
odile. "None is so fierce that
dare stir him up," Jehovah warns
Job; "he maketh the deep to
boil." Seymour Lipton's sculp-
ture uses a stylized whale form to
explore the primal forces of
nature. The material, Monel
metal (a white bronze alloy con-
sisting of nickel, copper, iron,
and manganese), was one of
Lipton's favorite media; he
achieved the unusual texture by
spreading molten nickel over the
surface.

Leviathan was exhibited in
Penn Center during the 1967
"Art for the City" project (see
p. 130). In 1969 it was purchased
through the City Planning Com-
mission with grant funds
received from the National
Endowment for the Arts.

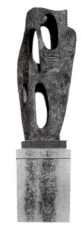
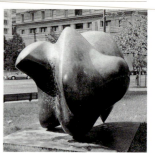

5-06

Nathan Rapoport (1911–1987)

Monument to Six Million Jewish Martyrs

1964

*Bronze, on granite base. Height 18'
(base 4' 4½")*

*16th Street and Benjamin Franklin
Parkway*

In the flames of a burning bush,
an anguished or dying mother
reclines, and above her a wailing
child throws out its arms. A man
raises his hands in prayer, while
another pair of hands holds the
Torah scrolls. Near the top, fists
clutch daggers, symbols of resis-
tance. At the apex the flames
become the blazing candles of a
menorah. This impassioned
memorial to the victims of the
Holocaust was commissioned by
the Association of Jewish New
Americans, which donated the
monument to the city in 1964 in
conjunction with the Federation
of Jewish Agencies of Greater
Philadelphia. Although the
work's theme is tragic and terri-
fying, it conveys a sense of spir-
itual redemption, as indicated by
the symbol of the burning bush
through which God appears to
Moses in Exodus 3:2: "Behold,
the bush burned with fire, and
the bush was not consumed."

The sculptor, Nathan
Rapoport, was born in Warsaw.
His *Warsaw Ghetto Uprising Mon-
ument* was erected after the war
on the spot where the struggle
began.

5-07

Evelyn Keyser (1922–)

Mother and Child

1964

*Bronze, on concrete base. Height 6'
(base 5")*

District Health Center Number 2

Broad and Morris Streets

Mother and Child was one of the
earlier results of the 1959 city
ordinance requiring that one per-
cent of the construction funds for
new municipal buildings be
devoted to fine arts. Both figures
gaze toward the sky—an attitude
explained by the work's alterna-
tive title, *See the Moon.*

A native of South Philadel-
phia, Evelyn Keyser attended
high school only a few blocks
from the site where the sculpture
now stands. Along with her twin
sister, painter Elsie Manville,
Keyser won a scholarship to
Temple University's Tyler School
of Art. Early in her career she
became known for wooden sculp-
tures that created a monumental
effect even when the dimensions
were small. *Mother and Child*
was her first sculpture that was
literally larger than life.

5-08

Barbara Hepworth (1903–1975)

Rock Form (or **Porthcurno**)

1964

*Bronze, on granite-clad base. Height
7' 11"; width 2' 6"; depth 1' 9 (base 5')
Pincus Brothers–Maxwell (installed 1979)
5th and Race Streets*

When Barbara Hepworth first
experimented with piercing a
hole in a sculpture, she "thought
it was a miracle. A new vision
was opened" (see pp. 144–145).
This was in 1931; in the fol-
lowing decades she refined and
extended the concept, sometimes
painting the holes or stringing
them with wire like musical
instruments. Her *Rock Form* is
one of an edition of six produced
in 1964. It was purchased by
Pincus Brothers-Maxwell in 1979
as part of the Redevelopment
Authority's Fine Arts
requirement.

5-09

Henry Moore (1898–1986)

**Three-Way Piece Number
1: Points**

1964

*Bronze, on granite base. Height 7' 3";
width 7' 5"; depth 6' 5" (base 4")
Benjamin Franklin Parkway between
16th and 17th Streets (relocated 1990)*

"Sculpture," said the English
artist Henry Moore, "should
always at first sight have some
obscurities, and further mean-
ings." His one-ton bronze on
the Parkway is an example of
such visual ambiguities. It may
appear to be a massive, pol-
ished, three-pointed stone, or a
weighty animal, with its three
"points" like paws on which it
delicately balances, or a
hunched bird. From certain
angles it even suggests a giant
tooth or a gnawed bone. What-
ever one's first impression may
be, the work changes as the
viewer walks around it.

"Pebbles and rocks show
Nature's way of working stone,"
Moore wrote in 1934. "Bones
have marvellous structural
strength and hard tenseness of
form, subtle transition of one
shape into the next and great
variety in section."

Moore received more com-
missions than any other sculptor
of his generation; his major
works appear at such sites as
the Lincoln Center in New
York, the UNESCO headquarters
in Paris, and the National Gal-
lery of Art in Washington. Phila-
delphia's *Three-Way Piece* was
purchased by the Fairmount
Park Art Association in 1967
and installed in John F. Ken-
nedy Plaza. In 1990 the sculp-
ture was relocated to a
landscaped area along the
Parkway (see pp. 128–129, 143,
184–185).

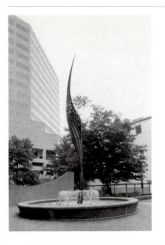
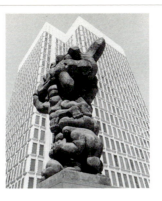
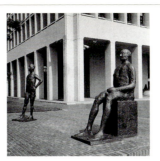
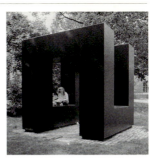

5-10

Clark B. Fitz-gerald (1917–)
Milkweed Pod
1965
Copper and stainless steel. Height 21'
Rohm and Haas Building
6th and Market Streets

When the chemical firm Rohm
and Haas erected a new head-
quarters in the Independence
Mall urban renewal area, Clark
Fitz-gerald was commissioned to
create a sculpture for the court-
yard under the aegis of the Re-
velopment Authority's Fine Arts
Program. *Milkweed Pod* was one
of the first examples of the pro-
gram's effect on the city environ-
ment (see p. 132).

A native of St. Louis, Fitz-
gerald studied at Washington
University and the Philadelphia
Museum and School of Indus-
trial Art. *Milkweed Pod* combines
a natural image—the release of
milkweed seeds into a breeze—
with formal, geometric elements.
The bright stainless steel seeds
contrast with the weathered
green copper pod.

5-11

Jacques Lipchitz (1891–1973)
Government of the People
1965–1976
Bronze, on granite base. Height c. 30'
(base 12')
Municipal Services Building Plaza
Broad Street and John F. Kennedy
Boulevard

An inverted pyramid of human
arms, legs, and torsos—that is
what *Government of the People*
appears to be at first glance.
With further study, however, the
figures emerge more clearly.
Those at the base resemble a
family group of father, mother,
and child—"the wellspring of
life," according to the artist. Far-
ther up are a young couple who
express "the hope and future of
society." At the top two mature
figures, a man and a woman,
hold aloft a turbulent form that
represents the banner of Philadel-
phia. The figures spiral upward
and grow from each other in a
totemlike arrangement. As a
symbol of democracy, the sculp-
ture suggests a process of con-
tinual struggle, mutual support
and dedication, and eventual tri-
umph; it carries on the heroic
themes of Lipchitz's *Prometheus
Strangling the Vulture* (**4-55**) and
The Spirit of Enterprise (**4-38**).

Jacques Lipchitz was origi-
nally commissioned under the
city's fine arts requirement. The
Fairmount Park Art Association
later took over the project in
order to have the sculpture in
place by the nation's Bicenten-
nial (see pp. 140–142).

5-12

Leonard Baskin (1922–)
**Old Man, Young Man, The
Future**
1966
*Bronze. Height: Old Man 6'5"; Young
Man 6'3"; The Future 4'3" (brick
base 5'3")*
Society Hill Towers
3rd and Locust Streets

A young man, standing, and a
seated older man confront a
winged creature representing the
future. According to Leonard
Baskin, the mythical bird also sig-
nifies external reality, "which is
good and bad, promising and
ominous." Baskin created this
sculpture, his first major one for
an outdoor setting, as part of the
Redevelopment Authority's one
percent program. The sur-
rounding apartment complex,
designed by I. M. Pei, was a land-
mark in Philadelphia's urban
renewal.

Calling himself a "moral
realist," Baskin has denounced
nonfigurative art as "an art of
cowardice, a triumph of the
trivial, a squandering of trea-
sure." He has stated that one of
the greatest goals of art is to
convey a deep human experience
to the viewer. "The human
figure," he once said, "is the
image of all men and of one
man. It contains all and it can
express all."

5-13

Tony Smith (1912–1980)
We Lost
1966
*Painted steel. Height 10'6"; width
10'6"; depth 10'6"*
University of Pennsylvania
Blanche Levy Park (installed 1975)
Near 36th Street and Locust Walk

A hulking open cube of welded
steel, painted black, stands in the
midst of a grassy area near Col-
lege Hall on the Penn campus.
This sculpture's two inverted U
shapes, joined together at their
tips, can be walked through but
also create a boxed-in feeling.
We Lost was first exhibited as
part of the Institute of Contempo-
rary Art's "Art for the City" (see
p. 135). The university purchased
it as part of the Redevelopment
Authority's percent for art pro-
gram, assisted by a grant from
the National Endowment for the
Arts.

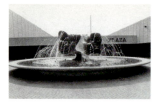

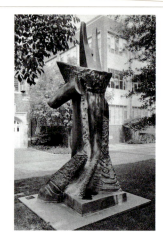

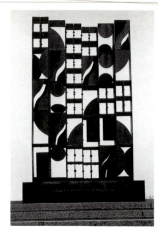

5-14

Harry Bertoia (1915–1978)
Free Interpretation of Plant Forms
1967
Copper tubes, bronze rods, in fountain basin. Height c. 12'; width c. 14'; depth c. 18'
Civic Center Plaza
34th Street and Convention Boulevard

Harry Bertoia's four-ton *Free Interpretation of Plant Forms* echoes the wave and trough forms and the sinuous curls of moving water. The fountain sculpture at Civic Center Plaza was commissioned to fulfill the city's fine arts requirement. Bertoia deliberately chose dark tones for the sculpture to contrast with the lighter walls around the plaza.

A native of a small village in Italy, Bertoia emigrated to the United States with his father in 1930. After becoming an American citizen in 1946, he moved to the small town of Bally in eastern Pennsylvania, where he created works of astonishing variety. For the University of Pennsylvania he designed the Annenberg Center's huge pendant, *Homage to Performing Arts*. Late in his career, Bertoia helped to broaden the very definition of sculpture with massive kinetic constructions whose parts moved together in the wind to produce strange swells of sound.

5-15

Alexander Archipenko (1887–1964)
King Solomon
1968
Bronze, on bluestone base. Height 14' 6" (base 3")
University of Pennsylvania
36th Street Walkway south of Walnut Street (installed 1985)

The influential Cubist sculptor Alexander Archipenko did not normally work on a monumental scale, but shortly before his death in 1964 he completed a 4-foot *King Solomon* that was designed for enlargement. His widow supervised the casting of a 14.5-foot, 1.5-ton version, and in 1985 this majestic bronze came to the University of Pennsylvania campus on extended loan from Mr. and Mrs. Jeffrey Loria, the parents of a Penn student.

Mixing hard angles with hollow curved spaces, *King Solomon* clearly recalls Archipenko's Cubist origins. The sculpture suggests a figure of the Old Testament monarch dressed in a robe, posed in a forceful stance with one foot forward.

5-16

Louise Nevelson (1899–1988)
Atmosphere and Environment XII
1970
Corten steel, on granite base. Height 18' 3"; width 10'; depth 5' (base height 2' 5")
Philadelphia Museum of Art, West Entrance (installed 1973)
Benjamin Franklin Parkway

Born in Kiev, Louise Nevelson moved with her family in 1905 to Rockland, Maine, where her father had begun a lumber business. Later she recalled that playing with wood scraps from the lumber yard influenced her to become a sculptor. In 1957–1958 she conceived of wooden collage "environments," wall-like sculptures painted entirely in one color and incorporating a myriad of abstract forms. Her long-standing interest in theater influenced both her concept of sculpture-as-environment and her use of vertical structures resembling stage sets.

Atmosphere and Environment XII is a product of her mature style. Made of 18,000 pounds of Corten steel, which gradually weathers to form its own patina, the work consists of six columns of five cubes each, bolted together. The cubes contain within them further geometric shapes, and the entire openwork composition seems to echo the severe landscape of a modern city. After exhibition in France and New York, the sculpture was purchased by the Fairmount Park Art Association. Another example of Nevelson's work in Philadelphia is *Bicentennial Dawn* (**6-02**).

5-17

Constantino Nivola (1911–1988)
Dedicated to the American Secretary
1970
Concrete and sand. Height 10' 6"; width 42'
Continental Building (interior)
4th and Market Streets
For access call 923 3322
Commissioned by Ludlow-Fourth Company as part of the RDA Fine Arts Program
See **5-02**

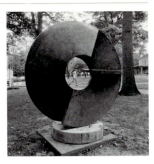

5-18

Robert Morris (1931–)
The Wedges
1970
Painted weathering steel. Height 4' 6";
width 20'; depth 20'
Kelly and Sedgley Drives (installed 1985)

Standing as if in convocation, eight wedges form a rounded square on the grass near Kelly Drive. Four curved pieces of steel form the corners of the square; four smaller straight pieces fill in the sides. From certain angles the work seems to float on the landscape, and the interior presents a mysterious locus from which the surrounding environment emanates.

The artist, Robert Morris, has always been interested in problems of perception. He studied engineering and art in his native Kansas City, then attended the California School of Fine Arts and Reed College in Oregon. After an early career as a painter, he turned his energies to sculpture and to improvisational works in dance and theater. Over the years he has been linked with such movements as minimalism, conceptual art, process art, earth art, and ecological art.

After exhibition at London's Tate Gallery in 1972, *The Wedges* was purchased by Mr. and Mrs. H. Gates Lloyd, who later donated the sculpture to the Fairmount Park Art Association. Originally the weathering steel surface was unpainted, but soon graffiti appeared on the work. In consultation with the artist, the Art Association painted the sculpture a rust color so that its even surface can be maintained.

5-19

Paul Keene (1920–) and
Neil Lieberman (1935–)
Martin Luther King Freedom Memorial
1971
Five fiberglass bas-reliefs. Central panel 7' square; other panels: height 2' 6"; width 3'
59th Street Baptist Church
59th and Pine Streets
For access call 474 8750

In 1968 members of the 59th Street Baptist Church decided to turn an underused church lawn into a garden where "people could come and meditate." When Martin Luther King, Jr., was assassinated later that year, the church resolved to place a memorial in the garden—a plan that was ultimately expanded to include other martyrs of the civil rights movement, both black and white. Funds came from bake sales, fashion shows, and benefit dinners, the Philadelphia Antipoverty Action Commission, other churches, and local businesses. As work proceeded, the Fairmount Park Art Association supported the sculpture commission (see p. 140). Sculptor Paul Keene was a Philadelphian who had taught at the Philadelphia College of Art and exhibited in the United States and Nigeria. Neil Lieberman chaired the Art Education Department at the Philadelphia College of Art.

The garden includes a fountain, curved benches, and five bas-reliefs by Keene and Lieberman. The largest relief, mounted on a brick wall above the fountain, portrays King addressing a large group. Church and neighborhood people, government officials, and relatives of the civil rights martyrs attended the dedication.

5-20

Edna Wright Andrade (1917–)
Belgian Block Courtyard
1972
Belgian block. Width 38' 3"; depth 82'
Salvation Army Community Services Building
Broad Street between Fairmount Avenue and Brown Street
For access call 787 2800

Instead of installing a separate "object" of art, Edna Andrade was commissioned to create a paving design for the courtyard next to the Salvation Army's new building. In 1971, this was an innovative means of satisfying the Redevelopment Authority's one percent requirement.

A designer, painter, sculptor, and muralist, Andrade had already executed a number of commissions in the Philadelphia area, including a mosaic mural for the Columbia Avenue branch of the Free Library. Her paving design for the Salvation Army can be seen as a natural extension of her earlier explorations in patterned compositions. The paving blocks are a greenish-black and pink-toned granite, arranged to emphasize textural and tonal contrasts. The greenish-black blocks form a swirling pattern linking the six locust trees that provide focal points for the design. Surrounding each of the trees is a circular pattern of pink blocks.

5-21

William P. Daley (1925–)
Helios
c. 1972
Tomasil bronze, on limestone base. Height 5' (base 6")
Germantown Friends School
31 West Coulter Street

For its T. Kite Sharpless mathematics and science building, dedicated in 1972, the Germantown Friends School commissioned William Daley to create an outdoor sculpture as part of the Redevelopment Authority's percent for art program. Daley faced the problem of representing not only the particular purpose of the new building but also the school's long tradition of Quaker education. He conceived a shape related to a double helix and a Möbius strip, mathematical forms that would suggest endless continuity. The title *Helios* suggests both the helical form and the ancient Greek god of the sun.

Daley is well known for his work in ceramics. For the RDA program, he also created a modular wall for the Ritz movie theater.

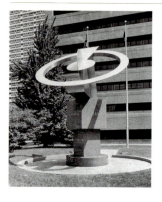
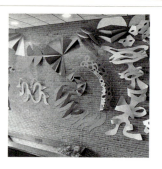
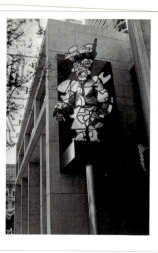
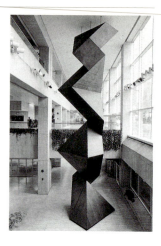

5-22

Dudley Talcott (1899–1986)
Kopernik
c. 1972
Stainless steel, on red granite base.
Height 12'; diameter 16' (base height 11' 8")
18th Street and Benjamin Franklin Parkway

Mikolaj Kopernik (1473–1543), better known as Nicolaus Copernicus, laid the foundations of modern astronomy. In an age when philosophers and the Church believed that the universe centered on the earth, the Polish mathematician and churchman dared to state that the earth revolved about the sun.

The memorial sculpture by Connecticut artist Dudley Talcott was commissioned and donated to the city by a committee of Polish Americans formed to honor Kopernik on the 500th anniversary of his birth. In Talcott's design, the 16-foot circle symbolizes the earth's orbit; fixed at the center is the sun, its rays extending to infinity. The angular framework alludes to Kopernik's homemade astronomical instruments, some of which were exhibited at the Franklin Institute before the sculpture's unveiling.

5-23

George Sugarman (1912–)
Untitled Wall Sculpture
c. 1972
Painted aluminum. Height 17'; width 23'; depth 18'
Albert M. Greenfield School (interior)
22nd and Chestnut Streets
For access call 299 3566

Brightly colored squiggles, fan-like objects, and other fantastic aluminum shapes have landed in the broad stairwell at the Greenfield public school as if cut from paper and tossed with enthusiasm. Commissioned for the school by the Albert M. Greenfield Foundation, this fanciful wall composition is the work of George Sugarman, a leader in the use of color to emphasize form.

Like his sculpture at the Greenfield school, Sugarman's aluminum *Wall Reliefs* for Wills Eye Hospital illustrate the musical and rhythmic nature of his work. The four reliefs, set into recesses in the wall of a parking garage along Locust Street near 9th Street, were commissioned as part of the Redevelopment Authority's percent for art program. An additional composition that arched over the hospital's main entrance and posed an obstacle for vision-impaired patients was placed on loan at the Morris Arboretum in 1991.

5-24

Jean Dubuffet (1901–1985)
Milord la Chamarre
1973
Stainless steel with black epoxy paint (granite platform on stainless steel column). Height 24' (base height 10' 2")
Market Street between 15th and 16th Streets (relocated 1990)

In acquiring *Milord la Chamarre* for Centre Square, developer Jack Wolgin was attracted by the figure's resemblance to a Philadelphia mummer in costume. Along with Oldenburg's *Clothespin* (**6-04**), *Milord* was installed in 1976 as part of the Redevelopment Authority's one percent program. The work also satisfied Wolgin's own expressed desire to offer "something outstanding—something that would be top level."

The artist, Jean Dubuffet, grew up in Le Havre, and studied art very briefly in Paris before entering his family's wine business. In 1942 he turned his full energies to art. Critics railed against his work, which seemed to insult artistic traditions. Undeterred, Dubuffet went on to develop his theories of *l'art brut*, a raw art untouched by convention. He believed that art, rather than offering beautiful lines and agreeable colors, should "dance and yell like a madman."

The irregular facets and heavy black epoxy tracings of *Milord la Chamarre* make the 5,000-pound work resemble a giant jigsaw puzzle, an effect both disturbing and humorous. With his open mouth and hands-out strut, *Milord* is a bit ridiculous, a bit fearsome, a bit sad—much like Everyman. Originally placed in the atrium of Centre Square, the work was relocated to the exterior when the building's new owners embarked on a major renovation.

5-25

Robinson Fredenthal (1940–)
Water (above)**, Ice, Fire**
1973
Welded steel.
Water: height 48'; width 12'; depth 12'.
Ice: height 28'; width 12'; depth 12'.
Fire: height 16'; width 12'; depth 12'
1234 Market Street (interior and exterior)
For access call 636 6300

Robinson Fredenthal has long been fascinated by the mysterious patterns made by simple geometric objects when they are joined, turned, or revolved through space. At 1234 Market Street, under the auspices of the Redevelopment Authority's one percent program, he created three steel sculptures based on linked tetrahedrons and octahedrons. *Water*, the largest of the three columns, extends from the basement level to the ceiling of the central lobby. Though from some angles it suggests a waterfall, its appearance changes as the viewer moves around it. *Ice* hangs like an angular icicle over the indoor subway entrance at the 13th Street corner. *Fire*, in the courtyard behind the building, loosely resembles a flame surging upward.

The New Hampshire-born Fredenthal studied at the University of Pennsylvania's School of Architecture. When a neurologic disorder (a form of Parkinson's disease) made it hard for him to draw, he turned to sculpture. By the early 1970s, with the help of assistants, he was producing large-scale public works based on the cardboard models that filled his studio. Other Fredenthal works in the city include *White Water* in the courtyard behind the CoreStates Plaza at 5th and Market, and *Black Forest* on the Penn campus at 34th and Walnut.

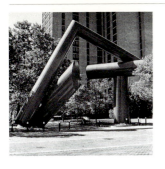 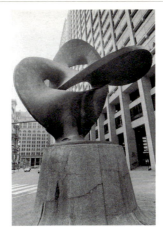 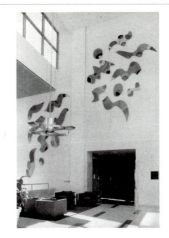

5-26

Alexander Liberman (1912–)
Covenant
1974
Painted steel. Height 45'; width 34';
depth 67'
University of Pennsylvania
Locust Walk near 39th Street

Students walking to or from the University of Pennsylvania's residential complex pass a giant, angular composition of tubular red steel. Weighing over 25 tons, *Covenant* was commissioned as part of the Redevelopment Authority's percent for art requirement. The artist, Alexander Liberman, came to the United States in 1941 after a childhood in Kiev and artistic studies in Paris. His sculpture has been described as so "wildly asymmetrical" that every change in the viewer's angle of perception alters the apparent axes. Over the years his sculpture has become increasingly monumental, and he characterizes his larger works as a kind of "free architecture" that should have the impact of a temple or cathedral. In *Covenant* Liberman specifically intended to convey a feeling of unity and spiritual participation. The installation was assisted by a grant from the National Endowment for the Arts.

5-27

Robert Engman (1927–)
Triune
1974
Bronze, on concrete base. Height c. 20';
width c. 18' (base height 6' 6")
South Penn Square, 15th Street near
Market Street

Opposite City Hall, on a portion of sidewalk that juts toward the whizzing traffic, massive bronze curves interlock to form Robert Engman's *Triune*. The three lobes are meant to symbolize the interdependence of people, government, and industry. The work on *Triune* involved a series of models and four separate castings at the Crown Foundry in Chester, Pennsylvania. Engman and apprentice Tom Cullen ground and polished the final cast themselves. The finished work weighs approximately 28,000 pounds. Commissioned jointly for this site by Girard Bank and the Fidelity Mutual Life Insurance Company, the sculpture was installed in 1975.

Engman, the son of a Massachusetts blacksmith, was on the faculty at the University of Pennsylvania. His sculpture *After B.K.S. Iyengar* is installed at the Morris Arboretum.

5-28

Sam Maitin (1928–)
Celebration
1975; enlarged 1985
Painted wood. Height c. 35';
width c. 50'
Annenberg School of Communications
(interior)
University of Pennsylvania
3620 Walnut Street
For access call 898 7041

Painted in bright, wildly mixed colors, the swirling shapes on the white wall of the Annenberg School look like birds and fish, eggs and teardrops, or any other organic objects the viewer might imagine. The artist, Sam Maitin, created and installed the original relief mural in 1975 and enlarged it in 1985. It now consists of 17 wooden pieces ranging from two to eight feet in length and occupying three and a half stories of the central lobby. Commissioned by the Annenberg School, *Celebration* helped to satisfy the Redevelopment Authority's percent for art requirement.

Maitin has been called the "quintessential artist-citizen." As a child he attended classes at the Fleisher Art Memorial, and at 16 he was studying at the Philadelphia Museum School of Industrial Art. Often described as "exuberant" and "playful," his art also reflects his social consciousness and deep involvement in city life. His other work for Philadelphia includes murals for Children's Hospital, the Free Library, and the Academy House condominium.

5-29

Arlene Love (1936–)
Face Fragment
1975
Fiberglass-reinforced polyester resin with
gold-leaf patina, on concrete base.
Height 10' (base 5')
Monell Chemical Senses Center
3500 Market Street

One of the most noticeable outdoor sculptures in West Philadelphia, *Face Fragment* presents a giant gilded nose and mouth. The 500-pound work is thematically appropriate for the Monell Chemical Senses Center, which conducts research into taste and smell, but the sculpture is also meant to have a humanistic quality to which the public can relate. It is mounted low enough to attract the gaze of pedestrians, and its size gives it an abstract effect when seen from the sidewalk. The sculpture was commissioned by the University City Science Center as part of the Redevelopment Authority's one percent program.

Arlene Love, a pioneer in the use of cast plastics, used a brass laminate for the original patina of *Face Fragment*, but when the surface showed the effects of weathering, she replaced it with a durable gold leaf. Her nine-foot *Winged Woman* stands at the Dorchester apartment building on Rittenhouse Square.

6-01

Walter Edmonds (1938–) and
Richard Watson (1946–)
Church of the Advocate Murals
1973–1976
*Painted mural. Maximum height 20';
width 25'. Minimum height 6'; width 8'*
Church of the Advocate (interior)
18th and Diamond Streets
For access call 236 0568

At the Church of the Advocate in
North Philadelphia, the Rev-
erend Paul Washington con-
ceived the idea of bringing the
"people's art" indoors by commis-
sioning murals for the church
sanctuary (see *A Legacy of
Murals*, pp. 118–119). As the site
of many civil rights events, the
Church of the Advocate was an
appropriate setting for such a
project. Reverend Washington
provided a focus for the effort by
presenting the artists with a com-
pilation of biblical excerpts and
contemporary thoughts about the
struggle for black equality. Using
these passages for inspiration,
local artists Walter Edmonds and
Richard Watson created a series
of 14 murals that link scriptural
themes with the history of blacks
in Africa and America. The
enslavement of Joseph in Egypt
provides a parallel for black
slavery; the Hebrews' escape
from Pharaoh corresponds to the
Emancipation Proclamation and
Nat Turner's rebellion. The art-
ists also interpreted events of the
1960s. The two largest murals,
each 20 feet by 25 feet, are
Watson's *Creation* and
Edmonds's *I Have a Dream*.
Both artists donated their ser-
vices; the church supplied the
materials.

6-02

Louise Nevelson (1899–1988)
Bicentennial Dawn
c. 1976
*Painted wood, on terra cotta pavers.
Height 15'; width 90'; depth 30'
(including pavers)*
*James A. Byrne Federal Courthouse
(interior)*
601 Market Street
For access call 597 4910

"*Bicentennial Dawn*," said artist
Louise Nevelson, "is a place, an
environment that exists between
night and day—solid and
liquid—temporal and eternal
substances."

Commissioned under the
Art-in-Architecture Program of
the General Services Administra-
tion, *Bicentennial Dawn* consists
of 29 intricately patterned
wooden columns, painted
entirely white, mounted in the
building's main entrance foyer.
In addition to the columns, the
central group has four pieces
affixed to the ceiling. Nevelson
extended the idea of a sculptural
environment that she had devel-
oped in earlier works such as
Atmosphere and Environment XII
(**5-16**). Like many other artists
who came of age in the early
20th century, Nevelson was
inspired by primitive art—and
this influence can be seen in the
mysterious, totemic forms of the
columns.

Nevelson's description men-
tions "the secret images that can
be found in nature." The overall
composition brings to mind
stalks shooting up from the
earth, while circular and semicir-
cular forms resemble suns. The
interiors of the many-layered col-
umns contrast with the white sur-
faces, hinting at the theme of
dawn as a time "between night
and day." The sculpture was ded-
icated at the dawning of the
Bicentennial year, and the art
critic Emily Genauer wrote in
the *New York Post*, "I know of no
single public sculpture anywhere
in the country more beautiful
than this newest Nevelson."

6-03

Charles Searles (1937–)
Celebration
1976
Acrylic on linen. Height 9'; width 27'
*William J. Green, Jr., Federal Building
(second floor interior)*
600 Arch Street
For access call 597 4910

At a street festival in North Phila-
delphia in 1970, a young artist
named Charles Searles displayed
his watercolors. Dancers and
drummers performed on an out-
door stage. Merchants sold food,
children played, and the crowd
basked in the sun. Struck with
the idea of painting this conge-
nial event, Searles took photo-
graphs for future reference.

The next year, as a student at
the Pennsylvania Academy of the
Fine Arts, he received the
Cresson Scholarship for study in
Europe. In 1972 he went to
Nigeria, where he painted street
traders and continued to ponder
the theme of a festival. His oppor-
tunity to realize the idea on a
large scale came after his return
to Philadelphia, when he was
commissioned to produce a
mural for the new Federal office
building. Under the auspices of
the Art-in-Architecture Program,
Searles recreated the Philadel-
phia festival of 1970 in a 27-foot
mural. *Celebration* presents the
drummers and dancers in vivid
colors with complex, interlocking
geometric patterns clearly influ-
enced by Searles's study of
African art. Because the nearby
cafeteria is open to the public,
many visitors as well as building
employees see the work daily.
Searles's other work in Philadel-
phia includes *Playtime* (**6-38**) at
the Mallery Playground.

6-04

Claes Oldenburg (1929–)
Clothespin
1976
*Corten steel and stainless steel on
concrete base. Height 45'*
Centre Square Plaza
15th and Market Streets

Rising out of a subway entrance
in center city, *Clothespin* has the
jolting and humorous effect of a
familiar object seen out of con-
text. This witty monument was
commissioned by developer Jack
Wolgin as part of the Redevelop-
ment Authority's one percent
program.

Claes Oldenburg, son of a
Swedish diplomat, was born in
Stockholm but spent much of his
childhood in the United States.
In the late 1950s he began to
experiment with large, soft sculp-
tures, such as giant hamburgers
or ice cream cones, as props for
Pop art "happenings." By 1965
he was drawing plans for huge
public monuments based on sim-
ilar everyday objects. His later
projects include *Batcolumn*, a
100-foot baseball bat for Chi-
cago; a *Flashlight* for Las Vegas;
and the University of Penn-
sylvania's *Split Button* (**6-31**).

Oldenburg is noted for his
attempts to democratize art, and
Clothespin certainly draws a reac-
tion from everyone who passes it
(see pp. 161–162). But its resem-
blance to a mundane object
should not obscure its artistic
qualities: art critics have praised
its "soaring" look and the "vel-
vety" texture of the Corten steel,
which turns a warm reddish-
brown as it weathers. It is not a
reproduction of an ordinary
clothespin, but a sweeping, styl-
ized version. Oldenburg himself
compared the form to Constantin
Brancusi's famous sculpture *The
Kiss* in the Philadelphia Museum
of Art: like Brancusi's work,
Clothespin presents two separate
bodies merging in an embrace.

6-05

Venturi and Rauch, Architects and
Planners
Ghost Structures
1976
*Painted steel. House: height 54' 6";
width 49' 6"; depth 33'. Print Shop:
height 32' 3"; width 48'; depth 20'*
*Franklin Court, Independence National
Historical Park*
314–322 Market Street

After two decades of research
and archeological excavations,
the National Park Service
engaged the Philadelphia archi-
tectural firm of Venturi and
Rauch to develop a plan to con-
vert several properties at 3rd and
Market Streets into a Benjamin
Franklin memorial. With John
Milner Associates acting as con-
sultants, the buildings were thor-
oughly restored on the exterior;
today they house historical dis-
plays, an archeological exhibit, a
post office and postal museum,
and a working 18th-century print
shop and bindery. In the court-
yard, however, there was little
left to restore: Franklin's own
"good House" and print shop
had been razed in 1812, and few
of the architectural details could
be discovered.

Architect Robert Venturi and
his associates devised a solution
that would appeal to the viewer's
imagination: if the house itself
could not be reconstructed, its
ghost might appear. Towering
Ghost Structures of painted steel
were erected to suggest the out-
lines of the house and print shop.
Descriptive quotations are
inscribed on the paving, "viewing
wells" allow visitors to look at
what remains of the foundations,
and landscaping has turned the
courtyard into an 18th-century
garden. An underground
museum lies below the court.
With its combination of historical
restoration and evocative sculp-
ture, Franklin Court offers a
unique means of exploring

Franklin and his times. The firm
of Venturi, Rauch and Scott
Brown, noted for its leading role
in postmodernist theory and
architecture, designed the
*Benjamin Franklin Bridge Light-
ing* (**6-54**).

6-06

Walter Erlebacher (1933–1991)
Jesus Breaking Bread
1976
*Bronze, on bronze plinth and marble
base. Height 6' (plinth 4¹/₄"; base 4')*
*Cathedral Basilica of Saints Peter and
Paul*
Logan Square, 18th and Race Streets

Commissioned for the 41st Inter-
national Eucharistic Congress,
which met in Philadelphia in
1976, Walter Erlebacher's sculp-
ture presents a figure of Jesus
holding two pieces of broken
bread, a symbol of Holy Com-
munion. During the Congress,
which attracted over a million vis-
itors to the city, the sculpture
was displayed at the Civic
Center. Later it was moved to a
site near the Cathedral Basilica
of Saints Peter and Paul, and its
formal blessing at this location
took place on May 26, 1978.
Standing near the sidewalk, it
offers an accessible, immediate,
and lifelike Jesus.

Erlebacher, born in Ger-
many, was known for idealized
renderings of the human body
that are reminiscent of classical
Greek sculptures of gods and
heroes. He also created the fig-
ures for *Day Dream Fountain*
(**6-45**).

 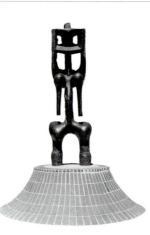

6-07

Robert Indiana (1928–)
LOVE
c. 1976
Painted aluminum, on stainless steel
base. Height 6'; width 6'; depth 3'
(base height 7')
John F. Kennedy Plaza
15th Street and John F. Kennedy
Boulevard

For the Bicentennial celebration in 1976, Robert Indiana lent the city a large aluminum sculpture of his "LOVE" image. Indiana first produced the design as a painting in 1964, and within a few years it had been used on jewelry, posters, plates, and a postage stamp (see pp. 165–166). The sculpture was installed in Kennedy Plaza, not far from City Hall, and remained there on "extended loan" for two years while Indiana's gallery in New York tried to sell the work to the city. But when the sale could not be arranged, the gallery had a truck remove *LOVE* to New York, where a potential buyer was interested in seeing it.

 An uproar ensued. The *Philadelphia Inquirer* and other local media demanded to know why the sculpture had been allowed to slip away. F. Eugene Dixon, local businessman and then chairman of the Philadelphia Art Commission, purchased the work and donated it to the city, and soon it was reinstalled in Kennedy Plaza.

6-08

John Rhoden (1918–)
Nesaika
1976
Bronze, on brick base. Height 9'
(base 3')
Afro-American Historical and Cultural
Museum
7th and Arch Streets

An official project of the Bicentennial celebration, the Afro-American Historical and Cultural Museum opened to the public in 1976, a few days after the unveiling of John Rhoden's *Nesaika*. Rhoden, a black American sculptor, wanted to express both the African and the American aspects of the museum. The forms of *Nesaika* clearly suggest the traditional sculptures of Africa; the title, however, derives from a word meaning "we" or "our" in the Chinook Indian trade language of America's West Coast. In merging elements from the two continents, Rhoden hoped to indicate the fundamental unity of all minorities. The masklike image at the top symbolizes "the wholeness of the shape of the universe."

 Rhoden grew up in Alabama and attended Talladega College before moving to New York in the late 1930s. He won the Prix de Rome fellowship for study at the American Academy in Rome and participated in three international tours sponsored by the State Department. *Nesaika* was commissioned as part of the Redevelopment Authority's percent for art program. The bronze was cast by the age-old *cire perdue* (lost-wax) process, known on the western coast of Africa. Also at the Afro-American Museum is Reginald Beauchamp's *Whispering Bells: A Tribute to Crispus Attucks* (1976).

6-09

Charles Fahlen, Virginia Jacobs, Ray King, and Gerald Nichols; Friday Architects & Planners and community volunteers
Old Pine Community Center: art works and tiles
c. 1976
Old Pine Community Center (interior and exterior)
4th and Lombard Streets
For access call 627 2943
A project of Old Pine Community Center as part of the RDA Fine Arts Program
See p. 173

6-10

Al Held (1928–)
Order/Disorder and **Ascension/Descension**
c. 1976
Acrylic on canvas. Height 13'; width 90'
(each of two murals)
Social Security Administration Mid-Atlantic Program Service Center (interior)
300 Spring Garden Street
For access call 597 8203

Solid lines, dashed lines, sharp angles, with hints of volume and complicated perspective—all in a stark black on white—make up the two murals that Al Held called *Order/Disorder* and *Ascension/Descension*. The work was commissioned for the Social Security building lobby under the Art-in-Architecture Program of the General Services Administration.

 These murals were Held's first attempt to integrate time and movement into the viewer's experience. In order to paint each mural as a whole, he located a Brooklyn warehouse where he could erect 90-foot replicas of the wall spaces that the murals would occupy. The huge canvases, each of which measured nearly 1,200 square feet, had to be ordered from weavers in Belgium, who required three months to complete the job. As Held worked, walking the full length of the paintings, he allowed his concepts to evolve until he felt that the sequence of visual components and perceptual phenomena was exactly as it should be. The murals are visible from outside the glass-fronted lobby as well as inside, and their complex use of volumes and perspectives offers different effects as the viewer changes position. The art critic Victoria Donohoe has called these murals "a metaphysical balancing act."

6-11

Beverly Pepper (1924–)
Phaedrus
c. 1976
Painted steel. Height 19'; width 8'
Federal Reserve Bank
100 North 6th Street

"I have always been interested in precarious balance," Beverly Pepper has said, "because it is also what life is about." She applied this principle to *Phaedrus*, a 12-ton sculpture that thrusts from the ground at an implausible, gravity-defying angle. Made of 13 steel plates painted white, *Phaedrus* was completed in 1976 and installed in November 1977 under the artist's supervision.

In the early 1960s Pepper turned from painting to sculpture, initially in wood and then in steel. She learned metalworking techniques in Italy by assisting a blacksmith and an ironmonger; soon she became one of the most prominent female artists of her generation. Her works have been installed at a variety of public sites. Along with Alexander Calder's *White Cascade* (**6-13**), *Phaedrus* was commissioned for the new Federal Reserve Bank building as part of the Redevelopment Authority's one percent program.

6-12

Joe Brown (1909–1985)
Punter, Batter, Tackle, and
Play at Second Base (above)
c. 1976
Bronze, on concrete bases. Height c. 15'
(bases 1' 7"–2' 6")
Veterans Stadium
Broad Street and Pattison Avenue

Set at the top of ramps leading to Veterans Stadium, four larger-than-life sculptures by Joe Brown present football and baseball scenes frozen in time. In each case the outcome is in doubt. Will the sliding runner be safe at second base? Will the tackler stop the ball carrier?

Joe Brown was born in South Philadelphia. He won a football scholarship to Temple University, where he was also captain of the boxing team. After graduating, Brown found work as a model at the Pennsylvania Academy of the Fine Arts. With the encouragement of Walker Hancock (see **4-60, 4-64**), he then tried sculpture himself. By the late 1930s, Brown was teaching boxing and sculpture at Princeton University. Perhaps the best-known sports sculptor in the country, he also produced portrait busts of novelists and poets and served for a dozen years on the Philadelphia Art Commission. Brown's monumental sculptures at Veterans Stadium were commissioned in response to the city's one percent program.

6-13

Alexander Calder (1898–1976)
White Cascade
c. 1976
Aluminum disks, stainless steel rods, electric motor. Height c. 100';
width c. 60'
Federal Reserve Bank (interior)
100 North 6th Street
For access call 574 6114

Created by Alexander Calder a few months before his death, *White Cascade* may be the world's largest mobile. From the skylight it descends through 100 feet of the Federal Reserve Bank's 130-foot-high East Court. Including its electric motor, the massive mobile weighs almost 10 tons. The 14 white aluminum disks range in diameter from 3.5 to 12.7 feet; the stainless steel connecting rods vary from 9 to 36 feet in length. Slowly, almost imperceptibly, the entire structure revolves clockwise in its vast atrium.

Calder was the son of Alexander Stirling Calder (see **2-07, 3-26, 4-10, 4-14,** and **4-15**) and grandson of Alexander Milne Calder (see **2-06, 3-01, 3-02,** and **3-10**), but he did not immediately choose a career in the arts. He received a degree in mechanical engineering at the Stevens Institute of Technology. In the late 1920s, however, he won acclaim in Paris for a miniature animated circus of wire figures. In 1930, visiting the studio of the modernist painter Piet Mondrian, Calder was impressed by the abstract arrangements of brilliant colors on the walls and decided that he would like to make such blocks of color "oscillate." Within two years he had created his first moving sculpture, for which Marcel Duchamp coined the term "mobile." *White Cascade* was commissioned for the Federal Reserve Bank as part of the Redevelopment Authority's percent for art program. Despite its massiveness, the mobile is both graceful and playful. As the artist Fernand Léger remarked, Calder's work is "serious without seeming to be."

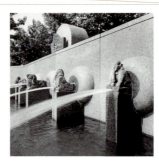

International Sculpture Garden

Dedicated 1976
Penn's Landing, Delaware Avenue between Chestnut and Spruce Streets

In the 1960s the Fairmount Park Art Association conceived the idea of an International Sculpture Garden that would celebrate the impact of other cultures on the American experience. "Each individual piece," the Art Association noted, "should not only be typical of that nation's heritage but should also be of the highest quality."

6-14

Artist unknown
Spheres
300–1525
*Granite monoliths. Diameter 4' 6"
and 6' 6"*
From Costa Rica (installed 1976)

Pre-Columbian stone spheres have been discovered at sites in Central America, Puerto Rico, and Mexico. The largest come from the southern Pacific coast of Costa Rica, where some reach eight feet in diameter and exceed 16 tons in weight while deviating less than a quarter-inch from perfect roundness. To shape such a monolith with primitive tools was a prodigious feat; the stone, moreover, had to be transported by river from outcrops in the mountains. Small spheres were placed in graves; larger ones were set on platforms or arranged in patterns that suggest astronomical alignments. The two spheres at the International Sculpture Garden are from a site near Palmar Sur in the delta of Costa Rica's Disquis River. The smaller one weighs 9,000 pounds, the larger one almost 24,000. The spheres were brought to Philadelphia with the cooperation of the Costa Rican government.

6-15

Artists unknown
Five Water Spouts, Frog, and **Lintel**
12th–13th century
*Volcanic stone. Height: Tiger 3' 4";
Makara 3' 1"; Ram 3' 3"; Makara 3' 2";
Elephant 3' 2"; Frog 2'
Lintel width: 2' 4½"*
From Java, Indonesia (installed 1986)

As long ago as the eighth century, temples expressing Hindu and Buddhist religious beliefs appeared on the Indonesian islands of Java and Sumatra. Many of the temple sites in eastern Java had pools for ritual bathing where the water flowed through carved stone spouts. In 1979 the Fairmount Park Art Association acquired five of these spouts as well as a frog figure and a lintel, and the Mabel Pew Myrin Trust supported their installation at the Sculpture Garden.

Three of the spouts resemble a tiger, a ram, and an elephant. Two are *makaras*, mythical creatures that appear in Indian and Indonesian art. The overhead lintel shows a *kala*, which was thought to be both a ferocious and a protective force: a visitor who passed through a *kala* gateway was symbolically devoured and reborn.

6-16

Artist unknown
Nandi
c. 1500
*Gray micaceous granite, on granite base.
Height 6'; length 8' 6"; width 3' 6"
(base 2' 4")*
From Madras, India (installed 1976)

The name *Nandi*, which means "happiness," designates the sacred bull belonging to Shiva, the Hindu god of creative power. In traditional Indian sculpture Shiva is often shown mounted on or leaning against the animal. As a symbol of Shiva, the Nandi represents power, virility, joy, and delight, as well as a controlled potential for destructiveness. When carved as a free-standing figure, the Nandi is always shown in a resting position that emphasizes the calmer aspect of its power. Nandi images are found in abundance at Shiva temples. Royal patrons often vied with one another for the honor of creating the most massive Nandi figure. The largest examples in India are twice the size of the 6-foot, 7.5-ton Nandi in the Sculpture Garden. This Nandi, however, is the largest ever to leave India. In 1969 the Art Association purchased it with the cooperation of the Indian government and Prime Minister Indira Gandhi.

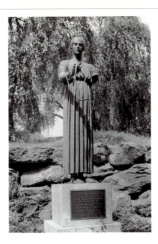

6-17

Artist unknown
Mangbusucks
c. 1695
Granite. Height 6' 3"
*From Yangjoo-kun, Kyunggi Province,
Korea (installed 1976)*

To flank the approaches to the
tombs of eminent people,
Koreans carved memorial stone
figures known as *mangbusucks.*
The two in the International
Sculpture Garden, dressed in cer-
emonial robes and holding
scrolls, represent scholar-offi-
cials. They were carved for the
tomb of Oh Ryong Suh, a court
official who advanced to the rank
of vice-minister before his death
in 1694. These figures, which
together weigh almost 3 tons,
were a gift to the Fairmount
Park Art Association from the
International Cultural Society of
Korea and the Korean Associa-
tion of Greater Philadelphia.

6-18

Attributed to Charley James or
Mungo Martin
Central Post
c. 1850
*Carved cedar wood, on stainless steel
pedestal. Height 12' 6" (pedestal 7' 11")
From Alert Bay, Vancouver Island, British
Columbia (installed 1980)*

Indians of the northwest Pacific
coast carved several different
kinds of cedar totem poles.
Inside the house, carved poles
supported the roof. Outside, or
attached to the front of the
house, were frontal or memorial
poles carved with mythical fig-
ures or symbols of the family. A
third type of pole served as a
coffin. The totem in the Interna-
tional Sculpture Garden
(acquired with support from the
Knollbrook Trust) is a central
house pole. It belonged to the
Kwakiutl of the coastal lands
around Queen Charlotte Strait,
and it has been attributed to the
famous Kwakiutl carver Charley
James or to his stepson and pro-
tégé, Mungo Martin. The iconog-
raphy includes a bird, a copper
coin (symbol of wealth), and a
grizzly bear.

6-19

Artist unknown
Charioteer of Delphi
*5th century B.C.; cast c. 1977
Bronze, on black marble base.
Height 5' 9" (base 2' 3")
Philadelphia Museum of Art, northeast
lawn
Kelly Drive near 24th Street*

About 478 B.C. Polyzalos, the
Tyrant of Gela in Sicily, commis-
sioned a statue to express his
gratitude to the god Apollo for
his charioteer's victory in the
Pythian Games. Now in the
museum at Delphi, this bronze is
considered one of the finest sur-
viving sculptures of classical
Greece. The cast near Philadel-
phia's Museum of Art was a gift
from the Greek government. Con-
temporary Greek artists Nikos
Kerlis and Theodora Papayannis
cast this faithful duplicate using
the lost-wax process, one of the
most accurate methods available.
As in the original, the left arm is
missing, as are the chariot and
horses that once formed part of
the sculpture.

6-20

Clarence Wood and Don Kaiser with
community residents, Department of
Community Programs, Philadelphia
Museum of Art
Community Mural
*1977
Painted mural. Height c. 45';
width c. 80'
1330 South 18th Street*

In a lush meadow by a stream,
two smiling girls hold a very
large fish. A boy stands near a
van; another perches on the seat
of a covered wagon. The figures
are portraits of neighborhood
children; the van was a recent
purchase of a local resident. But
the wagon offers a clue that the
mural is a symbolic interpreta-
tion of a crucial event in black
history. After the Civil War, it
was proposed that the govern-
ment help the freed slaves
become economically indepen-
dent by providing each freedman
with "40 acres and a mule." The
plan went largely unfulfilled.

Coordinated by local resident
Leroy Howell, the people of the
1300 block of South 18th Street
developed their own reassess-
ment of the "40 acres" for a wall
overlooking the community
garden. They planned and
designed the mural with the help
of the Department of Commu-
nity Programs of the Philadel-
phia Museum of Art (see pp.
174–175). By juxtaposing the van
and the wagon, the mural seems
to suggest that the dreams of the
1860s might be realized in this
century in a different form.

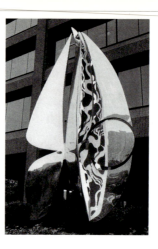

6-21

David von Schlegell (1920–)
Voyage of Ulysses
c. 1977
*Stainless steel with hydraulics, in
fountain base. Height 16'; width 28' 4";
depth 6' 6"*
*Plaza of James A. Byrne Federal
Courthouse and William J. Green, Jr.,
Federal Building*
*6th Street between Market and Arch
Streets*

In classical mythology, Ulysses
wanders in the Mediterranean
for 10 years before reaching his
home. Some of the magic of the
Ulysses tale is captured in David
von Schlegell's fountain sculp-
ture at the Federal courthouse
and office complex. Commis-
sioned as part of the Art-in-Archi-
tecture Program of the General
Services Administration, *Voyage
of Ulysses* was dedicated at the
same time as the murals by
Charles Searles (**6-03**) and Al
Held (**6-10**).

Von Schlegell worked as an
aviation engineer and in an archi-
tectural firm before turning to
painting and sculpture. For the
plaza on 6th Street, he decided
not to compete with the scale
of the government buildings.
Instead, he worked on a more
human scale, and his design fea-
tures diagonal lines to counter
the verticality of the architecture.
In basic shape *Voyage of Ulysses*
resembles a sail, but its appear-
ance varies from different per-
spectives. Hydraulic engineers
helped the artist produce dra-
matic effects with the water that
tumbles against and through the
sculpture.

6-22

Stewart Zane Paul (1951–)
Regional Ricky
c. 1978
*Carved wood. Height 6'; length 16' 7½";
depth 10' 1"*
*Northwest Regional Library (interior)
Chelten Avenue and Greene Street
For access call 685 2157*

A toothy dragon slinks along the
floor in the children's area of the
Northwest Regional Library. The
idea of a sculpture representing a
mythological animal originated
with architect Dennis Johnson.
He consulted Stewart Paul, who
proposed a sculptural representa-
tion of Puff, the Magic Dragon,
from the popular song of the
same name by Peter, Paul and
Mary. The dragon's side is a
bookcase, and its curving shape
corresponds to the building's inte-
rior design. The work was com-
missioned as part of the
Redevelopment Authority's one
percent program. The primary
wood is red oak, but walnut, but-
ternut, maple, and white oak
were also used. The title
Regional Ricky resulted from a
dragon-naming contest spon-
sored by the library. But many
local children still know the crea-
ture as "Puff," and it has become
a centerpiece for storytelling and
other children's programs.

6-23

Joseph C. Bailey (1937–)
Gift of the Winds
1978
*Stainless steel and manganese bronze,
on brick planter base. Height c. 17';
width c. 10'; depth c. 10' (base 4')*
5th and Market Streets

The leaflike forms of Joseph
Bailey's *Gift of the Winds* consist
of mirror-polished steel around a
core of manganese bronze. On
two of the surfaces, curving
shapes that suggest natural forms
such as roots or tendrils are cut
into the steel to reveal the bronze
beneath, and the central "leaf" is
positioned to reflect these images
on both sides.

Bailey, a native of Pittsburgh,
has created sculptures for several
public sites in the Philadelphia
area and has served on the Phila-
delphia Art Commission. In *Gift
of the Winds*, commissioned for
the entrance to a bank building
as part of the Redevelopment
Authority's one percent program,
Bailey wanted to link the
building's geometry with the
parklike setting of nearby Inde-
pendence Mall; thus, he used
hard-edged metal forms to sug-
gest organic shapes. Trees were
planted close to the sculpture so
that the leaves would be reflected
in the steel surfaces, and people
approaching on the sidewalk can
see themselves reflected as well.

6-24

George Rickey (1907–)
Two Lines
c. 1978
Stainless steel. Height 56' 6"
*Morris Arboretum (installed 1988)
9414 Meadowbrook Avenue
For access call 247 5777*

On the former site of the Morris
mansion, overlooking the
grounds of the Morris Arbo-
retum, stands a tapering steel rod
more than 30 feet high, bearing
two 30-foot arms that rotate
slowly in the breeze. The steel
reflects sunlight, and the config-
urations change with the wind.
According to the Arboretum's
consulting curator, Edward Fort
Fry, *Two Lines* "creates a meta-
phorical bridge between land-
scape and man's artifacts."

George Rickey began his
career as a painter but discov-
ered a mechanical bent during
service in the Army Air Corps in
World War II. After the war he
turned to kinetic sculpture,
evolving a style that featured
bladelike shapes of stainless steel
whose movement was governed
by the wind. The art critic
Douglas McGill referred to a
characteristic group of Rickey
sculptures as "hybrids of living
things and machines." *Two Lines*
is one of the tallest of Rickey's
works—over 56 feet high when
the arms extend upward—and
perhaps the last of his monu-
mental blade compositions, for
he announced that he planned
no further sculptures on such a
large scale. Acquired on loan, the
work was installed at its present
site in October 1988.

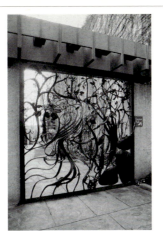

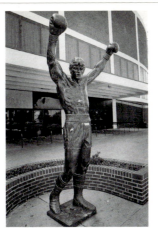

6-25

Theodore Miller (1921–)
Cubus Assemblage
1979
Painted aluminum modules on brick wall.
8' units; maximum depth 8'; wall
length 105'
Spring Garden Street between 5th and
6th Streets

A neighborhood of warehouses and industrial buildings seems an unlikely place for art, but the Redevelopment Authority's percent for art program has led to the installation of public art in such locations. Theodore Miller's *Cubus Assemblage*, a series of nine painted aluminum boxes, is mounted on the wall of the SmithKline warehouse on Spring Garden Street. Step by step the units change from a flat rectangle at one end to a full cube at the other; thus, the forms seem to grow out of the wall or recede into it, depending on the direction from which the viewer approaches.

Miller's task was to add visual interest to a long expanse of monotonous brick wall in an area where passers-by do not ordinarily linger. His geometric sculpture assumes that the viewer will be in motion, and it uses that motion to create an illusion of change.

6-26

Christopher T. Ray (1937–)
Wissahickon Valley Gate
1979
Forged iron. Height 8'; width 8'
Chestnut Street between 17th and 18th
Streets

In the late 1970s a small parking lot on the north side of Chestnut Street was transformed into Chestnut Park. Instead of asphalt paving and oil stains, the site now features a variety of native plants, a fountain with gargoyles, and two iron gates by Philadelphia sculptor and craftsman Christopher Ray. The smaller *Estuary Gate* at the Ranstead Street entrance represents the tidal wetlands environment along the Delaware and lower Schuylkill rivers. The larger and more ambitious *Wissahickon Valley Gate* on Chestnut Street incorporates images from the native life of Wissahickon Creek; in the midst of its curling iron foliage the viewer can find a lizard, a praying mantis, an owl, a man battling a snake, a gargoylelike fish, and other curious creatures. The park was developed by the Delta Group under the auspices of the PENJERDEL Regional Foundation with funding from the William Penn Foundation.

6-27

A. Thomas Schomberg (1943–)
Rocky
1980
Bronze. Height 8' 6"
The Spectrum
Broad Street and Pattison Avenue

In the movie *Rocky III*, a massive statue of Philadelphia fighter Rocky Balboa, arms raised in triumph, is unveiled in the courtyard of the Museum of Art. In real life, actor Sylvester Stallone, the former Philadelphian who created the fictional Rocky in a series of films, offered to leave the statue there as a gift to the city.

But unlike the people in the filmscript, the real citizens of Philadelphia argued over the work (see *Public Art Versus Public Taste*, pp. 178–179). As an image of popular culture it was unparalleled; local moviegoers wanted to memorialize Rocky's inspirational climb up the Art Museum steps. Others felt the sculpture lacked dignity and was essentially a movie prop that did not belong permanently at that location. After a prolonged dispute, the city formally accepted the gift, and it was moved to the sports complex in South Philadelphia.

Rocky the statue is the work of A. Thomas Schomberg, whose sculptures of athletes have been installed at the Astrodome, Superdome, and Yankee Stadium. The controversy was rekindled in 1990, when the film producers relocated the sculpture for the filming of *Rocky V*, but, in the end, *Rocky* was returned to the Spectrum, where supporters welcomed their hero.

6-28

George Segal (1924–)
Woman Looking Through a Window
1980
Bronze, Lexan plastic, polyester-dipped fabric. Height 8'; width 3' 4";
depth 2' 2"
Philadelphia Life Building
1 Independence Mall
Chestnut Street between 6th and 7th Streets

Peering through her window, partially hidden behind the shade, a woman studies the passers-by. Her arms are folded, and she appears to have been standing there for some time. One bare leg emerges rather provocatively from her robe. Passers-by stare back at her, and some walk behind the window for a better look.

Her creator, George Segal, is known for his sculptures of people in natural situations and his experiments with unusual materials—chicken wire, burlap, medical bandages soaked in plaster. His commissions include the *Kent State Memorial* at Princeton University, *Gay Liberation* on the campus of Stanford University, and a Holocaust memorial in San Francisco.

Woman Looking Through a Window, commissioned as part of the Redevelopment Authority's one percent program, uses bronze with a white industrial finish for the figure and the window frame, a clear, strong plastic for the window panes, and polyester-dipped fabric for the curtains. Segal designed the work to encourage viewer interaction. The observer outside the window, looking in, can change perspective by stepping behind the sculpture to become (like the female figure itself) an insider looking out.

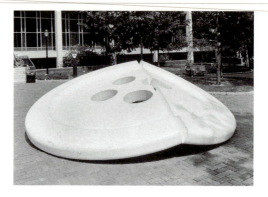

6-29

Jennifer Bartlett (1941–)
In the Garden
c. 1981
Enamel on steel plates. Height 10' 8";
width 33' 6"
Institute for Scientific Information
(interior)
3501 Market Street
For access call 386 0100

In 1979 Jennifer Bartlett spent a winter in the south of France, an area that inspired Van Gogh, Renoir, Picasso, and Matisse. Her rented villa turned out to be a drab one with a view of a rectangular pool, a screen of dark cypress trees, and a commonplace statue of a urinating cherub. Undeterred, Bartlett made numerous drawings and photographs and ultimately created a series of large paintings based on this unprepossessing scene. *In the Garden*, at the Institute for Scientific Information, evolved from the series. It was commissioned by ISI as part of the Redevelopment Authority's one percent program.

In the building's lobby, 270 one-foot-square steel plates present the garden in five variations. At the far left, it is seen from an aerial point of view in the morning; at the far right, it appears from a worm's point of view at night. Intermediate sections show the garden at various times and from other perspectives. The mural also exists in "dislocated" form: throughout the building duplicates of all 270 mural plates are mounted on carefully selected wall surfaces. By integrating the separate bits into a whole, the complete mural in the lobby refers to ISI's gathering and systematizing of scientific information.

6-30

Joyce de Guatemala (1938–)
Mayan Game Group
c. 1981
Stainless steel. Height 5'–8'
Howard Street between Huntingdon
Street and Lehigh Avenue

For a housing development in the Kensington area, Joyce de Guatemala created a group of polished steel structures that evoke an ancient Mayan ball court. Commissioned under the one percent program of the Redevelopment Authority, the sculpture consists of five pairs of vertical stainless steel bars, each supporting an open or closed circle. De Guatemala, though born in Mexico City, is a Guatemalan citizen who lives and exhibits in the Philadelphia area. Reflecting her passionate interest in Mayan archeology, her sculptures often combine ancient elements with modern, formalistic qualities.

6-31

Claes Oldenburg (1929–) and
Coosje van Bruggen (1942–)
Split Button
1981
Painted aluminum. Height 4';
diameter 16'
University of Pennsylvania
Blanche Levy Park
Between 34th and 36th Streets, Locust
and Spruce Streets

Since commonplace, mass-produced objects dominate American life, Claes Oldenburg makes them the subject of monuments. Like his *Clothespin* (**6-04**) at Centre Square, the *Split Button* in front of the Van Pelt Library at the University of Pennsylvania uses incongruity to snap the viewer to attention. It also incorporates a visual joke: Oldenburg and van Bruggen imagined that the nearby statue of Benjamin Franklin (**3-21**) might be missing a button. And students, they observed, were always losing buttons, "society's most disregarded object."

Oldenburg's collaborator on the project was his wife, art historian Coosje van Bruggen, who has worked with him since 1976 on large-scale sculptures. Commissioned by the university as part of the Redevelopment Authority's percent for art program, *Split Button* was partly funded by a grant from the National Endowment for the Arts as well as donations from private sources.

At first the artists planned to create an unbroken button of a grayish-black color, set parallel to the ground to form a bench. But Oldenburg and van Bruggen developed the concept further, giving the button both a fracture and a tilt and painting it white. Oldenburg's monuments generally cause controversy, and *Split Button* was no exception. Over the years, however, the *Button* has become a familiar part of the campus environment. Students sit on it; children play on and under it and poke their hands through the holes.

248

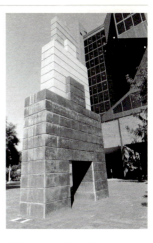

6-32

Rafael Ferrer (1933–)
El Gran Teatro de la Luna
1982
*Painted aluminum. Height 13'; width
60'; depth 10' 2"*
Fairhill Square
4th Street and Lehigh Avenue

Around the roof of the curved
concrete utility building in Fair-
hill Square, vividly colored alu-
minum acrobats tumble and
cavort. The silhouette figures
include a female dancer-gym-
nast, a juggler balancing on a
pyramid of spheres, a person
with a bright red dress and a
mustache standing on his/her
head, and strange, devilish per-
formers doing tricks on wheels.
Along the rim of the north side
of the building, lowercase script
letters spell out the title, *El Gran
Teatro de la Luna*—"Big Theater
of the Moon."

 The moon is recalled in the
wheels and balls used as the acro-
bats' props, and it becomes a
symbol for the inspiration behind
the performance. Observers have
seen both joy and sinister frenzy
in the postures and the extrava-
gant epoxy colors, which range
from red and pink to lavender
and chartreuse.

 Rafael Ferrer, a native of
Puerto Rico who moved to Phila-
delphia in 1966, proposed *El
Gran Teatro* for the Fairmount
Park Art Association's Form and
Function project (see p. 168).

6-33

Siah Armajani (1939–)
Louis Kahn Lecture Room
1982
*Painted wood, wood inlay, plaster, glass.
Height 10' 3"; width 16' 2";
depth 23' 9"*
*Samuel S. Fleisher Art Memorial
(interior)*
709 Catharine Street
For access call 922 3456

For his contribution to the Fair-
mount Park Art Association's
Form and Function project, Siah
Armajani wanted to create a
work for a school (see p. 168).
The result was a room dedicated
to Louis Kahn that serves as a
lecture room and meeting place
as well as a gallery for displaying
reproductions of Kahn's architec-
tural drawings.

 Armajani, an Iranian who
emigrated to the United States in
1960, is a principal theorist of
contemporary public art. His
work has been described as dem-
ocratic because it brings art into
the service of daily life. His
bridges, rooms, and garden struc-
tures are deceptively simple,
meticulously crafted, and often
inscribed with passages from his
favorite American writers,
including Emerson, Melville, and
Whitman.

 The *Louis Kahn Lecture
Room* is designed to accommo-
date about 35 people. Wooden
pewlike benches extend at an
angle from the walls. In the
middle of the room, Armajani
left enough open space to allow a
"meditative quality." The durable
hardwoods are painted in grayish
rose, bright yellow, and Pennsyl-
vania Dutch blue. At the
entrance a glass transom has one
of Kahn's designs etched in it,
and display surfaces on the walls
offer changing examples of his
work. Mounted on the cornice
are quotations from Kahn, and
an inlaid wooden rectangle in
the floor bears a verse by

Whitman that begins: "When the
materials are prepared and
ready, the architects shall
appear." The room's simple ele-
gance suggests a Quaker meeting-
house or a country church. In
fact, Armajani intended to evoke
the feeling of the adjacent Sanc-
tuary, which was originally built
as a church.

 The Fleisher Art Memorial,
with support from the city's
Office of Housing and Commu-
nity Development, funded the
building renovation and lighting;
the Fairmount Park Art Associa-
tion sponsored the room's design
and installation.

6-34

Charles Fahlen (1939–)
Major
1982
*Colored concrete. Height 23'; width 10';
depth 3'*
American Postal Workers House
8th and Locust Streets

Rising from a corner near Wash-
ington Square is what appears to
be a giant human figure made of
rectangular blocks like those a
child might use. According to
Gerrit Henry in *Art News*, this
"broadly humorous work" by
Charles Fahlen both embodies
and makes fun of the concept of
monumentality. Fahlen has
explained that he was inspired
not only by toy blocks but by the
"stepped" appearance of the
upper stories in the nearby Ayer
Building (**4-21**). He also intended
the sculpture to resemble a trium-
phal arch in a plaza, with the pas-
sageway reduced to a child's size.
A San Francisco-born artist who
teaches at Philadelphia's Moore
College of Art and Design,
Fahlen is known for sculptures
that use minimal shapes in an
unusual and referential manner.
Major is constructed of 37 con-
crete components arranged in
three main forms. The resem-
blance to toy blocks is enhanced
by the way the forms (colored
mars black, yellow ocher, and
red ocher) appear to fit together
with tabs and notches. The
53,000-pound sculpture was
installed as part of the Redevelop-
ment Authority's percent for fine
arts program.

6-35

Rosalie Sherman (1946–)
Eastwick Farmpark I and II
1983; expanded 1985
Painted aluminum plate; rubberized
coating; redwood benches with aluminum
tubing; concrete bases. Maximum
height c. 5'
84th and Crane Streets

Aluminum cows and sheep graze in a small park in the Eastwick neighborhood. On their sides are benches for visitors to sit on. To make certain the herd does not wander off, three aluminum border collies keep watch, while a mustachioed man in a Phillies cap sits nearby. This humorous installation is the work of Rosalie Sherman, who was commissioned by the Redevelopment Authority after an area-wide competition. Sherman reasoned that a grandiose sculpture would be inappropriate for the site. Instead, she created a light-hearted work that can be enjoyed by neighborhood adults and children. In the early 1970s she made wooden animal toys before turning to more ambitious and larger sculptures. Thus, her concept for *Eastwick Farmpark* was a natural extension of her previous work.

6-36

Richard Haas (1936–)
2300 Chestnut Street, Philadelphia
1983
Painted mural. Height 85'; width 113'
2300 Chestnut Street

In a long, multistory gallery at 2300 Chestnut Street, Calder's famous statue of William Penn (**3-02**) appears to be undergoing repair. To the right rests a statue of Ben Franklin, and behind that is a view of the old B&O railroad station. Below street level, through a pair of arches, one can see the Schuylkill River with sculls passing by. All of this is an illusion produced by Richard Haas's *trompe l'oeil* mural. *Penn* is still on City Hall. The B&O station no longer exists. And those men in sculls look familiar because they are from a well-known Thomas Eakins painting.

Richard Haas became known originally for prints of architectural subjects. Since 1974 he has also created large-scale, illusionistic murals that have been called a form of participatory art because their witty deceptions tease viewers into becoming involved with the work. When the Chestnut Street building was renovated, its owners invited Haas to propose a mural. For many years Haas has been concerned with the integration of his work into its surroundings. At 2300 Chestnut Street, the mural reproduces the building's actual cornices so faithfully that it may be difficult to recognize the painted ones as false.

6-37

Larry Rivers (1923–)
Philadelphia Now and Then
1983
Handmade ceramic tiles. Height 7'6";
width 75'
Gallery II, Food Hall walkway (interior)
11th and Market Streets
For access call 925 7162

The three 25-foot panels of Larry Rivers's ceramic mural in Gallery II present a multitude of scenes from Philadelphia's past and present. The mural occupies the mall-side wall of a JCPenney store and was commissioned by the Penney Company as part of the Redevelopment Authority's one percent program. Rivers's maquette was translated into ceramic tile at Bennington Potters, where most of the foot-square tiles were drawn by hand. The center panel offers a Mummer, Betsy Ross House, skyscrapers, a Mennonite pretzel vendor, the Centre Square *Clothespin* (**6-04**), and more. The panel at the left outlines the signers of the Declaration of Independence, while the right-hand panel presents a heroic-sized head of Ben Franklin surrounded by the nation's founders. By merely outlining the historical figures, Rivers offers shoppers a humorous history test.

6-38

Charles Searles (1937–)
Playtime
1983
Painted mural. Height c. 6'; width c. 38'
Mallery Playground
Morton and Johnson Streets
Commissioned by the Department of
Recreation, City of Philadelphia; percent
for art project
See p. 175 and **6-03**

6-39

Alan Sonfist (1946–)
Rising Sun
1983
Painted aluminum. Wall height 47';
length 64'; maximum wall projection 8';
sphere diameters 8"
Temple University School of Pharmacy
Broad Street and Rising Sun Avenue

On the south-facing wall of Temple University's School of Pharmacy, four open pyramids are mounted above four small spheres. These eight simple elements use sun and shadow to make viewers more aware of time, change, and the movement of the earth. The pyramids and spheres are colored to represent the seasons: green for spring, gold for summer, light gold-green for autumn, and blue for winter. At the beginning of each season, the shadow from the appropriate pyramid intersects the sphere below. Thus, *Rising Sun* is more than a pun on the street address; it indicates the work's function as a solar calendar. The work was commissioned by the university's class of 1980 as a gift to the school.

Alan Sonfist grew up in the South Bronx near the Hemlock Forest, a natural area that influenced him deeply. While in college he began to make arrangements or collages of natural elements such as leaves, twigs, and rocks. Later, as part of a series of works collectively called *Time Landscape*, he used a plot in Manhattan to recreate the area's natural history by planting native species of trees.

6-40

Michael Webb (1947–)
Sgraffito
1983
Stucco. Height c. 8′6″; width c. 11′6″
(each of 17 bays)
University City Townhouses
Market Street between 39th and 40th
Streets

Sgraffito is an ancient technique of incising designs in wet plaster, stucco, or similar material. At a housing development on Market Street, Michael Webb used this technique to create patterns in the stucco surrounding the bay windows. Although the basic design is identical on all 17 bays, the pattern in the top central portion varies from one bay to the next, presenting five different motifs: a torch of liberty, a sun, a bird of paradise, a shell, and a leaf pattern. These motifs are placed so that no two of the same kind can be seen from a single vantage point.

Webb's goal, developed in collaboration with Friday Architects & Planners, was to establish a sense of unity throughout the housing complex. Along with a free-standing bronze sculpture, *Balancing* by Elsa Tarantal, the sgraffito was commissioned as part of the Redevelopment Authority's one percent program.

6-41

Isamu Noguchi (1904–1988)
Bolt of Lightning . . . A Memorial to Benjamin Franklin
Conceived 1933; installed 1984
Stainless steel, painted steel base, steel guy cables. Height 101′ 6″
Monument Plaza
Base of Benjamin Franklin Bridge, near 6th and Vine Streets

At the first Sculpture International in 1933, Isamu Noguchi exhibited eight sculptures and a number of drawings, including a design for a monument to Benjamin Franklin in Fairmount Park (see pp. 90–91). The idea lay dormant for nearly half a century, until in 1979 the Philadelphia Museum of Art presented a retrospective exhibition of Noguchi's work. A reproduction of the 1933 proposal caught the attention of the trustees of the Fairmount Park Art Association, and the project was reborn. With financial help from the estate of George D. Widener, the Art Association commissioned the sculpture as a civic gift in celebration of Philadelphia's tricentennial. Noguchi himself selected the site, Monument Plaza, between the bridge and the square named after Franklin.

For assistance with technical details, Noguchi consulted his friend Paul Weidlinger of Weidlinger Associates, a New York engineering firm. Though Weidlinger's usual responsibilities involved bridges and skyscrapers, he had also worked on large-scale sculptures with such artists as Picasso and Dubuffet. Computer analyses were used to determine how the asymmetrical sculpture could withstand the force of gravity.

Bolt of Lightning refers to the famous experiment in which Franklin flew a kite in an electrical storm. A four-legged base supports an image of the key that

Franklin attached to the kite. On top of the key is the lightning bolt, a 45-foot truss clad with multifaceted stainless steel plates. From the bolt emerges a 23-foot tubular steel structure with a representation of the kite—all balanced by the tension of four guy cables. The cables appeared in Noguchi's 1933 drawings, symbolizing, he said, the eternal and essential contact between air and earth.

6-42

Sabrina Soong (1943–) with Chinese engineers and artisans
The China Gate
1984
Wood, glazed roofing tiles, stone bases. Height 41′8″; width 34′
10th and Arch Streets

The massive *China Gate* on 10th Street serves as a symbolic entrance to Philadelphia's Chinatown. Painted bright gold, green, blue, and red, it reflects the traditional Chinese architectural style of the Qing dynasty (1644–1912). The gate is adorned with dragon motifs, small sculptures of animals, and ornamental roof tiles. The overall design was supervised by Sabrina Soong, a local architect. The Philadelphia Chinatown Development Corporation received a grant from the National Endowment for the Arts to support the preliminary drawings; the rest of the American financing was supplied by the city of Philadelphia and community residents. Philadelphia's sister city of Tianjin, China, provided the tiles, and a team of Chinese engineers and artisans built the pieces of the arch. When the 88-ton gate was ready for assembly, the Chinese experts traveled to Philadelphia and completed their work in a Chinatown warehouse. The large Chinese characters on the gate proclaim "Philadelphia Chinatown."

6-43

David Beck Architects, with Verlin Miller and the Bio-Medical Engineering Laboratory of Case Western Reserve University
Commuter Tunnel Mural
1984
Ceramic tile. Height 12'–30'; width c. 900' (each of two walls)
Market East Station (underground)
For access call 580 7861

"It is the largest paint-by-number in history," jokes architect David Beck. Made of over 250,000 4-by-8-inch tiles, the *Commuter Tunnel Mural* is also the longest tile mural in the world. In 1981 the city sponsored a competition to design a wall treatment for the new commuter rail tunnel. Beck proposed an impressionistic tile landscape of trees, sky, and water that would cover both sides of the tunnel for the equivalent of four city blocks. When he was selected for the project, he had not decided how to realize his concept. Working out the number of tiles of each color and details of their arrangement might have taken years. The solution came from engineers at Case Western Reserve University who were developing computer software to help medical researchers study chromosome irregularities.

Local artist Verlin Miller developed Beck's concept into a series of watercolor panels painted to scale. From over 200 tile samples provided by the Gail ceramic works in Germany, a palette of 64 was selected. Then computer programs were designed to calculate how the tiles should be placed to replicate Miller's watercolors. Finally, the computer printed out a drawing for each small section of the mural, enabling contractors to install the quarter-million units in the correct order. A scene of oaks,

birches, and hemlocks splashed with sunlight and water emerges when the mural is viewed from a distance. Up close, the mural appears to be an abstract arrangement of colors.

6-44

Joel Shapiro (1941–)
Untitled
1984
Bronze. Height 12'; width 8'; depth 8'
One Logan Square (interior)
18th and Cherry Streets
For access call 569 1057

Made of simple shapes that look like a block of wood and four posts, Joel Shapiro's energetic figure is caught in the midst of ambiguous activity. From different angles it suggests a variety of possible interpretations.

The developers, One Logan Square Associates, recognized that the building's proximity to such works as the *Swann Memorial Fountain* (**4-14**) warranted contemporary art of comparable distinction. After a nationwide study they commissioned Shapiro, whose small-scale works in wood, bronze, and iron had made him one of the most widely recognized contemporary sculptors. Though his style connects him to the minimalist movement, his work is considered less austere, more "human." The sculpture for One Logan Square was the largest work Shapiro had yet produced. The bronze was cast from a wooden form, and the wood-grain detail was emphasized with a brown patina. The texture and the playful quality of the prancing figure provide a lively contrast to the lobby's stone and glass walls.

6-45

Ronald Bateman (1947–) and Walter Erlebacher (1933–1991)
Dream Garden and **Day Dream Fountain**
c. 1985
Mural triptych and two bronze sculptures. Mural height 14'; width 9'–10' (each of three panels). Sculpture height 2' 3"–2' 7" (from base); width 5' 9"; depth 2' 6"
ARA Tower (interior)
1101 Market Street
For access call 592 1400

Inspired by *The Dream Garden* by Maxfield Parrish and Louis Tiffany (**4-06**), the works in the lobby of the ARA Tower are incorporated into an architectural setting that includes a waterfall, trees and smaller plants, and a reflecting pool. In Ronald Bateman's acrylic-on-canvas mural, a stream winds through an idyllic pastoral landscape, passing Philadelphia's original waterworks (where City Hall now stands) and the Fairmount Waterworks. In the foreground the stream becomes a small lake that seems to spill out of the mural into an actual waterfall. From left to right, the scene changes from early morning to midday to evening—a theme of passing time echoed in Walter Erlebacher's bronze nudes: *S'élever*, a woman rising from sleep, and *S'endormir*, a woman preparing for sleep. The sculptures bring the dreamlike time of the murals into the present.

Bateman has also created works for the Wistar Institute and Hahnemann University Hospital; Erlebacher is the sculptor of *Jesus Breaking Bread* (**6-06**). This collaboration was a Redevelopment Authority one percent project. The garden and waterfall were designed by Cope Linder in collaboration with Bower Lewis Thrower.

6-46

Joyce Kozloff (1942–)
**Galla Placidia in
Philadelphia** (above) and
Topkapi Pullman
1985
*Glass and ceramic mosaic. Galla
Placidia: height 13'; width 14'4".
Topkapi Pullman: height 13'; width 16'*
One Penn Center (interior)
1617 John F. Kennedy Boulevard
For access call 567 0860

"Decoration," Joyce Kozloff has
said, "is where painting and
sculpture meet architecture."
For the lobby of One Penn
Center, the building that serves
as an entrance to Suburban Sta-
tion, she complemented the
elaborate Art Deco architecture
with two highly decorative and
symbolic mosaic murals, com-
missioned by developer Richard
I. Rubin as part of the overall
renovation of this 1929
building.
*Galla Placidia in Philadel-
phia* alludes to the mosaic inte-
rior of a mausoleum built in
Ravenna for the fifth-century
Byzantine empress Galla Plac-
idia. In Kozloff's work, vertical
columns of gold, dark red, and
brown create an illusionary
three-dimensional vault. At the
top of the vault, within a pat-
terned arch, the figure of Wil-
liam Penn stands against a blue
sky. (The corresponding site in
the Byzantine mausoleum bears
a Christian allegory of Christ as
the Good Shepherd.) *Topkapi
Pullman*, on the opposite side of
the lobby, includes floral motifs

adapted from the harem rooms
of the Topkapi Palace in
Istanbul. Seen through an arched
doorway, a streamlined image of
"The Standard Railroad of the
World"—borrowed from an Art
Deco poster for the Orient
Express—captures the magic
associated with railroads.
Kozloff, who has developed
mosaic murals for transportation
centers across the country, is a
leader in the pattern-and-decora-
tion movement that rebelled
against minimalist art by intro-
ducing extravagant and lyrical
ornamentation.

6-47

Jane Golden (1955–) and the
Philadelphia Anti-Graffiti Network
Mural
1985
*Painted mural. Height c. 15';
width c. 125' (each of two sections)*
Girard Avenue near 34th Street

Dirty, dingy, scary—these were
some of the terms applied to the
railroad underpass near the
entrance to the Philadelphia
Zoo. In 1984 Douglas Rich-
ardson of the Zoo Projects
Council began a campaign to
have the underpass painted, and
he contacted Tim Spencer, who
had been appointed by Mayor
W. Wilson Goode to head the
Anti-Graffiti Network. By early
1985 the young people in the
city's program were enlisted. City
residents sent contributions; local
paint and hardware companies
provided supplies; and Jane
Golden, an artist with an interest
in inner-city murals, supervised
the painting.
The mural has two parts,
located on opposite sides of
Girard Avenue. In the southern
section, a line of painted cars mir-
rors the real cars that stop under
the bridge for the traffic light.
Dominating the foreground is a
high-angle close-up of the Ben-
jamin Franklin Bridge, and the
background is a long cityscape.
The northern section offers
another image of the bridge, with
a green park landscape including
the Museum of Art and a rail-
road bridge crossing a river. In
effect, the mural lifts the
observer out of the underpass to
a wider and more imaginative
view of Philadelphia.
The Anti-Graffiti Network
has produced hundreds of
murals in neighborhoods
throughout the city (see p. 175
and *A Legacy of Murals*, pp.
118–119), including *Squirrel Hill
Falls* at 48th and Chester; *Mount
Kilimanjaro* at 20th and Dia-

mond; *Homage to the Black
Family* and *A Tribute to My Dad*
at 22nd and Dauphin; and the
Julius Erving Monument (**6-59**).

6-48

Richard Fleischner, artist
Mitchell/Giurgola Architects with
Richard Glaser and Harriet Pattison,
landscape architects
Columbia Subway Plaza
1986
*Granite and brick paving, plane trees,
turf, and granite sculpture. Lot c. 170' by
180'; portal structure 46' by 80'*
Broad Street and Cecil B. Moore Avenue

Every weekday thousands of
Temple University students com-
mute to the campus via the
Broad Street Subway. In the late
1960s, student, community, and
government leaders began to pro-
pose ways to make the area safer
and more attractive. The result
was an ambitious joint project in
which the city remodeled the
subway station while the univer-
sity built an adjacent plaza. The
architectural firm for both seg-
ments of the project was
Mitchell/Giurgola, a local firm
with an international reputation.
Joining the architects on the
plaza design team were artist
Richard Fleischner and land-
scape architects Harriet Pattison
and Richard Glaser. The campus
improvement program was sup-
ported by the Pew Charitable
Trusts, the William Penn Foun-
dation, and the National Endow-
ment for the Arts.

For the station, Mitchell/Giur-
gola designed a large head house
with a glass roof that allowed day-
light to penetrate to the train plat-
form, transforming the subway
exit into a campus entrance.
Fleischner created a portal-like
structure of granite blocks on a
grassy plot to act as a symbolic
entrance and focal point for the
plaza, while Pattison and Glaser
planted a formal grid of 20
London plane trees. The entire
design tends to merge the inte-
rior and exterior, so that the
plaza/garden environment seems
to extend virtually to the subway
platform.

6-49

William Freeland (1929–)
Elemental Intervals
1986
*Painted aluminum plate, bronze rod
mesh, limestone, brick. Height 35';
width 27'*
1001–1051 South Street

For the block-long garage and
retail complex on South Street,
artist William Freeland was com-
missioned to work with the archi-
tectural firm of Lawrence Polillo
Associates. In this Redevelop-
ment Authority one percent
project, the artist contributed to
the overall facade design. Free-
land conceived the areas of
darker brick that form shadow-
like stripes on the red brick wall,
and for the central portion he cre-
ated a two-part wall sculpture in
which cages of bronze mesh are
filled with 4.5 tons of limestone
rocks. The lowest piece of stone
in the mesh was brought from
the town of Loreto Aprutino in
Italy by the developer, John Acci-
avatti; it comes from the house
where his father was born. *Ele-
mental Intervals* was one of Free-
land's first large-scale creations;
he prefers to call it a "three-
dimensional work" or "construc-
tion" rather than a "sculpture."

6-50

Lily Yeh (1941–) with community
residents
**Ile-Ife Park: The Village of
Arts and Humanities**
1986–
*Mosaic sculptures, painted mural, and
plantings. Lot 280' by 140'*
*The Village of Arts and Humanities
2544 Germantown Avenue
For access call 225 3949*

Ile-Ife Park was the founding
project of the Village of Arts and
Humanities in North Philadel-
phia. According to Lily Yeh, the
Village's executive director, the
park has involved community res-
idents in every phase of develop-
ment—conception, design, and
construction. Yeh arrived in Phil-
adelphia from Taiwan to study
art in 1963 and later taught at
the Philadelphia College of Art.
When Arthur Hall, founder of
the Afro-American Dance
Ensemble and director of the Ile-
Ife (Yoruba for "House of Love")
Center for the Arts and Humani-
ties, offered the vacant lot
adjoining the Center as a site for
a community sculpture garden,
Yeh applied for a grant from the
Pennsylvania Council on the
Arts. Before work began, five
houses next to the lot burned
down, giving her a much larger
area for the project. Local rela-
tions among blacks, Hispanics,
Koreans, and Chinese were often
uneasy, but Yeh found an ally in
Joseph Williams, a long-time
neighborhood resident, who
encouraged and supervised the
young people who participated in
the work.

Philadelphia Green provided
trees, shrubs, and flowers; the
Anti-Graffiti Network brought
painters, equipment, and a pro-
tective cyclone fence. Within a
central brick circle, Yeh and Wil-
liams built nine-foot columns of
cement and wire on a mound of
cobblestones, and local children
painted these "trees" in vivid

colors. Later, both the "trees"
and the smaller sculptures
around them were covered with
multicolored chunks of tile. Wil-
liams, a professional cook, sug-
gested adding two pit ovens for a
community kitchen. Overlooking
the scene, on the 35-by-90-foot
wall of the adjacent building,
Yeh and her helpers painted a
mural.

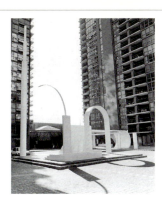

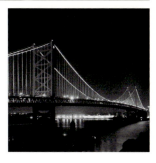

6-51

Noe Lugo (1942–) with the
Philadelphia Anti-Graffiti Network
**Los Tres Vejigantes en el
Barrio**
1986
Painted mural. Height 35'; width 100'
Taller Puertorriqueño
2721 North 5th Street

Three gigantic carnival figures
display their colorful costumes
on the wall of Taller Puertorri-
queño, an arts and cultural
center in the Hispanic commu-
nity. These *vejigantes* are charac-
ters from a Puerto Rican festival,
where they represent hope,
peace, and goodness. The car-
nival originated in the Spanish
and African traditions of Puerto
Rico, and the image of the sun
in the sky above the *vejigantes*
derives from the art of the Taino
Indians, Puerto Rico's original
inhabitants. The traditional sym-
bols are shown against the back-
ground of a Philadelphia street
scene closely resembling the
actual neighborhood at 5th and
Lehigh.

The work was designed by
Noe Lugo, a local artist born in
Puerto Rico, and the painting
was done by the young people of
the Philadelphia Anti-Graffiti
Network with help from children
participating in Taller Puertorri-
queño's summer art programs. In
1989, eight wooden figures repre-
senting other aspects of Puerto
Rican culture—created by chil-
dren in a Taller workshop spon-
sored by the Philadelphia
Museum of Art—were placed in
the garden space in front of the
mural.

6-52

Barbara Neijna (1937–)
Total Environment
1986
Painted aluminum sculpture, paving,
landscaping, lighting. Plaza 180' by 180';
maximum sculpture height 60'.
Pedestrian sidewalk 50' by 300'
Independence Place Condominiums
6th Street and Locust Walk

When she was shown the blue-
prints for the Independence
Place towers, Barbara Neijna con-
ceived an artwork far more ambi-
tious than the "central pedestal
sculpture" originally envisioned
for the Redevelopment
Authority's fine arts requirement.
For the plaza at the main
entrance, she created a complete
visual environment of sculpture,
trees, flowers, ornamental
paving, and lighting. The idea,
she explained, was to relate the
space both to the architecture of
the Society Hill area and to the
park atmosphere of neighboring
Washington Square. The sculp-
ture includes "majestically
scaled" forms as well as forms of
a more human size.

On a low platform in the
plaza's center stand a tall column
of cylinders, a square wall, and
an arch linked to a low curving
wall with a column that supports
a thin form reminiscent of a
curved lamppost. At the condo-
minium entrance rises a second
major assemblage of shapes,
including a drive-through portal.
All of the elements are painted a
stark, brilliant white.

6-53

Giuseppe Penone (1947–)
**Una Biforcazione e Tre
Paesaggi**
1986
Bronze sculptures, clay pots, plants,
fountain base. Fountain diameter 12';
maximum sculpture height 7'3"
Sheraton Society Hill (interior)
1 Dock Street

The title of Giuseppe Penone's
work in the Sheraton lobby trans-
lates roughly as "A Forked
Branch and Three Landscapes."
Una Biforcazione was commis-
sioned by Rouse and Associates
as part of the Redevelopment
Authority's Fine Arts Program.
Penone, whose works have been
exhibited at major museums
around the world, is associated
with an Italian movement known
as *arte povera*, "poor art." The
artists of this movement use com-
monplace materials to express
history, culture, and mythology
and the relationship between
human beings and the environ-
ment. In the circular fountain,
water bubbles gently through the
larger end of a long bronze
branch. Large clay pots hold low
plants, vines, and bushes. Among
the taller plants are the three
"landscapes" that represent
female figures. One is sitting
with her feet in the basin; one is
reclining near the edge of the
fountain; and the third seems to
be stepping away from the pool.
All three figures have a barklike
surface that reinforces the theme
of human integration with
nature.

6-54

Venturi, Rauch and Scott Brown
**Benjamin Franklin Bridge
Lighting** (or **Ben's Light**)
1987
Computerized lighting system. Height of
bridge c. 380'; length 7,456'
Benjamin Franklin Bridge

At night, from a distance, the
bridge's towers and curving sus-
pension cables emerge with a
blue phosphorescent glow. At
closer range, the vertical cables
appear, forming a delicate veil
across the river. Rather than
imposing a decoration, the lights
make visible the structural grace
of this 1926 engineering and
architectural landmark. And
when the computer sets the
lights pulsing, the effect can be
magical. Currently the lights are
programmed to create a wavelike
motion whenever a train crosses
the bridge.

The project began in 1986,
when the Benjamin Franklin
Bridge Lighting Committee was
formed by City Representative
Dianne Semingson. Soon the
PENJERDEL Council sponsored a
competition to select a lighting
design. The winning proposal
was submitted by Venturi, Rauch
and Scott Brown, the firm that
designed *Ghost Structures* (**6-05**).
Steve Izenour, project architect
for the firm, developed the con-
cept in collaboration with his
father, noted theater designer
George Izenour. Private contribu-
tions and a public "Buy a Bulb"
campaign helped to provide the
necessary funds.

At the foot of each of the 256
vertical cables, a set of metal
halide spotlights shines up
toward a conical reflector
mounted at the top. The state
and city seals on the masonry
anchor piers are illuminated, and
each tower is crowned by a large
phosphorus halide light tube.
The entire system is governed by
a computer. In addition to

Izenour, Miles Ritter and Malcolm Woollen served as project architects. General Electric manufactured special lamps and fixtures for the project. Although the lighting can be seen from many vantage points, it is virtually invisible from the bridge roadway and therefore presents little distraction to drivers.

Amid fireworks, a laser display, and a parade of boats, the bridge's lights debuted as scheduled on September 17, 1987, in celebration of the bicentennial of the U.S. Constitution.

6-55

Jody Pinto (1942–)

Fingerspan

1987

Weathering steel. Height 9'; length 59'; width 4' 10"

Wissahickon Creek trail near Livezey Dam

Fairmount Park

"It's one of the most breathtaking points along the Wissahickon," artist Jody Pinto said of the gorge south of Livezey Dam. A span once served to get people across the gorge; when it deteriorated, the Park Commission retro-fitted and installed a staircase from an old ship. To replace the stairs, Pinto designed *Fingerspan*, an outgrowth of the Fairmount Park Art Association's Form and Function project (see p. 166).

Pinto, born in New York, grew up in a family of artists and photographers. Many of her works use imagery from the human body. "For me," she says, "the body is the central source of information, of everything we understand, everything we see." In *Fingerspan*, her first permanent outdoor installation in the United States, she wanted to link the human body with the natural environment in such a way that viewers themselves, passing through the work, would help to establish the connection.

The artist considered issues of safety, security, and durability. The perforated-steel covering prevents people from falling or climbing over the edge but allows a view of the spectacular gorge below. The entire 18,000-pound construction is made of weathering steel that forms a protective coat of rust. As a reviewer commented, the bridge looks as if it has been in place since the days of the Lenni Lenape Indians. Samuel Harris of the firm

Kieran Timberlake and Harris, who served as architect and engineer for the project, collaborated in developing the concept into a practical structure. The span was fabricated in sections and installed by helicopter. A grant from the Art in Public Places Program of the National Endowment for the Arts supplemented funds from the Fairmount Park Art Association, and the work was donated to the city of Philadelphia.

Directions by car: Park on Allen's Lane in Mount Airy, and walk down Livezey Lane to the creek at a point where the dam and Canoe Club are visible. Turn left and follow hiking trail (15–20 minutes) to a small steel foot bridge, and climb stone steps to *Fingerspan*.

6-56

Albert Paley (1944–)

Synergy

1987

Painted steel, on concrete bases. Height 20'; width 17' 6"; depth 7' (each of two forms; base height 2')

Museum Towers

18th and Spring Garden Streets

Albert Paley's steel sculpture frames the 18th Street driveway entrance of the Museum Towers apartment building. Two tall columns are wrapped with banner and ribbon shapes that seem to be fluttering in the breeze as they extend toward the center of the drive. Each large pillar is flanked by two smaller columns bearing similar ribbons and banners that ripple downward toward the street. The overall effect of *Synergy* is one of frozen motion.

Paley is a leading figure in the revival of blacksmithing as an artistic pursuit. In 1972 he won a national competition to design the portal gates at the Smithsonian Institution's Renwick Gallery in Washington, D.C. He also created the 800 tree grates and 75 cast-iron benches that line Pennsylvania Avenue there.

Synergy was commissioned for the new apartment building as part of the Redevelopment Authority's one percent program. At Paley's studio in Rochester, the columns and banners were hydraulically bent and formed out of steel plate and bar stock. After welding, hand grinding, and sandblasting, Paley and his assistants painted the sculpture a bronze green to harmonize with the architecture. Lights in the circular concrete bases illuminate the massive steel forms at night.

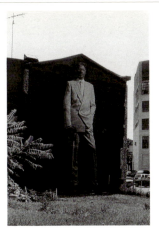

6-57

Keith Haring (1956–1990) with the
CityKids Coalition and Brandywine
Graphics Workshop
We the Youth
1987
Painted mural. Height 40'; width 70'
22nd and Ellsworth Streets

Like cartoon characters the fig-
ures jump and dance, their
motion emphasized by the sort of
"speed lines" familiar in the
Sunday comics. These images—
red, blue, yellow, and green on a
white background—are the cre-
ation of Keith Haring, an artist
who became famous for his
subway drawings and public
murals in New York. Assisting
him were young people from
Philadelphia's CityKids, an off-
shoot of the New York CityKids
Foundation. The Philadelphia
CityKids were sponsored by the
Brandywine Workshop, aided by
funding from the Pennsylvania
Council on the Arts; neighbors,
community groups, and local
businesses cooperated.

Haring was born in Kutz-
town, Pennsylvania, and studied
art in Pittsburgh and New York.
In New York he became inter-
ested in graffiti artists and soon
began his own subway drawings.
Although he was sometimes
arrested for vandalism, the dis-
tinct style of his drawings made
him a celebrity. He painted an
antidrug mural in New York and
designed posters for the antiapart-
heid movement. Perhaps his
most famous mural was one he
painted on the Berlin Wall in
1986. In 1989, fighting an ulti-
mately losing battle with AIDS, he
became active in fundraising
efforts to combat the disease.

6-58

Ray King (1950–)
Aurora Window, Canopy, and
Sconces
1989
*Glass, bronze, steel. Window: height
20'; width 14'. Canopy: height 3'; width
14'; depth 14'3". Sconces: height 3'–6';
width 3'6"–3' 10"*
Cosmopolitan
12th and Locust Streets

The Cosmopolitan apartment
complex combines two buildings:
a new seven-story structure and a
remodeled industrial building
dating from the late 1890s. To
fulfill the Redevelopment
Authority's one percent fine arts
requirement, the developers
asked Ray King, a Philadelphia
sculptor of glass and metal, to
integrate artwork into the archi-
tecture. Directly above the
entrance that serves both build-
ings, King placed a cantilevered,
conical glass canopy with raylike
supports of steel and bronze.
Over the canopy is the *Aurora
Window*, with spiral shapes that
refer to the aurora borealis. On
either side of the entrance are
two six-foot conical sconces of
patinated bronze studded with
glass lenses and surrounded by
vertical, sawtoothed glass fins.
Farther south on 12th Street are
two smaller sconces, and six
more adorn the Locust Street
facade. The composition is espe-
cially dramatic when illuminated
at night.

King, who began his career
by apprenticing with local
stained glass artist Marco Zubar,
has created large indoor works
for Graduate Hospital, Temple
University's Student-Faculty
Center, and the office building at
1608 Walnut Street.

6-59

Kent Twitchell (1942–) with the
Philadelphia Anti-Graffiti Network
Julius Erving Monument
1989
*Acrylic emulsion on stucco, varnished
with acrylic gloss medium. Height 35';
width 45'*
1219 Ridge Avenue

Three stories tall, former Phila-
delphia 76ers basketball star
Julius Erving looks down toward
the corner of Ridge Avenue and
Green Street. But he is not
wearing his familiar basketball
uniform; instead, he has on a
beige suit, yellow tie with
matching pocket handkerchief,
and polished brown loafers.
Artist Kent Twitchell and his
helpers from the Philadelphia
Anti-Graffiti Network wanted to
show Erving not as an athlete
but as a civic leader and role
model for the city's youth (see
p. 175 and *A Legacy of Murals*,
pp. 118–119).

Twitchell is one of the
country's most respected mural-
ists. In his home town of Los
Angeles, his huge "mural monu-
ments" are well-known sights
along the freeways. His sub-
jects—"cultural heroes," he calls
them—have included actors and
fellow artists. Although he began
his career as an abstract expres-
sionist, Twitchell is now a strict
realist and bases each mural on a
photo of the subject.

The *Julius Erving Monument*
was supported by a grant from
the Pennsylvania Council on the
Arts. The work has an alternative
title, *Dr. J*, the nickname by
which Erving was known to a
generation of basketball fans.

6-60

Stephen Antonakos (1926–)
Neons for Buttonwood
1990
*Neon with metal raceways. South
facade: height 23'; width 107' 6"; depth
2'. East facade: height 20'; width 15';
depth 12"*
Buttonwood Square
20th and Hamilton Streets

In dazzling neon, geometric
shapes and lines course along the
top of the KormanSuites building
at Buttonwood Square. Created
as part of the Redevelopment
Authority's Fine Arts Program,
Neons for Buttonwood has two
segments, one facing south, the
other east. The strong contrasting
colors—red, green, yellow,
blue—make the sculpture stand
out like a beacon in the evening
sky. The neon tubes are placed
at varying depths, and some are
set on raceways of a different
color; hence the sculpture seems
to change depending on the
viewer's position and the time of
day. One yellow tube on the
south facade is actually hidden
from direct view, so that it
appears only as a soft diagonal
stripe reflected off the building.

The artist, Stephen Anto-
nakos, emigrated from Greece as
a child. In recent years, working
from his New York studio, he
has created permanent neon
installations for more than two
dozen public sites across the
country.

6-61

Andrew Leicester (1948–)

Riverwalk at Piers 3 and 5

1990

Ceramic, concrete, steel, aluminum.
Height 24'; width 45'; depth 800'
Delaware Avenue north of Market Street

Mermaids and stevedores, gargoyles and fish heads—these are only a few of the fanciful objects that Andrew Leicester created for his *Riverwalk*, 800 feet of sidewalk and plaza at Piers 3 and 5. The piers now house residences and commercial space, but the British-born Leicester, working under the auspices of the Redevelopment Authority's Fine Arts Program, wanted to evoke Philadelphia's maritime past.

At the southern end, serving as an observation deck, a form called the *Hulk* resembles an abandoned ship hull. Gargoyle heads pop out of its portholes, and images of shipboard life are cut into the concrete floor. Framing the approach, two ceramic horse heads emerge from pedestals, straining as if they were hauling the hull ashore. The horses' "tails"—concrete forms on the opposite side of the sidewalk—serve as seats for passers-by. Farther north, besides more horses, the viewer finds semblances of ship figureheads: full-length male and female forms and mermaids with greenish-blue scales. All these ceramic sculptures were produced by Jack Thompson and students at Temple University's Tyler School of Art. Small tiles in the pedestals bear symbols of maritime cargoes such as flour and hemp.

Toward the northern end of *Riverwalk*, the sidewalk passes through the most dramatic structure, a 24-foot-high evocation of a harbor lightship. This concrete and metal form also recalls the *Atlas*, a floating derrick of bygone days. Figures of stevedores heave at it from either end. The tower columns emerge from goggle-eyed ceramic fish heads. On top is a weathervane that resembles a fish skeleton and at the same time echoes the superstructure of the Benjamin Franklin Bridge.

6-62

Brower Hatcher (1942–)

Starman in the Ancient Garden

1990

Cast stone, stainless steel, bronze, brick, stone, aluminum. Height 40'; width 12'; depth 12'
Walnut Towers
9th and Walnut Streets

Face down on a hard pedestal, Brower Hatcher's space traveler has crash-landed in the midst of a center city plaza. Above the 1,500-pound bronze countenance, a 27-foot steel mesh "star trail" stretches away into the sky like the tail of a meteor. Inside the mesh, suspended objects suggest elements of civilization or nature that *Starman* has picked up along the way: a car, a wagon wheel, snakes, a pineapple, fish, a falling person, geometric shapes, and more. The plaza surrounding the sculpture takes the form of an ancient amphitheater and garden, with columns, classical fragments, vines and other plantings, and a mysterious small pyramid. The columns also echo the neoclassical architecture of nearby buildings, especially the Walnut Street Theatre across the street. Surprisingly, *Starman*'s face is serene and classical despite his crash.

Hatcher, a sculptor from upstate New York, created this work for the Parkway Development Corporation as part of the Redevelopment Authority's Fine Arts Program. By mixing past, present, and future in a fantastic collision of civilizations, he hoped to entice viewers to reflect on "what we have been, what we are and what we may become."

6-63

Nam June Paik (1932–)

Video Arbor

1990

Color video monitors, metal, concrete, plantings. Height c. 12'; courtyard c. 50' by 26'
One Franklin Town Apartments
Franklin Town Boulevard south of Callowhill Street
For hours of operation call 567 5525

At the courtyard entrance to One Franklin Town, 84 color video monitors, mounted in three overhead metal beams, offer a dazzling swirl of images. Half of the monitors present a program of Philadelphia scenes—including buildings, historical sites, and some of the sculptures mentioned in this book—mixed with a multitude of colorful, changing shapes. Simultaneously, the other monitors play a program of fish, flower, and bird images, geometric shapes, airplanes, spaceships, nebulae, all constantly merging and changing. The two programs alternate so that no two adjacent monitors show the same images.

The three beams housing the monitors rest on 24 open metal columns, at the foot of which wisteria vines have been planted. The intent, says artist Nam June Paik, is to create a harmony of nature and technology. The flickering images may also suggest the fleeting nature of time, and this theme is reinforced by shapes like sundials or clocks placed on the beams directly above the vertical columns. With a touch of humor, Paik decorated the rear access panels of the beams with stylized diagrams of circuit boards.

Paik was born in South Korea and educated in Tokyo and Germany. He worked with

6-64

Stephen Berg (1934–) and
Tom Chimes (1921–)
Sleeping Woman
1991
Painted text on existing stone surface.
Length 1,125´; width 30˝; letterforms
5˝ high
Schuylkill River retaining wall between
Cowboy *and* Playing Angels
Kelly Drive, Fairmount Park

electronic music before he began to concentrate on the television sculptures and video installations that have been shown in public spaces and museums worldwide. *Video Arbor* was commissioned as part of the Redevelopment Authority's Fine Arts Program.

Poet Stephen Berg and visual artist Tom Chimes describe *Sleeping Woman* as a "choral voice rising out of the site." The collaborative work was created specifically for this location and was commissioned by the Fairmount Park Art Association with support from the Pew Charitable Trusts. The text, painted without punctuation on the top of the stone retaining wall that separates the Schuylkill River and the grass bank of Kelly Drive, was applied with a series of polyurethane coatings so that the words "emerge" from the stone. Depending upon the variable light and the angle of the observer, the letterforms appear and disappear. The center of the text is marked by the word "RIVER."

A few months after the project was completed, a 200-foot section of the wall sank into the river. Berg observed that the collapse embodied a major theme of the text: the power of nature and the transformation of life.

Map 1

Center City East

1	3-27	Eagle
2	1-02	Benjamin Franklin
3	1-04	Minerva as the Patroness of American Liberty
4	6-58	Aurora Window, Canopy, and Sconces
5	5-25	Water, Ice, Fire
6	6-43	Commuter Tunnel Mural
7	6-45	Dream Garden and Day Dream Fountain
8	6-37	Philadelphia Now and Then
9	6-49	Elemental Intervals
10	6-42	The China Gate
11	4-24	Federal Courthouse and Post Office
12	4-23	Wisdom and Commerce
13	6-62	Starman in the Ancient Garden
14	6-34	Major
15	1-01	William Penn
16	1-03	George Washington
17	4-21	N. W. Ayer Building
18	6-08	Nesaika
19	6-11	Phaedrus
20	6-13	White Cascade
21	6-03	Celebration
22	6-21	Voyage of Ulysses
23	6-02	Bicentennial Dawn
24	2-09	Gas Jet Eagle
25	5-10	Milkweed Pod
26	6-28	Woman Looking Through a Window
27	2-13	Benjamin Franklin
28	4-06	The Dream Garden
29	6-25	Cubus Assemblage
30	6-41	Bolt of Lightning
31	2-17	George Washington (bronze cast)
32	6-52	Total Environment
33	5-08	Rock Form
34	2-26	Religious Liberty
35	6-23	Gift of the Winds
36	5-17	Dedicated to the American Secretary
37	1-08	George Washington
38	6-09	Old Pine Community Center
39	6-10	Order/Disorder and Ascension/Descension
40	6-05	Ghost Structures
41	1-05	Eagle
42	4-20	Floating Figure
43	5-12	Old Man, Young Man, The Future
44	6-53	Una Biforcazione e Tre Paesaggi
45	6-54	Benjamin Franklin Bridge Lighting
46	6-61	Riverwalk at Piers 3 and 5
47	6-14	Spheres
48	6-18	Central Post
49	6-17	Mangbusucks
50	6-16	Nandi
51	6-15	Five Water Spouts, Frog, and Lintel

260

Vine St

Race St

Cherry St

Arch St

Filbert St

City Hall

Market St

Chestnut St

Sansom St

Walnut St

Locust St

Spruce St

Pine St

Lombard St

South St

Broad St

13th St

12th St

1

2 3

(000) Exterior

(000) Interior

N

| 0 | 200 | 400 | 600 | 800 | 1,000 feet |

| 0 | 100 | 200 | 300 meters |

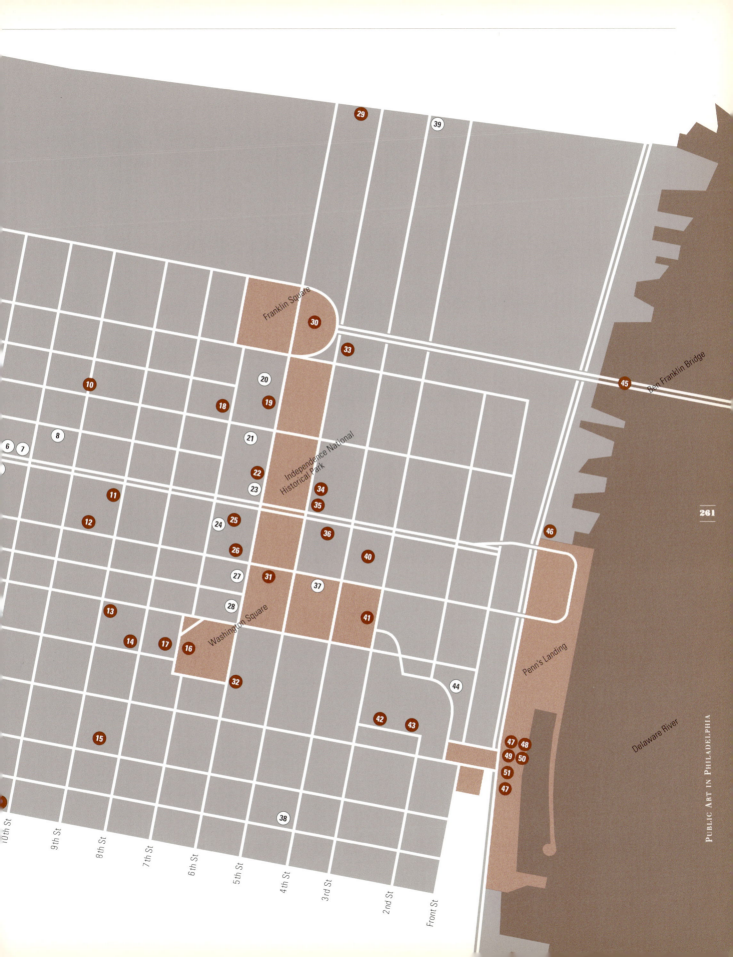

Franklin Square

30

33

20

10

18

19

8

21

6 7

22

11

23

34

35

12

24 25

36

46

26

40

27 31

37

13

28

41

14 17

16

Washington Square

32

Independence National
Historical Park

Ben Franklin Bridge

45

Penn's Landing

44

42 43

15

47 48

49 50

51

47

38

Delaware River

10th St

9th St

8th St

7th St

6th St

5th St

4th St

3rd St

2nd St

Front St

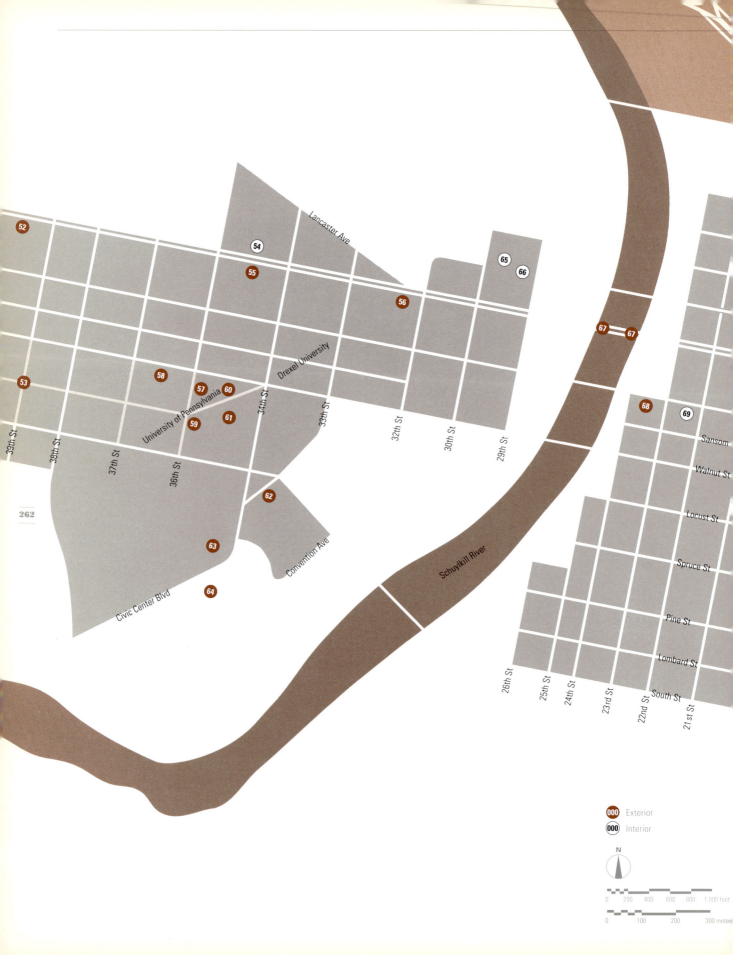

Lancaster Ave

54

55

56

65

66

67 67

Drexel University

58

57 60

61

68

69

University of Pennsylvania

59

Sansom

Walnut St

34th St

33rd St

32th St

30th St

29th St

Locust St

Spruce St

52

53

39th St

38th St

37th St

36th St

62

Convention Ave

Pine St

63

64

Schuylkill River

Lombard St

Civic Center Blvd

26th St

25th St

24th St

23rd St

22nd St

South St

21st St

000 Exterior

000 Interior

N

0 200 400 600 800 1,000 feet

0 100 200 300 meter

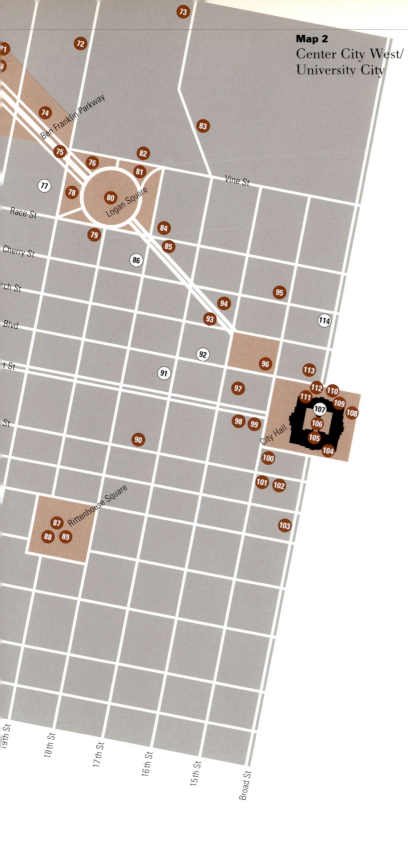

Map 2

Center City West/
University City

263

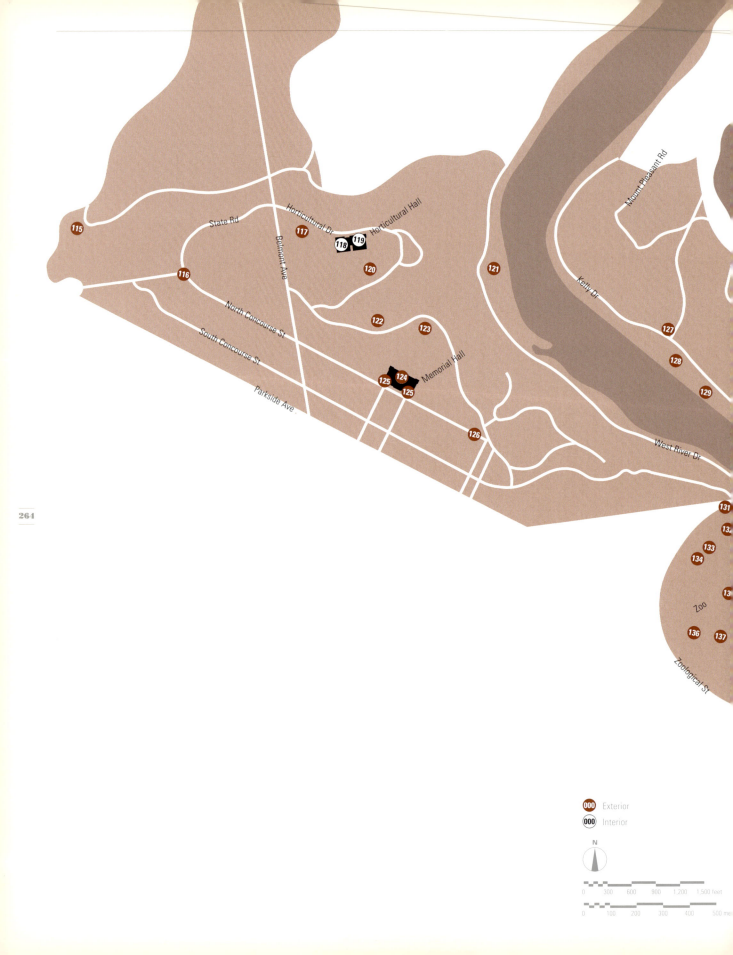

Map 3

Fairmount Park

East Park Reservoir

33th St

Girard Ave

Kelly Dr

Poplar Dr

Sedgely Dr

Pennsylvania St

Kelly Dr

Schuylkill River

West River Dr

Fairmount Ave

Art Museum

Ben Franklin Parkway

139 140 142 141 143 144 145 146 148 147 150 155 151 154 152 153 149 158 157 162 161 163 159 156 164 160 165 166 167 168

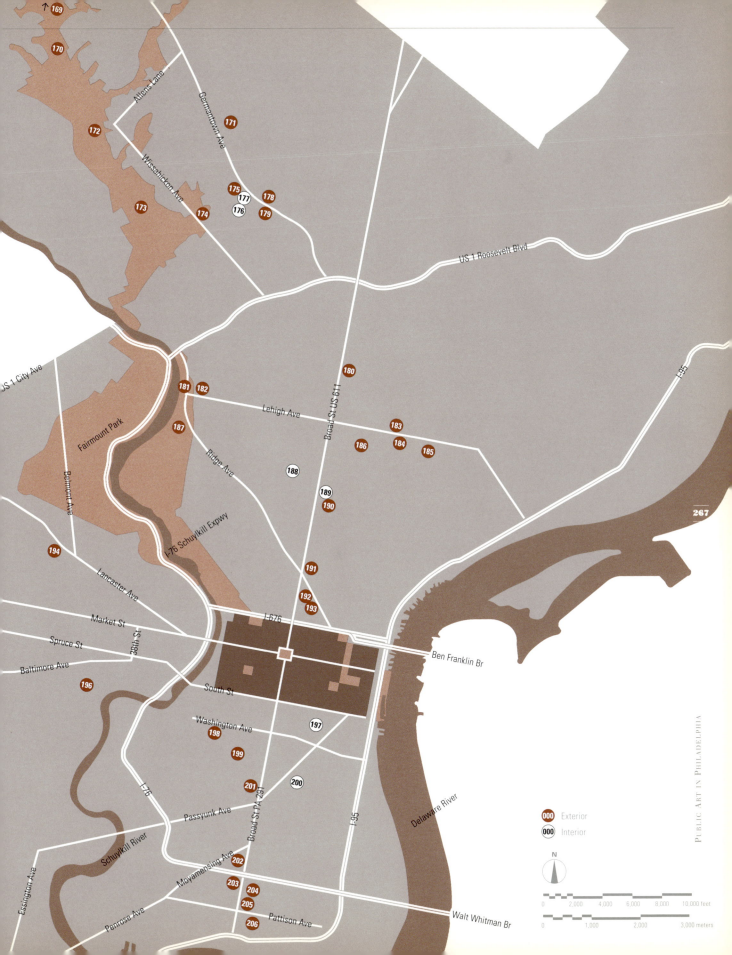

↑ 169

170

172

173

174

Allens Lane

Germantown Ave

Wissahickon Ave

171

175
177
176
178
179

US 1 Roosevelt Blvd

I-95

US 1 City Ave

Fairmount Park

Belmont Ave

181 182

Lehigh Ave

187

Ridge Ave

194

Lancaster Ave

I-76 Schuylkill Expwy

180

Broad St US 611

183

186 184 185

188

189

190

191

192
193

Market St

Spruce St

38th St

Baltimore Ave

I-676

South St

196

Washington Ave

198

199

201

Broad St PA 291

200

197

Passyunk Ave

I-76

Schuylkill River

Moyamensing Ave

202

203 204

205

206 Pattison Ave

Penrose Ave

Essington Ave

I-95

Ben Franklin Br

Delaware River

Walt Whitman Br

000 Exterior

000 Interior

N

0 2,000 4,000 6,000 8,000 10,000 feet

0 1,000 2,000 3,000 meters

Bibliography

Chapter 1

"Ancient Inscriptions Found on Rocks in State Defy Efforts of Archeologists to Read Them." *Philadelphia Inquirer*, September 9, 1934.

BANTEL, LINDA. "William Rush Esq." In *William Rush, American Sculptor*. Philadelphia: Pennsylvania Academy of the Fine Arts, 1982.

BENGE, GLENN F. *"Lion Crushing a Serpent."* In *Sculpture of a City: Philadelphia's Treasures in Bronze and Stone*. New York: Walker, 1974.

CADZOW, DONALD A. *Petroglyphs (Rock Carvings) in the Susquehanna River near Safe Harbor, Pennsylvania*. Safe Harbor Report no. 1, vol. 3. Harrisburg: Pennsylvania Historical Commission, 1934.

CRAVEN, WAYNE. "Images of a Nation in Wood, Marble, and Bronze: American Sculpture from 1776 to 1900." In *200 Years of American Sculpture*. New York: David Godine/Whitney Museum of American Art, 1976.

DICKENS, CHARLES. *American Notes for General Circulation* [1842], edited by John S. Whitley and Arnold Goldman. New York: Penguin Books, 1987.

GARVAN, BEATRICE B. *Federal Philadelphia 1785–1825: The Athens of the Western World*. Philadelphia: Philadelphia Museum of Art, 1987.

GIBSON, JANE MORK. *The Fairmount Waterworks. Bulletin of the Philadelphia Museum of Art* 84, nos. 360–361 (1988).

HIGHWATER, JAMAKE. *Arts of the Indian Americas: Leaves from the Sacred Tree*. New York: Harper & Row, 1983.

————. *The Primal Mind: Vision and Reality in Indian America*. New York: Harper & Row, 1981.

JENNINGS, H. ALONZO; CHARLES L. BLOCKSON; AND L. D. REDDICK. *Of Color, Humanitas and Statehood: The Black Experience in Pennsylvania Over Three Centuries 1681–1981*. Philadelphia: Afro-American Historical and Cultural Museum, 1981.

KIMBALL, FISKE. "The Beginnings of Sculpture in Colonial America." *Art and Archaeology: The Arts Throughout the Ages* 8 (May–June 1919): 185–189.

MERCER, HENRY C. *The Tiled Pavement in the Capitol of Pennsylvania*, edited by Ginger Duemler; illustrated by Linda Brown. State College: Pennsylvania Guild of Craftsmen, 1908; rev. ed. 1974.

MILLER, LILLIAN B. *Patrons and Patriotism*. Chicago: University of Chicago Press, 1966.

PEALE, CHARLES WILLSON. *Historical Catalogue of the Paintings in the Philadelphia Museum, Consisting Chiefly of Portraits of Revolutionary Patriots and Other Distinguished Characters*. Philadelphia: n.p., 1813.

SCHARF, J. THOMAS, AND THOMPSON WESTCOTT. *History of Philadelphia 1609–1884*. 3 vols. Philadelphia: L. H. Everts, 1884.

SELLARS, CHARLES COLEMAN. "William Rush at Fairmount." In *Sculpture of a City: Philadelphia's Treasures in Bronze and Stone*. New York: Walker, 1974.

TATUM, GEORGE B. *Penn's Great Town: 250 Years of Philadelphia Architecture Illustrated in Prints and Drawings*. Philadelphia: University of Pennsylvania Press, 1961.

TEDYUSCUNG. "Speech to the Colonial Council in Philadelphia." In *Indian Oratory: Famous Speeches by Noted Indian Chieftains*, edited by W. C. Vanderwith. Norman: University of Oklahoma Press, 1971.

THOMPSON, D. DODGE. "The Public Work of William Rush: A Case Study in the Origins of American Sculpture." In *William Rush, American Sculptor*. Philadelphia: Pennsylvania Academy of the Fine Arts, 1982.

WATSON, JOHN F. *Annals of Philadelphia, and Pennsylvania, in the Olden Time: Being a Collection of Memoirs, Anecdotes, and Incidents of the City and Its Inhabitants*. 3 vols. Philadelphia: Edwin S. Stuart, 1899.

Chapter 2

BECK, JAMES MONTGOMERY. "The Utility of Civic Beauty." In *50th Anniversary of the Fairmount Park Art Association*. Philadelphia: FPAA, 1922.

BREWSTER, BENJAMIN HARRIS. "Address to the Membership." In *Fairmount Park Art Association Annual Report*, 1872.

BURR, SAMUEL J.A.M. *Memorial of the International Exhibition*. Hartford, Conn.: L. Stebbins, 1877.

CAFFIN, CHARLES. *American Masters of Sculpture*. New York: Doubleday, Page, 1903.

CLARK, WILLIAM J. *Great American Sculpture*. Philadelphia: Gebbie & Barrie, 1898; reprint ed. New York: Garland, 1977.

CRAVEN, WAYNE. *"Abraham Lincoln."* In *Sculpture of a City: Philadelphia's Treasures in Bronze and Stone*. New York: Walker, 1974.

Frank Leslie's Historical Register of the United States Centennial Exposition 1876: Embellished with Nearly Eight Hundred Illustrations Drawn Expressly for This Work by the Most Eminent Artists in America, edited by Frank Norton. New York: Frank Leslie's Publishing House, 1877.

INGRAM, J. S. *Centennial Exposition Described and Illustrated*. Philadelphia: Hubbard Bros., 1876.

IRVING, WASHINGTON. *Guide to Laurel Hill Cemetery, near Philadelphia*. Philadelphia: C. Sherman, 1844.

JACKSON, JOSEPH. *See Philadelphia: A Visitor's Handbook*. Philadelphia: Joseph A. McGuckin, 1937.

JENNINGS, H. ALONZO; CHARLES L. BLOCKSON; AND L. D. REDDICK. *Of Color, Humanitas and Statehood: The Black Experience in Pennsylvania Over Three Centuries 1681–1981*. Philadelphia: Afro-American Historical and Cultural Museum, 1981.

MAASS, JOHN. *The Glorious Enterprise: The Centennial Exhibition of 1876 and H. J. Schwartzmann, Architect-in-Chief*. Watkins Glen, N.Y.: American Life Foundation, 1973.

NORTON, C. B., ed. *Treasures of Art, Industry and Manufacture Represented in the American Centennial Exhibition at Philadelphia 1876*. Buffalo, N.Y.: Cosack & Co., 1877.

PAINE, JUDITH. "The Women's Pavilion of 1876." *Feminist Art Journal* (Winter 1975).

Powers' Statue of the Greek Slave, Exhibiting at the Pennsylvania Academy of the Fine Arts. Philadelphia: T. K. and P. G. Collins, 1848.

RICHMAN, MICHAEL. *"Hudson Bay Wolves."* In *Sculpture of a City: Philadelphia's Treasures in Bronze and Stone*. New York: Walker, 1974.

SCHARF, J. THOMAS, AND THOMPSON WESTCOTT. *History of Philadelphia 1609–1884*. 3 vols. Philadelphia: L. H. Everts, 1884.

SELLIN, DAVID. "The Centennial." In *Sculpture of a City: Philadelphia's Treasures in Bronze and Stone*. New York: Walker, 1974.

THOMAS, GEORGE. "The Statue in the Garden." In *Sculpture of a City: Philadelphia's Treasures in Bronze and Stone*. New York: Walker, 1974.

WESLEY, CHARLES H. *Richard Allen: Apostle of Freedom*. Washington, D.C.: Associated Publishers, 1969.

William Rush, American Sculptor. Philadelphia: Pennsylvania Academy of the Fine Arts, 1982.

Chapter 3

BROWNLEE, DAVID B. *Building the City Beautiful*. Philadelphia: Philadelphia Museum of Art, 1989.

BURNHAM, DANIEL. "The City of the Future Under a Democratic Government," address to the London Town Planning Conference, 1910.

COHEN, CHARLES J. "Daniel Chester French." In *50th Anniversary of the Fairmount Park Art Association*. Philadelphia: FPAA, 1922.

CRAWFORD, ANDREW WRIGHT; GEORGE S. WEBSTER; AND WILLIAM PERRINE. "An Outline of the History of the Parkway." In *Fairmount Park Art Association Annual Report*, 1922.

CROWNINSHIELD, FREDERICK, et al. "The Fine Arts Federation, Its Aims and Ambitions." In *Fairmount Park Art Association Annual Report*, 1906.

DRYFHOUT, JOHN. "Garfield Monument." In *Sculpture of a City: Philadelphia's Treasures in Bronze and Stone*. New York: Walker, 1974.

FAIRMOUNT PARK ART ASSOCIATION. *Unveiling of the Memorial to General James A. Garfield*. Philadelphia: Allen, Lane & Scott, 1896.

GURNEY, GEORGE. "The Sculpture of City Hall." In *Sculpture of a City: Philadelphia's Treasures in Bronze and Stone*. New York: Walker, 1974.

———. "William Penn." In *Sculpture of a City: Philadelphia's Treasures in Bronze and Stone*. New York: Walker, 1974.

HINES, THOMAS S. *Burnham of Chicago: Architect and Planner*. New York: Oxford University Press, 1974.

"Let a Monument to McKinley Rise in Philadelphia." *Philadelphia Inquirer*, September 17, 1901.

McSPADDEN, JOSEPH. *Famous Sculptors of America*. New York: Dodd, Mead, 1924.

MERCER, HENRY C. *The Tiled Pavement in the Capitol of Pennsylvania*, edited by Ginger Duemler; illustrated by Linda Brown. State College: Pennsylvania Guild of Craftsmen, 1908; rev. ed. 1974.

MORRIS, WILLIAM. *Selected Writings and Designs*. London: Penguin Books, 1962.

PROSKE, BEATRICE. *Brookgreen Gardens: Sculpture*. Brookgreen, S.C.: Brookgreen Gardens, 1968.

REED, CLEOTA. *Henry Chapman Mercer and the Moravian Pottery and Tile Works*. Philadelphia: University of Pennsylvania Press, 1987.

RICHMAN, MICHAEL. "Stone Age in America." In *Sculpture of a City: Philadelphia's Treasures in Bronze and Stone*. New York: Walker, 1974.

———. "Ulysses S. Grant." In *Sculpture of a City: Philadelphia's Treasures in Bronze and Stone*. New York: Walker, 1974.

SALISBURY, STEPHAN. "Robeson Reborn." *Philadelphia Inquirer*, April 7, 1988.

SCHARF, J. THOMAS, AND THOMPSON WESTCOTT. *History of Philadelphia 1609–1884*. 3 vols. Philadelphia: L. H. Everts, 1884.

SELLIN, DAVID. "Cowboy." In *Sculpture of a City: Philadelphia's Treasures in Bronze and Stone*. New York: Walker, 1974.

TAFT, LORADO. *The History of American Sculpture*. New York: Macmillan, 1903; rev. ed. New York: Arno, 1924.

TANCOCK, JOHN. "The Washington Monument." In *Sculpture of a City: Philadelphia's Treasures in Bronze and Stone*. New York: Walker, 1974.

TOTTEN, GEORGE OAKLEY, JR. "The Influence of Aeronautics on City Building." In *Fairmount Park Art Association Annual Report*, 1910.

ZANTZINGER, C. C., HORACE TRUMBAUER, AND PAUL CRET. "Report of the Commission . . . to Study the Entrance of the Philadelphia Parkway Into Fairmount Park." In *Fairmount Park Art Association Annual Report*, 1907.

Chapter 4

BACON, EDMUND N. *Design of Cities*. Baltimore: Penguin Books, 1976.

"Brancusi No Artist, Customs Men Hold." *New York Times*, February 24, 1927.

BROWN, MILTON W. *The Story of the Armory Show*. New York: Abbeville Press/Joseph H. Hirshhorn Foundation, 1988.

BROWNLEE, DAVID B. *Building the City Beautiful*. Philadelphia: Philadelphia Museum of Art, 1989.

BURT, STROTHERS. *Philadelphia: Holy Experiment*. New York: Doubleday, Doran, 1945.

CAMPOS, JULES. *The Sculpture of José de Creeft*. New York: Da Capo, 1972.

CONTRERAS, BELESARIO R. *Tradition and Innovation in New Deal Art*. Lewisburg: Bucknell University Press, 1983.

CRET, PAUL. "The Fairmount Parkway and the Schuylkill Banks as a Site for the Proposed World Fair." In *Fairmount Park Art Association Annual Report*, 1921.

DEWEY, JOHN. *Art As Experience*. New York: Capricorn Books, 1934.

DONOHOE, VICTORIA. "Swann Fountain." In *Sculpture of a City: Philadelphia's Treasures in Bronze and Stone*. New York: Walker, 1974.

ELSEN, ALBERT E. *Origins of Modern Sculpture: Pioneers and Premises*. New York: Braziller, 1974.

———. *Rodin's Thinker and the Dilemmas of Modern Public Sculpture*. New Haven: Yale University Press, 1985.

FEDERAL WRITERS PROJECT. *Philadelphia: A Guide to the Nation's Birthplace*. Philadelphia: William Penn Association of Philadelphia, 1937; reprint ed. *(The WPA Guide to Philadelphia)*, Philadelphia: University of Pennsylvania Press, 1988.

GALLERY, JOHN ANDREW, AND RICHARD SAUL WURMAN. *Man-Made Philadelphia*. Cambridge: MIT Press, 1972.

GRÉBER, JACQUES. "Beginnings of the Parkway." In *Fairmount Park Art Association Annual Report*, 1962.

HALL, CHARLES B. "The Beautification of the Banks of the Schuylkill as Most Essential for the City Beautiful." In *Fairmount Park Art Association Annual Report*, 1926.

HULTEN, PONUS; NATALIA DUMITRESCO; AND ALEXANDRA ISTRATI. *Brancusi*. New York: Abrams, 1987.

INGERSOLL, R. STURGIS. "The Ellen Phillips Samuel Memorial." In *Sculpture of a City: Philadelphia's Treasures in Bronze and Stone*. New York: Walker, 1974.

JACOBSON, THORA. "History of the Sanctuary and the Samuel S. Fleisher Art Memorial." Manuscript, 1988.

KAHN, LOUIS I. Letter to Samuel S. Fleisher Art Memorial, December 4, 1973.

KELLY, ELLSWORTH. Statement accompanying exhibition at the Betty Parsons Gallery, 1959.

LARSON, GARY O. *The Reluctant Patron: The United States Government and the Arts, 1943–1965.* Philadelphia: University of Pennsylvania Press, 1983.

LARTER, ROBERT E., File. Textual Records of the Section of Fine Arts. National Archives and Records Administration, 1936–1938. Series 134, Record Group 121. Washington, D.C.

LONGSTRETH, EDWARD. *The Art Guide to Philadelphia, Being a Complete Exposition of the Fine Arts in Museums, Parks, Public Buildings, and Private Institutions in America's Oldest Metropolis.* Philadelphia: Edward Longstreth, 1925.

LUCIE-SMITH, EDWARD. *Art of the 1930s: The Age of Anxiety.* New York: Rizzoli, 1985.

MANSHIP, PAUL. "The Sculptor at the American Academy in Rome." *Art and Archeology* 19 (1925): 89–92.

"Milles, Hancock Lead Straw Vote." *Public Ledger*, May 28, 1933.

MITCHELL, ROBERT B. "Physical Development of Philadelphia." In *Fairmount Park Art Association Annual Report*, 1946.

MUMFORD, LEWIS. "Urban Planning for War and Peace." In *Fairmount Park Art Association Annual Report*, 1942.

O'CONNOR, FRANCIS V., ed. *Art for the Millions: Essays from the 1930s by Artists and Administrators of the WPA Federal Art Project.* Greenwich, Conn.: New York Graphic Society, 1973.

PARK, MARLENE, AND GERALD E. MARKOWITZ. *Democratic Vistas: Post Offices and Public Art in the New Deal.* Philadelphia: Temple University Press, 1984.

Press Report 3rd Sculpture International. 1949. Fairmount Park Art Association Archives, Historical Society of Pennsylvania.

PROSKE, BEATRICE. *Brookgreen Gardens: Sculpture.* Brookgreen, S.C.: Brookgreen Gardens, 1968.

RHODES, HARRISON. "Who Is a Philadelphian?" *Harpers' Monthly Magazine*, June 1916, pp. 1–13.

ROBBINS, DANIEL. "Statues to Sculpture: From the Nineties to the Thirties." In *200 Years of American Sculpture.* New York: David Godine/Whitney Museum of American Art, 1976.

SAARINEN, ALINE B. "The Strange Story of Brancusi." *New York Times Magazine*, October 23, 1955.

"70 Sculptors 70." *Life*, June 20, 1949.

SHARPE, LEWIS. "The Smith Memorial." In *Sculpture of a City: Philadelphia's Treasures in Bronze and Stone.* New York: Walker, 1974.

SIMS, PATTERSON, AND EMILY RAUH PULITZER. *Ellsworth Kelly: Sculpture.* New York: Whitney Museum of American Art, 1982.

TAFT, LORADO. "Public Monuments." In *Fairmount Park Art Association Annual Report*, 1924.

TANCOCK, JOHN. "Social Consciousness." In *Sculpture of a City: Philadelphia's Treasures in Bronze and Stone.* New York: Walker, 1974.

———. "The Gates of Hell." In *Sculpture of a City: Philadelphia's Treasures in Bronze and Stone.* New York: Walker, 1974.

———. "*Prometheus Strangling the Vulture* and *The Spirit of Enterprise.*" In *Sculpture of a City: Philadelphia's Treasures in Bronze and Stone.* New York: Walker, 1974.

———. *The Sculpture of Auguste Rodin: The Collection of the Rodin Museum, Philadelphia.* David R. Godine/Philadelphia Museum of Art, 1976.

THOMAS, GEORGE. "Art Deco Architecture and Sculpture." In *Sculpture of a City: Philadelphia's Treasures in Bronze and Stone.* New York: Walker, 1974.

THOMAS, WALTER. "Recreation and the City Plan." In *Fairmount Park Art Association Annual Report*, 1936.

WATTENMAKER, RICHARD J. *Samuel Yellin in Context.* Flint, Mich.: Flint Institute of Arts, 1985.

WHITMAN, WALT. *Complete Poetry and Selected Prose*, edited by James E. Miller, Jr. Boston: Houghton Mifflin, 1959.

YELLIN, SAMUEL. *Transcript of a lecture given before the Architectural Club of Chicago. 1925.* Philadelphia, Yellin Archives.

ZIEGET, IRENE N. *History of the Samuel S. Fleisher Art Memorial.* Philadelphia: Samuel S. Fleisher Art Memorial, 1963.

Chapter 5

"Art-in-Architecture Procedures." April 13. Washington, D.C.: Public Building Service, General Services Administration, 1989.

BACON, EDMUND N. "Introduction." In *Art for the City.* Philadelphia: Institute of Contemporary Art, 1967.

BAXTER, AUGUSTUS, AND WILLIAM CHAPMAN. "Community Designing with People—The Work of the Architects' Workshop." In *Fairmount Park Art Association Annual Report*, 1970.

BEARDSLEY, JOHN. *Art in Public Places: A Survey of Community Sponsored Projects Supported by the National Endowment for the Arts.* Washington, D.C.: Partners for Livable Places, 1981.

BROWNLEE, DAVID B., AND DAVID G. DE LONG. *Louis I. Kahn: In the Realm of Architecture.* Los Angeles: Museum of Contemporary Art; New York: Rizzoli, 1991.

D'HARNONCOURT, ANNE. "*Three-Way Piece Number 1: Points.*" In *Sculpture of a City: Philadelphia's Treasures in Bronze and Stone.* New York: Walker, 1974.

DALI, SALVADOR. *Dali on Modern Art.* Translated by Haakon M. Chevalier. New York: Dial, 1957.

FERRER, RAFAEL. Comments in *Christo Wraps a Staircase: Ferrer Deflects a Fountain.* Philadelphia: Philadelphia Museum of Art, 1970.

FORGEY, BENJAMIN. "A New Vision: Public Places with Sculpture." *Smithsonian*, October 1975, p. 5.

FREDENTHAL, ROBINSON. Comments in "Sculptor Robinson Fredenthal Has Cosmic Yo-Yo of a Show." *The Columns* (Philadelphia Colleges of the Arts) 3, no. 1 (1987).

GLUECK, GRACE. "Philadelphia Shows Way-Out Sculpture in Public Places." *New York Times*, January 28, 1967.

GOODYEAR, FRANK H., JR. *Contemporary American Realism Since 1960.* Boston: New York Graphic Society/Pennsylvania Academy of the Fine Arts, 1981.

GREENBERG, JOSEPH, JR. Telephone interview with author, March 7, 1990.

HEDGECOE, JOHN, ed. *Henry Spencer Moore.* New York: Simon and Schuster, 1968.

HULTEN, PONUS; NATALIA DUMITRESCO; AND ALEXANDRA ISTRATI. *Brancusi.* New York: Abrams, 1987.

INGERSOLL, R. STURGIS. *Recollections of a Philadelphian at Eighty.* Philadelphia: National Publishing Co., 1971.

LIPCHITZ, JACQUES. *My Life in Sculpture.* Documents of Twentieth Century Art, ed. H. H. Arnason. New York: Viking, 1972.

LUCIE-SMITH, EDWARD. *Movements in Art Since 1945.* Rev ed. New York: Thames and Hudson, 1984.

Credits

153

Human Puzzle
Courtesy of Phillips Simkin

STEAMSHUFFLE: Philadelphia
Steamshuffle © Joan Brigham/Christopher Janney © 1981–1987
Photographs: Rachael Katz (day) and Gary McKinnis (night)

154-155

Clothespin
Photograph: Howard Brunner

156

Percent for Art Proposal
Collection Claes Oldenburg and Coosje van Bruggen
Photograph: Dorothy Zeidman, New York City

157

Untitled
Photograph: Howard Brunner

158

White Cascade
Photograph: Howard Brunner

Starman in the Ancient Garden
Photograph: Howard Brunner

159

Bicentennial Dawn
Photograph: Howard Brunner

160

Voyage of Ulysses
Photograph: Gary McKinnis

161

Clothespin
Photograph: Howard Brunner

Design compared to Brancusi's *Kiss*
Philadelphia Museum of Art; gift of the Friends of the Philadelphia Museum of Art

162

Ghost Structures
Photograph: Howard Brunner

Nesaika
Photograph: Howard Brunner

163

Columbia Subway Plaza
Photograph: Howard Brunner

Total Environment
Photograph: Howard Brunner

164

Synergy
Photograph: Howard Brunner

Aurora Window, Canopy, and Sconces
Photograph: Howard Brunner

165

LOVE
Photograph: Gary McKinnis

166

Woman Looking Through a Window
Photograph: Gary McKinnis

167

Eastwick Farm Park
Photograph: Gary McKinnis

168

El Gran Teatro de la Luna
Photograph: Gary McKinnis

Louis Kahn Lecture Room
Fairmount Park Art Association Archives
Photograph: Rick Echelmeyer

169

Fingerspan
Fairmount Park Art Association Archives
Photographs: Wayne Cozzolino

170

Rising Sun
Photograph: Gary McKinnis

Una Biforcazione e Tre Paesaggi
Photograph: Gary McKinnis

Transient Earth Structure
Marsha Moss, Sculpture Outdoors
Photograph: Joseph Nettis

171

Measure and Profile
Marsha Moss, Sculpture Outdoors
Photograph: Peter Odell

Going Green
Marsha Moss, Sculpture Outdoors
Photograph: Gary McKinnis

172

Philadelphia Cornucopia: Washington's Ship of State
Institute of Contemporary Art, University of Pennsylvania
Photograph: Eugene Mopsick

Philadelphia Cornucopia: Victorian Life Drawing Class
Institute of Contemporary Art, University of Pennsylvania
Photograph: Eugene Mopsick

Philadelphia Cornucopia: Peale Dining in the Ribcage of a Mastodon
Institute of Contemporary Art, University of Pennsylvania
Photograph: Eugene Mopsick

173

Riverwalk at Piers 3 and 5
Photograph: Howard Brunner

Philadelphia Now and Then
Photograph: Gary McKinnis

Philadelphia Cornucopia: On the Schuylkill
Fairmount Park Art Association Archives

Painted Relief
Photograph: Gary McKinnis

174

Twin sisters posing for *Community Mural*
Collection of Penny Balkin Bach; courtesy of the Philadelphia Museum of Art
Photograph: Patrick Radebaugh

Community Mural
Collection of Penny Balkin Bach; courtesy of the Philadelphia Museum of Art
Photograph: Patrick Radebaugh

175

Playtime
Photograph: Gary McKinnis

Julius Erving Monument
Photograph: Gary McKinnis

176

Ile-Ife Park: The Village of Arts and Humanities
Courtesy of Lily Yeh

177

We the Youth
Brandywine Workshop
Photograph: Donnie Roberts

178

Diana
Philadelphia Museum of Art; gift of the New York Life Insurance Company

Swann Memorial Fountain
Photograph: Howard Brunner

Joan of Arc
Photograph: Howard Brunner

179

Artist Thomas Schomberg and Sylvester Stallone with model for *Rocky*
Courtesy of the Philadelphia Museum of Art
Photograph: Mort Bond

City Hall
Photographs: Howard Brunner

180

Nandi
Photograph: Gary McKinnis

181

Five Water Spouts, Frog, and Lintel
Photograph: Howard Brunner

Penn's Light
Fairmount Park Art Association Archives

182

Benjamin Franklin Bridge Lighting
Venturi, Scott Brown and Associates, Inc.
Photograph: Matt Wargo

183

Proposal for *Four New Squares and a Garden for Every Lot*
CertainTeed Award for City Visions, The Foundation for Architecture, Philadelphia

184

Three-Way Piece Number 1: Points
Photograph: Howard Brunner

185

Styrofoam replica of *Three-Way Piece Number 1: Points*
Fairmount Park Art Association Archives
Photographs: Gary McKinnis

186

Public Center for the Collection and Dissemination of Secrets
Collection of Phillips Simkin; courtesy of the Institute of Contemporary Art, University of Pennsylvania

Signs
Collection of Paula Marincola; courtesy of Collaborations, Inc.
Photograph: Ron Walker

187

Video Arbor
Redevelopment Authority of the City of Philadelphia
Photograph: Tom Crane

Neons for Buttonwood
Photograph: Gary McKinnis

188

Sleeping Woman
Photograph: Gary McKinnis

189

Sleeping Woman
Photograph: Gary McKinnis

190

All Wars Memorial
Fairmount Park Art Association Archives
Photographs: Franko Khoury

William Penn
Courtesy of Moorland Studios
Photograph: Barbara L. Johnston

190-191

Abraham Lincoln
Fairmount Park Art Association Archives
Photographs: Franko Khoury

192-193

Eye and Hand
Photograph: Howard Brunner

Illustration Credits for the Catalog

Howard Brunner: 1-03, 1-11, 2-01, 2-04 *to* 2-07, 2-18, 2-19, 2-21, 2-27, 3-01, 3-03, 3-10, 3-11, 3-13, 3-16, 3-18, 3-20, 3-22, 3-25, 3-28, 3-35 *to* 4-03, 4-05, 4-08, 4-13, 4-14, 4-16, 4-20, 4-21, 4-24, 4-34, 4-37, 4-38, 4-47, 4-48, 4-53, 4-55, 4-66 *to* 4-68, 4-70, 5-12, 5-15, 5-16, 5-18, 5-19, 5-26, 5-29, 6-02, 6-04, 6-05, 6-08, 6-13, 6-15, 6-16, 6-44, 6-48, 6-52, 6-56, 6-61, 6-62

The Children's Hospital of Philadelphia: 4-22

Fairmount Park Art Association Archives; *photograph by Wayne Cozzolino:* 6-55

Fairmount Park Art Association Archives; *photograph by Rick Echelmeyer:* 6-33

Fairmount Park Art Association Archives; *photograph by Gary McKinnis:* 6-32

Gary McKinnis: 1-01, 1-10, 2-08, 2-11 *to* 2-16, 2-20, 2-23 *to* 2-26, 3-04 *to* 3-09, 3-12, 3-15, 3-17, 3-19, 3-21, 3-23, 3-24, 3-26, 3-29 *to* 3-31, 3-33, 3-34, 4-04, 4-06, 4-07, 4-11, 4-12, 4-15, 4-18, 4-19, 4-22, 4-23, 4-25 *to* 4-33, 4-35, 4-36, 4-39, 4-46, 4-49, 4-50, 4-51, 4-56 *to* 4-65, 4-69, 5-01 *to* 5-04, 5-06, 5-07, 5-11, 5-14, 5-20 *to* 5-25, 5-27, 5-28, 6-01, 6-03, 6-06, 6-07, 6-10 *to* 6-12, 6-14, 6-17 *to* 6-32, 6-34 *to* 6-37, 6-39 *to* 6-43, 6-45 *to* 6-47, 6-49 *to* 6-51, 6-53, 6-57 *to* 6-60, 6-64

Courtesy of Moore College of Art; *photograph by Gary McKinnis:* 5-04

Office of the City Representative, City of Philadelphia; *photograph by Richard McMullin:* 3-02

Redevelopment Authority, City of Philadelphia; *photograph by Tom Crane:* 6-63

Redevelopment Authority, City of Philadelphia; *One Reading Center Associates* © *1985:* 6-45

Venturi, Scott Brown and Associates, Inc.; *photograph by Matt Wargo:* 6-54

Text Credits for the Catalog

Doug Gordon: 1-10, 2-01, 2-05 *to* 2-07, 2-11, 2-14, 2-25, 2-27, 3-01, 3-02, 3-05, 4-01, 4-02, 4-12 *to* 4-14, 4-16, 4-21, 4-23 *to* 6-63

Deenah Loeb: 1-01 *to* 4-22 (except those listed above)

Acknowledgments

This publication has benefited from the interest, support, and cooperation of many people. I would particularly like to thank The William Penn Foundation and Dr. Bernard Watson for supporting the project and for giving me the opportunity to make many discoveries, and David Bartlett, Charles Ault, and David Updike of Temple University Press. I had always wanted to work with Joel Katz and Katz Design Group, and the Foundation and Press made this possible. Jane Barry's advice, skill, and stable temperament brought the manuscript to press and me to my senses. Special gratitude is extended to Doug Gordon and Deenah Loeb for their research and writing of the Catalog entries.

Photographers Howard Brunner and Gary McKinnis brought their considerable talents to this project, maintaining persistent good humor. Their work was divided, more or less, according to individual interests and strengths, Brunner concentrating on details and materials, and McKinnis photographing most of the works in the Catalog in their architectural and landscaped settings. Bernie Cleff, Wayne Cozzolini, Franko Khoury, Rick Echelmeyer, and Patrick Radebaugh kindly made individual photographs available for our use.

The staff of the Fairmount Park Art Association have given generously of their time and enthusiasm. Particular thanks are due to Laura Griffith and Naomi Nelson for their endless devotion to various aspects of manuscript development and to the details associated with photographic research and permissions, and to Ginger Osborne for her capable work on manuscript preparation. Elizabeth Holland, Sheila Kessler, Allison Rudesyle, and Margot Berg all provided research assistance. It was they who tracked down the answers to seemingly infinite questions regarding artists' biographies and other such details. Randy Dalton conducted site visits to verify measurements and specifications. Deenah Loeb supervised the initial design of the inventory of Philadelphia's public art works, working with researchers Naomi Nelson, Heidi Nivling, Rebecca Strong, and Diane Mallos.

My great admiration is extended to the scholars who contributed to the Art Association's 1974 publication, *Sculpture of a City: Philadelphia's Treasures in Bronze and Stone*, a work that continues to be a landmark and an important reference. Leslie Gallery generously shared information about the Foundation for Architecture's 1984 guidebook, *Philadelphia Architecture*. Oliver Franklin, then Deputy City Representative for Arts and Culture, was a vociferous advocate for this project.

Colleagues at primary research institutions and commissioning agencies were most supportive and generous with their time: Sandra Gross Bressler at the city's Art Commission, Mary Kilroy at the Redevelopment Authority's Fine Arts Program, and Linda Stanley at the Historical Society of Pennsylvania. Among the many people who helped us, special thanks are extended to the staff at the Atwater Kent Museum; Joseph DiRese, Jr., Harvard C. Wood II, and the late John Francis Marion, who provided information about Laurel Hill Cemetery; Dick Nicolai, information officer, and John McIlhenny, historian, from the Fairmount Park Commission; librarian Marietta Bushnell and archivist Cheryl Leibold at the Pennsylvania Academy of the Fine Arts; Barbara Sevy from the Philadelphia Museum of Art Library; Kenneth Finkel and Susan Oyama at The Library Company; and Marsha Moss, Sculpture Outdoors. Many institutions and individuals loaned materials for publication, and many artists and their descendants were most generous and shared detailed information with us.

I would like to thank those who spoke freely with me to cast some light on the origins of Philadelphia's percent for art programs: the late Joseph Greenberg, Jr., Michael von Moschizker, Henry Sawyer, and Edmund Bacon. Helping me figure out other pieces of the puzzle were Charles L. Blockson, whose Afro-American Collection is housed at Temple University, and Steve Warfel, Curator of Archaeology at the Pennsylvania State Museum.

I would like to express my deepest gratitude to the Board of Trustees of the Fairmount Park Art Association for their trust and understanding when many other matters were put aside as I planned the book and worked on the manuscript. Particular thanks are extended to President Charles E. Mather III and Treasurer Theodore T. Newbold, as well as the other distinguished members of the Board: Anne d'Harnoncourt, Jennie Dietrich, Frank H. Goodyear, Jr., Gregory M. Harvey, J. Welles Henderson, H. Gates Lloyd III, Noel Mayo, G. Holmes Perkins, David Pincus, Philip Price, Jr., Richard Ravenscroft, Henry W. Sawyer III, Ana D. Thompson, William P. Wood, and C. Clark Zantzinger, Jr.

Finally, and most important, I would like to acknowledge my parents, Rose and Charles Balkin, who made certain that every Sunday of my childhood, rain or shine, like it or not, my cousins and I visited a different cultural institution in Philadelphia, and my son, Alexander, who inherited this family tradition.

286

Author
PENNY BALKIN BACH

Coordinating Organization
FAIRMOUNT PARK ART ASSOCIATION

Photography
HOWARD BRUNNER
GARY MCKINNIS

Catalog
DOUG GORDON
DEENAH LOEB

Manuscript editor
JANE BARRY

Research assistance
ELIZABETH HOLLAND
SHEILA KESSLER
DEENAH LOEB

Photographic research
LAURA GRIFFITH
NAOMI NELSON

Manuscript preparation
GINGER OSBORNE

Publisher
DAVID M. BARTLETT

Katz Design Group
JOEL KATZ
CHANDRA DEIBLER
DAVID E. SCHPOK
RITA S. COHEN

Production director
CHARLES AULT

Production assistance
DAVID UPDIKE

Composition
MONOTYPE COMPOSITION COMPANY

Printing
STRINE PRINTING COMPANY, INC.

This book was composed in Walbaum, Garamond 3, and Univers typefaces. It was printed on 100# Cham Tenero paper and bound in Scholco Rainbow book cloth.